Apache
Indian
Baskets

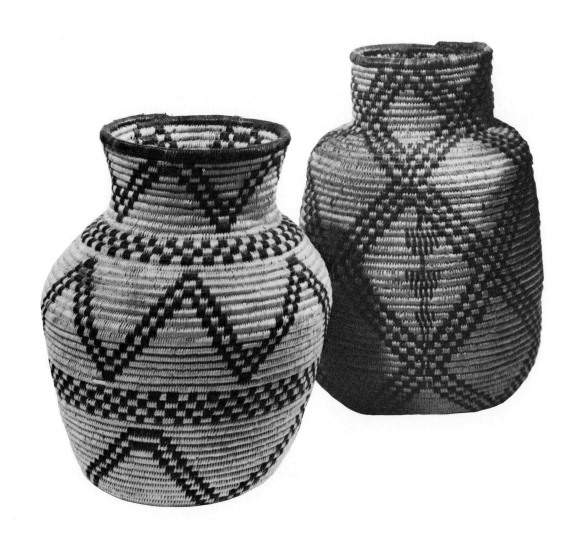

Clara Lee Tanner

Apache
Indian
Baskets

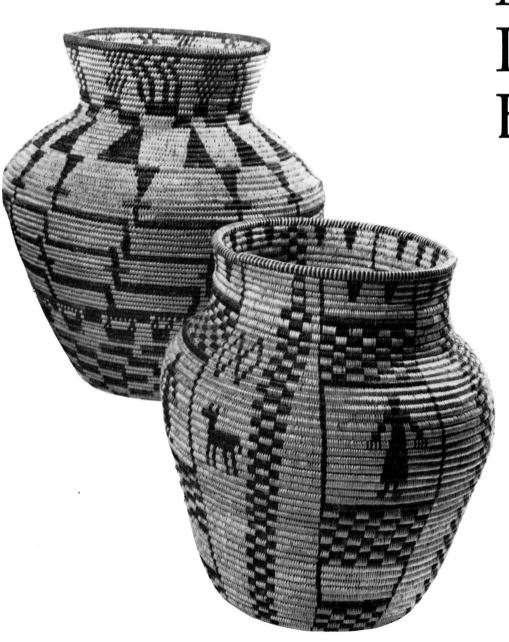

THE UNIVERSITY OF ARIZONA PRESS, TUCSON, ARIZONA

About the Author...

CLARA LEE TANNER is the author of *Southwest Indian Craft Arts, Southwest Indian Painting,* and *Prehistoric Southwestern Craft Arts,* as well as of many articles on Indian arts, crafts, and religion. A member of the Anthropology Department of the University of Arizona since 1928, she has traveled extensively among the Indians of the Southwest and has frequently served as a jury member for Indian craft and painting shows.

Details of the frontispiece: from left, a rounded form with alternating horizontal bands and deep zigzags (ASM E2803); a straight-sided formless jar with a network pattern (ASM GP4313); horizontal design and partially diagonal arrangement on a pleasing shouldered form (ASM 9091); and a very wide-necked jar with vertical design arrangement (ASM E7359). Western Apache baskets. (*Photo by Helga Teiwes*)

Sources of photographs, with abbreviations used in this work: AF, Amerind Foundation, Dragoon, Arizona; AHS, Arizona Historical Society, Tucson; ASM, Arizona State Museum, University of Arizona (Helga Teiwes, photographer), Tucson; D.H.C., Desert House Crafts, Tucson; LA, Laboratory of Anthropology, Museum of New Mexico Collections, Santa Fe; SAR, School of American Research, Santa Fe; WAC, Western Archeological and Conservation Center, National Park Service (Helga Teiwes, photographer), Tucson.

THE UNIVERSITY OF ARIZONA PRESS

Copyright © 1982
The Arizona Board of Regents
All Rights Reserved

This book was set in 12/13 pt. V-I-P Trump
Manufactured in the U.S.A.

Library of Congress Cataloging in Publication Data
Tanner, Clara Lee.
 Apache Indian baskets.

 Bibliography: p.
 Includes index.
 1. Apache indians—Basket mak-
ing. 2. Indians of North America—
Southwest, New—Basket making.
E99.A6T25 746.41'2'08997 82-6920
ISBN 0-8165-0778-3 AACR2

To Dorothy Inslee

Contents

APACHE INDIANS have long been basket weavers, as indicated in the first significant references to Western Apache production in this craft early in the 1860s. Excavated materials would push this date back some decades if not several centuries. That this craft still lives is apparent in limited weaving among all Apaches, and in a brisk production of San Carlos burden baskets which reveals continued creativity in the first use of life forms in these pieces in the early 1980s.

The earliest publications on Apache basketry are by explorers or army men and a few others who usually said little more than that a given group of Indians made basketry vessels, sometimes adding a tantalizingly short reference to forms, or weaves, or designs, but little more. Then came the 1904 report by Otis T. Mason on *Aboriginal American Basketry,* with a little specific technological information about and a few illustrations of Apache baskets.

Unquestionably, the best publication on this craft art has been Helen H. Roberts' 1931 *Basketry of the San Carlos Apache Indians,* which represented the results of her 1916–17 research on collections of baskets of this Western Apache group. Short scholarly articles on some aspects of this Apache craft preceded and followed Roberts' report. Additional important publications of the 1970s and 1980s include a few scholarly reports plus several well-illustrated books on basket collections, Museum exhibit and auction catalogs, and articles in popular magazines.

A comprehensive coverage of the basketry of all southwestern Apaches has been needed, and this book is my attempt to answer this need. It is based on research involving hundreds of baskets of all these groups—San Carlos, White Mountain, Jicarilla, and Mescalero Apaches. Most of the research has been concerned with museum or private collections or with those in trading posts or at special exhibits. Historic developments have been covered with individual baskets dating from at least the 1870s (some possibly earlier) into the 1980s.

Analyses have been made for each tribal style, based on such matters as design layout, basic elements, and motifs, and the nature of decoration in different techniques and on multitudinous forms. Similarities and differences among the baskets of the four major Apache groups are stressed. Withal, the major artistic characteristics of baskets of these groups have been delineated.

A NOTE OF THANKS

Acknowledgments are always a pleasure to write, for private individuals and institutions are eternally gracious and cooperative when asked for the privilege of researching their collections. Among the many collections where baskets were studied over the years were those at the Arizona State Museum (Ellen Horn, Diane Dittemore, and Michael Jacobs), Arizona Historical Society, Western Archeological Center, Desert House Crafts, and Morning Star Traders, all in Tucson. Other Arizona collections of note include those at Heard Museum and the State Capitol Archives and Museum, Phoenix; Amerind Foundation, Dragoon; Museum of Northern Arizona, Flagstaff; and the E. E. Guenther Collection, Whiteriver. Additional Arizona traders whose collections were studied include Bowser's Indian Shop, Casa Grande; Reservation Crafts Trading Post, Window Rock; San Carlos Trading Post, and Lois Fain, Trader, both at San Carlos; Tanner Indian Arts and Woodard's Indian Arts in Scottsdale; Jerold Collings, Paradise Valley; Hubbell's Trading Post, Ganado; Bruce McGee Trading Post, Keams Canyon; Don Hoel and Garlands, both in Sedona; Peridot Trading Post, Peridot; and D. R. Truax Trader, Forestdale.

Among the many fine Apache basket collections researched in New Mexico are those of the Museum of New Mexico, Laboratory of Anthropology, Wheelwright Museum, School of American Research, and particularly the Indian Arts Fund Collection, and Dewey-Kofron (Traders), all in Santa Fe. Other New Mexican traders and museums include Tobe Turpin, Gallup; C. G. Wallace at Zuñi; Russell Fouts, Farmington; Mescalero Apache Cultural Center, Mescalero; and the Carlsbad Municipal Museum, Carlsbad. Very fine collections were worked on at the Southwest Museum, Los Angeles, California; the Denver Art Museum at Denver, Colorado; and the Taylor Museum, Colorado Springs, Colorado. Exhibits also often bring together fine collections of baskets; such has been the case through the years with the Gallup Intertribal Indian Ceremonial Association, Gallup, New Mexico; O'Odham Tash, Casa Grande, Arizona; Scottsdale Annual Indian Arts Show, Scottsdale, Arizona; and the Arizona State Fair, Phoenix. Private collections abound, and, in fact, many of the owners of these prefer to remain anonymous. However, I want to mention especially the very interesting Mescalero baskets of the Arthur Blazers, Mescalero, New Mexico.

One of this book's merits is the outstanding photography by Helga Teiwes of the Arizona State Museum. Another is the assembly of excellent drawings by Chris Van Dyke in Chapter 3; the sketches show every stitch in each design unit or motif. These drawings were made possible by a grant from the University of Arizona Foundation, at the University of Arizona, Tucson. I am most grate-

ful to both, for without the grant these exceptional drawings would not have come to life.

In writing a manuscript, there are those who stand by, willing to give limitless time and energies. Dorothy Inslee typed most of the original pages, Carol Gifford made presentable the final copy for the Press, Virginia Sonett performed many tedious tasks, and my husband John contributed in innumerable ways to the completion of the manuscript. To these and others—my most grateful thanks.

As always, the University of Arizona Press, and most particularly Marshall Townsend, director, Elizabeth Shaw, assistant director, Marie Webner, my editor for this manuscript, and Francis Morgan, book designer, made happy work of many details which could have been tedious. To all four my deepest appreciation.

CLARA LEE TANNER

Prehistoric and Historic Background

T HE SOUTHWEST is that portion of the United States which includes Arizona, New Mexico, Colorado, and Utah, plus small sections of the adjoining states, California, Texas, and Nevada. Archaeologically and ethnologically, northern Mexico could also be included. Through prehistory and history, this area has been extended or compressed according to the movements of the people occupying the territory. For perspective in the major part of this study, the states of Arizona and New Mexico are preeminent, with adjoining sections of Colorado and Utah of some significance.

PREHISTORY

In the Southwest, one of the richest areas in North America in terms of continuous occupation, the story of man begins no later than 12,000 years ago. Hunters of big game wandered over the eastern portions of this area, with a few penetrating southern Arizona; seemingly, they disappeared when mammoths succumbed around 8,000 B.C. Occupying a vast and more westerly area, from Oregon into Mexico, were a simpler but also wandering folk who gathered native foodstuffs and hunted small game. It is likely that their food habits, particularly the gathering of grass seeds and other small produce, were responsible for their developments of basketry. Twined and coiled baskets were found at both Hogup[1] and Danger Caves[2] in northern Utah. In these ancient sites forms were simple, yet there were large and small trays and deep burden baskets. Except for rare and simple examples, design is absent in basketry at these early sites; however, Loud and Harrington found decorated wicker baskets at fairly early prehistoric levels in Lovelock Cave, Nevada.[3]

It is also significant that the usage of seeds by the gatherers and small gamesmen probably prepared them for the acceptance of corn as a cultivable product. At any rate, these folk gradually, over many hundreds of years, settled down in permanent communities. In time they are thought to have given rise to the three dominant cultures of prehistoric time in the Southwest, the Anasazi[4] in northern and

central parts of New Mexico and Arizona, Hohokam[5] in southern Arizona, and the Mogollon[6] in southern and southwestern New Mexico. Each culture spread out, with some overlapping, but by the time of historic contact in 1540, each had again withdrawn to more limited areas or, as distinct entities, had entirely abandoned the Southwest.

A brief summary of certain aspects of the culture of these three groups is pertinent to early Apache contacts in the Southwest. There was not only a probable general influence of one or several of these cultures on the Apachean groups as a whole but also, very likely, a more specific effect on the development of basketry by the Western and possibly some Eastern Apaches.

Hohokams and Mogollones appeared several centuries prior to the opening of the Christian era as small but settled, sedentary cultures, whereas Anasazi settlements were not in evidence until four or five centuries later. Eventually all three developed village life centered about the cultivation of corn, beans, and squash, along with varying types of hunting. All three built homes in the form of pit houses, the Hohokam preferring a shallow type which lingered among their presumed survivors, the historic Pima-Papago. In time, both the Mogollon and Anasazi folk abandoned their pit homes for multistoried, multiroomed pueblos, with direct-line descendants of the latter, the puebloans, continuing to reside in the same type of home to this day. Around 1350 Mogollon residences were abandoned; perhaps some of these people went into the Rio Grande Valley of north and central New Mexico and into western New Mexico–eastern Arizona to mix with already established puebloans; it is also possible that others went into Chihuahua, Mexico.

All of these prehistoric people were nature worshippers, to judge by what is found in their ruins plus what their survivors practice. They were greatly concerned with the sun, water, with Twin Gods and Mother Earth. Health was a problem met with religious rituals; ceremonies among the puebloans, and possibly the other two groups as well, involved the use of masks, perhaps sandpainting, certainly many dances. The two Athapascan groups, Navajos and Apaches, who came into the Southwest several centuries before the arrival of the Spaniards in 1540, surely were affected in diverse ways by many of these ideas. Both Apachean groups made sandpaintings in historic times, wore masks, were concerned with Twin War Gods, and developed rituals that were health oriented. The rich legends and myths of the puebloans are found in generous measure among both Apaches and Navajos.

All three prehistoric cultures, the Anasazi, Hohokam, and the Mogollon, developed crafts typical of simple village-dwelling folk. There is a strong likelihood that these people inherited stone tools and basketry and possibly simple weaving traditions from the earlier food gatherers. Later contacts from the south, possibly from as far as the Valley of Mexico, boosted weaving by way of the introduction of cotton and the loom, probably pottery, and possibly influenced other craft developments. The more southerly locations of the Mogollon and Hohokam no doubt account for the earlier effect of these introduced culture traits on them, but eventually most of these influences reached the Anasazi as well.

It would be profitable at this point to say a word or two further regarding basketry in the prehistoric Southwest. The earliest phases of development in the Anasazi have been labeled "Basketmaker" by the archaeologist, and for good reason. The first definitely known of these, the Basketmaker II people, produced baskets which were already developed both technically and artistically, possibly an inheritance from their predecessors, the seed gatherers. A short time later, Basketmaker III people were weaving some of the finest and certainly the most artistic baskets known during prehistory. The three basic techniques, coiled, wicker, and plaiting, were developed by them; designing reached a peak in the use of black and red patterns on natural grounds. Complex geometric patterns were built on the line, squares, rectangles, triangles, steps, plus others, and on endless combinations of several or many of these; rare life themes were beautifully executed. Bowls, trays, jars, burden baskets, and other miscellaneous forms were produced. The later Anasazis, or puebloans, were not so adept in designing, but they did carry on and excel in all three techniques, particularly in coiled ware. Among other traits should be mentioned a three-rod foundation coiled style known to and highly developed by the puebloans, with many baskets of this type, particularly the tray, found archaeologically.[7] This style was also known to the later Mogollones; examples of their coiled baskets have been found preserved in caves of southeastern Arizona and southwestern New Mexico.[8] Whether the Apaches borrowed this technique of basket weaving and the tray form from the Anasazi or the Mogollon, or neither or both, remains a moot point.

As the puebloans evolved out of the Basketmakers and as they increased in population, it is quite likely that they shoved some of the people of the latter culture into peripheral areas. Some archaeologists believe that historic Ute and Paiute tribes may be lingering Basketmakers. Whether or not this can be proved, there is no doubt about the facility of these two tribes in the basketry craft. They, too, have carried on technologies and forms developed by their presumed ancient ancestors, and they seem to have passed some of them on to the Navajos of northern Arizona and New Mexico and perhaps to some of the Apaches, particularly the Jicarillas of northern New Mexico.

HISTORIC DEVELOPMENTS

When the Athapascan-speaking Apaches and Navajos arrived in the Southwest some time between 1000 and 1500, they met widespread populations. Some of these native peoples, such as the puebloans, were still at a high level of cultural expression. The nature of the contacts remains something of a mystery, but that contacts existed cannot be doubted. Roberts implies that the style comparable to Apache three-rod coiled ware came from Basketmaker plus later widespread pueblo tradition.[9]

Navajos settled in the eastern San Juan drainage of northwestern New Mexico, eventually to push westward into Arizona. Apaches, on the other hand, seem to have entered southern New Mexico first, spreading into southern Arizona; by 1500 they were to be found

from northwest Texas to central Arizona[10], and, on occasion, some drifted into Mexico. There was much shifting about of Apache populations through the years, partly due to the arrival of Spaniards in 1540 and Anglo-Americans early in the nineteenth century. At least some Spaniards contacted some Apaches first, then the Navajos later on, for they referred to the latter as Apaches "de Navahu."

After Spanish contact and the acquisition of the horse, there followed a two-hundred-year period of lucrative raiding on the part of the Apaches, well over the Southwest, into Plains territory, and into Mexico. During these years and as part of the raiding business, the Apaches took a number of other tribespeople into their groups, often marrying them, thus becoming a mixed type physically and undoubtedly adding many new items to their own culture. Efforts to subdue the Apaches were more successful after the arrival of more Anglos about 1850; however, it was not until Geronimo surrendered in 1886 that peaceful relationships were established in the West. In the 1848 Treaty of Guadalupe Hidalgo the United States acquired from Mexico all of the Southwest except southern Arizona; in 1854, the Gadsden Purchase added this last small area, and, along with both, more Apaches.

Shortly after this, the "Reservation Policy" was established, with Navajos placed on theirs in northern New Mexico–Arizona in 1868. Jicarilla Apaches were located in northern New Mexico in 1887 (Fig. 1.1) after living with the Mescalero for four years, and the Mescalero Reservation was set up in south-central New Mexico in 1873. Both of the Apache groups are constituted of mixed subtribes. Two reservations were set up in east-central Arizona where the now-designated Western Apache were established; to the north, the White Mountain Fort Apache Reservation (Whiteriver), in 1871 by an act of Congress and, in 1872, by a similar executive order, the San Carlos Reservation which joins the first on the south. On the first Arizona Reservation are the Northern and Southern Tonto, Cibecue, and several White Mountain subtribes. On the southern Reservation are the San Carlos Apaches. There are also some Apaches mixed with Yavapais on the Camp Verde Reservation as well as some members of the Apache tribe on the Fort McDowell Reservation near Phoenix.

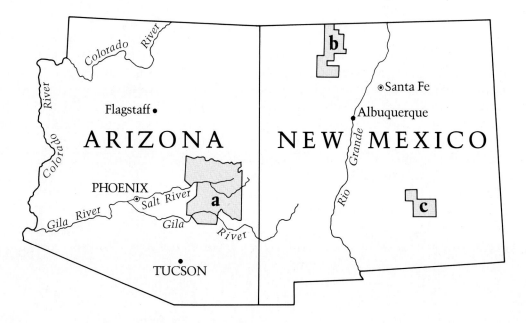

Fig. 1.1. Apache Indian Reservations: (a) Western Apache, (b) Jicarilla Apache, (c) Mescalero Apache.

Western Apaches

Despite their raiding, the Western Apaches practiced some farming;
also they did much hunting and gathering as major means of subsistence, these pursuits varying in degree among the different bands of
the Western Apaches. There were many bands among these Indians,
each guided by an individual leader or chief who was chosen for his
hunting abilities, his prowess in war, oratorical ability, and frequently for his wealth. Seemingly, their social and political organization was based on a grouping of family clusters or matrilocal
extended families; there were also cooperative groups for various
economic and other tasks. Local groups were made up of bands, and
in turn each of the Western subtribes was composed of from two to
four bands.

Western Apaches lived in single-family homes called wickiups;
these were circular rooms partially excavated into the ground, with
a timber-brush covering, and a smoke hole in the center top. The
floor was of earth; there was a central fire pit and often a raised
section on one side serving as a spot for a bed. Furnishings were
conspicuous by their absence, but the ever-present basket was to be
noted both inside (Fig. 1.3) and outside the wickiup or other structure, such as a shade. A half-dozen of these homes, more or less,
formed a "camp" (Fig. 1.2). Into the 1930s or in some locales until
a later date, this was the typical Apache settlement pattern.

In earlier years and in varying degrees among the three main
Apache groups basketry about the average home would include
from several to a fair number of trays, to be used both indoors and
outside for multiple purposes. The water jar, often a smaller one,
was filled by the woman at the nearby creek, usually emptied into a
large tus about the home or in the shade of a nearby tree. If traveling, the Apache woman took her "belongings" in her burden basket,

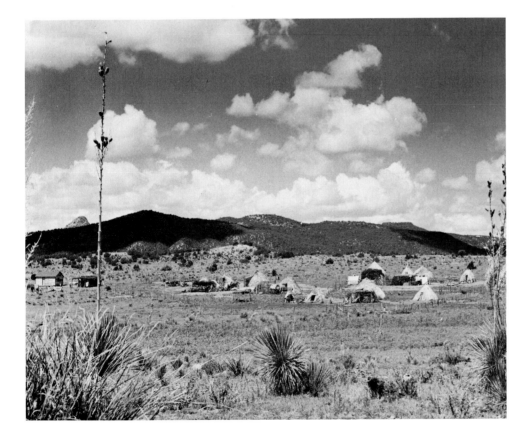

Fig. 1.2 *(left).* Western Apache
camp, about 1940. A camp
consisted of a half-dozen or so
wickiups. *(Photo by E. Tad Nichols)*

Fig. 1.3 *(above).* Interior of a
Western Apache home (called a
wickiup). Note water bottles.
(Photo by E. Tad Nichols)

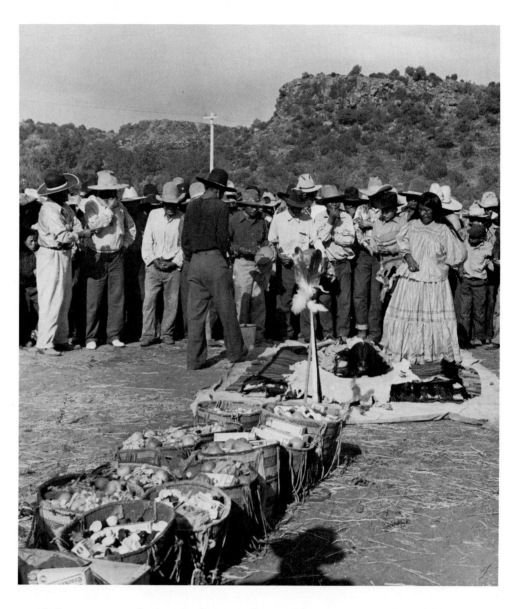

Fig. 1.4. Double line of Apache burden baskets filled with foods and candies for the young girl's puberty rite. *(Photo by E. Tad Nichols)*

or if she went to the trading post she might return with it filled with groceries or other commodities, or she might carry wood in it. When a "coming-out party" for the young Apache girl was in progress, two rows of the colorful burden baskets used to be filled with foodstuffs and other items for all the guests (Fig. 1.4).

The country occupied by the Western Apaches varies tremendously, ranging from 2,000-foot desert lands in the south with high summer temperatures to 7,000-foot elevations with heavy winter snows in the White Mountains. Peaks rise above the latter elevations, some to as much as 12,000 feet above sea level. The permanent creeks in the more northerly parts of the Reservation nurture rich growth, some of which (such as squawberry and willow) is significant in basket making. Added rainfall, up to 20″ to 30″ per year in higher elevations, supports stands of pine, piñon, oak, juniper, and aspen.

On its northern edge, the San Carlos Reservation is mountainous, but the rest is desert country. The Gila River runs through the southern part, with this and lesser streams supporting cottonwood and other more limited growth; bear grass, mesquite, yucca, and cactus are among the more typical desert plants. Wild foods were derived from some of these and other plants, more in earlier years

but fewer and fewer as time rolled by; these would include mesquite beans, juniper berries, saguaro fruit, agave or maguey hearts, and several small greens. Baskets were often used in gathering some of these foods. Widely distributed also is devil's-claw or martynia, an important plant used in basket making. Other plants which grew abundantly on these two Reservations and which have been significant in basket weaving will be discussed below.

Wild animals are found in considerable numbers on these Reservations, perhaps a few more in the mountain regions than in the drier desert area. Deer, rabbits, and wild turkeys are widespread and were among the favorite foods of the Apaches. Elk, bear, squirrels, and wild pigs are also found in various parts of the Reservations. Thus, native flora and fauna were significant to the Apaches, particularly in the past, not only as a source of supply for many of their craft arts but for food as well.

The basic economy of some Apaches was and to a degree still is related to limited cultivation and some hunting and gathering. San Carlos Apaches have been cattlemen for years, with their herds of ever-increasing importance to their economic well-being.[11] Cattle are also raised by White Mountain Reservation Indians but they are not so important as they are to their southern tribal brothers; the more northerly group also herds sheep. All Apaches cultivate corn and have done so for many generations; a few other products of the field are raised locally, such as wheat in the White Mountains. This product is not significant as food, for these Indians sell their wheat and buy commercially ground flour.

Since World War II many changes have occurred among the Apaches. Tribal income has increased on the northern Reservation through motels, resort areas, fish hatcheries, and lakes stocked with fish, and on both Reservations through the lumber industry and reclamation of a few other natural resources. On the San Carlos Reservation, in the 1970s, a new industry was introduced, the cultivation of the jojoba bush, which has many commercial potentials. A candlemaking plant, utilizing the jojoba bean for this product, was established at this time. As with so many other Indians, there has also been a considerable increase in individual income through wage earning among all of these Apaches. The great interest in Indian arts and crafts on the part of the white buying public, beginning in the late 1960s and with concomitant increase in prices, undoubtedly has encouraged some revival of basket weaving and developments in other crafts as well as easel painting.

Native ways of life have continued to prevail among these Western Apache Indians, more so in some areas than in others. The wickiup has disappeared on the San Carlos Reservation, but occasional ones are to be seen in the Cibecue and other White Mountain sections. Government housing has modernized living to a degree for many Apache families. In some locales the camp of half-a-dozen wickiups has been replaced by fairly large communities, such as Whiteriver and San Carlos proper. Formerly the sewing machine was the only common, larger, white-influenced addition to the Apache home; now the non-wickiup dweller has a wide variety of household furnishings. In earlier years the Indian woman furnished her own household with basketry utensils; now a wide use of pots and pans from the trading post would explain the almost complete disappearance of this craft for native purposes. Some older women

still wear the eighteenth-century-inspired long, full skirt and loose blouse, but the schoolgirls and younger women wear the short and slim-lined dress, often the slacks, of their contemporary white sisters. Only in the puberty rite, or rarely on other occasions, does the young girl wear the more traditional long and full dress.

Although some Apaches have been Christianized, many follow the "old way," the native beliefs, in part or in toto. Witchcraft is still rampant. The introduction of young girls to Apache society by way of the puberty ceremony still prevails, although some more acculturated individuals look upon this as an antiquated custom; to many it is far too expensive to continue. Healing through the use of native medicinal plants by medicine men is less common although not unknown. Education, Reservation hospitals, and a changing economy have had much to do with alterations in religion, particularly with curing rites.

In the puberty rite the main performers are the young girl initiate, her godmother, and a medicine man. Then there are singers and drummers. Friends from far and near come to aid the young initiate in her passage from girlhood to womanhood, and incidentally to visit

Fig. 1.5. Western Apache men holding tray baskets; each man performs at a puberty rite. *(Photo by E. Tad Nichols)*

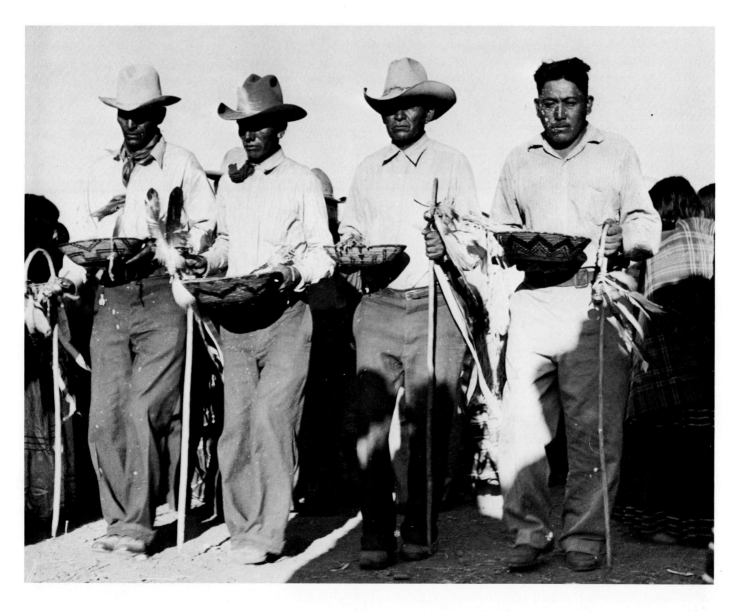

and gossip with old friends; for four days and nights there are rituals and feasting. Rites for the young girl are the center of interest, but there is also entertainment for all who have gathered for the occasion. In the evening appear the four Mountain Spirits and a clown, costumed and masked, who dance about great bonfires. Formerly these dancers performed curing rites. At one point in the ceremony all present may participate by sprinkling pollen from a basket onto the heads of the girl and her godmother, thereby bringing good fortune to them and to all of the tribe (Fig. 1.6).

Many aspects of organization have completely changed or been forgotten by these Western Apaches. No longer are there chiefs; rather are there two well-functioning tribal councils, one for the White Mountain Apaches and another for the San Carlos group.[12] Each Reservation has a council with representation, this quite different from a small local group led by a chief. Some remember and function along lines of matrilineal clans, others have forgotten their clan affiliations. There is still respect for the aged and wise, for the orator and good provider, for one who continues in the ways of the ancestors.

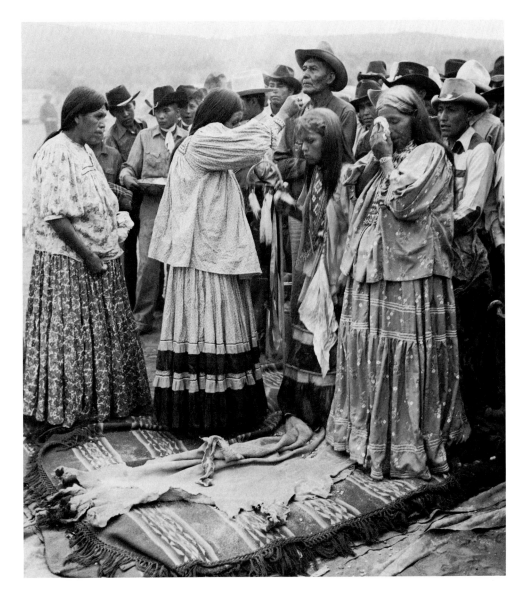

Fig. 1.6. Sprinkling pollen over the initiate and her godmother at the puberty rite. *(Photo by E. Tad Nichols)*

Many more young Apaches than ever before are completing their secondary schooling, and certainly more are continuing with higher education, attending colleges and universities. Unquestionably these will be among the ones who will qualify to change the native ways, to alter the traditional culture, particularly as some return to their Reservations to become leaders. However, some of these better educated individuals have influenced the continuation of at least parts of native Apache life. It may seem a paradox that highly educated individuals should desire the preservation of aspects of the old way; only as one has lived in the richness of another man's culture can he appreciate this point of view.

Despite what men of another way of life would view as inadequacies, Apache culture offers much that is worthy of preserving, not only to the Indian but to others as well. Pride in native culture is extremely important in the continuity or revival of craft arts; from 1940 to 1980 there has been a slight regeneration of interest in basketry as well as a growing concern with new forms of art such as easel painting among some Apaches, because of their own interests as well as those of the white man. As a group, they are stronger for their common interest in a Council directed by their own tribesmen, for their revived concern with their own culture, for their growing ability to live in two worlds.

Mescalero Apaches

History reflects a very confused and mixed background for the Mescalero Apache Indians. It is quite likely that these Athapascan-speaking people first settled in the Plains area after their many years of wandering out of northeast Asia into northwestern North America, thence southward through Canada into the United States. After the Spaniards arrived in the Southwest in 1540 and shortly continued into the Plains area, they encountered bison hunters who probably included ancestors of the later Mescalero Apache Indians.[13]

A brief summary of probable Mescalero Apache life on the Plains is given by Dobyns.[14] He posits an early period when women were dominant, for life was centered on their basic activities of gathering, preparing, and cooking wild foods, and the men hunters brought the kill to the woman's door. A nuclear family of mother, father, married daughters, and unmarried children was basic, particularly to a third economic activity, namely, simple horticulture centered about the cultivation of maize, beans, and squash.

It is quite possible that certain traits known in later years were established during bison-hunting days on the Plains if not in prior wandering years. One, apparently, was the mother-in-law taboo, a custom in which a young man neither looks at nor speaks directly to his mother-in-law. Another was the destruction of one of a pair of twins, for it was impossible for a woman to take care of two babies in her busy life of gathering, following the bison, and moving to the horticultural spot. All of this activity was on foot, often with burdens on the back or at best on a dog travois. A third trait which may have developed during these early years was attitude toward well-being, with emphasis on religious ceremonies to maintain good health. On occasion these Apaches apparently traded with the New Mexico puebloans.

The coming of the horse introduced by the Spaniards shortly after 1540 changed the Mescaleros' lives somewhat. Hunters now gained in their pursuits of the buffalo: there was more meat, there were more skins for tipis and other items, and a larger travois pulled by the horse which could carry heavier loads, thus partially relieving women's burdens. After 1630 the horse, coupled with metal-tipped lances and other equipment, probably gave the Mescaleros greater military supremacy. They began raiding New Mexico settlements and rapidly expanded their territory. Too, these Indians increased in numbers. Further, owing to the horse and accompanying equipment, the Plains Mescaleros seem to have developed strong chiefs, particularly a war chief. It is quite likely that at this time the Mescaleros evolved "as a social and political entity—a tribe in the political sense."[15]

As various other tribes in the Plains area acquired Spanish-introduced horses and other advantages, the Mescaleros suffered. Comanches and Utes were especially troublesome, stealing the Apaches' horses and attacking their small and vulnerable horticultural groups. Indians of this area formerly captured by Mescaleros and traded by them as slaves could no longer be taken, a great loss as this practice had been a major source of exchange. Thus the Plains Apaches lost their military power and were "plunged into immediate poverty."

In time the Plains Apaches were driven into the mountain areas of New Mexico. Here they had to thatch their tipis with grass as they no longer had buffalo hides. Again women became more important as they turned back to more gathering, adding mesquite beans, piñon nuts, and prickly pear cactus to their diet. Small game hunting increased. Farming in these new semi-arid spots demanded irrigation. Possibly the agave (mescal plant) again became one of their chief foods; thus, the name "Mescalero" became appropriate: "ero," person who makes, plus "mescal."

There was considerable trouble with the Spaniards during the eighteenth century, despite efforts of some of them to make peace with the Indians. Many of the Indians lived adjacent to Spanish military posts during certain of these periods of contact. Some advantages accrued through such circumstances: for one, the Indians acquired cattle. Some Apaches served as scouts for the Spanish military; among these, certain band heads were recognized by the Spaniards for their diplomacy. These opportunities, plus acceptance of the leaders by their own tribesmen, eventuated in eight Mescalero bands. Unfortunately the location of some of the Indian camps close to the Spanish settlements exposed the Mescaleros to European diseases. "Masked clown dancers likely gained importance during this period of exposure to epidemic disease, because they danced when an epidemic was anticipated so that one of them could obtain supernatural instructions for combatting the disease."[16] Borrowing from Christian Spaniards, these Indians used the cross, among other things, to ward off ghosts. From Spanish contact, too, they picked up more witchcraft to add to their own. They also learned to make a liquor called tiswin from corn.

After Mexico gained its independence from Spain in 1821, situations changed for the Mescaleros. They went back to their mountains better able to make a living because of some of the knowledge acquired during Spanish contact. Having worked as scouts for the

Spaniards, they were familiar with details of the country and settlements, even into Mexico. Living close to these Europeans, they had also learned more about horses and guns and various other supplies. Their own background included dealing in slaves. All of these things and more gave Mescalero Apaches expertise in their raiding days from 1825 to 1850.[17] Their raiding brought them prosperity, a decline of the former power of chiefs to the benefit of the raiding leaders, and a decline in the importance of women, for captive female Mexicans were brought to camp from raids.

Then came the Americans.[18] New Mexico became part of the United States with the 1848 Treaty of Guadalupe Hidalgo. Treaties were made between Indians and whites only to be broken. In 1855 a treaty was made but never ratified; it placed the Mescaleros on lands comparable to the area of their present Reservation. Troubles continued, culminating in reverberations of the Civil War in the form of more conflicts between Indians and whites. Efforts at establishing peace resulted in the incarceration of Mescaleros at bleak Fort Sumner (Bosque Redondo), eastern New Mexico. All able-bodied Mescaleros broke out of Fort Sumner in 1865, most of them disappearing for seven years. There was much wandering about on the part of some of the tribesmen, but by 1871 there were 830 Mescalero Apaches at Fort Stanton, north of the present Reservation. Two years later (1873) a Mescalero Indian Reservation was officially established, with the addition of some lands north of the present Reservation. Lacking surveys, the Indians were wary of moving about too much and became, once again, dependent on government rations. Offenses by white men once more caused the scattering of some Mescaleros to Mexico.[19] They had more troubles with the Comanches, whiskey from the whites created havoc, smallpox took a heavy toll. Hostilities continued, usually one-sided in favor of the white man, until in 1881 an Indian Agent created a Mescalero Police force which in turn created more peace than had any prior action. This peace was short-lived, followed by four years of further disturbances, the last of which was the placement of 721 Jicarilla Apaches on the Mescalero Reservation. Jicarilla Apaches objected to this action and were removed to their own Reservation in 1887, leaving "438 Mescaleros as sole occupants of their reservation."[20] By the 1970s there were about 460,000 acres of land on this Reservation and the Mescaleros numbered more than 2,300.

The lives of Mescaleros were affected for both good and bad at the hands of a succession of Reservation agents.[21] Some were cruel, some more kindly; most of them lacked any understanding of native culture and did all they could to destroy it. All rations were terminated in 1902. Economically these Apaches were fairly successful, but they were declining in population, a trend that continued into the 1900s. However, new blood was introduced to the Reservation when 187 internees from Fort Sill, Oklahoma, were added to the Mescalero Reservation in 1913; these were Chiricahua and Warm Springs Apaches. Population figures began to rise and there was greater attendance at school, but boredom bred of earlier enforced inactivity continued. Native ceremonies were prohibited except for the girls' puberty ritual.

Then came the Indian Reorganization Act in 1934. Two years

later the Mescaleros established their own tribal government under a consitution and federal charter. Later they organized a tribal council (1964) under a revised constitution. Economy spurted forward, education profited, with some students continuing into college. By 1942 all Apaches on the Mescalero Reservation had Anglo-type homes. In the 1950s their health situation was improved. In 1967 they were awarded $8,500,000 as a result of suing the U.S. Government under the Indian Claims Commission Act; significantly, the tribe invested 80 percent of this sum. These Apaches built a tourist center high in the mountains which has been most successful; even more remunerative has been a ski run. Recreational facilities for their own people have added to their pleasures.

The Mescaleros are learning that there are limitations to the amount of agriculture they can pursue, for the season is short and cultivable lands are scarce; similarly, they are restricted in the number of cattle they can raise, owing to limited grazing lands. Other trades and professions of interest have been and will need to be developed: teachers, fish hatchery workers, various specialists (everything from maids to managers), game wardens, nurses, and so on. Much of the future development of the Mescaleros depends on their ability to cope with the problem of diversifying their economic interests.

Jicarilla Apaches

The history of the Jicarilla Apaches is not well known. They, too, came from the north; they, too, had some kind of contacts with the Plains Indians but exactly what these were in earliest years is little known. In later years they made raids, each under a head man, against the Plains Indians; always these were traumatic experiences for they were surrounded by ritual and restrictions—they were feats of daring which had to be protected with ceremony. And always the Jicarillas were happy to return to their beloved mountain country. As has been said of them, they were essentially a mountain people in their outlook which might indicate that they did not live on the Plains as did the Mescalero Apaches. Much of the same story is told of their buffalo hunts or raids for horses as is for their attacks against the Plains Indians: "They definitely felt vulnerable to the peoples of the plains whenever they moved toward the level stretches to the east—these expeditions were considered so dangerous that participation became as much a ceremony as a practical venture."[22]

Evidences of Plains contacts are numerous among the Jicarillas. For a long time they lived in tipis covered with skin or cloth; they made parfleches, the large envelope-like Plains saddlebag; much beadwork appears on moccasins, purses, buckskin clothing, and other items; and they painted designs on rawhide bags.

Contacts with puebloans were also much in evidence; some attribute to these folk the Apache development of agriculture, and certainly there are many evidences of puebloan beliefs in Apache religious expressions. It is possible that some pueblo basketry influenced that of the Jicarillas. Otherwise the culture of the Jicarilla tribe tends to conform to Apache standards as a whole.

Matrilineal descent and matrilocal residence prevail, although they do not have clans. The girls' puberty rite has been the most important and the one significant lingering ceremonial of these people. They did preserve ceremonial races and did make sandpaintings, the latter associated with the healing rites, as among the Western Apaches. Mother-in-law taboo has prevailed, as among all of these Apachean people. In earlier years there were chiefs whose leadership could be questioned, and one such leader might even be displaced by another man who was braver and better equipped for the position. Hunting and war parties were directed by head men.

During these early years the Jicarilla Apaches were friendly with the Utes of southern Colorado. This is important as there are certain aspects of basketry which may have resulted from this association. It is said, in fact, that the Jicarillas were as much at home in southern Colorado as they were in northern New Mexico.

In early years, too, these Apaches did not depend too much on the cultivation of corn. In addition to the buffalo they hunted deer, antelope, and other game. Undoubtedly they also gathered nuts, berries, wild fruits, and seeds just as did the Mescaleros.

In earlier years these Apaches occupied territory both to the east and to the west of the Rio Grande. Each group considered the other as of the same tribe, and there were close relationships between them, including intermarriages between the two groups. When the Apaches were moving about a great deal, so too were the Jicarillas, and not always by their own choice.

Today the Jicarilla Apache Reservation consists of more than 722,303 acres of land situated in northwestern New Mexico, all west of the Rio Grande.[23] Almost half of this acreage is timberland, with a little less than half just sheer brushland. Very little can be used for farming; in fact, only a little over 3,000 acres are suited to this pursuit. However, there are natural resources including oil, minerals, and gas, plus timber; all bring substantial money to tribal funds. Some cattle raising is done by these Indians; they also have a few sheep, although they seem to look down on sheep raising.

In recent years life for the Jicarilla Indians has been quite different from that of the past. Much activity has taken place on their Reservation in general. For example, a fine highway brings in traffic from Colorado to the north, Arizona to the west, and from New Mexico from the west, the east, and southeast. Parts of this highway are spectacular and attract some tourists. Not only have accommodations been provided for tourists in Dulce but also south of this center of the Reservation the Indians have built an artificial lake and an attractive motel and restaurant.

Other ventures have been developed on the Jicarilla Reservation. An annual rodeo, sometimes with special horse shows, is held in Dulce. These and other events, Indian needs, and tourist traffic have been influential in the construction of community motels, stores, a cocktail lounge, tribal offices, a service station, a gymnasium, and other accommodations. Primarily for their own people the Jicarillas constructed and manned a package liquor store, thereby hoping to control some of the drinking problems of these Indians. Some years ago, in the 1960s, the Tribal Council passed a zoning ordinance to assure more order and plan in the growth of the community of Dulce.

The Jicarilla tribe has also organized an Arts and Crafts center where they market baskets, leather and buckskin crafts, and other native handwork. This center has been an incentive to production and has encouraged certain trends in the revival of basket weaving.

All of these developments plus many more have affected the general state of Jicarilla Apache life. Economically they are better off than they have been for some time, for many of the above developments have brought money directly to individuals or have given employment to them. Housing has been modernized for many of these people, with the disappearance of the native tipi and the building of more adequate, more comfortable, and better equipped homes.

Problems still face these Indians, of course, and one of the most important is education.[24] As among so many other Indian tribes, there is a high rate of dropouts. Education is necessary to meet some of the basic problems related to language; it is necessary on the vocational level as preparation to fulfill job requisites; it is necessary to equip these people for numerous other positions connected with tribal industries such as directive jobs related to the timber industry. There are still both skilled and unskilled workers who could profit by such training. In the past fifteen years certain funds available specifically to Jicarilla Indians for such training or other education beyond the high school level have gone begging, partly because these people knew nothing about the availability of such monies—or were not interested. Common complaint not only for the Jicarillas but also for Mescaleros and other Indian groups is inadequate training on the elementary level, particularly in the English language. This deficiency defeats the Indian at many points, especially discouraging him when he makes an effort to go on to college. Some Western Apaches seem to be meeting this problem more successfully than are either of the two New Mexican groups.

Jicarilla Apaches are governed by an elected Tribal Council. This Council concerns itself with all matters from family housing to health, education, and the general economy of the tribe. Perhaps most important are developing knowledge and concern of Council members with natural resources of the Reservation and jobs for tribal members. It is the Tribal Council which has effectively encouraged the Jicarilla Arts and Crafts Shop in Dulce; too, through them, the Tribal Saw Mill is operated.

Although it is a slow process, it is obvious that change is occurring as a result of the activities of the Tribal Council, of education to a degree, and of participation by these Apaches in what is going on in diverse areas of the Reservation from community housing to running a motel. A 1978 visit to the motel south of Dulce showed Jicarillas working in all phases except the main desk of this setup, including effective production out of the kitchen. Reflective of a growing interest in reviving some of the old ways of this tribe were remnants of ramadas or shades close to this attractive motel where many Jicarillas had recently gathered for dances, ceremonies, and the sale of some of their crafts.

Seemingly, the Jicarillas have never lost their feeling of oneness as a tribe; they have retained their language; they have maintained close family and other kinship ties. Certainly, these essential basics, together with an active Council interested in the betterment of all

in the tribe, natural resources which they are developing and the revival of ceremonies and crafts, should assure the future of the Jicarillas. The future of the tribe will depend, however, on the willingness of individual Indians to learn and to produce.

Technical Background

ALMOST ALL PEOPLES around the world have made baskets at one time or another; the majority of the Indians of North and South America are no exception. In North America there are three outstanding areas of basket production: the Northwest Coast, California, and the Southwest.[1] Prominent as basket makers in the Southwest are the Apache Indians, including both Eastern and Western groups, but especially the Western.

Basketry is a woman's art; certainly the high craftsmanship of the aboriginal American Indian is an exceptional example of the artistic genius of primitive women. The patience, creativity, and loving care given to this craft by Apaches not only provided one of the greatest needs of these native people, but also satisfied the esthetic yearnings of the weavers themselves. To be sure, the artists in this craft are limited by materials, technology, and use value; the Apache weaver accepted these controls and went far beyond them in the addition of designs and other decorative effects. Basket materials the technology basically stress angular design; however, within these limitations, the Apache woman not only expressed endless potentials in angularity but also added curvilinear qualities in some geometrics, as well as life forms.

Quite generally, basketry is developed to a higher point by more wandering peoples than by sedentary groups. This is natural, for a well-woven basket can be used for carrying water and for cooking as well as for other purposes, and it is easier by far to carry than a clay vessel; too, it will not break as will pottery. Until shortly before the turn of the century, the less permanently settled tribes of the Southwest, the Utes, Paiutes, Chemehuevis, and Apaches, were more outstanding as basket weavers than were the sedentary puebloans, with the exception of the Hopi Indians. The agricultural Pimas of pre-1900 are another exception, primarily because they produced baskets in response to white contacts. In some measure so are the Papagos prior to about the 1920s, for they reflected in their continued basket making for their own uses something of their earlier semi-permanent summer-winter residences of constant back-and-forth movement.

Both Hopis and Papagos have made comebacks in quantity of basket production in the 1960s and 1970s, with Hopis attaining much higher levels of artistry than are to be noted in the continued flourishing basketry craft of the Papagos. Again, interest on the part of the white man has been responsible for much of the Hopi-Papago resurgence. Although the Apache basket weavers were affected by contact with the white man at an early time, the later extension of this interest did not seriously divert them from traditional styles.

Uses of basketry are many and varied, no less so among Apaches in earlier years than among other tribes. Household utility is endless. Such a form as the tray served all purposes from gathering, mixing, cooking, and serving food to washing. On special occasions the same form was (and still is) used to hold the sacred pollen used in ceremonies. This basket form was also used in curing rites. Among many tribes the tray might be turned upside down to serve as a drum; too, it was used by some Apaches as a container in which to parch seeds or for winnowing.

Any dry foods, such as nuts or seeds, might be stored in deeper or more closed forms. Large or small, narrow-necked vessels were used for both carrying and storing water. Goodwin reports, "To further harden boys and girls, they were made to carry pitched water bottles and light loads when their families were on the move."[2] A 1903 publication describes an Apache "war basket," a large, shallow, circular traylike piece; it has an elaborate and very irregular design on it.[3] Just how it was used is not indicated.

Jars were made by Apaches in coiled weave and often they carried elaborate decoration. Although the majority of these pieces seem to have been made for sale to the white man, through the years they have been referred to as used for storage; Field so labels a coiled jar and dates it 1890.[4] Some small baskets were reportedly made by young girls and perhaps even used by them, but in more recent years these, plus real miniatures, have been woven solely to sell; this is particularly true of the burden basket. Large burden or carrying baskets played an important role in Apache life, perhaps for longer than any other form; in addition to practical purposes, they were used on ceremonial occasions to hold food and other items to give to guests.

Technical analysis of basketry is significant in itself as well as in understanding certain esthetic developments relative to this craft. Materials and methods of producing a basket control both form and design to a degree, with the basic uses and cultural trends of a given group also evident within these influences. The physical environment plays the basic role in relation to materials used, while both culture and available materials are reflected in technologies.

In discussing materials and technology, certain terms will be used such as warp and weft. Warp is the foundation or base element upon which the weft or filler is sewed or woven. In this chapter equipment also comes into focus; in Apache basket making, it is extremely limited (Fig. 2.1). In gathering materials a knife is needed; undoubtedly in aboriginal times and certainly well into historic years the knife was of stone, while in later historic years it has been of metal. An awl is used in sewing the coiled basket; formerly it was of bone or a cactus needle, later of metal points set in wooden

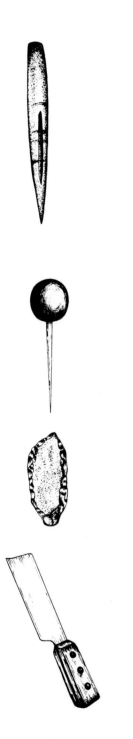

Fig. 2.1. Tools of the basket weaver: *(from top)* bone awl, metal awl, stone knife, metal knife.

handles. Beautiful beaded buckskin awl cases were used by these women (Fig. 2.2). Certainly a yucca paint brush was employed in earlier years for decorating rare pieces; later a commercial brush could be substituted. For applying piñon pitch to the water bottle, a cloth tied to the end of a stick was later used in place of the earlier bit of rabbit tail.

MATERIALS

Materials for Apache baskets may be divided into two categories: those which carry the burden of creating the basket and those which are solely decorative. In the first grouping are the foundation rods (warp) and sewing materials (weft). The latter can be and often are design-bearing even though they play a functional role in basket production. In the second category are additions to the basic basket, such as buckskin patches, bands, and thongs, tin tinklers, beads, and some additional colors; all of these happen to be applied after the basket is woven. Piñon pitch, which is added after the tus or water-bottle basket is woven, serves the utility purpose of water-proofing.

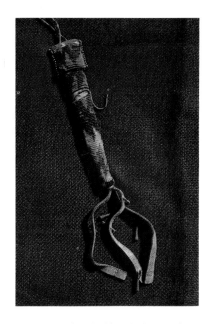

Fig. 2.2. A beaded buckskin awl case, made and used by the Western Apache basket weaver *(ASM E5075).*

Like other Southwest Indians, the Apaches were more apt to use materials found nearby than to make long treks for them; to be sure, some were more conveniently located than others. Perhaps more distant trips were made for piñon pitch than for any other material, particularly among some Western Apache groups; sometimes these Indians traveled many miles to collect this waterproofing substance for their woven bottles. Mason reports that the collector or student might find Apache weavers "borrowing materials" as well as "forms, and even designs from outside."[5]

Certain materials are used in more limited ways than others for the production of baskets. In some instances this is due to availability; in other cases it is a matter related to technology or form, or use to which the basket is to be put; in still other situations, it is a matter of personal preference. With the exception of the Mescaleros, Apache Indians do not employ grasses in the production of their baskets as do some other southwestern tribes; rather the majority use "wood," a term applied to the harder shoots of certain trees and shrubs.[6] The latter, plus variety of weave, explains in large measure the lack of flexibility in most Apache baskets.

The following comments on Western Apache basketry materials are based on the 1916–17 research of Roberts on old collections of baskets plus other references,[7] and on personal observation. Two varieties of willow (*Salix nigra* and *lasiandra*) were most commonly used in Western Apache coiled baskets and frequently in burden baskets, while willow or sumac (*Rhus trilobata*) was used by the Jicarillas. One kind of cottonwood (*Populus fremontii*) was second in importance, particularly for trays, among the Western Apaches. A soft off-white or almost tan or yellow color characterizes the two materials, willow and cottonwood, while sumac tends to be a little darker. White is typical when the basket is first woven; with age this turns into soft tans. Roberts distinguishes between the two willows used among the San Carlos Apaches: "One is considerably darker than the other, as may be easily seen in some baskets...in

which the yellow is much deeper, the satiny sheen of the sewing splints more lustrous...In this darker material the withes are not so finely split as when the lighter variety is used, with the result that the work appears coarser, but the sewing is as perfect as in fine specimens...." On the other hand, she stresses the whiter color and duller quality in cottonwood.[8]

In earlier years mulberry (*Morus* sp.) was popular in the Western Apache area but was not employed later on; it was also favored by the Jicarillas. It turns to a pleasing, soft, almost silver-gray color with age. Particularly was it used for the finest of burden baskets, and quite generally for other basket shapes as well, especially among White Mountain Apaches who used it "almost exclusively." This material had the bark removed, revealing "a rich golden brown with a satiny sheen."[9] Because of the nature of mulberry, some pieces woven in this material were slightly flexible, a quality not common in Apache baskets. Baskets of mulberry were durable enough to be used even for cooking. In time, willow and cottonwood replaced mulberry, which undoubtedly reflects changing customs among these people, particularly commercialization replacing native use.

Sumac is infrequently used in water jars and burden baskets among the Western Apaches. As reported by Roberts, little "twigs" were left on the ends of the approximately 36" rods until the water bottle was completely woven;[10] this custom continued into later years (Fig. 2.3). This is also true of squawberry (*Vaccineum stamineum*); the bark is left on these rods when they are to serve as warps, but it is removed from them when they are to serve as weaving splints. The inner pith is also cut out when the rod is split to make it more flexible for sewing. Rarely, sumac was used for coiled basketry among the western tribes, but it was commonly employed by the Jicarillas, particularly in their trays.

Cottonwood and willow in the form of young shoots or twigs are most generally gathered in the spring when the sap is flowing. The whole twig is peeled so that it can be used for foundation or warp material; frequently, these rods are bundled and stored against the future. Peeled whole twigs from these sources are also split three ways, with fingernails and teeth (Fig. 2.4); bundles are made of the withes, and they are tied together and stored for later use as weft or sewing material. Mulberry is prepared in like manner for sewing splints. All three of these materials are finer in cross section than either sumac or squawberry.

The black decorative material in Western Apache baskets is derived from devil's claw (*Martynia proboscidea* or *louisiana*). Green pods on this plant turn black in time and are gathered in the fall. Like many other Southwest Indians, the Apaches strip off the outer black covering, remove the core, and use it as a decorative sewing material. In preparing all varieties of these sewing materials, the better weaver may be more careful in sizing the strips, both thinning them and cutting edges so that they will be even and regular.

Rarely there is a bit of natural red in the design of a Western Apache coiled basket; this was bark from the root of the yucca (*Yucca baccata* or *elata*). More frequently, dyed elements were used, with the same material as the rest of the light tan wefts in the basket being colored. Dyes include a rare green, some red, and a Prussian blue, all derived from commercial sources by the

western groups. As the Mescaleros used yucca in their tray basket, color tended to be the natural material itself. A light green was from leaves carefully chosen from inner parts of the plant, a light yellow was from a partially faded leaf, and white was from leaves which were faded or bleached in the sun. In early years the Jicarillas used limited colors of native plant or clay origin which included black, red, yellow, and purple. These were, however, replaced by bright-colored aniline dyes; time has changed all to odd shades. Following the shift in color source, little basketry was produced by Jicarillas for a while; then a major revival in the early 1960s brought more and brighter anilines into focus. These included yellow, red, green, black, brown, blue, and turquoise, all derived from "Navajo Rug Dyes" sold by a Dulce trader.[11]

Essentially the same major materials cited by Roberts, willow and cottonwood, were still being used for the making of Western Apache

Fig. 2.3. Twigs with leaves still attached on the ends, as used in the making of the Western Apache water bottle. *(Photo by E. Tad Nichols)*

Fig. 2.4. With teeth and fingernails, a Western Apache weaver is splitting a whole twig three ways. *(Photo by E. Tad Nichols)*

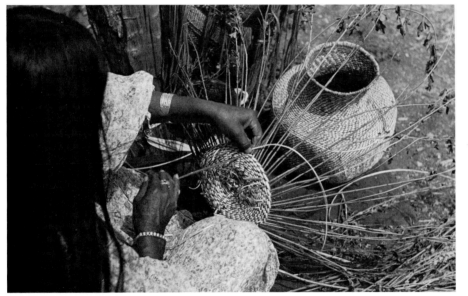

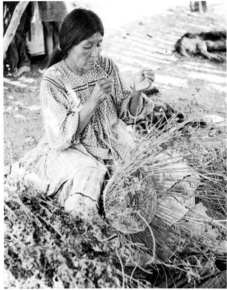

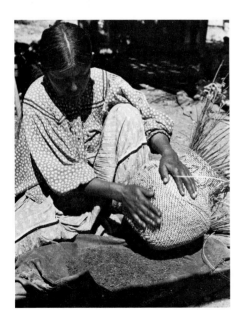

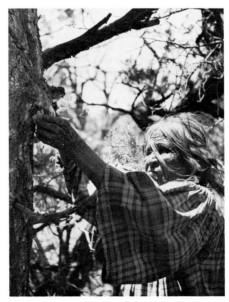

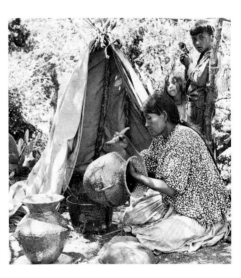

Fig. 2.5. Rubbing crushed leaves into the wall of the water bottle to aid in waterproofing. *(Photo by E. Tad Nichols)*

Fig. 2.6. An elderly Apache woman digging out pitch from a gash in a piñon tree. *(Photo by E. Tad Nichols)*

Fig. 2.7. Western Apache applying pitch to a water jar. The basket rests on the edge of the bucket of melted pitch. She holds in her hand a stick with a rag wrapped around the end for applying the hot pitch. *(Photo by E. Tad Nichols)*

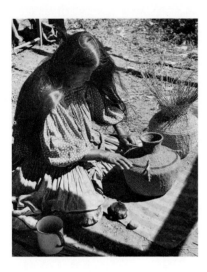

Fig. 2.8. Western Apache woman applying a black line to a water jar. Soot for this line was ground on the stone beneath her right hand. *(Photo by E. Tad Nichols)*

burden baskets in the later 1930s and 1940s, the last years of more abundant production, according to research by Douglas. Warps were made of whole twigs, wefts of the same material split three ways. Douglas further supports Roberts in saying that mulberry was used in a limited number of finely woven burden baskets; even less sumac was used for this piece.[12] Four heavy interior ribs were formed of two U-shaped rods.

On the other hand, sumac was not uncommonly used in the making of the Western Apache water bottle in later years, as was squawberry. Weaving was frequently poor as the entire basket was to be covered over with pitch; it was customary to rub into the basket surface a coating of juniper leaves, pounded into fineness, along with red ochre (see Fig. 2.5). On this was smeared a thick layer of melted piñon (*Pinus edulis*) pitch (Figs. 2.6, 2.7), through which the red ochre shows, imparting a pleasing color to the basket water jar.

As decoration was rare on water bottles, decorative materials for this purpose were limited. Occasionally a Western Apache woman would dip her finger in soot and draw a ring or some other simple geometric pattern on the shoulder of the tus (Fig. 2.8). Any such designs were made more or less permanent as the piñon pitch was placed over them. Usually several horizontal bands of red and black small geometrics adorned the burden basket; these were woven in with dyed strips of the same material of which the basket was formed (see Fig. 4.6). Rarely designs might be painted on the finished basket, the colored material in reds, greens, or blues, and usually of commercial paints.

Details on some baskets, such as rim finish and lugs, may involve materials quite different from those in the basket proper. The rim of the Western Apache burden basket may be finished off with a single or double coil, with some foundation ribs carried over the heavier rod of wood. Or, sometimes, one rim coil foundation may be of wood and the second or topmost may have a warp of heavy metal wire; or two metal wires may form this part of the rim. Lugs on the burden basket for supporting the carrying strap may be of buckskin; they were placed two, three, or more inches below the rim and usually about eight to ten inches apart. Again among the Western Apache, material in the water bottle lugs may differ, for it may be of horsehair, wood, or occasional other substances. Two lugs generally appear, although there may be three, evenly spaced; in one case they were fourteen (plus or minus) inches apart and of bent wooden pieces caught into the wall of the basket with elements of the same material as the wefts.

Largely decorative are the additions of buckskin on the Western Apache carrying basket. First, there is a round, plain or fancy piece of buckskin over the base which serves a dual purpose: one, protection for the base as the basket spends much of its life in contact with the ground; two, it adds a decorative note, often with a scalloped, colored cloth beneath it and/or fringes at its edge. Also there are four vertical bands of buckskin, each an inch more or less in width, running from rim to base; occasionally these may have been utilitarian, for they were directly over the location of two crossed inner rods which gave added strength to a basket. On these bands and between them, at the rim, and also about halfway down them may be arranged a cluster of four longer or shorter buckskin thongs.

In later years, chamois or other commercial skin was substituted for the native-tanned buckskin. Often small metal "tinklers" were added, each held in position by a knot in the bottom of the thong; these were made of small pieces cut from tin cans and rolled into a cone. Less frequently, one or several colorful trade beads might be added to the thongs.

Early pictures of Eastern Apaches sometimes show water bottles and/or burden baskets of Western Apache types, some of these obviously provided by the photographer. Museum and other collections of these Jicarilla and Mescalero specimens seem to have few of or lack entirely the decorative devices common to the Western styles. Jicarilla water bottles are of coiled weave and sometimes are designed.

TECHNIQUES

A knowledge of technology is vital to understanding design, for it is in the method of weaving involved that design can be refined, elaborated, or curtailed. Too, it is not just the basic technique alone that is significant, but all aspects of methods of manufacture, from materials, stitch size to coil width, from the use of single to multiple elements, from tight and even sewing, to loose careless work. It is in a combination or sum total of the many aspects related to technology that the individual tribal product can be identified. Interesting, too, is the fact that some of these traits resist change, some are less stable.

Apache basketry as a whole tends to be well done, for the first purpose in producing it was utility; the better woven a piece was, the better service it gave and the longer it lasted. However, exceptions to this statement are to be noted, for the twined work in the Western Apache burden baskets frequently surpassed the execution of the same technique applied to making water jars, for, as noted, the latter were pitch-covered to insure no leakage; knowing that the weaving would be covered perhaps invited the weaver to be more careless with her work. Some Western Apaches used both long and narrow stitches while others preferred short, stubby ones in coiled weave; this, of course, was due partially to material. The Mescalero use of yucca and a wide coil made for great differences between their baskets and those of other Apaches. Thus, not only were design potentials related to materials and techniques but also to use value, and to preference on the part of a given Apache group or band, or to individual ability. These and other traits might combine to give distinct character to a specific type of basket weaving.

Two basic techniques were employed by Apache basket makers, coiled and wicker (Fig. 2.9). Coiled work is more a sewing process, whereas wicker is true weaving. As previously noted, two basic elements were employed in both of these types of basket making, a stationary warp or foundation and a moving weft or a filler or sewing element. In coiled work, the foundation is held in a horizontal position by the weaver while the weft is vertical or nearly so. In wicker the opposite is true, for warp is vertical or nearly so and weft is horizontal to the weaver.

Three rods placed in pyramidal arrangement form the foundation for all Western and most Jicarilla Apache coiled baskets, with some use of five rods in the same ordering on the part of the Jicarillas.

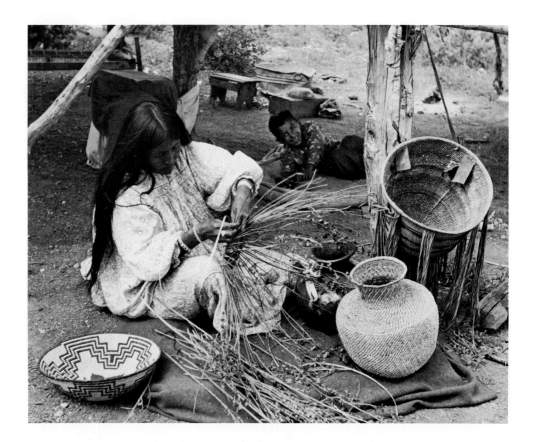

Fig. 2.9. The three major types of Western Apache baskets: *left,* a coiled tray; *upper right,* a wicker burden basket; *lower right,* a twined water bottle before pitch has been applied. *(Photo by E. Tad Nichols)*

Thus, all these coils are round. On the other hand, Mescaleros used one rod or slat, or two rods plus other elements, always stacking them vertically, thus producing a flat coil. Sometimes a slender bundle of a few slit elements is added at the top. Except for the Mescalero warp bundle and weft, the material chosen for the coiled piece included whole rod warps and the same or similar material with the rods split three ways for the wefts. Fingernails and teeth have always been—and still are—used for splitting rods for the sewing elements, with a knife sometimes substituted. Before elements are used, they are soaked in a dish of water, buried in wet sand, or wrapped in wet cloths to make them pliable for the sewing or weaving process.

Sewing is done with narrower or wider splints; these wefts are wrapped closely and more or less vertically about the warp. Size of element is significant: smaller or larger rods and fewer or more of them form a smaller or larger coil and result in thinner or thicker walls, respectively, in the finished basket. San Carlos and Jicarilla Apaches tended to use larger elements; thus, the basket walls are frequently quite heavy. Also in the Jicarilla basket of five rods are heavier walls. White Mountain Apaches often produced the lightest walls because of the use of finer materials. Obviously, the Mescalero coil was usually flat and thin and often quite wide.

As most sewing is "tight" or well executed, walls are sturdy, which explains the fact that many such baskets withstood hard usage by Apache families. In fact, many a basket was used until a coil gave way, usually at the point of greatest stress, or, in some instances, the entire bottom might be worn to the point that a complete substitution would be necessary. In the first instance the worn coil would be caught with large stitches at both sides of the

tear. In the second situation, substitution might be made in the form of a single or double layer of cloth or a piece of buckskin either covering or completely replacing the coiled base. In these cases also the substitute pieces were usually attached to the basket with large stitches (see pp. 104).

An Apache coiled basket is started by wrapping a short part of the foundation with the sewing material, then bending it back on itself into a circle, and sewing into the top element of the coil of the small circle thus formed. Some Jicarilla beginnings are in the form of knots. If an oval basket is to be made, a long length of foundation is wrapped, a sharp turn is made, and sewing is into this longer beginning, first down one side, another abrupt turn is made at the end, and sewing continues into the opposite side. Practically all Apache coiled weaving is executed in a counter-clockwise fashion, that is, from right to left of the weaver. Some think that rare left-to-right sewing was executed by left-handed women.

Holding the current warp on top of the last completed one, the weaver uses an awl with which to pierce the top of the upper element of the pyramidal foundation below or under the split elements on top of the rods in Mescalero pieces, this from the working side. She then pushes the sewing element through the resulting hole. This weft is pulled taut about the whole current foundation by bringing it up on the back side, over the foundation, and again through another hole pierced into the warp below, always keeping the sewing element in a vertical or nearly vertical position. Stitches are non-interlocked, that is, the moving stitch is not interlocked with the stationary one in the coil below. In other words, the stitch does not go under the one in the preceding coil, but rather, between two stitches below; this is true of baskets of both Eastern and Western Apache tribes.

In the coiled technique, new weft material for designing can be added at any point. For San Carlos baskets, Roberts says, "When it is necessary to renew a sewing splint the old one is merely pulled through to the wrong side," later to be cut off. The new weft "is drawn through the hole made for it, the short end on the right side being held under the left thumb until covered by the ensuing stitches."[13]

The ends of weft elements which are pulled to the back side away from the working surface are cut off; quite generally this makes for a rougher surface on this side of the basket. If one is dubious about which side of the basket was the original working surface to the weaver or the "right" side, he can run his hand over both sides and the smoother face will be the answer to his question. There are rare exceptions to this, such as Chemehuevi baskets which are so carefully made that it is often impossible to tell which was the working surface. Apache women sewed from the inside of all trays, from the outside of deep forms such as jars, and, with some exceptions, from the outside of bowls. Quite generally design is more clear-cut and clean on the working surface or right side, in part due to the fact that stitches on the back side are sometimes split in the sewing process. Counterclockwise sewing can also help to establish the working surface of Apache baskets, particularly in contrast to Chemehuevi pieces, for the latter are often done in clockwise fashion.

Size and evenness of sewing materials, or wefts, are very significant in relation to design. If short and broad, a more pronounced angularity results; contrarily, a fine, narrow stitch can give smoother lines from coil to coil or offer greater potentials for curvilinear design. This can be demonstrated in the very popular triangle in Western Apache baskets—which may be wide-stepped and angular or, because of fine stitching, the steps may be more blended and the triangle can thus assume a curvilinear quality. The long slender stitch so common in Mescalero baskets often produces straight, vertical bands or edges to designs. To be sure, numbers of stitches in steps and placement of them, as well as their length, can affect the straighter or more curvilinear nature of patterning. Uneven sewing can also contribute to irregularities in design.

Another important point in technical treatment is the size and evenness of the coil, a factor quite significant in relation to wall quality as well as design. As a large round coil is generally conducive to heavier walls and patterns, so too can stitch size play a part in counteracting this quality, at least to a degree. Of course, both stitch and coil sizes are frequently adjusted to the relative dimensions of a basket. Uneven coils contribute to uneven design.

The rim is a point of interest in Apache coiled basketry. Practically always the Western Apache and Mescalero piece is finished in the regular sewing stitch of the basket, rarely in braiding for San Carlos,[14] and typically braided on Jicarilla baskets. But there is some variation in color treatment of the rim. Sometimes the design is carried into this last coil, thereby giving either regularity or irregularity to the alternation of black and white or yellow and white stitches. This capriciousness might also occur when the pattern terminates a coil or two below the rim, with the lack of any established rhythm, or, perhaps even due to planned carelessness or just careless or uneven sewing. Far more usual is a distinct style of finishing the edge of the basket, with an all-black rim most prevalent in Western Apache pieces. Rarely is it all-white, but fairly common are alternating single stitches of black and white. Design is commonly carried into Mescalero rims but seldom into the rim of the Jicarilla piece with its braided edge.

The end of the rim coil is usually gently sloping; this is accomplished by diminishing the coil size by gradually cutting away the foundation elements. Less often it is abruptly ended; both of these statements apply to Western and Eastern Apache baskets alike. One very old Jicarilla piece is most abruptly ended, while an example of a Mescalero basket shows an extreme prolongation as the top rod was first diminished in size, then completely cut away. Often the Western Apache termination will be gently sloping, then abruptly cut off.

An interesting, albeit rare, feature in Western Apache basket sewing is a "split coil," a trait appearing after a number of coils have been completed (Fig. 2.10). Why the weaver did this is not known, but at a planned point she divided the current foundation and took off with two coils rather than one, continuing in this manner to the rim, where, in one instance, each coil terminated opposite the other. It is possible that this was experimental on the part of the weaver; whatever the reason, it never became a popular bit of technology. As a matter of fact, Roberts reported but three examples of this unusual trait.

Fig. 2.10. A "split coil," an interesting trait of rare occurrence in Western Apache coiled jars.

Coiled weave is not only capable of producing a greater variety of forms but also it is far more productive of designs. Weft carried design; its greater flexibility, its closeness, and the ease with which colored elements can be introduced combined to offer the greatest potential in decoration of any weave used by all of the Apaches. They took advantage of this, and the Western Apaches particularly explored design to a greater degree than any other southwestern basket makers, in this or any other technique. Of the Apache groups, the Jicarillas are second in this accomplishment, but the Mescaleros lag far behind as they developed limited patterning.

Wicker weaving differs greatly from coiled in many respects. Already mentioned above is warp-weft relationship of coiled work; in wicker, it is the opposite. To reiterate, in wicker weaving the warps are in vertical position and the wefts are horizontal to the weaver. In such wicker weave the warp is usually a single rod, or sometimes two warp rods function as a single unit or they may be divided in alternate rows. Wefts can be single, double, or triple. As noted above, and as in coiled weave, essentially the same materials have been or are used for these elements, often with one plant providing rods and sewing splints alike for a given basket.

This second technology, wicker, or its common variation termed "twined," was highly developed by the Western Apaches. Basically this weave involved the use of sturdier, whole warp rods; this warp was crossed in various ways by slighter weft elements of split twigs. As noted, the water jar is almost always covered with piñon pitch; thus, it was not absolutely essential that the weave be as carefully executed as it was in the burden basket of the Western Apaches. The wall of the latter basket was always exposed; therefore, it was not only practical but also a matter of pride that one should produce a better weave than is usually found in the water jar. To be sure, there was some variation in wall construction of both forms. Practically no design occurred in the weaving of water jars, whereas in the burden basket a design was present in all observed pieces, either in the weave itself and/or in color.

The whole warp element in twined weave was both heavier and stiffer than the split weft. As there was some variation in the number of weft elements and in their relation to the warp, a breakdown in styles of this weave will be given. The basic wicker which involves the use of one warp and one weft element was generally not used by the Apaches; however, it is the common weave employed by some other Southwest Indians. In most Western Apache water bottles, the weaver started out by carefully or carelessly wrapping bundles of warps, usually two, or by crisscrossing them with sewing elements. These base elements are splayed out beyond this wrapping, others are added as needed as the basket increases in diameter, or cut out for a decreasing neck, and the weaving is developed from close to or several inches from center bottom in an over-under fashion.

The particular wicker weaves employed include plain two- or three-strand twined, and twilled. Roberts aptly defines twined weave as follows: "...two or more active elements pass over one or more passive elements, the active going before and behind the stiff (passive) warp element, and above and below each other, alternately, so that they twine about the warp and at the same time, about one another."[15] Apache plain twine weave involves the use of two wefts

passing over one or two warps in the manner just described; in the latter case, the two elements are treated as a single warp. In both of these variations of twined weave there are vertical ribs. In twilled there is a skipping of warps in successive rows resulting in diagonal lines that are basic in this weave. What Roberts calls a diagonal twilled twine is a true twill, for the weaver uses one element from a two-unit warp and a second element from the next pair of warps, continuously repeating this so as to obtain diagonal lines on the surface of the finished basket.

In Western Apache baskets, three-strand twining is frequently used for decorative purposes or to give strength to the basket at points of stress as well as at any other poiint on the basket. It is accomplished by using three weft elements with each weft passing under one warp then over two warps. Each weft likewise appears on one side of the other two wefts. This weave resembles plain twine on the basket interior (away from the weaver) but appears more like a twisted cord on the exterior (the working surface or side toward the weaver).

Roberts notes that diagonal twining is used for all San Carlos water jars and that it also appears on some burden baskets. Plain twining was also used in making the latter, or both techniques might be combined in some individual burden baskets; she notes particularly the use of the two in subtle banding on some mulberry baskets. Three-ply twined, says Roberts, may be used as the sole weave in rare mulberry baskets.[16] Otherwise this last twined weave may be employed for decoration, or, as noted above, to strengthen a basket at such weak points as the turn at the base or shoulder of a jar. Rim finish in wicker weave may involve the cutting off of all vertical elements and the sewing on of one or two wood or wood and galvanized iron wire hoops.[17] Or the "rib pieces are often interwoven at the rim [and] a strong withe or wire is added for firmness."[18]

FORMS

To a degree, technology and materials play parts in the creation of form. If materials are heavy, they limit the weaver, often to pedestrian forms; if refined, they allow greater potentials in this direction. In like manner the experienced weaver with wide technological knowledge can produce or perfect delicate variations of a typical tribal style. Combined with individual creativity, these factors lead to variety in a single form, particularly among the Western Apaches. Both Mescaleros and Jicarillas were more strongly controlled by materials, technology, and tradition, thus expressing less variation in any basketry forms they produced.

Forms in basketry are intimately related to use. Holmes maintains that man devises specific shapes for specific usages, all based on the cube, the cone, the sphere, and the cylinder; Apache basketry as a whole adheres to this basic scheme.[19] In continued use of the vessel, form becomes refined to a degree, but this never interferes with utility; thus, refinement is another clue to variety in a given form. Then from the use shape follows the creation of distinctive tribal qualities of artistry, and, from that point on, any further diversity within these tribal limitations reflects individual creativity.

Within the Apache tribes there was some diversity both in range of basic forms and within a single form. Essentially there were trays, burden baskets, a water jar, bowls, a large vessel often called a storage jar (noted above) as made by Western Apaches, and most of these plus a hamper and creel produced by the Jicarillas (Fig. 2.11). Occasional odd shapes appear, although these are far less common in Apache baskets than in those of some other tribes. Certainly this can be explained, at least in part, by the fact that Apache basket weaving did not succumb to the commercial to the extent that basketry of some other tribes did, for example, the later Papago and, to a lesser degree, the Hopi. Many forms produced by the Papago tribe were adapted to specific uses for the white man, such as purses, waste baskets, handled trays, and so on. Little development of this nature occurred among the Apache basket weavers, although the Jicarilla creel and hamper fit into this category. Hampers were straight sided, flat bottomed, and often had lids. One side of the creel was rounded, the other flatter, and there was a lid, all of these features adapted from the white man's original piece. Miniatures, such as a burden basket which followed the larger form exactly in very small sizes, did not become popular until recent years, particularly in the 1960s and 1970s. Seemingly, this is another concession to white man's wishes in this craft art. Miniatures by other tribes, such as Piman baskets, were produced in earlier years, some about the turn of the century.

As the tray basket was an all-purpose vessel, serving multitudinous household and ceremonial uses, it was made in the greatest abundance; therefore, among some Indians it received the greatest

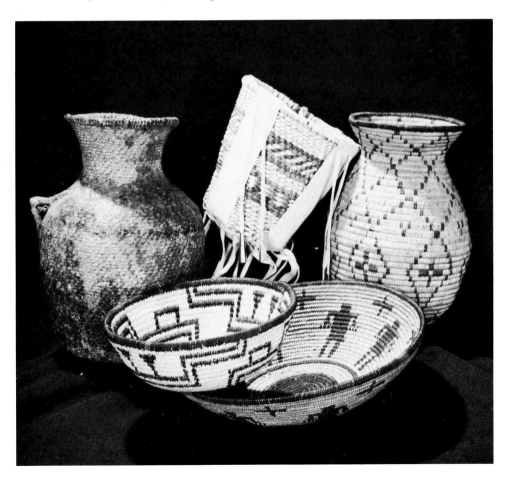

Fig. 2.11. Basic forms of Apache baskets: Tray in foreground *(74573)* with a bowl *(E2781)* on its left edge; *upper left,* a water jar *(E3320); center,* a burden basket *(7415-1); upper right,* a coiled jar *(E6157). (All from ASM.)*

attention in relation to variation in form and decoration. This is especially true of the Western Apache piece, with less variation in Jicarilla styles, while Mescalero trays are quite consistently shallow and wide. The tray varied in size, although quite generally it was a shallow piece as made by the Mescalero, while in the Jicarilla tribe it was much deeper in this dimension. There is considerable variation in the relative diameter-depth measurements in Western Apache trays. Here the wide-rim dimensions gently or more abruptly sloped to a rounded or flat bottom; there is variation in the degree of slope and in the quality of the rounded or almost flat base. In fact, there was considerable variation from shorter, sloped sides and a wide base to an extended curve with practically no flat base. Conical shapes are rare, but they are found in earlier Western Apache forms; among the Jicarillas they are quite typical. Outflared rims are also uncommon in all groups, but some are to be noted in later times in Western Apache pieces. Sometimes the Western Apache trays also have become deeper in later years. In some trays the flat base was often greatly exaggerated through use. Harmonious curves characterize Western Apache more than Jicarilla or Mescalero tray forms.

Burden baskets, which are characteristic of Western Apaches, were used for carrying a variety of objects; thus, an all-purpose pail shape served as a standard form throughout the known history of this piece (see Fig. 2.8). Some older pieces tended to decrease in width from rim to base, this giving them a form slightly different from the usual pail style. However, slight variation in depth-width proportions did prevail, while occasional recent pieces featured a wide top and small base. Bottoms of burden baskets may be concave or convex or neither; a skin covering usually conceals this feature on the outside, but it is observable on the interior. Always there are two loops high on the wall of this piece which served to accommodate a line suspended from a tump band which the Apache woman usually wore on her forehead, or, sometimes, across the chest.

Collecting water from a nearby stream or creek, often in a smaller jar, and storing it close to or in the wickiup, usually in a larger piece, was common practice among Apaches for many years. Basic requirements in the form of the vessel accommodating this custom included a more or less constricted neck and mouth and a full body. Among the Jicarillas and Mescaleros, the water jar was usually small-necked and very round-bodied, with little deviation from this form. On the other hand, when basic requirements were fulfilled by the Western Apache, the weaver often branched out to a considerable degree in matters of both neck-mouth and general body shape. Perhaps the original form of the Western Apache water jar, or *tus* as it is commonly called, had a medium-narrow and straight-sided mouth-neck and a rounded body; this style was pictured in Wittick pre-1900 photographs; it seems to have been long lived. In time the mouth varied; sometimes it became outflared and wider, the neck might be longer or shorter, and the body form responded to Western Apache artistry in several ways. One variation had a distinct shoulder which was slightly sloping, with more or less inward slant in the body wall from the high shoulder to a flat base; or, another was hourglass shape, with a constricted center and globular upper and lower sections. Almost always there was a deep concavity on the

outside bottom of the water jar. Like the burden basket, the tus has two, rarely three, loops high on the wall and/or shoulder to facilitate carrying the vessel.

Bowls are far less common than trays; they are distinguished from the latter form in their generally straighter side walls, deeper proportions, and flatter and more generous bases. There is, however, considerable variation in Western Apache styles (see Fig. 2.11), from a more vertical-sided, flatter-bottomed type, to a distinctly sloping but straight-sided and deep vessel. Curving lines from rim to base are also encountered as a bowl form variation. The majority of bowls are round in form, with oval styles not common. Jicarilla bowls are both straight and sloping sided, with flat bottoms; Mescalero bowls tend to be oval and often have lids.

As noted, there is some difference of opinion regarding the so-called storage jar of the Western Apaches—whether it was made for native use or for sale. The two eastern groups did not produce this form. Whatever the basic idea in its production, certainly these Indians would not have overlooked the potential of use for storage if one of these jars happened to be around. Yet some researchers among these Apaches, such as Basso,[20] note that they have not been observed around wickiups. Too, they are rare or non-existent in early as well as many later photographs of Apache wickiups or camps. These observations would support the idea that many, if not all, were apparently woven solely for sale to the white man. Also favoring this thought is the fact that jars are greatly varied in form and often elaborately decorated. Seemingly, the same trends occurred in trays when they were made for sale, and there is less form variation in early pieces.

Some of these jar forms can be compared with that of the tus: for example, the high, sloping-shouldered style with a gently in-sloping lower body line culminating in a flat base. For the most part, proportions tend toward a more slenderized form than that of the water jar, yet they run the gamut from low, flat and full styles to tall and slender pieces. Some few look like wide-mouthed globular cook pots. There is greater diversity in the region of the shoulder, ranging from beautifully rounded forms to sharply turning styles, or even double-shouldered pieces, a refined version of the hour-glass water jar. Some walls are almost vertical-sided but the majority are curved or straight and sloping; the amount of slope dictates the size of the base.

Proportions in relation to mouth, shoulder, and base diameters are reflected in both simpler and more graceful forms. For example, one piece has a low neck, an almost horizontal and wide shoulder, is vertical sided, and has a wide, flat base, all of which results in a heavy and less artistic form. On the other hand, another example is most esthetic in a medium outflaring neck, a wide and curving shoulder which gracefully merges into the wide wall which , in turn, inclines gently to a small base. Placement of the shoulder varies also, from higher positioning to a lower, almost mid-vessel location. The mouth-neck area may also vary, from short-straight to long-straight, from low to high outward sloping, to curved neck and out-flaring mouth. It may be reiterated that the esthetic in all these matters is often related to neck and body proportions as well as interrelationships of all parts of the basket. One outstanding and

interesting feature regarding this jar is that the base is always decorated.

Mason[21] states that among Apache basket weavers "the Tontos should rank first, making chiefly ollas, which require more skill than plaques or bowl shapes, and their work is universally even and good." Mason attributes their efficiency to the fact that these Tontos occupied the least productive land on their Reservation; therefore, they were dependent on basket making for a living.[22] These comments may also bolster the above suggestion that the Apaches did not make ollas for their own use but, rather, for sale.

Seemingly, the favorite miniature made by Apaches is the burden basket. Most of the very small ones have been made in recent years; the earlier small burden baskets (referred to above as baskets for little girls) are duplicated today. Many of the miniatures are quite good replicas of the large basket, reflecting the same proportions and complete with all the characteristic decoration of the larger pieces. Some do not have the loops for carrying, but instead, have a single and rather large chamois loop attached at the rim, probably so that they can be suspended on a wall. In the mid-1970s several very large-sized burden baskets were produced; one example was three feet in diameter and just over two feet high. These over-sized baskets were deeper and had smaller bases than the usual work basket. Obviously they were not made to be used.

A few additional points relative to odd forms should be set forth. For example, Mescalero Apaches on rare occasions wove a pitcher form, complete with a handle; its form is that of the simple jar with a handle added. Also they produced a deep, straight-sided, and fairly large form, similar to a wastebasket and probably made for that purpose. The water bottle of the Jicarillas is coiled, of simple form, and sometimes this jar has a lid and a handle which goes over the entire top from the upper part of the body. Some Jicarilla bowllike forms have smaller rim diameters than base measurements; the drawn-in top is rather unique to this tribe. Another unusual form produced by the Jicarillas is a footed dish; one such piece became a pitcher with the addition of a handle and a false spout. Not uncommonly made by this tribe are handles on hampers or trays. Two types were produced, one a simple upward extension of usually two coils, the first wrapped rather than sewed into the previous coil and the second sewed into this. The other style simply leaves an open space by turning back the coils, then carrying them over the top.

These comments on materials, techniques, and forms will be elaborated upon in further, more detailed discussions of the baskets of each major Apache group.

Decoration

DECORATION OF A BASKET is not a haphazard, unplanned, accidental performance. It is a conscious, planned, well-thought-out expression. It is a procedure of order, partly determined by the technology of weaving, largely by the weaver's creativity. Much is directed by what the weaver has seen all her life—that is, the tribal style. Further bias is often expressed in the direction of family or clan; too, the individual can and often does put herself into her basket designing to the degree that her pieces can be recognized not only as the handicraft of an Apache but as that by a particular Apache woman.

Decoration tends to be a formal matter; it involves not alone design elements and motifs and total patterning but also includes the arrangement of all in relation to specific forms, as well as the forms themselves. For purposes of better describing the artistry of Apache basketry, *field of design* (where design is to appear), *layout* (specific style of adaptation of pattern to this area), and *design elements, units, and motifs* will all be described concisely in terms of Apache usage. Immediate descriptions are not all-inclusive, but they will indicate what happens in relation to each situation in general. Further, specific application to individual pieces will follow in later discussions.

The first concern of the weaver is what form she is to produce. Immediate need dictated this in earlier years, for a woman usually made all baskets used in her own household. Later, when a sale was involved, choice on the part of the weaver was dominant—in fact, so much so that a woman, or even a group of women, might become famous for a particular shape. Such was the case with one Tonto Apache tribal woman who became known for the production of jar baskets. Undoubtedly much thought ensued after the gross form was decided upon—what size, a deeper or shallower tray, an oval or round bowl. Materials were then chosen.

Mental planning continued as to how much time could be given to design creation. More specifically, the weaver then thought out how much of the basket was to be decorated, where the decoration

should appear, what the specifics of design should be. That these details relative to weaving a basket were pursued mentally by the weaver is attested in the finished product, for primitive women had neither the time nor the inclination to ravel or "unweave" a basket. Thus, an uncluttered, well-formed mental picture of the finished piece was envisioned before materials were actually taken in hand. More specifically, and in terms of analysis of the finished basket, the weaver clearly established in her mind the above points possibly in this order: one, where she wanted to place the design on the form she had chosen; two, how that pattern was to be arranged or divided in the chosen space; and three, what design elements, units, and motifs she could use. This terminology may not have been in her vocabulary, but that these items were uppermost in her mind cannot be doubted.

FIELD OF DECORATION

The area or field of decoration is that portion of the basket which is to receive the attention of the weaver. Will it be the entire basket or a portion thereof? Will it be on the wall alone or wall and neck? The Apaches expressed some distinctive ideas along these lines; for example, the flat and unexposed base of the Western Apache coiled jar always carried a design, as did most of the wall. Too, the tray basket of this same tribe was more apt to be decorated in all-over fashion than to receive a limited band or spotted pattern, perhaps just because the Western Apache preferred all-over patterning to more limited arrangements, even in earlier, more sparsely decorated pieces. The tray was an open form which in itself invited an all-over decorative style. More generally the twined burden basket had repetitive bands of decoration rather than a single one, all confined to the walls of the piece, owing in heavy measure to its deep shape and to technology. Water jars, for the most part, carried painted decoration on the shoulder only, rarely below this point.

Jicarilla tray baskets were rather deep and straight-sided; perhaps that is why the wall alone was more apt to be chosen for the area of decoration; if decorated, bottoms were given secondary attention. Contrarily, the very flat tray made by the Mescaleros invited attention to the entire surface and the sparse decoration used by this tribe was often spread over most of this field. Deep forms of the Jicarilla also had flat bottoms which were not decorated, but all of the side wall was open for consideration—and frequently used—as the field of design.

LAYOUT

After choosing the field or area of decoration, the weaver mentally decided on the layout style she wished to use (Fig. 3.1). Layout is the adjustment of design to the specific and established field or area of decoration. There may be applied (woven) or mentally visual lines of enclosure within which to confine the design, to aid in the organization of pattern. Layout may further be defined as the plan for the total design, with the objective of integrating its parts into a whole.

Almost all Western Apache coiled basketry, trays, bowls, and jars, had a smaller or larger black circle or other all-black form in the

Fig. 3.1. Design layouts on basketry: (a) banded, (b) half-banded, (c) organizational banded, (d) centered, (e) repeated, (f) all-over, (g) composite (centered-banded).

center of the piece. In essence, this might seem to invite "all-over" designs; in actuality, this central theme was handled so differently that several other layouts can be defined. Occasionally both Jicarillas and Mescaleros used a darker center, either a plain circle or a more complex theme, but here, too, several different layouts were utilized.

Basically there are three layout styles: divided, undivided, and composite. A divided layout is one in which lines, real or imagined, contain the total design or part of it. An undivided layout is one in which there are no dividers, either real or imagined, but all lines are part of the pattern. There are, essentially, two basic divided layouts used by the Apaches, the banded and the half-banded. Among undivided layouts are repeated, centered, all-over, and organizational banded, while composite styles combined two or more of the foregoing layouts.

Briefly defined, a banded layout is one in which two parallel lines contain the design. In many Western Apache coiled baskets, the outer edge of the plain central black circle served to define the inner edge of a band; so too with the inner circle of Eastern Apache baskets. If a single band only was used for design, the rim usually served as the second "line" parallel to the central one; as this was frequently black in Western baskets, it was more real than imagined. When these two features are concerned with layout in this way, it can be said that much Apache basketry decoration is banded; however, if the black center, such as a star or flower, is looked upon as part of the decoration, the resultant design is often all-over, or composite if this central theme is massive. Certainly, the artistic feeling is often one of banding. Apaches also used multiple bands, up to five within this area; in such instances, black lines in the weaving contained the patterns of each band. Apaches did not use further dividers occurring within the larger band in the form of vertical or oblique lines. However, Apaches not infrequently used what was part of the overall design to serve as a divider, with decorative units placed between two such motifs. Withal, the Apache weaver preferred to use the band as a single area and treated it with a continuous or a separate repeated motif. Half bands have one line from which the design is suspended.

The second large layout style, the undivided, was greatly favored by Apache basket weavers. This was accomplished by Western tribes by converting the larger plain central circle into a star or other design motif. Frequently the Eastern Apaches, lacking the center circle, used the undivided layout in other ways. Centered layouts usually involved the magnification of the central motif, with no further decoration in the basket. An organizational-banded style is one in which the design is continuous or repeated but forms a band within itself, such as a fret or a line of repeated scrolls, with no containing band lines. All-over layouts include a larger middle theme related to one of a variety of integrated or non-integrated designs which move to the rim or appear throughout most of this basket area without forming another layout style, or they may consist of scattered units or motifs over the entire basket. A repeated layout involves the placement of three, four, or more dominant and often single discrete motifs at regular intervals, for example, on the wall of a Jicarilla tray.

Several composite layouts were developed by Apaches in their coiled basketry. One which was favored was an enlarged center motif combined with a banded or half-banded theme or repeated motifs close to the rim. A second combined the middle motif with one or several organizational bands; a third involved an organizational band plus discrete units rather more scattered than in a band. In some instances it is difficult to distinguish between this last layout and one which might cross over into the all-over style. Occasionally a Western Apache tray basket in particular may have several definitive bands, with spaced-out elements or motifs in the "in-between" sections. The elements placed in such an arrangement are, to all intents and purposes, bands, but, in the final analysis of design, they give more of a feeling of repeated themes. If so accepted, this would be classified as a composite layout of banded-repeated style.

DESIGN

A design is made up of several parts including element and/or unit, motif, and the total pattern (Fig. 3.2). It is the manner of utilizing these, or the "putting together" of them into the end product, that creates distinctive tribal styles of decoration. Differences exist between the Eastern and Western Apache styles, sometimes with widely diverging end products.

An *element* is the smallest part of a design and is fundamental or basic to all geometric patterns which cannot be divided further without losing their character. In the narrower sense, this definition would include a line and a dot; in a realistic application it further admits squares, rectangles, triangles, parallelograms, and a few others.

Closely related, or perhaps overlapping, is the *design unit.* Strictly defined, these represent simple combinations of elements which are used by the weaver as she would the element itself; particularly are they the products of specific traditions of decoration in a given cultural or tribal area. An example of this in Apache basketry might be the arrow point, a coyote track, or variations on the star. However, the Apaches did not really evolve many units strictly peculiar to their traditions alone, but, rather, combined and recombined the basic elements mentioned above. So much confusion appears in the literature regarding the use of the terms "element" and "unit" that the two are unfortunately used interchangeably.

Perhaps more important than the distinctions between unit and element is the definition of *motif.* A motif is usually a combination of like or different elements and/or units. As a matter of fact, an element or unit alone can also be a motif, for instance, a repeated simple diamond encircling a basket wall. Apaches did use such simple motifs, but they became alive under the weaver's hands. A motif, then, is one or more dominant themes in the total pattern. Examples of such motifs might consist of a series of short or long zigzags built up of squares or rectangles; a solid stepped diamond outlined with small squares, often with outcurving upper and incurving lower outlines; a great open star consisting of one to three separate outlines of built-up squares; a human or animal created by piling squares and rectangles one on another; plus many others. The

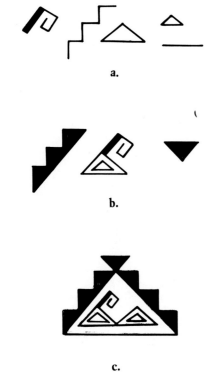

Fig. 3.2. Parts of design: (a) elements, (b) units, (c) motifs, (d) pattern.

pert human and animal personalities of Western Apache baskets are units as distinctive as any part of their design repertoire; sometimes they become motifs.

Total design is the all-over, complete pattern found on any basket form. It is the combination of any and all elements, units, and motifs used on a single piece. The design can be simple or complex. As noted, it may consist of a single repeated simple motif, perhaps including an element or unit; or it may be made up of one or several motifs with one or a number of additional units or elements thrown in between them. A simple example would be a twice-repeated star. A more complex design might consist of a two-motif theme, a centered double star and a wide checkered band vertically placed; between the stars are coyote tracks, and between the bands are deer plus a geometric extension of the outer star points.

STYLE

Style concerns all aspects of total design and, rightfully, form as well. Expressions of style would include color and other types of decoration; where the pattern appears on a given form; what the elements, units, and motifs consist of; and the interplay of all of these in the total pattern. Too, the use of positive and negative patterning reflects style, as do dynamic and static themes, or center-to-edge or encircling arrangements of patterns. Other expressions of style reflect the creativity and imagination of the weavers, the quality of the weaving itself, and symmetry or asymmetry of total design. Simplicity or complexity can be expressive of style: Mescalero tray designs are basically simple, while many of the same woven by Western Apaches are complex.

Form alone is expressive of artistic style, but even more so is the adaptation of design to a form. Undecorated water jars of the Western Apaches often reflect a distinctive style in their shapes alone. Certain styles of decoration are adapted to a general form, and, more intimately, a specific design may be adapted to a specific basket. In the latter case all the innuendos of variety in a given form, plus the same in design, come into play as a result of the creativity of the weaver.

Fluctuating variety occurs in the relation of design and form in a single tribe such as the Western Apache, from little or no decoration on the water jar, to rather severe banded styles on the burden basket, to greater or lesser quantities of decoration on the coiled tray, bowl, and jar forms. The vast majority of design is executed in color, basically among the Western Apaches in black, which is the natural color of martynia, or in dyed black or red; more commonly among the Mescaleros other colors, such as tans or soft yellows and greens are used, or, among the Jicarillas, a wider variety of colors. A decorative note, however, is also expressed in weave variation. A third type of decoration, as mentioned previously, occurs in the addition of buckskin in the form of patches, or thongs with attached tin cones (or "tinklers" as they are commonly called). A bit of cloth around the edge of a buckskin bottom patch may also add a note of style to a burden basket of the Western Apaches.

Style of decoration will now be discussed with these points in mind: form, design in color, other additions, and weave variation.

The tus or water jar has less decoration than any other form in all Apache tribes; basically it is undecorated in the twined piece. However, as suggested, some variation in weave occurs, usually with a three-element, twined wicker at such points as turns at base and shoulder or on the bottom, which gives strength but also adds a note of beauty. Decorative variation of weave also occurs on the shoulder or sometimes at other non-stress points in the wall or elsewhere. Infrequently a Western Apache woman would dip her finger into ground charcoal and make a black ring or some other simple geometric design on the shoulder of the tus. The rubbing of the entire surface of the water jar with red ocher before pitching it also imparts an esthetic quality to this vessel. Very rarely, a Western Apache tus may have a woven design; infrequently, the coiled water jar of the Jicarilla will be patterned, usually in simple geometric style.

Western Apache burden baskets almost always carried distinctive styles of decoration from colored bands woven into or painted on the vessel wall to buckskin and tin tinkler additions. The wall decoration consisted of two or more horizontal encircling bands, usually black, or red, or red and black, and generally of woven design; very rarely, purple, red, green, or orange was painted on the finished piece. Designs were usually between two woven or colored lines or bands; often the band was organizational or it might be a half-band. Simple geometrics characterized this style of decoration; most popular were slanting or vertical lines, or zigzags or a few other small geometrics such as squares, triangles, or diamonds, plus solid bands and checks (Fig. 3.3). There was a close correlation between fineness of weave and well-executed design.

Fig. 3.3. Wicker designs: simple and irregular lines and geometrics. *(Drawing by Chris Van Dyke)*

Burden baskets of the Western Apaches were characteristically decorated with buckskin in the form of a bottom patch and four vertical bands along the wall of the vessel, with longer or shorter thongs along both and sometimes between bands at the rim. Thongs often terminated in tinklers cut from cans and rolled into cone shapes. In older pieces the bottom patch was frequently scallop-rimmed, often with a piece of red cloth under the patch and showing at this edge. Quality of cutting the buckskin, or lack of it, for patch, bands, and thongs added to or detracted from the total esthetic nature of the burden basket. It is thought that in earlier years the Mescalero and Jicarilla made comparable burden baskets. However, the few noted were usually simpler in style.

Some similarities existed among all three Apache groups in the decoration of coiled tray, bowl, and jar baskets, plus the hamper of the Jicarillas. Predominantly among Western Apaches, the first three of these forms had black designs, all-over patterns were not uncommon, and black centers were characteristic. More commonly in Jicarilla baskets, the center would be plain or light colored, and design colors were varied with little or no black. Some differences also occurred in the artistry of these first three pieces in the three Apache groups.

The Western Apache oval bowl featured both continuous and separate, or at least partially separate, bottom and wall patterns. For example, in one instance a more geometric theme appeared on the bottom with a row of life subjects on the wall. However, in some oval bowls the weaver brought part of the base design into the wall, for example, at the two sides; then the end would have an independent row or two of life themes on the wall. Or the geometric design

of the base continued onto the wall, sometimes with slight variation at the ends. This break in sidewall-end arrangement was emphasized in the Western Apache oval bowls, for such composition does not appear in round bowls, or in either oval or round Jicarilla pieces. Horizontal patterning is featured in bowl designs.

Jar decoration of Western Apaches is more varied than bowl ornamentation. Both vertical and horizontal dispositions of design were popular, as was all-over patterning. The base was decorated either simply or in complex fashion, either independently or integrated with side-wall pattern. Some bottom themes were quite ornate. Horizontal wall arrangements tend to be banded, either regular and/or organizational, but sometimes what seem to be horizontal arrangements were integrated from row to row, thus becoming all-over. Vertical patterning is in panels or organizational schemes, as are diagonal arrangements; often there is also a distinct verticality to the all-over jar patterning. On the other hand, Jicarilla jars were used for water and were pitched; hence, design is absent, or usually simple when it does exist.

Coiled trays enjoyed the greatest diversity of patterning of any form of all Apache baskets. All styles given under the section on layouts appear in trays, with emphasis on a variety of composite arrangements of design. Additional characteristics discussed below are more commonly applicable to tray baskets than to any other form.

One quality of decorative style which is quite generally typical of Apache basketry design is repetition (Fig. 3.4a). The same unit or motif may be repeated (a-a-a-a), or alternate units or motifs may recur (a-b-a-b), or there may be an a-b-c-b-a repetition, or exact repetition may be ignored, particularly by the Western Apache weaver, a-b-c. The first type, a-a-a-a, is the most common in Western Apache baskets, while Jicarillas and Mescaleros favored the a-b-a-b style. If several units or motifs are to be found in the decoration of a Western Apache basket, sometimes they will follow the second type of a-b-a-b repetition. For example, one interesting variation involves rows of quadrupeds, dogs, horses, or deer moving from toward the center to the rim in a curving manner, alternating with zigzags; in the total design this is an a-b-a-b repetition, but with an a-a-a-a rhythm for the details of each curving line.

There are other rhythms used by the Western Apache, sometimes related to smaller details in larger motifs. For example, contained within five Apache diamonds are two rows of figures: one row is a-b-c in each, and the other row is a-b-a in three diamonds and a-b-c in the other two. The overall feeling of the patterning is one of balance and symmetry.

Repetition may or may not be perfect and absolute in Western Apache baskets but tends to be more consistently so in Eastern pieces. Often star points vary in sizes in designs of the first group; perhaps this is more accidental than intentional. Or, if life forms are used, again in Western Apache baskets, often there is imbalance; for example, in a ten-division area on one basket, seven spaces have a man and two dogs, one has a man and a single dog, another has a man and two dogs, and the tenth has a man and four dogs. In this instance, irregular space division may account for discrepancies, but in other instances it would seem that intent, perhaps from boredom,

Fig. 3.4a. Types of design repetition: (a) repetition of same element, (b) alternation of two elements, (c) three different elements, (d) alternation and repeat.

might account for irregularities in designing. For instance, in another Western basket, there are a larger and a smaller quadruped atop four triangles but only one animal on the fifth triangle—and this despite ample room. Regularity of spacing characterizes this piece. Or, perhaps an extra cross or dog might be put in just for fun. Too many perfectly designed and balanced Western Apache baskets exist to believe that plan or conscious effort was not involved with at least some of these irregularities.

Another concern of style might be summed up in positive versus negative patterning (Fig. 3.4b). In positive design, the black (or other color) forms the pattern against a lighter ground; negative is when the design shows through in white (natural) as it is surrounded with black or another color, a favored expression of many Western weavers. Positive designs are by far the most common in all Apache basketry, but some of the finest work in this craft incorporates a smaller or larger amount of negative patterning, often in the same piece, with the positive style. A good example of negative design is a white coyote track or a man in a black triangle. Positive designs run the gamut from simple line themes and small solid life or geometric elements, and outline geometrics, to elaborate solid geometrics and life forms; many smaller units or themes are duplicated in negative style.

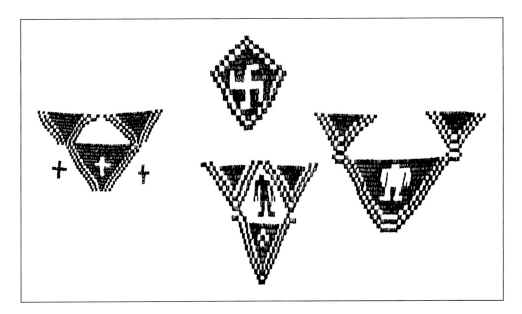

Fig. 3.4b. Negative and positive designs. *(Drawing by Chris Van Dyke.)*

Analysis of Apache basket designs reveals great variety in both static and dynamic styles. The Western Indian patterns are dominantly dynamic, although some static schemes do occur; Jicarilla and particularly Mescalero tend to be static. Perhaps small static elements, which are so frequent in the Western tribal baskets, were intentionally added on occasion to stop—or at least slow down—some of the more active motion in patterning.

Designs in Apache baskets follow two basic general schemes of total arrangement, with variations within each: a center to edge or an encircling style. Center to edge can proceed in a static fashion, moving directly outward in a straight manner, usually from the black or lighter-colored center circle to the rim. Or the motif may curve or move slightly or dramatically, accordingly giving less or

more dynamism to the total pattern. In the second style, a band of repeated elements may appear singly or in multiple rows to encircle the basket. Depending upon the nature of the motif, the end result may be dynamic or static. For instance, encircling zigzags can suggest motion while repeated rows of checkerboard are rather static. Straight-lined or angular floral or star themes sometimes portray the static, but when the flower becomes very rounded it conveys a feeling of motion.

In center-to-edge designs, the Western Apache weaver was most versatile, the Eastern group less so. In the first group's trays, there were quite simple bands, plain or checker, in positive or negative; or simple and small zigzags; or stacked triangles which went straight out from the black circle to the edge. The first were always static, but the zigzag might be enlarged to the point that it became dynamic because of its deep form. Rather typically in Western Apache trays these were simple or complex, wide or narrow zigzag or circling themes arranged singly or in parallel groups of two or three which emanated from the black circle and curved to the rim. The bend or curve might be slight or great, thus suggesting less or greater movement. Jicarilla weavers repeated more of the static than the dynamic style, but there was dynamism in their encircling bands of zigzagging steps or in stepped diagonals moving from near-center to near-edge, or in great stepped stars.

Another dynamic style of the Western Apache weaver was the outline star or floral theme mentioned above as executed in multiples. For example, a single five-petaled flower takes off from the black center circle, a second takes off from the tips of the first, and perhaps even a third or fourth might be repeated in like manner. The end result is considerable motion. Many combinations of the static and dynamic appear in Western Apache baskets, but Mescalero and Jicarilla designs tend to follow the single more static style.

Because of tremendous variation in their treatment, an analysis of specific design elements and units follows.

BASIC ELEMENTS AND UNITS

Basic to designing in coiled basketry are the line, square, rectangle, and circle (Fig. 3.5). Then there are numerous geometrics such as steps, triangles, or diamonds which tend to be outgrowths of the square and/or the rectangle. The line may be but a single stitch or several of them, or, in fine basketry, a single coil. Increase of stitches and coils would move the line into the category of a band. A square could be a single coil high with enough width stitches to equal its height; more length in the coil or more stitches would change this into a rectangle. Stacked rectangles which draw inward from both sides bottom to top will produce a triangle, while two of the latter, base to base, will make a diamond. Thus, angular geometrics grew out of varied combinations of stitches and coils against a natural background, and design units grew into motifs.

Starting with color in the beginning center of a coiled basket and continuing it for several or many coils will create a smaller or larger circle. Dropping the color then picking it up again for a complete coil will produce a ring. Thus another basic form, a curvilinear geometric, will be possible.

Fig. 3.5. Square, rectangle, line, circle, and triangle, all basic elements. *(Drawings for Figs. 3.5–3.26 are by Chris Van Dyke.)*

Whether borrowed from someone else or created by the Apaches themselves, from the few above basic design elements dramatic expansions were made by these Indians. Most particularly did the Western Apaches grow in creativity, using primarily the black and natural combination. Jicarillas also expanded greatly, employing a wide variety of colors. Perhaps the wide coil of the Mescaleros served as a control in patterning, for their designs are far more limited in contrast to the above two.

The *line* is the simplest design element used by all Apache basket weavers; its variations are numerous (Fig. 3.6). Both fine and broad lines were expressed: alone; in groups of two, three, or more, usually in a horizontal row although sometimes vertically arranged; or in combinations of narrow and broad lines. Shorter and longer one-stitch lines might appear together. Lines, particularly broad ones, were used by all three Apache groups to express a variety of forms, some meaningless, some in specific geometrics; again these forms might appear alone or in continuous vertical or horizontal arrangements. Some solid geometrics had lines or almost-lines projecting from them, such as a horizontal band or some other geometric form with narrower lines above and below. Also geometrics were outlined with narrow lines, for example, a stepped diamond or an hourglass form, each with a narrow single-stitch line to right and left.

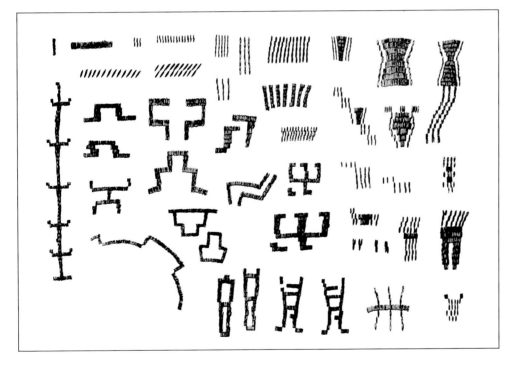

Fig. 3.6. Lines and bands.

Occasionally, Mescaleros filled a geometric form with short parallel lines, or these lines might appear in diagonal arrangement without any connection with other forms. Or several parallel lines might be used as part of the total design, for instance, by Jicarillas. Mescaleros also frequently outlined a square, triangle (or rectangle) with a line on two sides leaving the third side untouched; Jicarillas sometimes connected two geometrics with a short line or band.

A *band* is little more than a broadened line, and it is employed frequently by Western Apaches, less so by the Eastern tribes (see Fig.

3.6). Like the line, the band element may be used alone, although it is more commonly repeated, or it may be employed to create a specific or general form, such as squares, rectangles, triangles, beginning or full meanders, various odd geometrics, and almost-bird and almost-human figures.

Squares and *rectangles* are basic to practically all basketry designing, although different tribes tend to use them in different ways (Fig. 3.7). All Apaches use the square as a solid; Western and Jicarilla

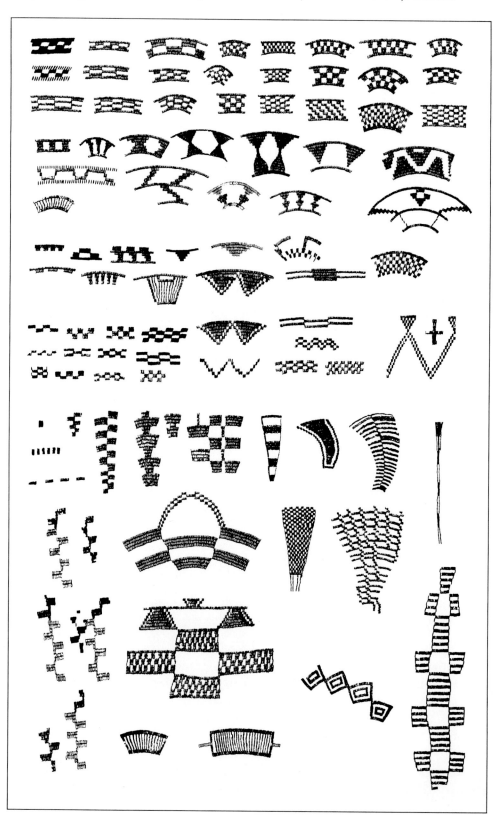

Fig. 3.7. Squares and rectangles.

tribes also employ single or double outline forms. Rectangles and squares are commonly used to build up other geometric and life forms. There is a great deal of variation in proportions of the rectangle, as it may be longer or shorter, thin or fat, resting on its longer side or standing on its narrower end.

Certainly the Western Apache once again utilizes these two elements in the greatest variety of ways. They use the square or rectangle to form or be part of everything except the complete circle or lines; they form larger squares and rectangles, open or outlined triangles, diamonds, arches, zigzags, netting, and other geometrics; and certainly everything that is stepped employs the rectangle or square. Although solids are dominant in life forms, parts are made of rectangles and squares, such as ears, horns, feet, hands, arms, and legs. Some legs, some animal ears, and most fingers are apt to be lines. Any additions to humans, such as hats or objects in the hands, are frequently created in rectangles or squares.

The nature of coiled basket weaving, most of it the crossing of elements at right angles, naturally creates squares and rectangles when color is introduced. Thus, it is not surprising to find these two basic elements so prominent and so basic to design creation.

Sometimes the Western Apaches used the rectangle and square almost like building blocks. Horizontally arranged they might create a chain effect, or, when repeated one row above another and alternating, checkerboarding (with or without bordering lines), or alternate black and white boxes, or even zigzags. Quite obviously other odd forms, such as triangles, coyote tracks, and crosses, were created of either squares or rectangles or of the two in combination. Common, too, were vertical arrangements of these two elements, in blocks creating bands, or along both sides of a line or band, in regular or irregular succession, or in vertical checker effect. Sometimes they may appear in diagonal arrangements.

Distinctive uses of these two elements by the Jicarillas include the creation of one square or rectangular form inside another, each of a different color, or an encircling band of rectangles arranged in two rows, alternating and touching corners. Some squares or rectangles appeared within another form, in a different color. Solid squares might be woven at the upper corners of a triangle or coyote tracks, or alone among other larger motifs. An interesting Mescalero treatment is the single rectangle of yellow which is edged by narrow red-brown lines.

All Apache groups used squares particularly, and sometimes rectangles, to outline any geometric form. This might occur on two sides of a triangle or all around a diamond or other shapes, or along continuous vertical lines of these forms. Jicarillas frequently used different colors in the solid form and in outline squares, and often in squares or rectangles making up some other geometric shape.

Practically all Western Apache basketry begins with a black *circle* or with some elaboration of this *center* such as a star, also in black (Fig. 3.8). Eastern Apaches, on the other hand, seldom use a darker beginning center; when the Jicarillas use such a theme, it is usually in yellow, green, tan, or some other lighter shade. Even less frequently used is the plain-colored center circle of the Mescaleros; it is usually yellow or tan, rarely darker in color.

In Western Apache baskets the plain circular black center varies in size from tiny two- or three-coil examples to great circles, some

of twenty-one coils in diameter, with every possible count in between. Jicarilla centers vary also, from those of two coils to eleven or more colored coils. Mescaleros favored yellow centers of small size when they used color.

Next in simplicity for centers is a variation of color with the natural material in successive coils or sometimes black-white, yellow-white, or other alternate stitching. In Western Apache and Jicarilla baskets, coils of alternating black and white or light stitches, respectively, are to be noted. Some Mescalero pieces will start out with two tiny coils in natural, then for some distance alternate single coils of brown and natural stitching or yellow and natural. One Jicarilla variation in the center of a basket had three yellow coils, three of alternate dark-light, then three more yellow coils, all forming a joined center. Other combinations of plain light and dark or alternate stitching also were used by both Eastern and Western Apaches.

Fig. 3.8. Circles and other centers.

Centers of Western Apache baskets consisted of three additional types: namely, a black circle with short attached design elements, a black circle with some unit of pattern surrounding it and obviously a part of it, and a black circle from which the main design takes off, often to the rim. The last style seems to be less numerous in these Apache baskets, while the first and second are more abundant and often more dynamic.

Quite common, of course, are relatively simple black geometrics added a coil or two beyond the solid circle. These may be broken or continuous. They may be encircling solid or alternating bands of lines or stitches, or squares or rectangles with smaller squares at the corners; or some type of stepped arrangement; or a star or flowerlike "wreath" about the black circle. Raylike projections may also appear; in many cases they are one coil removed from the center plain black circle. Some of these ideas are combined in a single, more elaborate center. One interesting deviation from the

geometric in the unattached style is a basket with a very small
(two-coil) center and one coil away are four men with their feet
toward the center. They are quite simply presented, with narrow
hips, wider bodies, and outstretched arms ending in two fingers
on each hand.

The most typical arrangement for this center circle in Western
Apache baskets is some black theme immediately attached to it. In
some instances this is not as obvious as in others, but the intent is
there. Next in simplicity would be one or several plain circles a coil
or two beyond the solid center. Then come the rays or coglike pro-
jections which may be long or short, slim or fat. These are some-
times clustered, for example, in three or four groups, or they may
be single and evenly spaced. In one basket they are made up of a
large number of tiny but relatively heavy, slanting and spokelike
elements. Sometimes these extensions are gently splayed out,
the end product resembling golf tees. If the inner circle is tiny
in such cases, these centers look more like design units than
circles with additions. In some instances these "tees" become so
enlarged that each may contain negative elements such as crosses
or coyote tracks. Occasionally each such unit, usually plain, may
have a number of single-stitch lines projecting from the tips of
the tees. One very dynamic tee theme has four outcurving units
extending from the center circle and at the right corner of each a
long-stemmed graceful tee.

Other variations of simple projections would be the addition of
blocks to one side and at the tops of projecting squares, this giving
a dynamic feeling to the center motif. Stepped themes of various
kinds are common; they may be close-set or more widely spaced,
the steps may be thin and long or they may be short and fat, all
adding a feeling of dynamism to the central theme.

Checkers represent another category of motifs attached to black
center circles. These may take off in double or multiple rows, in star
points or in some other geometric shape, such as the graceful tee.
The checkers may be squares or rectangles, and they may be fat or
delicate. In one example, six V-shaped steps take off from the black
center and each has a solid stepped figure within it, thus giving a
feeling of partial checkering.

Composite motifs are frequent in the attached centers of Western
Apache baskets. These run the gamut from one with crudely exe-
cuted, unidentifiable geometrics to another with a more delicate
triple swirl motif, each composed of five spokelike projections out
of a solid base to which is attached a large four-coil rectangle. From
the left tip of each of the latter there reach out successively, seven,
five, and eleven spokes or lines. In another basket there are five
extending almost-triangle units, each capped with a diamond with a
wide negative slit in it. All themes beyond the circle have stepped
outlines.

There are, of course, many varieties of more elaborate motifs
attached to the central circle. One more of this general category
consists of five design units which extend from a well-made black
circle of eighteen coils. Each unit is made up of a wide, flat-topped
element out of which juts an almost-triangle which, in turn, has
five heavy irregular wooden "fingers" extending from its top. Low
on each side of the first solid element projects a long unit termi-

nating in three ribbonlike irregular lines. All in all it is a pleasing
creation.

One specific class of motifs attached to the center circle might
be termed floral, for the majority of these do suggest a flower in a
general or more specific way (see Fig. 3.8). Some of these are referred
to as "stars." Too, some would classify the majority of these as
Yavapai; many could certainly be Western Apache. Three catego-
ries of this theme can be established: one, outline or nearly so; two,
a solid style; and three, a negative type. A few examples cannot
be positively placed in any of these categories. Outline styles may
use one, two, or three rows of stepped elements with which to out-
line the floral form; the heavier form may be Yavapai. Five petals is
the most common representation, although four, six, and up to twelve
are occasionally executed. Most of these are attached to a simple
circle. There are some which have a second outlined flower, or a
solid-petaled flower, or other geometrics such as triangles in the cor-
ners within the outline. One solid-petal central flower of six points
has a twelve-pointed attached outline beyond it. Occasionally,
one outline flower emanates from another onto the rim of the bas-
ket, as previously mentioned.

The negative style is very limited. Often it is no more than five or
more outline triangles coming off the black center circle, with tiny
black triangles whose center tips touch the black circle, leaving a
white floral theme. One negative six-pointed flower has first a
double-stepped outline, then a filler to the heavy circle of alter-
nating black and white stitches.

Much more common are flowers of solid black petals, sometimes
with a negative theme such as a cross or coyote track in each petal.
Simple all-black styles may have from three to twelve petals, with
five the most common number. Petals may be grossly heavy, round-
tipped, and irregular, or they may be gracefully curved from a small
base to a wider near-center and then tapered to a pointed tip, with
either regular or irregular spacing of petals. Rarely a sharp tip may
be topped with a square. The tapered, slender leaf is more apt to be
attached to a smaller center, while stepped triangular leaves fre-
quently emerge from larger, heavier centers. Occasional solid
flowers are outlined with a single, stepped line.

Space between petals varies, as mentioned. Some of the more
shapely leaves have a narrow or wider space between their bases,
while the triangular style more often has little or no space at this
point. The curvacious leaf style is also apt to be more regularly and
evenly woven while other types are sometimes very irregular in leaf
size and shape.

Some life themes are also attached to or near a central unit. In two
instances there is a black circle from which floral extensions sup-
port the figures. In one there is a four-petaled flower with a cross at
the termination of each petal, and then a dog (?) with its hind feet
on the very tip of the left arm of the cross. The second basket is more
elaborate. On each of six petals (two touching) stands a man, each a
little different. Moving counterclockwise and beginning with the
double petal are men with these differences: one with a cross near
his right elbow; one with a left arm missing; another with a cross
near the right elbow; a dog (?) on the right upper arm of the fourth;
one with both arms plain; and another fellow with a dog on the right

elbow. Each stands full front, with simple legs, out-turned feet, and arms attached to wide shoulders.

Thus is variety the spice of the center theme in Western Apache baskets, while simplicity prevails when the same area of Eastern Apache baskets is decorated. In fact, the centers of most of the latter pieces are plain. Some might even be thought of as negative in that an outlining band of decoration emphasizes the plain center. In one Jicarilla instance an outline, single-coil ring supports seven V-shaped units which project outward, while in a second example a comparable ring has four triangles projecting toward the plain center.

Triangles as elements were greatly favored by the Apache basket weaver, for here she could use her imagination to the limit (Fig. 3.9). Generally they are equilateral or nearly so, with the point up or down; occasionally they are isosceles. Jicarillas stressed the latter more than did other Apaches, usually outlining them with a contrasting color, sometimes with two colors, and frequently with an internal design of a different color. Also they used different colors in opposed right triangles or turned the latter into two isosceles triangles through the use of a different color for each half. Although the majority were stepped on two sides, some few had two (rare) or three smooth sides.

Most frequently triangles were solid black, sometimes solid red, now and again red and black, as used by Western tribes, or in the Eastern groups, yellow and another color or two. Almost never did they appear in outline form among the Western Apaches, but Eastern groups frequently made them in outline with a natural or differently colored interior. They were sometimes made up of checks or alternating dark and light squares by Western groups or of various colored lines by Jicarillas. Among all Apaches, though infrequently, negative patterns were used within triangles: crosses and coyote

Fig. 3.9. Triangles.

tracks, and, in addition, swastikas, humans, or just a geometric without specific form in Western Apache pieces. Within large triangles this negative patterning may include multiple elements, such as four coyote tracks plus one other unit.

Frequently Western Apaches used single triangles with the point downward with some kind of projection such as a square or another triangle at each top corner: a row of stitches across the top, or with an elaborate bar one row above the triangle and attached at the corners, plus dangling elements hanging below the point of juncture. The major variation with the Jicarillas was another triangle at each corner. Less frequently, the base of the triangle is down, the point up, and these may have additions pendant from the base. Two triangles may be joined at their points to serve as a unit of design in either Jicarilla or Western Apache baskets.

Additional comments are applicable to the Western Apache development of the triangle. It was common practice to outline triangles whether they were simple three-row or many-rowed creations. Outlining in some examples gives the illusion or denial of a triangle, but it is there; this is especially true of smaller and simpler forms. On occasion the weaver starts out with a perfectly good triangle outlined on each side with steps but loses herself in a non-flat upper part of the design.

Typically, outlining is done in this manner: a stepped-sided, flat-topped solid black triangle has single rows of stepped squares along each side, with the apex down or, less frequently, up. There are flurries, of course, for this element may have curved sides and/or top (or bottom), the most graceful combining these two features; there may be a negative life or geometric figure inside these triangles, and the outlining may be in double or triple steps, joined or not at the bottom (or top). Rather infrequently, the solid form is red and the outline black. If there is an additional touch it is

seldom more than a single black triangle at each side of the top. Outlining detail is usually in the form of squares, although sometimes oblongs on end add a different feeling.

Triangle elements or units are put together in multitudinous ways to form a variety of motifs. Often plain triangles are joined to form an encircling band, or a group of three or six of the same size may be built up to form a larger triangle; these may alternate points up or down. When various details are added, such as negative patterns, stepped outlines, points up or down, then some potential of individuality is established. Variations in these horizontally arranged motifs include, among others, alternating point up, point down, in joined triangles; triangles linked in continuous fashion with other geometrics; innumerable projections above, below, or at the sides; bands between rows of triangles; and combinations of solid and checkered triangles. Then there are triangles on bands, in single or double rows. Large and small triangles may be combined; so too may solid and outline ones be joined. Or triangles may be nested in the bottoms of open diamonds. Other geometrics, such as crosses, steps, and coyote tracks, may be thrown in here and there along with these varied arrangements.

Then there are vertical alignments of triangles. Some bridging of horizontal and vertical styles is not an uncommon Western Apache motif, with two vertical rows of stacked stepped triangles, points down, with a horizontal row connecting them near the top. Perhaps the most simple vertical arrangement is multiple-stacked triangles, points down usually though sometimes up, going straight out or in a slight curve or diagonal arrangement from near center to edge. Generally these are plain and in solid black; rare exceptions would include a block off one top corner of each triangle; an addition on the top triangle; or the triangle in alternate black and white stitches or blocks. More or less right triangles may be joined in vertical arrangements, singly or in opposed vertical rows, in the latter style with a plain center or with a vertical thin or thick line between the two rows.

Diamonds are varied, to say the least; it was in this form that the Western Apache expressed much ingenuity (Fig. 3.10). Sometimes it is a true diamond; often an element was obviously inspired by this shape and started out in this direction but deviated in some manner. An example of the latter is so characteristic that it is herein dubbed "Apache diamond"—it features a smaller and incurved lower part and a larger, slightly or greatly outcurved upper portion. Frequently this is an esthetically pleasing creation.

Although most highly developed by the Western Apaches, the diamond was also used by the Eastern tribes. It appears singly, in joined rows or other groupings, and in combination with other design units. In one or another of the Apache groups, diamonds occur in solid black or in other colors; in outline or filled with checkers or lines; in solid black outlined with single, double, or triple steps; with a single or double cross or other unit in positive or negative within its heavier or lighter borders; and in a few other variations. Vertical stacking was a very popular arrangement, or rows of diamonds might occur horizontally around a basket, or the diamond might be combined with other geometrics.

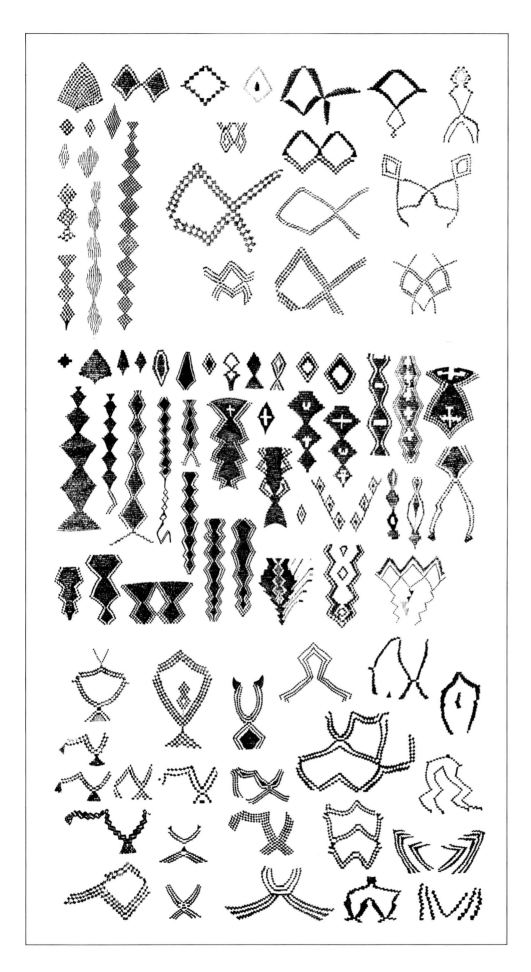

Fig. 3.10a. Diamonds.

Fig. 3.10b. More diamonds.

Western Apaches expressed all of these styles. Mescaleros used a few of them, such as a diamond with a yellow center plus a reddish brown border (but not a separate outline), or a double outline in two joined colors touching a natural center. Jicarillas used this same style but also varied the diamond a little more than the Mescaleros. In fact, they sometimes used the Apache diamond, usually in one color outlined by another. Sometimes they wove this design unit in more elongate fashion, or it might be almost smooth-sided as well as stepped, or the bottom might be more pointed. An individual feature in the Jicarilla diamond was a line extension with a crossbar out of the lower part of the design unit.

As Western Apache design elements tended to be smaller than those of the Eastern tribes, their vertically stacked diamonds might number as many as twelve in a row. Often each diamond was complete within itself, touching the top of the next one, but in other instances the diamonds merged one into the next, each losing something of its true shape. Outlines of this last style were also less definitive in total form, assuming a more free-flowing and continuous style. Too, some of these vertical rows of black diamonds, with white designs within some or all of them, were quite impressive, particularly on a tall Western Apache jar form.

Occasional Western Apache diamonds were spaced out along diagonal lines. Too, interesting outline diamonds were sometimes arranged in joined vertical and horizontal rows. The variety of outlines is amazing, presenting great differences from simple squares to irregular heavy black bands with projections out of the latter. Sometimes solid black or checked triangles are fitted into the lower part of the Apache diamond.

Like the above example, there were also other Western Apache elements which look as if they started out as diamonds but became distorted along the way. Some lack the lower part of the form; some seem to be double diamonds which were not quite joined in their central areas; and some are not joined in the upper top of the diamond. Perhaps these were just diamond-inspired themes or diamonds-gone-astray.

Chevrons or chevronlike figures appear in abundance in Apache baskets, particularly in the West, and, as to be expected, here they enjoyed considerable variation (Fig. 3.11). Basically a chevron is but a flatter or more steeply sided V-shaped form built up of squares and/or rectangles. In Western Apache baskets the standard presentation has them standing on their apices, stretching out and up to right and left. Some few are on their sides, with the apex either to right or left.

The simplest chevron is made of three rectangles or squares, either two or three coils high. From here on the blocks increase in number, and the coils are five or more. Variation occurs in the number of blocks used for the base, with one, two, or three being the most common; in shapes of blocks, there is a range from squares to elongate rectangles, even in a single chevron; and in left-right treatment, from identical on both sides to heavy on one side, light on the other. Single chevrons were occasionally woven, double ones are quite common, and then there are multiple chevrons with as many as five rows together. These are not to be confused with nested chevrons, for in the latter each V-shape is separate while in the former they are joined at the corners of each block.

Much variety occurs in the weaving of chevrons. Single chevrons may be made with squares or wide rectangles, the latter usually having a heavier feeling. Double chevrons are good examples of the steep-sided V or one which is flattened out. Some three- and five-row chevrons have a solid line on one side. An unusual arrangement is of a heavy chevron with a two-stitch, very light one inside it. One interesting treatment is a double row of squares on one side of the V and very wide rectangles on the other side; the latter side is then sometimes outlined in single stitches on one edge and blocks on the other. In other examples there are heavy black sides to the V-shaped figures, with both outlined inside and outside, one with blocks, the other with single stitches. This unit is well integrated into the total pattern in Western Apache baskets. In one tray, for example, there is a row of alternating single and double chevrons.

Nested chevrons of different and alternating colors appear occasionally in Jicarilla baskets, usually combined with some other themes. In one instance, upside-down Vs were enclosed by a vertical bar on either side. Many of the triangles in Mescalero baskets might seem to be chevrons, as frequently there is a solid yellow center (triangle) outlined in red-brown on the two sides but not across the top. The dark emphasis is indeed a V-shaped outline or chevron. This tribe, however, produces some simple chevrons outlined in squares or several with one inside another.

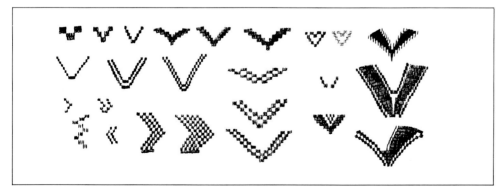

Fig. 3.11. Chevrons.

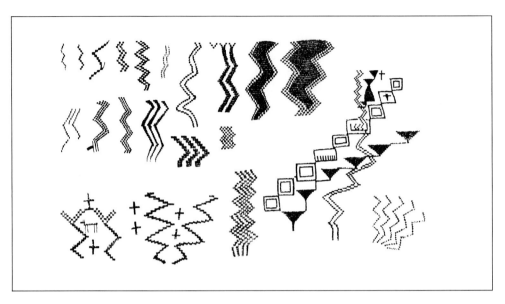

Fig. 3.12. Zigzags.

Diagonal *zigzags* present one of the most dynamic of Western Apache basket designs; such are rare among the Eastern tribes (Fig. 3.12). This style moves from close to center to the edge or near it, sometimes straight out or in a more dynamic curving fashion. Zigzags are plain or have accompanying design elements. Simplest are single zigzags, light or heavy, usually irregular, but with movement in their joined squares. Some of these are nested, some are opposed pairs, the latter sometimes giving a feeling of disorganization. Some seem to be paired from start to finish; some spread out in groups of three, often irregular in their movement; more regular groups of four parallel zigzags seem almost like checkerboarding. A few elements or units occur with zigzags such as crosses, animals, or additional lines between single rows of zigzags, with other themes at the tops of rows, or with irregularities in the zigzags themselves. Verticality is dominant in zigzags.

In Western Apache basketry, there are quite a few zigzags of complex nature. Some of these may have a wide solid center with varying outlines of either single or double-stepped squares. Often the black center is irregular in form but the outlining zigzags tend to be quite regular. As a rule these go straight out from center toward the edge. More complex themes sometimes appear, such as one in which double-stepped, more or less vertical zigzags run through diagonal, stepped triangle themes plus a varied stepped-square-rectangular motif—with a few additions of other units here and there. This really does not make much sense as a design.

In Mescalero baskets zigzags are not common; they tend to be simple, usually single or double. Jicarilla weavers varied this theme more in terms of both form and color: some are shallow, others deeper; some are very heavy; some are a single color, others two or three colors. Also, the zigzag used by the Jicarilla often formed a star or a flower.

A *network* of joined open diamond motifs was popular among Western Apache basket weavers (Fig. 3.13), but nothing so ornate as this has been observed in either Jicarilla or Mescalero pieces. As usual, this theme runs the gamut from quite simple to very elaborate expressions, and in many instances there were other elements associated with the net motifs. Frequently this theme took off

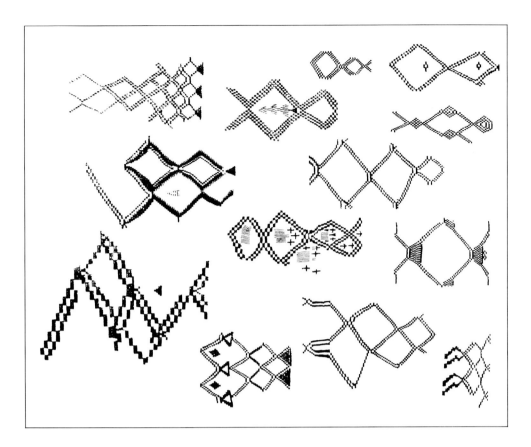

Fig. 3.13. Network.

either close to or some distance from the center of trays or near
the turn of a jar base; in the jar it then covered the side wall of
the vessel.

Seldom was the network of less than two parallel sets of stepped
diamonds. These might begin in starlike fashion, then continue
from each tip outward to the tray edge or jar neck. Each diamond
creating the net might differ in form from short and stubby to
elongate. Sometimes the units in the network outline were large,
heavy rectangles; at other times they were very delicate squares or
diamonds; less frequently very wide band outlines for the diamonds
are woven. Outlining squares or rectangles were usually double,
sometimes triple. Junctures where two ends or sides of diamonds
came together varied a great deal: some were no more than the
regular square of the top or side of one and bottom or side of another
diamond, or short or elongate bars might also be added at this point
of joining. Quite elaborate themes involving extensive checker-
boarding might mark angles, as did separate smaller, all-checkered
or solid diamonds or plain triangles. Different details might be used
for this purpose in different rows of diamonds of the same basket.

Within one or several or all of the enclosures of the network there
may be some other patterning. Long, parallel vertical lines and
crosses appear on one basket up to the top diamonds which are
much smaller, and here crosses alone appear. In another basket
there were three stacked arrowlike affairs executed in alternating
stitches in central diamonds, with humans and animals within this
form. There are, of course, many other original ideas in basketry
decoration involving other units of design associated with a net-
work of diamonds.

Closely related to the line or band is the *step,* an element used by all Apache basket weavers (Fig. 3.14). Stepped units are legion in Western Apache baskets; in fact, many designs not included here are built on the step. However, some are distinctly step motifs alone, or are dominantly so, having but a small solid or other addition. Each step can be a solid square or rectangle, or made up of long vertical and horizontal lines, or a combination of the two. Infrequently, steps are made of alternating black and white stitches which really form vertical lines, which, in turn, form squares or rectangles. The majority of steps go up from right to left in relation to the weaver; a few go from left to right.

Solid square-rectangle steps two or more coils high may vary in width in a single series. The same is true of both elements in the rectangle-square riser and the flat portion of the steps. In line styles, the riser may be more or less straight or irregular at the edges, but the flat portion is always even; here are found double, triple, and quadruple parallel steps, usually one coil and three or four stitches in width. Most of these motifs are quite the same width in riser and flat portion, but occasionally the use of double coils makes the flat part thicker; these relative measurements of riser and flat parts may be varied, sometimes equal, and often there is a longer flat step. Another variation in these Western Apache designs is the step made of checkers; still another, the step of triangles.

Stepped themes occur in Jicarilla baskets. In one instance a very heavy motif with a dark center step of rectangles is outlined by the same form on each side in red. Lighter, but still on the heavy side as compared with most Western Apache steps, are seven curving stepped units which are suspended from a line near the rim and which decrease in size in each overlapping step from this line for six coils toward the tray center. Another Jicarilla example is more like Western Apache in that each step touches the next at the corners of successive rectangles.

In all Apache basketry, both Eastern and Western, stepped edges to many forms are common. For example, such are found for diamonds and triangles in baskets of all tribal groups. The same is true of the popular star or flower motif, particularly in its outline style, for it is almost always formed of steps.

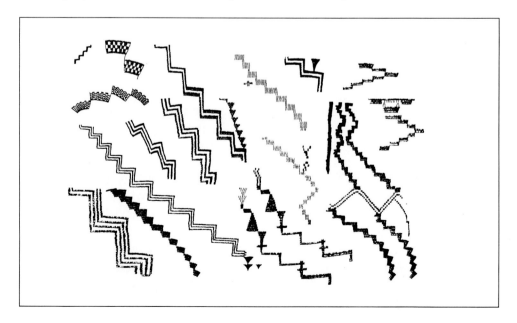

Fig. 3.14. Steps.

Thus, in Western Apache baskets, steps often formed separate units or motifs or the outline of other themes. Much less often was this unit used by the Jicarillas as a distinct motif, and then usually as the chief one. Much more frequently in the Jicarilla and Mescalero Apache baskets are steps used to outline or form other geometrics.

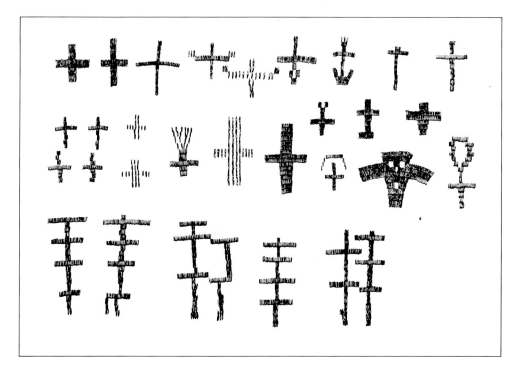

Fig. 3.15. Crosses.

Among the Western Apaches, *crosses* are of two types, equal-armed (+) and Latin (†) (Fig. 3.15). The first may be solid black and plain, or with additions such as squares or "rays" at corners, these in alternate black and white or simple line stitches. Christian crosses are plain, or often with additions over the top or at the base. Then there are piled-up crosses—these are difficult to identify as either equal-armed or Latin. One Latin cross appears to be suspended on a neck chain, and interestingly, another has a coyote track at the bottom. Crosses may be thrown in helter-skelter or they may appear in well organized, alternating repetition with another theme.

Crosses are not found frequently in Eastern Apache baskets, and, when used, they are equal-armed and rather heavy. Among Jicarillas they serve as intimate parts of other designs, for example a heavy-armed, darker, equal-armed cross forms the center of a lighter colored diamond.

The *swastika* appears not infrequently in Western Apache baskets. It may be solid or in outline (Fig. 3.16). Arms may turn clockwise or, not uncommonly, counterclockwise. Not uncommon, too, are deviations: an arm may be missing, or one may have a small addition in the way of a square, or one arm may turn in a direction opposite to the other three. Arms are usually very uneven. Swastikas used by the Western tribes may be solid or outline, or, rarely, may have a "shadow" created by a solid one having an adjoining, alternate-stitch "repeat." Usually the swastika is an independent unit thrown in with other patterns; rarely, it is in negative and thus a part of another design. This motif has not been observed in Eastern Apache baskets.

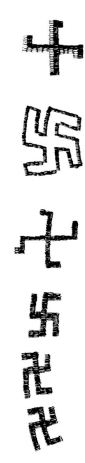

Fig. 3.16. Swastikas.

The *coyote track* is a simple but very popular design element used by many basket weavers in the Southwest, including all Apache groups (Fig. 3.17). Basically it is four squares or rectangles so placed with corners touching as to leave a white square or rectangle in the center. These squares or rectangles may be one or two coils high, but there is amazing variety in proportions. Most of these are plain, solid black, but some have a projection out of the top or they are stacked two or more tracks high, all joining in a central square or rectangle. Usually they are placed between other elements, or they may be negative units in a larger theme. Sometimes the Western Apaches made the four parts of the track in stripes and stacked them one above the other to form a rather unusual motif along with one or more other motifs.

Occasionally a Mescalero woman placed a yellow coyote track within an outline diamond or a Jicarilla woman would make the track negative within a multicolored diamond. Interestingly, the Eastern Apaches were more apt to use this unit in conjunction with another design while the Western Apache more frequently employed the coyote track as a separate entity.

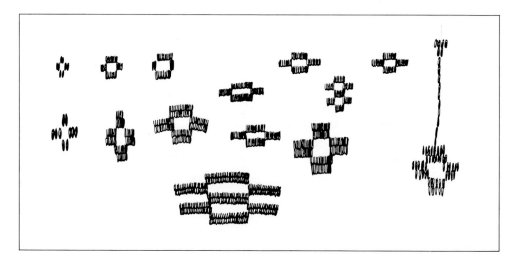

Fig. 3.17. Coyote tracks.

An interesting *arch* (for want of a better term) exists in Western Apache basket designing, seemingly growing out of an open triangular concept (Fig. 3.18). In fact, except for their more curvilinear nature, these designs often could be designated as complex chevrons. Expressed in single, double, triple, or rarely quadruple outlines of steps, there is usually a distinct outer curvature to the arches; often these emanate from the points of a central star or flowerlike theme. A feeling of lightness appears in some of the single styles, but a progressive heaviness dominates from here into the four-outline style. Even heavier are some broad outlined single arches or those with one heavy and one or two light, stepped outlines. Variations in craftsmanship add to or detract from the effectiveness of this motif, and usually this theme continues around the entire basket. Obviously, some arches are more distinct and better organized than others.

That at least some of these design units are related to the triangle is to be noted in examples where joined triangles have become so curvilinear that the areas formed by them are distinctly arched. In

fact, the same could be said of the triangles themselves. Double arches are created in some instances where the otherwise triangular form is excessively wide. Some of these arches are also the result of the weaver giving more curvature to the upper tips of zigzags or chevrons. Even in a few stepped designs the arched look is acquired by curving the steps.

This arch detail has not been noted in either Jicarilla or Mescalero basketry. What might be called a distant suggestion of this is to be seen in a Jicarilla tray which has seven sets of stacked rectangles with a definite right-center to left-rim curvature. A heavy quality dominates as the rectangles start out small toward the center and become progressively larger as they move to an outer ring two coils from the rim.

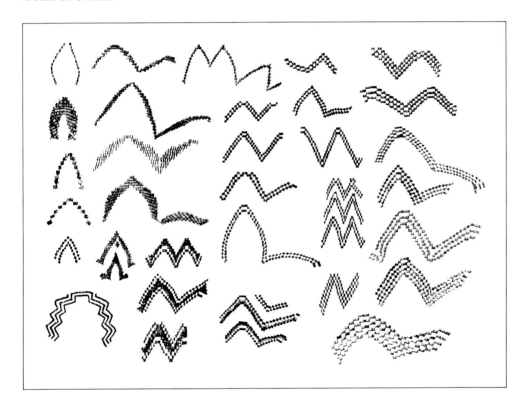

Fig. 3.18. Arches.

Curvilinear units form one large group of design expression which might seem to belong to other categories but are placed here to demonstrate a typical Apache trait; thus, for want of a better name this motif is so labeled (Fig. 3.19). Some are composed of stepped squares or rectangles presented in curved fashion. Some are large or small line-steps placed in the same curved position.

Quite a few curved, stepped lines create irregular motifs, such as an almost-U-shape, or single or double joined waves. Some just wander aimlessly but with graceful curving; some form almost but not quite complete circles. It is possible that the natural curvature of the basket coil encouraged this curvilinear quality. Perhaps this, combined with a less definitive pattern in the mind of the weaver, brought out these curvilinear themes which are typical of some Western Apache baskets. Occasional curvilinear lines exist in Eastern Apache designing but always as part of a larger motif, such as a leaf in Jicarilla baskets.

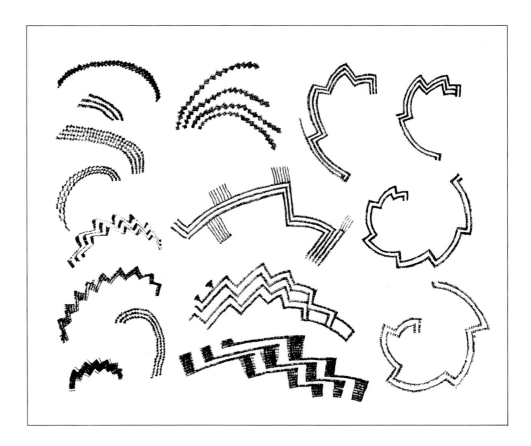

Fig. 3.19. Curvilinear units or motifs.

Meanders in vertical and horizontal alignments are common devices in decorating Western Apache baskets, but are much less so in Eastern Apache expressions (Fig. 3.20). As usual, Western Apache meanders present a wide range from simple to complex themes. Sometimes they involve other geometric patterning, but not infrequently life forms are added in conjunction with some of these motifs, particularly with the vertical style.

Horizontal patterning including the meander is more common on Western Apache tray and bowl baskets than on jars, but it is found on the latter in vertical style as well as on occasional other forms. Inasmuch as their decoration tends toward dynamism, it is not sur-

Fig. 3.20. Meanders.

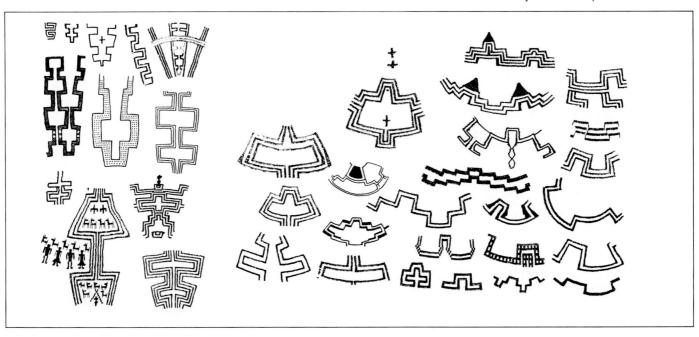

prising that plain, regular encircling lines are seldom used; when used, some are embellished. Much more appealing are the various meandering lines, plain or stepped, and occasional continuous and repetitive meanders expressed in a wide variety of styles.

True meanders were created in single, double, triple, and some quadruple line compositions by the Western tribes. Many are plain; quite a few are in steps. On occasional baskets there are opposed arrangements of the same treatment. Several types of single meanders appear; among them are one, plain and quite open, and two, stepped. In double meanders, there is usually greater depth and again they may be plain or stepped. Embellishment in the double style takes a variety of forms. Here are a few: heavier uprights (almost triangles), or with small steps at the corners, or filling between the meanders with blocks. One very elaborate example shows a meander turning back on itself at the highest point, then back to back, and a repeat starts. In the lowest part rise two stepped diamonds supported on blocks taking off from meander corners. In a sense this is not a true meander, but, rather, a broken one.

In her usual manner the Western Apache basket weaver developed the triple meander in still another way, in spacing and with additions to the total meander. She did not duplicate the triple meander any more than she did single and double ones. In plain styles there are variations in relative heights and widths of the parts of the meanders, as there are in thickness of the lines of which they are made. Embellishments occur here also, with triangles occasionally projecting from each of the lowest elements in the meander. Each meander is usually an independent theme, but in some triple styles each may be joined at the corners by a single stitch. One common device in this meander is to oppose it with a like style, using the third bar in each as a joining mechanism. Within the large rectangle thus created (at small open areas center top and bottom), there may appear crosses or other small design units. Other elaborations occur, of course. Although not common, some four-part almost-meanders do occur; often they are treated not unlike the triple type except that one of the four meandering lines may not be continuous in itself.

Few horizontal meanders occur in Eastern Apache baskets. One Mescalero example emphasizes narrow verticals and wider horizontal elements. Jicarilla basket weavers are apt to use several colors in their meanders which are usually simpler single and double styles. In a single type of one color, a second color is placed under the horizontal top of each meander, while a different color was used for each line in a double style. Some of these Jicarilla motifs are balanced left and right, up and down, while others have a wider top and a much narrower bottom. One interesting Jicarilla meander covers quite a bit of a tray: the total pattern is balanced on opposite sides, wider and larger to right and left, smaller and farther from the rim on the two remaining opposed sides.

Vertical meanders were a "natural" for Western Apache jar designs; they are not common but are found on some Jicarilla pieces. Here again the Western basket weaver left no stone unturned to present variety. Most frequently the meander is balanced by an opposed duplicate, although now and then only one meander was presented on a side wall, to be repeated usually three or four times in the same fashion.

Some single-line styles are almost fretlike. In another style it is the single line meander which is opposed by a second one, establishing a left-right balance throughout the motif. A third meander is a double-line affair (like the horizontal style) which does not have an opposed balancing theme; a fourth is a double-line style with opposed balancing units, and these are not uncommon. Some of these last types are filled with tiny squares between lines; or the same meander style may be filled with red stitches. In one instance the continuous concept is further applied alternately to the bases and tops of these tall designs, thus making them doubly meandering. A fifth style, as triple line and balanced vertical meander, is fairly common on tall jars. Sometimes they are plain; in many there are variations, small or large. The "necks" or narrow parts between rectangles created by the meandering lines may be short or tall and slender; the rectangles themselves may have their form somewhat altered as the weaving progresses, for example, they may be a bit more constricted at one end, or they may increase or decrease in size in response to wider or narrower parts of the jar form. Life forms or geometrics may be added to the rectangular or quasi-rectangular areas. Rarely a sixth style, a quadruple vertical meander, was created by one Western Apache basket weaver.

Roberts says that the *arrowpoint,* as herein illustrated, is distinctive of the San Carlos Apache (Fig. 3.21). Here it is pointing either up or down, here it is slender or fat, and almost always it is solid black, but occasionally it may be in outline. Apparently this unit was not used by other Apaches except rarely by White Mountain weavers; in some Jicarilla baskets there are triangles with stems which might be called arrow points. In one Western Apache example outlined points are repeated to create a band with other units of design forming additional rows.

Frequently there appear in Western Apache baskets certain design units which seem to be or are *letters;* less frequently but quite definitely were *numbers* woven into baskets (Fig. 3.22). One Western Apache example has quite a few representations of the letter H; it has been seen in Jicarilla baskets as well and in several different styles. The letters F, T (in a fancy style), and P have also been clearly defined in Western baskets.

Woven into another Western basket not once but twice is the date "1902," once in black, then repeated in red (see Fig. 7.13b). This large tray basket belonged to an early collection and was probably woven as of this date. In the Guenther Collection is a basket with

Fig. 3.21. Arrowpoints.

Fig. 3.22. Letters, numbers, and life forms.

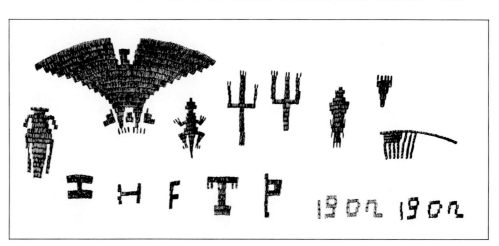

the year 1922 woven into it, the result of the Reverend Guenther giving a calendar to an Apache basket weaver at this time. Both of these dated pieces are probably important in relation to any dating, for such are rare. General dating of Western Apache basket styles would support the time indicated in these two pieces.

Humans are represented almost exclusively by Western Apaches, for this figure is apparently very limited as a design unit in Eastern Apache baskets (Fig. 3.23). A cursory glance might indicate that most humans were represented very much alike—straight body, rectangular head, arms out from body and down, straight legs with each flat foot turned outward. But this list gives a false impression for actually variations in details of figures are legion. Some have a bent knee, some are very broad shouldered, one arm may be upraised, the other down, or both may be upraised. Hands seem to exist infrequently; more often great fingers (two to four) appear at the ends of the arm or on enormous hands. Some are like cloven hooves—or does the hand hold an object? Heads are generally rectangular and sit on a square or smaller rectangle of a neck; they are plain, or have two objects (feathers?) projecting from the top, or are hatted, or some wear what appear to be the crowns of the gans

Fig. 3.23. Humans.

dancers or other ritualists. Then there are those bodies which have no heads at all, or there may be a crown above but separate from the head.

Bodies are often straight up and down, yet some are slender hipped; rarely is there a waistline. Legs may be one to ten stitches at the thigh to three or four stitches in the ankle. Most out-turned feet are plain; some are bedecked with what look like cowboy high-heeled boots. Rarely, both feet are moving in the same direction; rarely, too, are both feet lacking. And in some of these creations blocks or lines of weaving are so irregular that bodies, legs, and arms are all awry.

Black is the basic color for most human figures portrayed by the Western tribes, but red is used fairly often. Several men are all red; one is red but wears a black hat; several are bedecked with red pants and black shirt. One is all red except for his legs, feet, and top of his crown, another the same except for hat, legs, and feet. Women are rarely represented and generally they are all black, although some do have "striped" skirts or blouses indicated in alternate stitching, usually black and white.

Some woven figures seem to start out as human representations but end up less than recognizable as such. However, in a majority of cases the weavers left no doubt as to what they were picturing. Although heads are lacking in some figures, or just a pair of legs alone is woven, in some instances this is because the edge of the basket was reached; there are other cases where these appear without reason. Did the weaver weary of her task or just forget to complete the form? Too, there is one upper body with head and arms represented but without legs.

Little or no detail exists on figures of humans. The alternate black and white stitches in some women's skirts may imply designed material. Two white blocks on the chest of one may be a decoration —so too with two white lines down the black legs of the same figure. Another figure has several similar white streaks alternating with black ones—a skirt or striped pants? About the middle of one man are alternate, short black and white vertical areas— a belt? Although facial features are conspicuous by their absence, a very few have large, ghostlike eyes.

In addition to humans, life elements on Western Apache baskets include *quadrupeds* (Figure 3.24). Animals probably involve more species than will be mentioned, but because of a basic simplicity in all of them, five or six only will be named as recognized types. These include dogs, a bobcat, horses, and deer, with a possibility that some of the latter could be elk, plus one example of rabbits. Other attempted identifications are admittedly guesses. Size alone in relation to closely placed humans might indicate certain creatures to be either horses or dogs.

Bodies of quadrupeds are one or two coils high. In one group of 96 baskets, 55 were single coil high. The so-called bobcat is four coils high in its body, presenting a rare exception in this feature. From head to tail, bodies run the gamut from very long and thin to very short; one example of the latter presents a body shorter than the animal's neck and head. Most bodies are just a straight section of one or two coils with a neck extending straight up or nearly so. Once in a while the upper coil of a two-coil body extends a few stitches beyond the lower coil, which suggests a little more form.

Fig. 3.24. Quadrupeds.

This may continue in successive projections into the neck, sometimes in horses and almost always in those forms thought to be deer. Heads and necks are usually one coil high each, although on simpler forms they are, together, but one coil high. Frequently on deer, less often on other forms, they are three coils high. Muzzles often project unrealistically beyond the neck; tongues (?) sometimes hang out.

Most often animal heads extend forward but now and again they may be turned completely backward. Ears are two upright projections, thick or thin, long or short, usually out of the back part of the head. Sometimes they are omitted altogether. Elaborate horns appear in the same spot, more or less, on those animals thought to be deer or elk. Facial features are lacking.

Quadrupeds most commonly are represented with four legs although some have but two. Legs may be fat or thin, straight, wavy, or stepped. Most have no "feet" or hooves, but some have squares or rectangles—moving forward or backward—serving in this capacity. Some have cloven hooves and are definitely deer (or elk), while one horselike creature has cloven hooves (cow?). Also, legs may be placed two toward the front of the animal and two near the back, or they may be evenly distributed on the underside of the animal. Rarely, five legs are represented. One animal is presented with its feet in a moving position, and, whether by intent or accident, it looks more like a bobcat than anything else. Legs usually go straight down although in some two-legged creatures they slope inward toward the feet.

Tails on quadrupeds are a delight to behold. Many are short and ready to wag (dogs?), whether they be fat or thin. Some short or medium tails hang down, less often they are long and positioned downward. One such long tail has a crook at the very end to accommodate to a backward projecting foot—all four feet are turned toward the back of the animal. Sometimes a tail is an afterthought in the weaving process and is not actually attached to the animal. There are several representations that barely resemble four-legged creatures and may or may not be quadrupeds. Perhaps they are the products of inadequate weavers, or perhaps they are abstractions.

All of the above comments apply to Western Apache basket designs. Little can be said for this unit in Eastern Apache baskets, for life forms rarely appear. The horse is to be noted on the Jicarilla tray. A deer represented on a Jicarilla basket is quite different from those in Western pieces for there is more suggestion of form in it. Legs are larger near the body and its neck is heavier where it comes out of the body. Horns are more realistic and are presented in an almost-front position.

Some tribes were quite clever at representing *varied life forms* (see Fig. 3.22) in basketry; however, except, as noted, for men, horses, deer, dogs, and possibly several others, Western and Eastern Apaches lacked facility in this line. Among other Western Apache examples are represented a well-depicted eagle in a style typical of most basket weavers, namely, one in which there is left-right balance throughout except for the bird's head which is turned in one direction. The reptile, not commonly depicted by Apaches, is questionable—is it a short lizard or a long horned toad? Two plants are unmistakably saguaros, complete with blossoms or fruit. Is the small five-digited object a foot? Is the object with apparent feelers

a bug? And, a last object in this grouping seems to be a flag, rather generalized, to be sure; it is repeated in a band which continues all the way around the basket; in a second piece of Jicarilla weaving there are two rows of flaglike objects.

Plants, including trees plus others which appear to be blooms or flowers, occur occasionally in Jicarilla baskets; rare examples of petal-like or floral themes have been noted in Mescalero pieces. Butterflies and bird themes have been identified in Jicarilla trays.

Composites or group life forms include men and animals associated with various design elements or with each other (Fig. 3.25).

Fig. 3.25. Composite or group life forms.

For instance, men ride horses, or a man stands on a geometric form. Men on horseback are sitting or standing, some seem astride the animal, and, although the animal is in full profile, the man is full front. In several presentations a man stands on the back of an animal; could this be a rodeo performer? Or artistic inability? In a few instances there is a design above the horse (?) which might symbolize a man. Then there are many examples in which men are associated with dogs, or swastikas, or a cross, or a mass of parallel lines. Occasionally dogs (?) are pictured with geometrics—if there is a meaning here it has long since vanished.

Perhaps no weavers were so prone to throw *"odds and ends"* into a basket design as were Western Apaches (Fig. 3.26). In Jicarilla and Mescalero baskets there is less tendency toward this; in fact, although simpler, their designing was also cleaner in this respect. Of course many Western baskets were well planned and executed, with complete and balanced patterns and no "extras." Perhaps the extras were reflective of creativity, or perhaps it was sheer boredom which caused some women to deviate from the tribal storehouse of pattern and throw in an element which either does not fit in with the rest of the design or which defies description. These might be large or small, poorly done or well executed, sensible or nonsensical. Such are the following examples of Western Apache "odds and ends."

Single or double squares or rectangles, or some with smaller bases or with other irregularities, may have another square or two within them, or a row or two of different color plus a little block off one upper corner or dangles off another. Some have no describable form to them, some are double-row stacked forms, or stacked rows of stitches with equally irregular negative patterns within them. Some are like crooked ladders. There are irregular shapes with projections, short or long, even or irregular. Sometimes a meaningless extension of stitches moves upward. Parallel steps just take off in a left to right direction. Another uptrending motif is quite like a diseased plant; a pair of wide spaced single steps has crossbars, triangles, and other odd bits incorporated here and there. One motif looks like an upside down torso with legs, bespeckled with rows of small squares, and with a row of pendant triangles aimlessly taking off one side. Another motif incorporates familiar units but in an odd manner —an extended swastika with one arm ending in a triangle and a second arm in a meandering line.

Fig. 3.26. Odds and ends in design units.

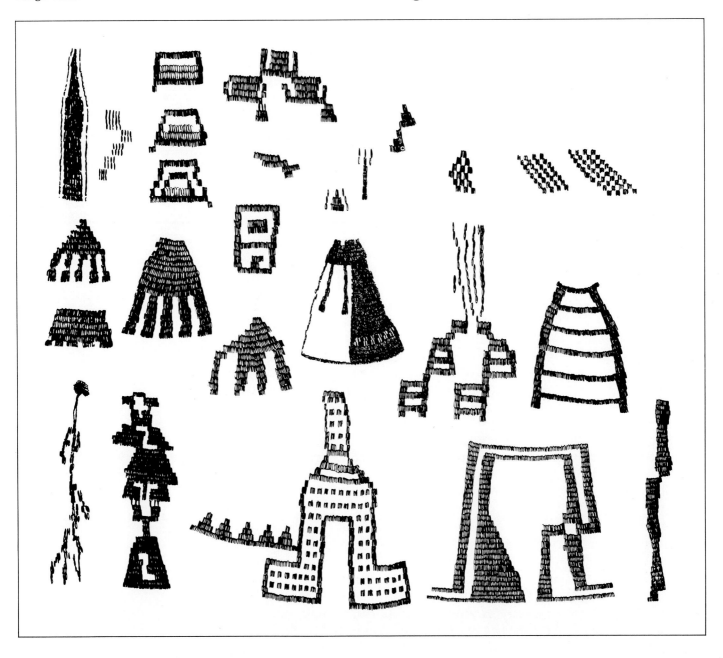

There are many other small units of design thrown in here and there. A few would include a stack of checker squares of no particular form; four rows of successive rectangles of irregular length but meaningless; a long line with two short ones on either lower side; a stepped triangle with a stepped half triangle taking off a corner. Then there are larger almost-hands with fingerlike projections. Another unreal unit presents one side black with delicate negative designs near the top while the other side features two rather meaningless lines projecting into its largely white area.

In the above analyses, some described elements or units may seem to fit more properly into the category of motifs, and often they do. However, in the total basket design they may start out as units or elements—hence their inclusion in this discussion. Certainly life forms are usually made up of squares, rectangles, and sometimes lines, but they are used as units of design more often than as motifs. Meanders, steps and zigzags frequently are used as motifs, but because of their basic form they are included here. It is in their growth and elaboration that they may become motifs, or even in some instances total design, such as all-over zigzags. Certainly motifs and designs will be discussed in greater detail in the following chapters.

Western Apache Basketry

ANALYSIS OF THE ARTISTRY OF BASKETRY of each of the three great Apache groups, the Western, Jicarilla, and the Mescalero, will point up outstanding tribal differences but few similarities. It is in this analysis that tribal individuality is expressed; it is here that Apache women said in their basket weaving, "This is Western Apache," "This is a Jicarilla basket." Some technologies overlap, such as in the use of the three-rod foundation in all Western baskets and in some Jicarilla pieces. In forms there are broad similarities; the tray, for instance, was made by all three groups, but there were tribal differences even in this one form. Design proper varies greatly, despite a common use of many similar and basic elements and units.

Of course, it is in a totality of all these aspects, in the putting together of form, design elements and motifs, that the individuality of tribal groups is expressed. Most of all, it is in the total design that full tribal styles come forth. It is in the manipulation of the many common units and elements plus a few different ones that the individual tribe expresses its own artistry. Individual women were subject to the pool of designs, the reserve of their own tribe, for inspiration of design creation.

Inasmuch as basket making was a craft in which each woman produced necessary items for her own family, little attention was paid to individual accomplishment. When the craft was converted to making objects for sale in the late 1800s, aims were shifted to what the white man bought, and the latter was even less interested in the maker of the basket. Design became more elaborate and remained so to the end of greater production in the 1930s and 1940s. Revived production by the Jicarillas in the 1960s and 1970s has inspired new directions in designs. Otherwise Apache basketry as a whole has declined.

In many ways, Western Apache basketry is the most significant of any of the several groups because of its far greater production and tremendous variety. Its greater variation is reflected in shapes and sizes, in all aspects of decoration from elements and units to total pattern, in the addition of other materials to the finished basket. Seemingly, San Carlos basketry was more varied than that produced

in the White Mountain area. For this and other reasons the following discussion will present a coverage of the entire Western area; there will then follow a summary of White Mountain characteristics for comparison. Many of the traits of the latter group will point up differences and bring out similarities within Western Apache basketry in general and between White Mountain and San Carlos in particular. Several discussions will also be presented relative to older Apache baskets. Provenience of some baskets in this first discussion is known, in many pieces it is not; hence, the term Western Apache in general is doubly applicable.

MATERIALS

Only a few words need to be said regarding materials used by Western Apaches in their basketry, for they have been named and discussed in Chapter 2. First, it may be noted that these people were familiar with a vast and diversified country, for in earlier years they wandered widely over much of Arizona and into some adjoining regions. Undoubtedly they became familiar at an early time with a wide variety of plants and continued to use them for long years. It may be that specific basket weavers became familiar with the materials of a specific area and used them alone. Perhaps in some measure, one could determine more exact proveniences for particular baskets if a detailed botanical map could be produced for the area occupied during those early years.

Where a variety of materials is found in more limited regions, there is also the possibility of personal preference on the part of the weaver. Certainly Western Apache women as a whole preferred the more sturdy woods rather than grasses, for the latter are rarely used. One exception is the infrequent occurrence of red, which is the bark of the root of a yucca plant—and even this could hardly be called a grass. Although produced for utility, which undoubtedly played a part in the use of wood employed in making these baskets, it is quite likely that the esthetic did play a part in choice of materials. For instance there would seem to be no question about the popular early use of mulberry, for in time it turned a pleasing, soft, almost silver-gray color. It is possible that the Indian woman preferred this mulberry herself, but as she made more and more baskets to sell she used other materials, some of them perhaps easier to obtain. Availability and traditional use of certain materials undoubtedly influenced their continued popularity when baskets were made to sell.

Time and contacts with non-Indians also played a part in the choice of other decorative materials used by Western Apaches in their basketry. Native tanned buckskin served consistently to decorate burden baskets until someone discovered commercial leather and chamois. Some of these substitutes were employed as early as the 1920s. Also, on some of their burden baskets a piece of red baize cloth was placed under the buckskin patch on the basket bottom. When baize was no longer available, this decorative note disappeared, although occasional substitute materials were used for a while. Another example of a substitute through contact was heavy metal wire in the top of this same burden basket style, some reported before 1905. Too, occasional colorful trade beads were added to the ends of the thongs; they may have come into the Southwest prior to the more popular tin tinklers, which certainly were the result of Anglo contact.

TECHNIQUES

Little more need be said about techniques used by the Apache Indians in their basketry for this subject is also quite well covered in Chapter 2. However, it would be expedient to bring into focus a few points.

Frequently the Western Apaches handled their materials in a more proficient fashion than did the Jicarillas or Mescaleros. To begin with, often although not always, they prepared finer sewing elements for coiled work, particularly in cottonwood and willow; the Jicarillas used more sumac than willow, which may explain some of the difference, at least in part. It must be kept in mind, however, that there is some fine Jicarilla sewing.

Western Apaches never deviated from the three-rod foundation in their coiled baskets. When rods were well chosen, this could result in relatively small coils. They did not use the five-rod foundation which produced the Jicarilla heavier coil, but the Jicarillas also used three rods on occasion, with resultant lighter coils. Certainly five rods also contributed at least a share to simpler pattern. On the other hand, the three-rod Western Apache foundation, which was often quite small, may well have influenced or made possible much of their more complex designing. Of course the Mescalero weavers with their very wide coils could not approach the elaborate and finely detailed patterns of the Western groups.

In wicker technique the Western Apaches excelled in fineness of weave and in the frequent use of two or three different types of this weave in a single basket. The last point has been mentioned previously, but it should be stressed for it added greatly to a subtle esthetic quality in both burden baskets and water bottles. Frequently a three-element stitch bordered colored bands either in the base color or in one of the decorative colors, thus adding this suggested note of subtlety. Further, pitching of water bottles did not always conceal this feature whether used in the basket for either decorative effect or for added strength. Twined was the typical wicker employed in all Western Apache baskets of this type, with plain or twill combined with the three-element twined style.

FORMS

Western Apaches produced the basic utilitarian forms used by native southwestern Indians and a great variety of each. To reiterate, in coiled technique were trays in abundance, jars, and bowls, and in wicker were burden baskets and the water jar, or tus. One of the interesting aspects of this Western Apache basketry is the lack of certain forms, particularly as the craft became commercialized. The jar is the one likely exception to this statement. Missing forms, or forms produced by other tribes but not by Western Apaches for sale to the white man, would include the flat plaque, wastebaskets, straight-sided and footed "vases," and "gadgets" such as match holders, purses, and modeled figures of plants, animals, and humans. All of these non-native forms were woven by the Papago basket maker, and some by other tribes, but none was of interest to the Apaches. Three flat plaques only were observed, certainly few enough to say that they were to all intents and purposes not important. Since only one cup and saucer set was recorded, the same can be said for this odd piece.

Fig. 4.1. Western Apache coiled tray and bowl forms. (a) Tray shapes, showing the tremendous variation, from very shallow with both straight and curved sides to ever deepening forms of the same types. (b) Bowl shapes. Quite generally, bowls are deeper, more straight-sided, and with proportionately flatter bottoms. *(These drawings, as well as drawings for Figs. 4.2, 4.3, and 4.4, are by Chris Van Dyke.)*

Form is treated in a general manner in Chapter 2, but here in this chapter the great amount of variation in Western Apache styles, particularly in the tray, will be stressed (Fig. 4.1). Forms in this figure are not divided according to age, but a few words here may explain some of the differences between the older and newer pieces.

Old forms of Western Apache tray baskets, particularly from about 1900 back twenty or more years, tended to have more examples with curving sides all the way from rim to base. Some pieces stressed this feature to such a degree that they were conical or nearly so in shape. Flat bases were common, of course, and, as noted above, this feature was often exaggerated from use of the basket. Many of the older pieces were more shallow, especially some of the very large trays. Interestingly, there were also quite a few smaller and deeper tray baskets in the early years; this has been noted both in actual baskets and in some of the older pictures from 1880 to 1900. Roberts illustrates an older example (no dates) with a strange tiny tip on the very center bottom.[1]

More gently rounded lines seem to characterize later tray basket forms. Although a slight outflaring rim is occasionally encountered in older pieces, it was noted in several collections that a more exaggerated flaring occurred in a few later trays. Otherwise the majority of later examples have a continuous and pleasing, gently curving line from rim to base. Some later trays are also proportionately deeper, but, of course, the majority remained characteristically shallow. Even though some later pieces were made for sale, the native trend, which had dominated shape as far back as these pieces are recorded and used, was more toward the shallow tray. Generally speaking, the flatter bottoms of later years tended to deny conical shapes found in some earlier pieces. Thus, from Figure 4.1a it may be concluded that no very early trays are represented. However, the subtleties of variation in this form are well demonstrated for, in spite of seeming similarities at first glance, there are no two forms in this illustration that are exactly alike.

Western Apache bowls (Fig. 4.1b) do not present the discriminating differences in forms so typical of the trays of this tribe. The majority are proportionately deeper, and most have a wider base, although there is some overlapping in this latter trait. That they are bowls is further indicated in exterior sewing, for quite consistently they are woven from the outside while trays are woven from the inside.

Although the flat bottom predominates in these bowls, there are some that are rounded (Fig. 4.1b, top row, left). A few examples have a tendency for a straight side wall to round out a bit as it approaches the flat bottom (Fig. 4.1b, lower row, left). Some walls are absolutely straight (Fig. 4.1b, second row, left) from rim to flat base, while others tend to be less severe (Fig. 4.1b, third row, right).

Amazing variety in form is also to be noted in the Western Apache woven jar (Fig. 4.2). This, of course, results from varying combinations of neck-body relationships with short-bodied neckless styles at one extreme and tall slender or medium-bodied styles with out-flaring necks at the other. The first can be called "jars" by virtue of an incurved line at the rim, while there are numerous examples of the second style.

Fig. 4.2. Western Apache coiled jars, showing variations in this form. Bodies vary from straight-lined to extremely graceful forms, from tall and slender to squat, from no shoulders to wide- and high-shouldered, from no necks to narrow or wide ones, short or tall ones.

In general, coiled jar necks may be short and straight, or almost straight, and slightly or extremely outflaring. Actually taller necks follow this same general scheme, with extreme examples of distinct extended lips. These are standard shapes of necks. Rare exceptions would include among others, a double, outward and rounding curved neck.

Western Apache jar bodies are equally varied in shape. Some short styles are rounded, almost bulbous, while others are squat. Some have equal height-width dimensions, with rounded lines from neck to greatest diameter and a repeat from here to the base. Some jars have stark lines, with an abrupt short line from the neck-shoulder shifting to a dull straight line all the way down to an equally abrupt and short curve into a flat base. Such jars lack esthetic qualities.

High and wide shoulders in other jars often invite more graceful total shapes. Some of these have gentle or more abrupt lines from the base of the neck to the widest point in the jar, while others may be executed in a more rounded outcurve. All three styles may then continue in straighter or more outcurved lines to a wider or narrower flat base. In the majority of these attractive pieces widest diameters are above center. Rarely is the greatest width of a jar body below center, and in the few observed examples total shape was unattractive.

A few additional general comments might further illustrate variety in Western Apache coiled jars. Unattractive are bumps or humps in neck, shoulder, or body lines, some seemingly intentional, some perhaps not so. Lacking the esthetic also are straight necks on straight bodies. On the other hand, a curved neck relieves part of the tension of a straight body; by the same token a straight neck does not destroy the attractiveness of a more curving jar body. As to be noted in Figure 4.2, there are many variations in the several forms stressed here, with more or less slender- or fat-bodied styles plus diverse proportions in neck-body dimensions. Thus the Western Apache coiled jar is the most varied in more outstanding or obvious ways of all Apache styles.

More is known about the twined burden basket of the Western Apaches than about this form as produced by the Eastern tribes; thus, again, comments on the Western piece can best describe its variety. Range in shape runs from a parallel-sided piece to one approaching the cone, with a general bucket shape predominating early and late (Fig. 4.3). Some pieces made solely for sale in the 1970s leaned heavily toward the cone shape, whereas the piece woven strictly for utility adhered more generally to the bucket style.

Certain aspects of the burden basket were retained because of its use. A wide mouth was necessary for putting objects in and taking them out as well as for carrying capacity. Less significant for these purposes were side-wall slope and base form, although a wider base did increase load potential.

A few of these burden baskets had shallower proportions; if they were not in twined weave and did not have carrying loops, they might be suspect. One such piece is illustrated in Figure 4.3, bottom row, second from the left. Most were much deeper, almost straight-sided and with slightly rounded bases (Fig. 4.3, top row, left).

Straight sides are illustrated in Figure 4.3, first and second rows. An occasional outturned lip is to be noted (Fig. 4.3, second row, left). Outside concavity in the base is represented in dotted lines in many examples in Figure 4.3.

Water bottles (the *tus*) also present a fair amount of form variation as produced by the Western Apaches (Fig. 4.4). Perhaps the most common shape involves a fairly wide mouth, medium-high neck, rounded and high shoulder, and a full body. Deviations from this are many and varied. Some have a more sloping shoulder line, some an abrupt, flat shoulder, some no shoulder at all with a continuous line to and then below the widest diameter—all this without attracting

Fig. 4.3. Western Apache wicker burden basket forms. Although basically bucket-shaped, this form shows an amazing variation, in large or small sizes, straight or sloping sides, or almost cone-shaped, flat or round base, straight or slightly out-turned lip.

much attention. Some water bottles are straight-sided to a flat base, some are fully rounded, some are double-rounded with a constricted waist between each "bulb," some are squat with heavier lower portions. A few of these twined water bottles are conical in shape, with a bulbous base not unlike some Paiute water bottles.

Necks of the tus vary in height, width, and form. Some are short, some proportionately tall, some are narrow, some very wide. Perhaps the last width was featured on the tus which stayed in or close to the wickiup so that one could dip out the water.[2] Form of necks may be straight sided, gently or extremely outcurved. One of the most attractive Western Apache water jars has a wide outflaring neck, a wide and almost flat shoulder, and a body gracefully rounded from shoulder to base.

Again, in the tus as in the other Western Apache forms, the weaver had much to choose from, many directions guided by tribal standards plus her own taste. As a result there is much variation in body and neck lines, and in the combinations of the two.

DECORATION IN WICKER BASKETS

Hrdlicka says that an Apache girl was first given a young yucca plant so that she could learn to intertwine its leaves. Then reputedly, the first real basket she made was a burden basket;[3] not until she became more proficient did she attempt a coiled piece. It would seem that the Apaches recognized the fact that the coiled basket was the most difficult style to weave. Too, it was apparent that girls learned this craft from their mothers or grandmothers,[4] helping in basket making of all kinds at sixteen but not really producing in earnest until they were married. To be sure, times have changed, yet a few young Apache women learn to weave today. This is particularly true of those in the San Carlos area where a fair number of burden baskets are woven, and to the east of this community where some coiled pieces are produced.

All Western Apache basketry designing in burdens, the tus, and all coiled work involves greater elaboration than in comparable pieces in any other Apache groups. To be sure, the tus has little decoration even in Western Apache pieces. Over all, the burden basket of this group presents a great variety of a basic limited style of patterning, and, certainly, the coiled pieces are the most elaborate in design of all Apache baskets in every respect.

Tus or Water Jar

It has been noted that the exception to lack of decoration on the tus or water bottle was an occasional three-strand band at intervals on the vessel body; color decoration is even more rare, but a few such have been noted on the tus (Fig. 4.4). The simplest is, of course, a single black line around the top of the shoulder of one of these jars. Even more rarely an irregular addition will be made to this line, for example in the form of outline triangles above, on the shoulder proper, or below, on the vessel body. One jar has the line below the shoulder, an irregular diamond above moving from the shoulder onto the neck, and alternately larger and smaller diamonds on the body proper (Fig. 4.4, bottom row, left). Another tus has a wide band on the sharp shoulder.

Fig. 4.4. Western Apache wicker water bottles (tus). Three basic forms characterize this tus: round-bodied, shouldered, and double-lobed. Other details vary, such as wide or narrow mouth, short or tall neck, small and large sizes. Decoration is rare. Two or three lugs may appear.

One very interesting White Mountain water jar has designs quite like those on burden baskets. Diagonal lines are enclosed in three bands, one on the neck, one just below on the body, and a third at the widest diameter of the rounded form. Below the last is a pair of lines enclosing repeated chevrons. A bi-lobed water jar has the horizontal band at the vessel constriction plus two irregular lines running from rim to base with a third taking off one of these on the upper lobe and moving to the center black line. An interesting comparable tus has one wide black band on the upper lobe and two similar bands on the lower. In rare early pieces additions such as beads or silver buttons were embedded in the soft pitch for decorative effect.[5]

Several additional tus designs appeared on baskets at the 1955 Arizona State Fair including the following. Three diamonds were on the side wall of one piece, one each between handles (three handles in this instance). Another showed the usual encircling line with numerous irregular short cross lines, most of the latter more or less on the diagonal. Small triangles extended beyond the same type of encircling line on the shoulder of another tus. In a last example, there were two encircling lines with irregular diagonals between them. There are also variations in tus forms (Fig. 4.5) as well as in decoration.

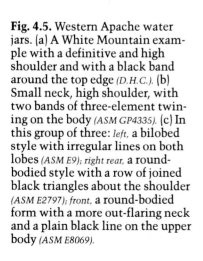

Fig. 4.5. Western Apache water jars. (a) A White Mountain example with a definitive and high shoulder and with a black band around the top edge *(D.H.C.)*. (b) Small neck, high shoulder, with two bands of three-element twining on the body *(ASM GP4335)*. (c) In this group of three: *left,* a bilobed style with irregular lines on both lobes *(ASM E9); right rear,* a round-bodied style with a row of joined black triangles about the shoulder *(ASM E2797); front,* a round-bodied form with a more out-flaring neck and a plain black line on the upper body *(ASM E8069)*.

Burden Baskets

Twined burden baskets offer some very interesting designs, most of them woven in color. A few simple lines, however, are executed in three-element twine against a background of plain twine, as in the tus. Decorative colors used include the older black and red, and sometimes brown, all derived from natural materials or native dyes, and later a variety of colors from aniline dyes including red, black, and brown plus blue, yellow, and green.

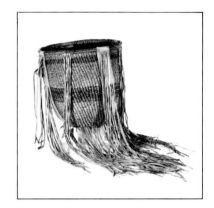

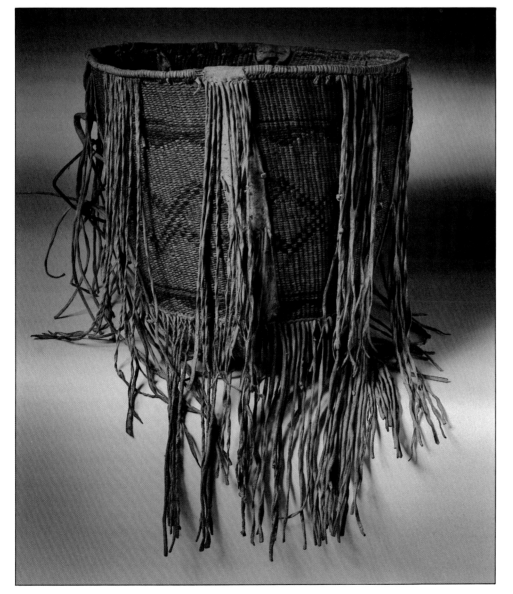

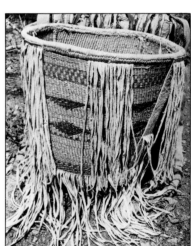

Fig. 4.6a–e. Burden baskets showing variety of design. (a) Four repeated organizational bands *(ASM 13511)*. (b) A more conical form (from 1981) with three solid brown bands and diagonals pendant from them *(ASM 56948)*. (c) A narrow band near the rim and a wider one lower on the basket. Spacing is farther apart than usual *(ASM E4597)*. (d) A fine old example with half-bands above and below and a centered organizational band *(photo by Ray Manley, private collection)*. (e) Regular bands with checkered design above, diagonal lines below, and a wide central band with triangles pendant from the top line and diamonds above the bottom line *(photo by E. Tad Nichols, private collection)*.

Three-element twined designs are confined to line patterns, or, at most, narrow bands. For example, there may be one, two, or three rows of this stitch against the plain twine ground. Less frequently there may be more—for example, five of them. Or two or three rows of the triple element twine may occur on either side of one, two, three, or more rows of plain-twine sewing. If all stitching is in natural colors, the patterning is more subtle, if color is added to the triple-twine, the design is more obvious.

Color decoration, on the other hand, is definitely more obvious, for the most part. Colors do fade, of course, and in some of the older baskets it is difficult to follow patterns. It was not uncommon for design to be painted on the finished baskets; in such instances the technique is clear, for color may appear only on parts of the decorative stitches or overlap onto adjoining stitches which are obviously not part of the design.

Basically, burden-basket layouts are in bands of one form or another (Fig. 4.6). True bands bound with a line on each side are common. So too are half bands, with a line at the top only or, occasionally, at the bottom alone. Many bands are organizational with no banding line on either side. Further, there are innumerable combinations of these different schemes in the one to six bands which may occur on Western Apache burden baskets.

Woven designs on burden baskets involve much more than meets the eye at first glance (see Fig. 3.3). For example, they entail the use of a variety of design elements including the following: lines and bands, diagonals, triangles, zigzags, chevrons, squares, rectangles, and combinations of several of these, plus a few crosses, and several examples of a life form. Lines are usually one stitch wide and generally encircle the basket all the way around. There are also horizontal bands which are made up of two to four or more stitches to create this form. Too, there are bands of one or several solid colors which serve as background against which other design elements are placed. Also, both lines and bands serve to border plain or decorated lighter or darker areas, on one or both sides, these areas usually bands and often wide ones. Both bands and lines are also used alternately with each other as the total pattern, and frequently they are of different colors. Thus, lines and bands are versatile in their uses in the burden basket.

Diagonal elements are also commonly found in the color decoration of burden baskets. In a sense, they are short lines usually one stitch wide, or they may be bands of several stitches in width. Some diagonals are done in two colors side by side, for example, a red and black on natural ground. Diagonals may be just beyond a vertical position, extremely slanted, or in between; usually they move from lower left to upper right, although some move in the opposite direction. Two-stitch-wide diagonals are produced less often than the single stitch type. Another device is to make one-half of the diagonal one color, say top red, and the other half a second color, bottom black, then alternating in the next diagonal, top black, lower half red. Sometimes natural color may occur between each of such colored diagonals. Or a single-color diagonal may be divided in the center by a horizontal line or band. Perhaps one of the most elaborate diagonal arrangements is the following: a very wide band with diagonals running all the way across. Variety occurs in one such piece in the use of a nine-stitch red band above and the same

below, and a 21-stitch natural band between them with black diagonals cutting across and standing out against the entire area. Diagonals may appear without borders, although single- or double-stitch lines of the same or a different color, or even alternating colors, often enclose them top and bottom. Variation occurs in all these matters.

Vertical elements are not as common as the true diagonal. They occur in a single stitch in one color or several colors side by side, one stitch each.

Sometimes squares in alternating arrangements in successive rows may give the impression of almost vertical lines. One example has black squares alternating with natural ones in one row, then short diagonals of four stitches, then a repeat of the black-natural squares. Another basket is decorated with a row of alternate red-white squares with a band above and one below. Sometimes another color simply alternates with the same in natural. A checker effect results from several rows of alternating red-black or black-natural squares. Most of these squares are of two or three stitches each.

Chevron units result from running diagonals from lower left to upper right for four or five stitches then reversing them for the same number of stitches. They become zigzag units when reversals occur several times. All of these are vertically placed, but there are also horizontal zigzags. One such used two parallel black stitches throughout most of the pattern. Another is more elaborate: there are triple, double-stitch black zigzags with the same form twice repeated between them in red, all on a natural ground.

Perhaps one of the most popular of the more elaborate design units is the triangle, often represented as a black one pendant from a line or band of the same or another color. Equally common are two opposed rows of black (or another color) triangles with tips touching or almost touching, this at the dictate of the weaver. In either case diamonds or near-diamonds result in the base color, usually natural, between the colored triangles. Triangles may be equilateral or very flattened. Also this design unit may be solid or checkered.

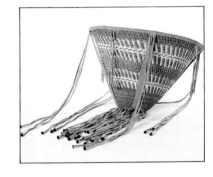

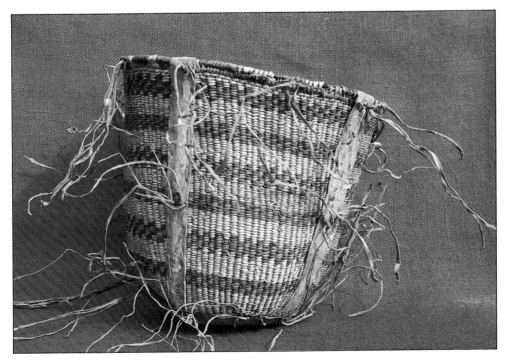

Fig. 4.6f–h. Burden baskets. (f) An elongate, conical form with a solid band top and bottom, a designed band near each, and an organizational band in the center *(ASM 56947)*. (g) Six bands alternating, organizational and regular styles *(ASM 13512)*. (h) A five-times repeat of a half-band; note also buckskin bands to right and left and thongs attached on and between them *(ASM E4328)*.

Odds and ends in the way of additional elements or units on twined burden baskets appear occasionally. A cross or almost-cross is one, with arms frequently longer than the vertical or upright bar, or the latter may be very thick, the arms thinner. This design unit may be in positive black or natural, or negative, natural on black. A few odd stitches in contrasting color but without specific form also occur now and then. Of all the many Western Apache burden baskets observed a few only revealed a life form. At a February 1980 competitive show, a piece woven within the year appeared at the exhibit, a burden basket with the figure of a deer in dark brown on a light natural ground. The individual animal was repeated four times around the basket, just below center. Total design will be discussed below.

And, of course, the weaver could and often did combine any two or more of the above elements or units of design, usually into a single band, in a simple or more complex fashion. One example shows a top two-stitch band of alternating black and white in each, a three-stitch band of red, a wide band with red triangles pendant from a black line, and a bottom band made up of a black single-stitch line from which are pendant short four-stitch diagonals.

So much for Western Apache burden basket design elements and units and an example of a combination of several of them into a single band. The arrangement of the total design on the basket offers further variety to this piece and its decoration. Repetition of a total design from one basket to another does not exist, for the Apache weaver was too creative to copy. At first glance some might seem to be identical patterns but detailed analysis would prove this conclusion untrue. One example of similarity would appear in two baskets with three rows of bands, each enclosing diagonals. In one the diagonals are close to vertical in position and run from lower right to upper left. In the second basket the extremely slanting diagonals run from lower left to upper right. Spacing in other three-row examples filled with diagonals would account for other differences; so too would varying colors. The above examples were all-black while a fourth basket had three rows of black-outlined red diagonals. Some of these bands are single bordered, some double, some have a double top bordering line and a single lower one. Varying widths of bands would also result in distinct differences. Many other styles were expressed in the triple band: for example, no borders to the diagonals, or a single border, or a line across the center, or tips of diagonals extending beyond the bordering line. Thus, putting together all the possibilities of combinations of these variables plus others would posit a lengthy list of differing designs using three bands of diagonals.

As three bands have tended to be very popular through the years, a few additional examples will further demonstrate the complexity of this scheme. On a seemingly older burden basket (based on shape) are like top and bottom rows, each with bordering lines enclosing spaced-out squares, and a central row of red (faded) ornamented with a series of paired horizontal stitches, a black pair then a white one. A turn of the century Whiteriver piece has three different bands. The first is close to the rim and is made up of single six-stitch verticals which alternate with the same in natural, all pendant from a single, black-stitch line. A little below this is a row of joined black

diamonds outlined with two red stitches both above and below, and
with three rows of red single stitching running through the centers
of the diamonds. Quite a bit lower is the third band made up of
seventeen alternating lines of black and natural.

Long popular have been three bands involving diamonds in one,
two, or in all three areas. One turn-of-the century example has a
checkered band at the top, a simply outlined band at the bottom,
and a very elaborate central band involving two rows of diamonds
creating a wide zigzag through the center, and through this runs a
line-wide zigzag. Small elements appear above the top band and
below the bottom one, but they are hardly noticeable. An undated
example has three similar bands covering a goodly portion of the
burden basket wall. In all instances there are large flattened
diamonds touching tips in the central row but not quite touching
in the other two, thus creating negative diamonds or diamond-
like patterns.

Another burden is decorated with three identical rows, each
having black lines enclosing a natural plain band, and with pendant
red rectangles on exteriors of both black lines. Three different deco-
rative areas appear on an older basket: a top row of black triangles
heavily outlined in red; a central band of a thin upper line with
a touching wide zigzag enclosing black flat triangles, and with
another row of triangles below not quite touching; and a third
band made even-edged by horizontally touching flat triangles
which enclose a wide red zigzag between them.

Actually the variety of three-band decoration on Western Apache
burden baskets is endless. The above is but the barest sampling of
such arrangements. Add to these other design units, multitudinous
arrangements, varying colors, different spacing, additions of three-
ply twined lines or bands, and again, variety is endless. Actually
there was no need for copying, for each weaver could truly "do her
own thing."

Although the number of bands on the side walls of burden baskets
runs from one to six, these are variables in addition to those men-
tioned above which add to the possibility of every basket becoming
an individual creation. Single bands near the center of the wall may
be narrow or broad, simple or complex. One such is composed of a
row of alternate black and white squares, a plain narrow row of
natural color, and a row of black and white diagonals with heavy
outer tips but no bordering lines. A two-row example has a simple
top band and a very complex one below. At the top are seven rows of
alternate stitching, with three in red and three blue, and below the
red are four blue stitches and below the blue are four red stitches,
then this same alternation continues all around the basket wall.
The second band is red-bordered at both top and bottom, one stitch
each, and has, further, this complex alternation of a group of colors:
blue, red, natural, red, yellow, red, natural, red, blue, then this entire
cluster is repeated. A much simpler two-row decoration is in red,
with a three-line upper band with pendant dots and a lower single
line with the same.

One five-band decoration on an early 1970s burden basket was
composed of the following, all in dark brown: a row of verticals
enclosed by horizontal lines and with projecting small squares at
top and bottom, a second and narrower band of the same minus the

top squares, a third row like the first, a fourth band like the second, and the bottom or fifth row of solid brown. Spacing is too close together between the last two bands, making them look crowded. A further example of these burdens has six bands all with black diagonals alternating with red ones. Variation is supplied in black squares at tops and bottoms of red diagonals in bands one, three, and five, while the in-between bands have smooth edges. This basket is a fairly old one.

A last example to be described has the life form on it mentioned above (Fig. 4.7). Woven in dark brown, the entire wall is involved with decoration. Immediately beneath the rim is a deep band terminating in triangular tips, and below this is a narrow zigzag leaving a white zigzag between these two brown patterns. Below this is a white area and then a repeat of the above. The base of the latter is reversed so that the heavy band is at the bottom, with the narrow zigzag above it. On the wide natural band is a very conventional and solid brown (except for the eye) figure of a deer, repeated four times and alternating with an outlined almost-diamond with a dot in the center. In 1981 and 1982 additional life designs were noted, including eagles, antelope, and doglike creatures.

Horizontal banding in the decoration of the Western Apache burden basket has remained dominant throughout the history of this piece, and for good reason. First, the twined technique invites this type of patterning. Insofar as is known, from earliest times

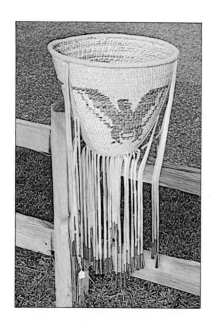

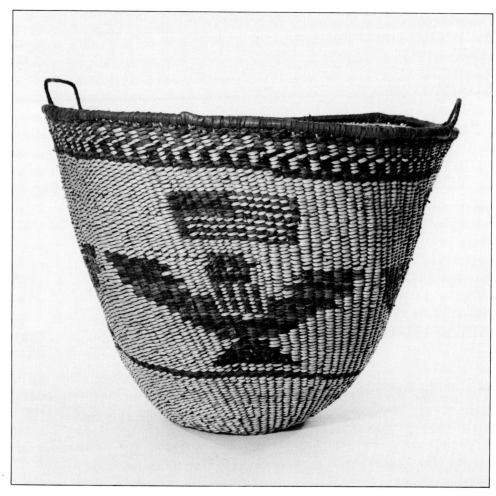

Fig. 4.7. Life forms on burden baskets
(a) A 1982 eagle *(O'Odham Tash)*. (b) A large 1981 basket with an eagle and a flag as decorative motifs in red-brown. Note the unusual handle at the top *(ASM 56949)*.

vertical bands of buckskin were attached to the basket wall at four intervals, adding a pleasing, quiet contrast to the horizontal color bands (see Fig. 4.6).

Rim finish in burden baskets might also add to the decorative aspect, or it might remain neutral. A binding of a dark piece of chamois so commonly used today, plus the same for a bottom patch, define and limit the area of decoration. When done in the lighter buckskin of earlier years, this feeling of definition was less pronounced but subtly there. Frequently the base buckskin or chamois will be cut in scallops or cogwheel-like edges, adding a decorative touch. So too did the earlier red baize with its edge peeking out from under the skin patch. Very decorative too were the buckskin—or chamois—thongs, long or short, with or without the tin tinklers. Placed at two points on the vertical bands of skin and at another midway between them on the rim, these thongs added a feeling of motion to the all-over design when the Indian woman was walking with the basket on her back.

Without question the burden basket was a piece which the Apache woman wove with care, for she was to use it frequently. It seems that it was creative care, an individual expression of pleasure as long as these were made for the Indian's own use. Technically these baskets were consistently well woven and certainly they were well designed. Pride in craftsmanship and creativity went hand in hand in making of the Western Apache burden basket.

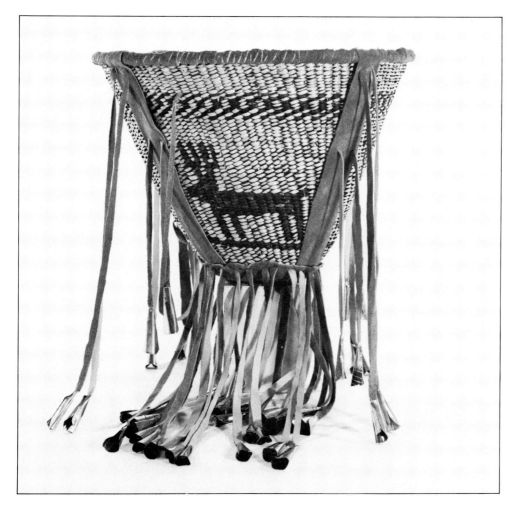

Fig. 4.7. (c) A fine specimen of a deer repeated three times. However, there are the usual four vertical chamois bands on the exterior, and, contrary to tradition, there are only two thongs instead of four at the top and they are lower on the bands *(Bereneice Smith Collection)*. (d) A pine tree, also in red-brown, the first plant form observed on these burden baskets *(O'Odham Tash, 1982)*.

DECORATION IN COILED BASKETS

The subject of designs in Western Apache coiled baskets is so complex that at best it can but be touched upon. An attempt will be made to cover enough for the sake of illustrating this complexity in contrast to the designs of baskets of the other weave and of both other Apache groups, and also to bring into focus some of the esthetic qualities of this fine work.[6]

In a well-woven Western Apache basket, material, technique, form, and design are all integrated into an artistic whole. Particularly are large trays and jars beautifully conceived and executed, reflecting throught and plan as well as creativity. These and some other pieces would rank in all respects with the finest in the Southwest, with the possible exception of superior weaving in Chemehuevi baskets. Design, in particular, shows great variety, imagination, and creativity on the part of these Apache women. Yavapai baskets would be a close second in design, and for good reason—they lived on the San Carlos Apache Reservation just before the turn of the century. Undoubtedly there was intermarriage, plus sharing of designs in this close living together. Although the Yavapais undoubtedly developed some of their own ideas of decoration, there are unquestionably many products of this time which certainly cannot be determined beyond doubt as being from the hands of a weaver from one tribe or the other. Also this trend continued for an unknown period of time after the two tribes lived together.

In the coiled basket the Western Apache expressed the greatest play of artistic skill, with the work of the Eastern groups reflecting more reserve. Western weavers had a rich pool of design elements, motifs, and patterns; Eastern Apaches were more limited in all these matters. Some designs of Western groups were reserved, but many more were vital and dynamic. Symmetry would seem apparent in designing of both Eastern and Western groups, but upon closer observation it becomes obvious that the latter tribeswoman frequently adds an "extra" design in the form of a cross or other geometric, a human or an animal, or some other isolated element or motif to break this balance—or the same end was attained by omitting a comparable detail. Perhaps she did this to relieve the tension created by repeating elements and motifs, perhaps it was just a pleasant game to play, perhaps it was a desire to express a thought or whim of the moment. Whatever the reason, it was a pleasant diversion when it did occur.

Whenever the extra small themes are woven into the Western Apache basket they appear in one of two areas, either between or within major motifs. Primary designs are geometric, frequently with life forms between or touching them. For example, on one jar wall there are four rows of large checkered diamonds, with a man standing on the top of each in the bottom and top rows and quadrupeds placed more or less above the diamonds of the two intermediate rows. Great zigzags ornament the surface of another piece with quadrupeds thrown in between the high points of these geometrics. Checkered triangles form a network over the entire surface of a jar, creating open triangles between; within all of the latter are differing quadrupeds. Although some of these figures may

seem to be an afterthought as the weaver moves along, others seem to have been planned from the start. Another organized pattern would be a positive, solid black triangle in which is a negative figure of a man or a quadruped. More helter-skelter arrangements of figures might suggest their unplanned appearance.

Several additional traits characterize these extra elements on coiled pieces. First, they may or may not be exactly repetitive. For instance, a single man may appear in all spaces but one, and here there may be two men. Second, small differences may appear in the individual, repeated figures. If a row of horses is repeated, all but one may be facing forward, and this one will have his head turned backward. If a man is presented in each open space, each with his arms at his sides, the exception may have one arm in this position and the other upraised. Again, these small details reflect a delightful turn of mind of the weaver.

Because Western Apache baskets are so numerous, they will be broken down into different forms, then each form will be treated in terms of a few smaller matters and more specifically in their design layouts and the total patterns. This will reveal the ability of these Indian women to adapt their artistic expressions to a variety of areas in differently shaped baskets. It also reflects their great creativity in terms of endless uses of the same elements and motifs, particularly in combining them into hardly ever repeated total designs. Forms will include trays, bowls both round and oval, jars, a few odds and ends, and miniatures.

Trays

An analysis of 383 trays will tell something of their sizes and their stitch-coil counts. Of this number 117 pieces came from the Hubbell Collection; 13 and 12 from the Bedford and Collings private collections, respectively; from the Amerind Foundation, 84 baskets; Elliott Collection, 12; and from a large number of miscellaneous private collections, 144 baskets. Not all aspects are given for each basket; therefore, there will be some differences in totals. Many of the Hubbell baskets are large and old, and practically all of the Elliott pieces are old. Withal, there is a good range in the matters of size and stitch-coil features, in age, and in decoration in these pieces, as well as in the general quality of Western Apache trays as herein presented.

In diameters, these baskets ranged from a low of 6" (four examples) to a high of 29" (one only). The largest number of trays were 13" and 14" across, with 52 in each category. In the 12" diameter size there were 35 baskets, of the 15" there were 39 pieces, and 34 measured 16" in diameter. From these stated width figures, the number of pieces decreases both up and down.

Although more limited in range, heights are about the same in terms of general distribution. Range was from ½" to 6", with a clustering from 2" to 4". Three baskets each were counted in the most shallow and the deepest pieces. There was a concentration in the 3" category, with 138 pieces counted here. Next in numbers were 91 of 2" depth and 78 of 4". There is a terrific drop-off both above and below these height figures.

Stitch counts are interestingly distributed, with a concentration in the 13, 14, and 15 to the inch groups; 51 of the first measurement, 56 of the second, and 44 of the third. There are 12 stitches to the inch in 35 of these baskets, 40 with an 11 count, and then erratic numbers: 32 with 10, 39 baskets with a 9 count, and finally two baskets with a count of 7 stitches to the inch. At the other end of the scale where the counts go up, the number of examples goes down, with one each with counts of 15 and 16, and two baskets with 17 stitches to the inch. As a whole, there is good sewing in these Apache baskets.

An overwhelming number of baskets have a five-coil count to the inch, 135. Again, there is quite a drop both up and down from this figure, with 91 trays of a four-coil count and 86 with a six count; drops from these two figures are great. As with stitches, it can be said that coil counts are fairly high in a majority of these trays, pointing to good craftsmanship.

Design in trays is most varied and interesting of all Western Apache baskets. The tray was the most used form, it is most abundantly found in collections, and needless to say the most difficult to analyze. Individuality expressed by weavers in this form make it an exceedingly important segment of Apache basketry to study.

Design layouts on these basket trays, as mentioned previously, are difficult of analysis because the vast majority begin with a black center (see Fig. 4.8). One could thus consider all of these pieces to be of all-over or banded style. However, because of their complexity, they need to be broken down into sub-styles, and will be. Other factors also come into focus: for example the center may become a distinct motif to be—or not to be—incorporated into the rest of the design, or it may be so insignificant in the total pattern that it can be ignored.

Positive patterning dominates in the majority of tray designs, but now and then a negative one prevails and may take a distinctive form. Design may be very static or become simply or greatly dynamic. Severe and rigid banding may occur, or more integrating organizational banding may be the choice of the weaver. Thus, many of these secondary factors are strong and must be taken into consideration as one of the bases of design analysis in these Western Apache trays.

Rarely there is no black center in the tray; there seem to be more baskets of this type in old collections, though even then a small black center was more common than the plain one. Seemingly more and more attention was given this central motif as baskets were decorated with more and more solid black, as designs became more complex, or as an ever greater amount of the basket was covered with patterning. It must be kept in mind, then, that the naming of some layouts really stresses that part of decoration beyond a relatively simple and insignificant central motif. Obviously there will be many decorative schemes which do not fall completely into one category or another. For example, what layout is expressed in a tray with a greatly exaggerated star motif with tips touching the rim and with medium-sized coyote tracks spotted just under the rim? For the sake of simplicity this will be classed as centered, although it might be classified as all-over. However, the feeling of a great centered motif dominates, and thus it will be labeled.

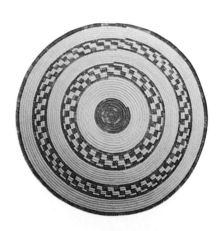

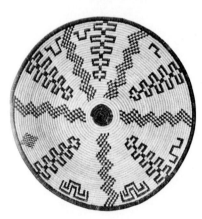

Fig. 4.8. Tray layouts
(a) Regular banded *(ASM E2426).*
(b) Organizational banded *(AF 1165).*
(c) Centered; despite the background, the star is dominant *(AF 1140).*

The following layouts will be postulated for the sake of discussion about these tray designs (Fig. 4.8). Banded will be used in those cases where the center is simple or but slightly complex, and where there are true and dominating bands made up of two lines enclosing patterns, or a black center circle and another line to make a band, and with the major pattern confined within such a band or also in additional bands. Generally organizational-banded consists of one or more banded designs without benefit of the enclosure lines about a center circle or a slightly elaborated central theme. Half-band is not common, but a few do exist. One example has pendant triangles fairly close to the rim with a negligible black center. Centered layouts are not too common, but some do exist. The above example will serve to illustrate this style. More common is a distinctive centered motif plus a secondary style, thus making for a composite layout. These would include centered-banded, centered organizational-banded, centered-half-banded, and centered-repeated.

Although all-over is generally categorized as of a fairly even distribution of elements or motifs over the entire tray surface, surely this layout designation can be applied to other arrangements as well. In fact, the term could conceivably be applied to many of the composite layouts or even to others in these Apache trays. There are examples where the central unit becomes so much a part of the total design that it is almost lost as a separate entity. These secondary configurations may be so highly integrated as to have no specific layout feeling, or they may move out from the central motif to the rim in a dynamic or static manner, dominating the whole pattern. These are true all-over layouts.

Thus, in naming layouts for individual baskets the nature of the total design must be taken into consideration. If an insignificant center is completely dominated by bands, the layout will be termed banded in spite of that little central circle, or organizational-banded, or otherwise, according to the nature of the outstanding motifs and their interrelationships.

Banded layouts may be simple or complex; they may consist of from one to seven bands in a single basket (Fig. 4.9). Bands may be well defined, standing out against a plain background, and containing all of the design on the individual basket, or there may be major patterns in the bands and lesser motifs in the areas between them (which are usually bands also). Or there may be continuous bands of decoration from center to rim, really an all-over arrangement. Obviously, arrangements vary a great deal.

True banding was not a popular style in the earliest baskets observed. Several examples indicated that the area between the central black circle and rim was treated as a single space where sparse elements appeared in a rather scattered or even helter-skelter manner. Certainly there were no severe black line-enclosed multiple banded styles in these early pieces.

One of the simpler banded layout styles has a plain or a slightly elaborated central theme, then two or three or sometimes more bands between this and the rim, and usually with plain bands between the decorated ones. Within the black lines are repeated elements such as triangles; or there may be two, three, or four coils of checkers. Often the same design element is in all bands. Or there

Fig. 4.8. (d) Centered organizational-banded *(AF 1166).* (e) All-over *(AF 1114).*

Fig. 4.9. Banded layouts on trays. (a) A wide single band *(ASM 1630).*

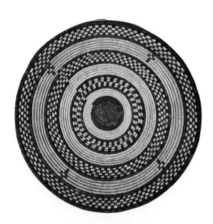

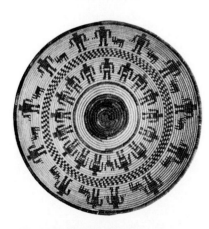

Fig. 4.9. More banded layouts
on trays
(b) Three narrow bands *(ASM E4596).*
(c) Five narrow bands *(ASM 1635).*
(d) A wide band enclosing two
rows of men and rabbits and a nar-
row, centered organizational
band *(private collection).*

may be three bands of checkers alternating with plain ones and a
fourth at the rim containing a different design unit such as fairly
large, repeated, and joined triangles. Sometimes there may be a sim-
ple design element in the otherwise plain bands between the check-
ered ones. More ornate are bands with different and often larger
elements within them.

One basket has a small central star surrounded by a narrow
checkered band, and a wide band from this to the rim; within the
latter are, first, a row of black, stepped, joined triangles, and second,
beyond triangle tips an encircling light line fret. Three plain coils
separate the line fret from the second enclosing band line, the black
rim. One interesting arrangement consists of seven touching bands,
thus banded all-over: the first band is filled with triangles, the sec-
ond, third, fifth, and seventh with rectangles that alternate with
plain areas of the same shape. Fourth and sixth bands are like the
latter four except they have quadrupeds in the areas between the
rectangles. Triangles and rectangles are formed of vertical and alter-
nating black and white lines.

An interesting banded layout has a plain black center, a plain
black coil, a wide band filled with sixteen men and a very large
rabbit, a four-coil checkered band, and a second wide band with
thirteen men and eleven small rabbits. In the first group of sixteen
men all stand close together, with their arms hanging at their sides,
very simply represented in all black except for a white belt. In the
second row one rabbit appears between each two men except for
one pair where there is no animal. Incidentally, this is the only ob-
served basket decorated with this familiar desert creature, the rabbit
(Fig. 4.9d).

Other banded arrangements were produced by the prolific
Apache designers. The above is but a sampling, with, of course,
great variation within each of the styles mentioned or described.

Organizational-banded layouts were popular among Apache bas-
ket weavers from very early times and into the present (Fig. 4.10).
This style, too, was extremely varied. Center circles were quite
small; if they became a star or other more decorative scheme, they
remained, for the most part, relatively simple. Most of the other
motifs were arranged in an organizational manner, that is, without
benefit of enclosing lines. Again it might be reiterated that if there
is a central circle and a black rim all of these might be classed as
banded or all-over—it is the nature of the major motifs which
determine this category of organizational-banded.

Some few baskets studied had white centers, each with a single
heavy band of organizational nature. These bands tended to be
much more dominant than those in other baskets; there is the pos-
sibility that they are not Apache. As a matter of fact, they have no
real "Apache feel" about them.

Much more typical would be a small black center circle plus from
two to six organizational bands between this and the black rim.
The bands are dominant, the circle insignificant. Bands may be in
a variety of forms including the following. Encircling fretlike units
alone were popular, or they were combined with other elements
such as a row of spaced triangles at the rim and double crossed lines
in between the two. Or there might be three rows of these: encir-
cling lines with short pendant lines on each; or one row of a fret and

three rows of outlined and joined squares, and at the rim a row of spaced-out, stepped, alternating solid and outline triangles. Another variation involves a neat arrangement of a row of short frets, then three successive rows of joined coyote tracks, the last touched by outlined and spaced-out triangles at the black rim. There is more variation in these bands about a small circle: a row of joined coyote tracks, an eight-pointed, double-stepped outline of a star, a four-coiled checked band, a single stepped zigzag, and two-coil, alternate black-white blocks. A feeling of lightness prevails in a great many of these arrangements.

Light in feeling also were more pointed star and more rounded flower themes, in single, double, or triple outlines—all favored styles. These might be repeated two, three, four, or more times, and the number of points or petals varied greatly. Most often they were plain, but sometimes there were animals here and there in one or more rows. When these star and petal themes maintain organizational rows, they remain in this class, but when they overlap, they can be classed as all-over.

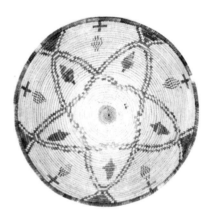

Then there were more obvious combinations of motifs in such organizational arrangements. For instance, there was this elaborate sequence from center to edge: a central five-pointed star, two coils of alternating black and white squares, a row of step-sided triangles, a repeat of the black-white squares, a row of alternating solid and outline arrowpoints and large crosses, and at the rim a second repeat of black-white squares. A more "spotty" effect results from the use of the black triangles and arrowpoints, perhaps because they are spaced out.

Many other arrangements of organizational-banded were executed by these weavers, including combinations of the above mentioned designs plus other themes, and various geometrics such as diverse groupings of triangles, swastikas, chevrons, varied parallel, straight, and zigzag lines, plus others. There were also life forms, particularly men and quadrupeds, in different positions in relation to the encircling bands.

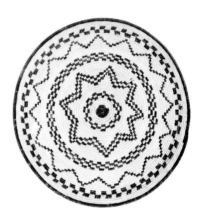

One of the loveliest of organizational-banded layouts consists of repeated rows of the graceful "Apache" triangle, the one with incurved lower sides and outcurved tops. Basket centers may be anything from a small and plain black circle to the same with attached radiating lines or elongate triangles or other such units, or it may be a negative star. Usually attached to and extending beyond the total motif will be two or more rows of triangles. The triangles may be plain solid black, usually with stepped sides; sides may be outlined with one, two, or three stepped lines; tops are usually plain and minus outlining. Frequently negative figures, such as men, dogs, crosses, or coyote tracks, appear in these triangles. Rows of the triangles may number two to four, often with the beginning of another at the rim, or, even, an additional row of many small triangles.

In one basket the innermost row was made up of small triangles, the second of larger triangles, and the third and last of quite large ones. Each triangle is outlined with double lines. A second piece has an unusual detail in that the first row is made up of checkered, small triangles followed by three rows of plain solid black ones, again each row slightly larger than the preceding one. At the very edge and touching the rim is a rectangle joining every two triangles.

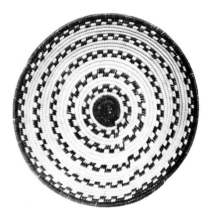

Fig. 4.10. Organizational-banded layouts on trays. (a) A wide single band; note the very small center circle *(ASM 1577)*. (b) Multiple, mixed organizational bands *(ASM E2830)*. (c) Repeated bands *(ASM E2757)*.

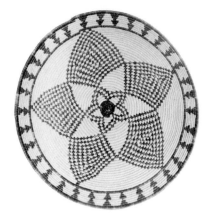

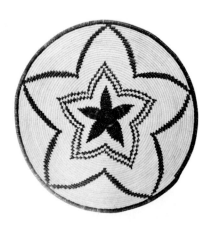

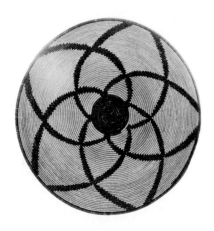

None of these forms is outlined. Above each triangle in the second row is a single dog, except for one spot where there are two; and in like positions in rows three and four there are two such pert little creatures.

At first glance this design would seem to be a true banded rather than organizational style, but it is not. Always there is a slight jog or break in the would-be line, thus denying continuity for the creation of the enclosing lines necessary for bands. Sometimes the basic element is more petal-like, and there is a definite break or open space between rows. Or rarely, there may be a regular band interspersed between the rows of triangles. In many of these patterns planning and execution are so perfect that there are negative triangles between the positive ones. Depending on the shape of the latter, on outlines, and on spacing between them, they may be identical or different in shape. Again, much variety resulted from the ingenuity of these excellent weavers.

It might also be mentioned that there are various combinations of regular banded and organizational-banded styles. Perhaps a checker band will appear with a row of double meanders and an outer row of life forms. Or a central meander might be combined with a second row of star shapes made up of triangles, these touching a true band of checkers at the rim.

Variety in star and flower schemes which might take them out of the organizational-banded class and into the all-over was great (Fig. 4.11). This might be done with separate but overlapping rows, or by successive rows taking off from the tips of a previous row. Too, between rows there might be added small geometrics or life forms. All of these devices made for overlappings which also took the style out of the organizational-banded class and placed it in the all-over.

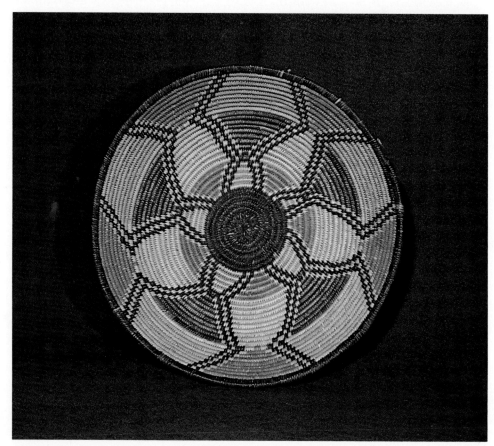

Fig. 4.11. All-over layouts on trays. (a) A large, five-petaled flower made up of diamonds *(ASM E2839).* (b) A solid central flower with two outlines of the same beyond the central motif *(ASM E2817).* (c) Intergraded triple floral outlines *(ASM E2820).* (d) An interesting all-over sequence of red-green-red triangles *(ASM E2759).*

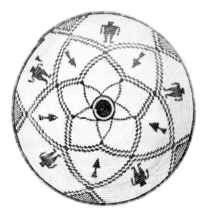

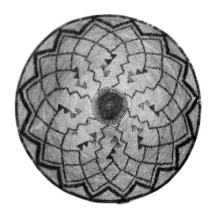

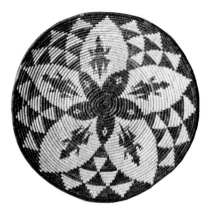

One pleasant treatment is to be noted in a tray basket where the woman wove a vertical line of tiny stacked triangles through the lower or inner points of three or more concentric, single-outline stars. This resulted in a spider-web effect, a very delicate and appealing design, and definitely an all-over layout (Fig. 4.12). One of the most charming trays with this type of design looks like a many-petaled, full-burst flower. Actually it is composed of short zigzags including plain ones alternating with ones made up of open and solid triangles leading from close to the center motif to the lower point of diamonds forming an inner row. A second row of the same takes off from the outer tips of the inner diamonds, with all lines to this point most delicate, in fact, veritable tracery. A wider outline encircles the edge of the pattern, its outer tips touching the black rim.

Another variation on the all-over layout has one of several motifs which move from center or near center straight out to or close to the rim. It is called a static arrangement because little or no motion is

Fig. 4.11. (e) Another triple floral outline with additions within and beyond the outer petals *(ASM E2814).* (f) A very delicate all-over pattern made up largely of zigzags and diamonds *(ASM 1552).* (g) A positive flower with a negative coyote track in each petal; beyond, a negative flower with a positive Gila Monster in each petal *(photo by Ray Manley, private collection).*

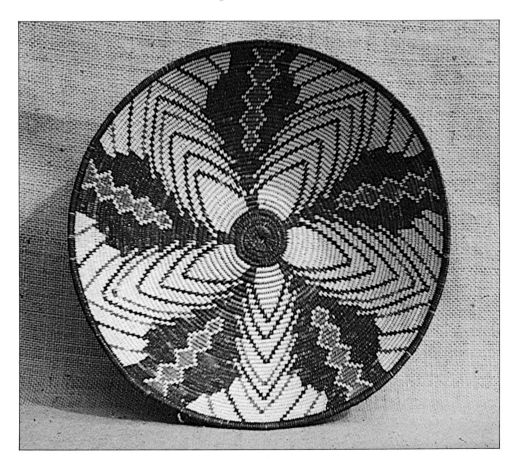

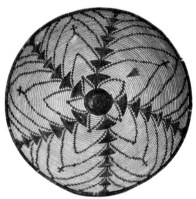

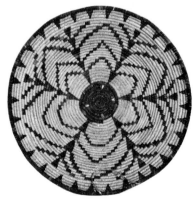

Fig. 4.12. All-over layouts on trays: "spider-web" decorative effects. In each piece, very light star or floral outlines appear to be superimposed on a darker motif. (a) This basket has a touch of red in the diamonds *(ASM 2812).* (b) *ASM 1597.* (c) *ASM 1598.*

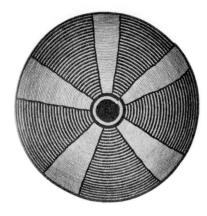

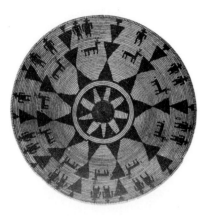

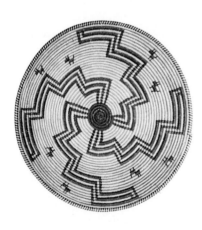

suggested in the design. There are, of course, a few borderline cases where the barest motion is discernible. An example of this style is to be noted in a tray with a large central theme out of which come twenty "spokes" of stacked triangles which touch the rim. Some of these spokes are straight, some are very slightly curved, but the total effect is one of static patterning (Fig. 4.13f). This was a favored design, sometimes moving from a small center or a slightly larger one, sometimes with the stacked triangles very straight, sometimes not so straight. Sometimes the stacked triangles are much larger, and there are fewer rows of them, such as four, five, or seven, but all are plain like the smaller ones mentioned above. Sometimes the vertical rows were bounded by two or three parallel, zigzagging lines at each side, these almost giving dynamism to the total effect.

Many other motifs were used for these static designs, often two of them alternating, one from the center circle, the other from a point beyond it. For example, a solid heavy line with a light one on each side comes out of a black circle; this theme alternates with four parallel lines which angle off three parallel lines which start six coils from the center circle. Then between these two motifs are other and smaller geometrics plus animal figures. In another basket six heavy vertical lines moving from an insignificant black circle terminate in a small diamond, then this in turn joins a larger diamond, the latter touching a rim of alternate black-white stitches.

Some of these static verticals take off from the points of a central star. For example, nine rows of three outlined diamonds each do

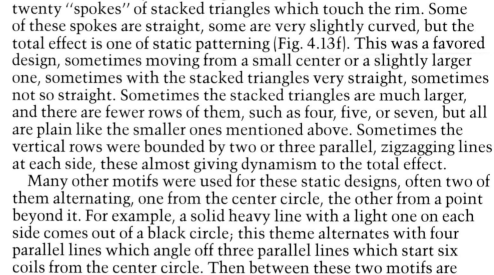

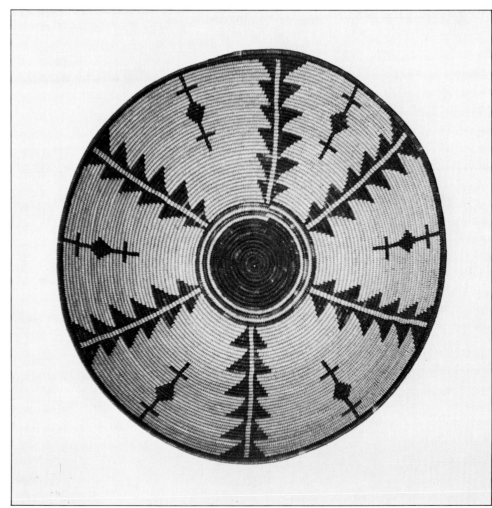

Fig. 4.13. All-over static and dynamic tray decoration (a) Rays of concentric lines move in a static manner from center to rim *(AF 1161)*. (b) Static rows of triangles with many figures between them *(AF 1109)*. (c) A very popular Western Apache dynamic theme: sets of steps moving from the center almost to the rim *(AF 1136)*. (d) Double rows of triangles move straight out in a static manner *(AF 1160)*.

this; they offer variety in a sequence of solid-outline-solid forms, the latter touching the rim. Between every two rows is an outlined, heavy line pendant from the rim. Points of another star become double parallel lines, one of them giving way to a large solid triangle. Between these paired lines are swastikas which have continuing ends blending in with the lines.

Sometimes these static center-to-rim lines or geometrics are interrupted by one or two encircling bands, but the latter do not interfere with the feeling of verticality in the total basket design. One such basket with plain stacked triangles has a checkered band about a dozen coils from the rim; a second similar tray has two such interruptions. The fact that all of these bands displace one or two of the triangles again does not interfere with the over-all vertical feeling of pattern. Nor is this feeling interrupted in another tray where the stacked and outlined triangles look as though caught in a web of fine-line, concentric outlines of stars forming a complete background for the dominant triangles.

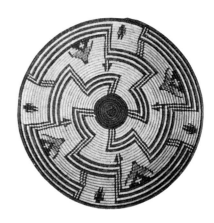

Quite different from all-over static is the all-over dynamic feeling in tray pattern (Fig. 4.13c, e, f). From the standpoint of design, the first indication of this dynamism is when vertical zigzag lines are employed, usually clusters of them, or a line of triangles; either is bent slightly from center to rim. Some triangles are large, with few rows of them, usually four, or they may be smaller and more numerous, for instance, six rows of them. Even in early times the latter style was not unknown: one such basket has ten curving lines while another has six sets of three, each of very small triangles forming gently curving rows. In these earlier pieces arrangements tended to be less well ordered; for example, spacing between rows was poor, or sizes of triangles in a single row were varied. Too, additional lines pendant from the rim might be added; sometimes these were not only poorly spaced but also were of uneven lengths, shapes, and numbers, and took off at varying angles.

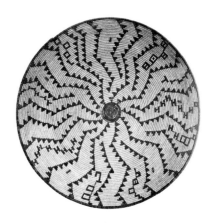

As dynamic radiate patterns became more popular, some also became more elaborate. For example, the rows of triangles might alternate with rows of multiple zigzag lines or other motifs. In some baskets the zigzags were used alone, or combined with a second and different motif, often with small static units thrown in between these active themes. Steps became popular as dynamic motifs, for it was easy to weave a square or oblong line in the current coil off a comparable one in the previous coil. Perhaps these steps became popular because they had so much potential for variety. One frantic pattern of this style has nineteen such steps zigzagging their way to the rim from a small black center, with ten more of the same crowding their way in between, beginning a short distance from center. Not yet satisfied, the weaver then added seventeen more short lines as she approached the rim. Another simpler and better designed basket has nineteen whirling steps off a large center, with squares of each step enlarging as the space increased toward the rim. In another such basket twenty rows of squares take off center; these are so close-spaced and so evenly increased in size that they give the viewer a feeling of double-whirling, that is, both left to right and right to left, particularly in the beginning rows.

Long steps are also varied, particularly as made up of two, three, or four parallel lines, or in their open to very closed arrangements, or in the number of groups coming off center. Parallel lines are

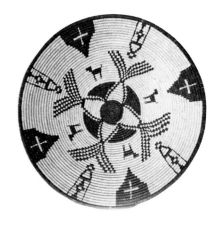

Fig. 4.13. (e) Sets of steps moving from the center almost to the rim but with designs on, under, and between the steps *(AF 1102)*. (f) Popular early and late: irregular zigzags of small geometrics which move dynamically from center or near center to rim, often with other elements thrown in here and there *(AF 1153)*. (g) An interesting combination of static plus a slightly dynamic touch in the elaborate center theme; this then overlaps with the outer organizational band, thus creating an all-over layout *(AF 1126)*.

remarkably regular in many baskets, with longer steps and shorter risers as a rule, although there may be irregularities in these matters in some baskets. In certain pieces the arrangements are so open that there is no problem distinguishing the number of the path followed by each group of steps. In one tray six groups of three parallel lines each are so regular and so close together that at first glance the pattern looks like parallel encircling bands joined by spaced out "spokes"; it is only upon closer examination that it is obvious that here is another example of angular long steps and short risers. Another basket has an even less obvious grouping of seven sets of four parallel lines each, with little space between both steps and risers.

Other devices which contribute to variation in this stepped, angular, dynamic style include the addition of life forms or geometrics between the major motifs; or the increase of the size of risers from lines to bands; or the reversal of direction from center-right to upper-left to center-left to upper-right of the basic theme.

Many combinations of the dynamic style were presented in the Apache tray; a favored one was curving rows of zigzags alternating with various static themes, or with curving units of triangles. In one basket opposed long steps alternate with zigzags.

Centered patterns are not common in Apache tray baskets but they are found now and then (Fig. 4.14). One of the most interesting is a five-pointed, negative star which reaches from the center to the rim; it is presented against a simple banded background. The latter does not detract from the centered layout. Another example has a negative star on a black background; its tips touch small negative diamonds which in turn touch negative triangles which move into and become part of an otherwise black rim. The result is an unusual black and white rim. Both of these baskets are quite dramatic in appearance.

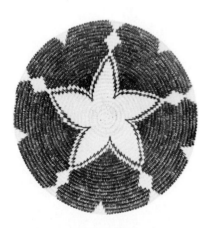 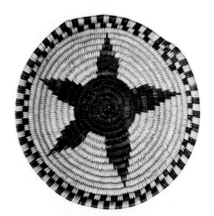 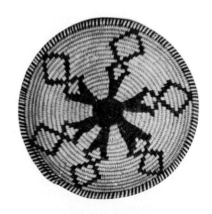

Fig. 4.14. Trays with centered layouts. (a) A negative star centered against a dark background *(ASM E2773)*. (b) A centered star with a small edge decoration which is insignificant in relation to the dominant center motif *(AF 1180)*. (c) A centered, six-element dark motif with outline diamonds at the ends *(ASM E2359)*; here the edge outline diamonds seem to fade away.

Many of the more complex layouts labeled composite might well be classed as all-over. One tray, for example, is centered organizational-banded, wherein a central black and outlined star of fair size shares the tray wall with two bands of frets (Fig. 4.15a). Much blank space favors the classification given here. A centered-half-banded example (Fig. 4.15c) is so named because of this space factor: again a central star dominates; then some coils away is a star outline pendant from the rim. An example of a centered-spotted style has an elaborate flower-star surrounded by a line, and beyond

it are double-outlined Apache diamonds with a cross in the center of each; this form is repeated five times.

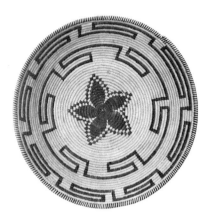
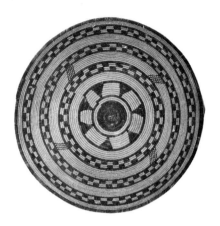

Fig. 4.15. Composite styles of decorating trays. (a) Centered organizational-banded *(AF 1146)*. (b) Centered-banded *(ASM 13510)*. (c) Centered half-banded *(ASM E2780)*.

A rather unusual and rare layout treatment for an Apache tray basket is one in which there is a feeling of a division down the middle (Fig. 4.16). One of these might be classed as all-over, the second as organizational-banded; however, the center division must be kept in mind. The first piece has a centered star with checkered fillers on its outside to round it out to a circle. On one side is a very large eagle with a fairly large man standing by; on the other side are four short, slightly curved half-bands made up of a line and three open diamonds on each. Two lines each appear to right and left a bit, and there are five small animals between the two sets.

The second piece has a large center motif made up of the following. In the very center is a circle not quite half black and a little more than half white. It is surrounded by a band divided not quite in the middle, with one side black (next to the center white) and decorated with double and negative coyote tracks. The other side (next to the center black) is white with the same coyote tracks in black. Next, and against the black area, is a white half-band with figures of two deer with a man between them, and the same in negative on the other half of this band, which is black. The black band has a deeply scalloped white edge to match the same which was added in black to the white half. Beyond this very interesting center is a half-band pendant from the rim and made up of black triangles with negative triple coyote tracks, and between the triangles alternate black figures of men and deer.

Another style is different from the usual Apache layouts which are balanced all the way around. This style presents opposed balance in the total design, with two very different patterns used, usually one much heavier than the other. In one tray large checkerboarding fans out on two opposite sides, while in the remaining opposed sides are two sets of stacked triangles and an arrowpoint, a much lighter arrangement. The checkerboarding dominates the entire design.

Although the above examples show great variety in Western Apache tray decoration, by no means do they even begin to posit all variations on basic layouts and designs. The statement that these Indians never duplicate patterns, although some are very much alike, can be supported over and over again. And, of course, the

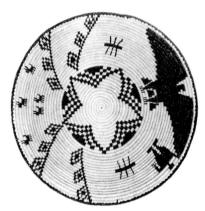
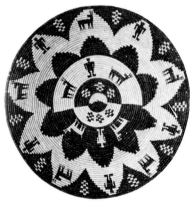

Fig. 4.16. Oddly divided layouts. (a) A centered-banded pattern, with a different motif in each of the band halves *(ASM E2829)*. (b) An almost half-and-half division of the centered motif with partially balanced positive-negative design and with a regular half-band at the edge *(AF 1111)*.

same applies to other forms but not in the degree to which it applies to tray baskets.

Before leaving the subject of trays, two additional sections will be added, one on old tray baskets in general and one on a specific group, the so-called Lockett Collection. In both, an effort will be made to point out specifics which seem to characterize old Apache trays. It is believed that the majority if not all of the baskets in the first collection would date about or before 1880, and the Lockett Collection about 1890.

Old Tray Baskets

A small selection of thirty-one tray baskets from various collections will be presented separately as they seem to be old, particularly in design. Their major qualities, including size, stitch-coil counts, and especially their artistry, will be analyzed. Selection and analysis are a reflection of many years' study of hundreds of Western Apache baskets with these particular pieces seemingly embodying what appear to be diagnostic old traits as they are compared with hundreds of other baskets.

First, in relation to diameters, there are more baskets with diameters of 16", 17", and 19" than smaller-sized pieces. These sizes corroborate opinions that early pieces made for Apaches were large, an opinion supported by many other known older pieces. Stitch and coil counts average nine and five, respectively. This would seem rather coarse, but as the baskets were thin-walled, this count is a little misleading for they are fine in texture.

Centers are predominantly black, with twenty baskets in this category. Only two trays in the old group were white; however, the centers were missing in the remaining nine baskets, thus this feature cannot be fully tested. Rims pose an even greater question, for thirteen of them are missing and in seven more such a small part is present that it cannot be determined whether they were all white or black or just partly so.

Designs in these pieces have certain general characteristics which seem to fit in with many other baskets thought to be or known to be old. In general, these include irregular patterning, a feeling of lightness of design given by a predominance of line work or small solids rather than greater solids, a basic simplicity, and poor spacing (Fig. 4.17). And last, when the base is present, and even in some instances when it is not, it can be determined that patterning tends to be all-over.

Fig. 4.17. Traits of early basket weaving persist into later years. (a) An oval tray design showing irregularities in size of elements and in arrangement *(AF 1185)*. (b) This dynamic stepped motif shows even more irregularities *(ASM E2354)*.

Irregular patterning and poor spacing can be illustrated in a basket with radiate, dynamic lines of tiny triangles moving out from a small black center. They are spaced as follows: two close together, one single, two together, a single, then four lines rather widely spaced. In another tray, from a black center and a black single coil two coils away, move four sets of two pairs each of zigzagging stepped lines; then they stop some distance from the rim. These paired zigzags are irregular in spacing and even more irregular in relation to short lines of triangles with their tips pendant from the rim. There are six of the latter—which adds to haphazard design relationships. Another example of disorder is to be noted in a basket which has three different patterns reaching from a fairly small central motif to the rim in this repetitive order: a, b, c, c. This last detail is very uncommon in Apache baskets.

There is a predominance of line or near-line motifs in these older baskets which give a feeling of lightness to design as a whole, as noted. Zigzags are made up of lines of tiny squares. Triangles are small to very small, with occasional large ones. Squares are basically of one coil; rectangles are the same, and if larger, alternate with white ones, which adds to their lightness. Irregularity is often expressed in different sizes of squares, rectangles, and triangles which make up lines, or in the triangle as it appears in stacked position.

Basic simplicity and openness in feeling are expressed in a general spacing out of motifs. For example, there may be but three static lines of stacked triangles from near center to the rim, with wide empty spaces between them. In one tray there are opposed and irregular arrangements of tiny stacked triangles on two sides, and a large man close to the rim on the two remaining opposed sides, again giving an open feeling to total design. Less simple are the black center-to-edge dynamic dozen rows of joined rectangles which appear crowded and which deny both simplicity and openness.

Certainly contributing to simplicity in many of these older baskets is the fact that a single design element or motif is used. Even static or dynamic rows of large triangles appear relatively simple, for frequently no other units or motifs are woven into the basket. Where several motifs are used, one or two may be in outline, a third solid, thus maintaining a feeling of simplicity and openness. For instance, in one basket with a missing bottom there are three spaced-out outline rectangles, a one-coil black line beyond this, three sets of stacked triangles which take off from the black line, and between them are double outline V-shaped units. Another basket with a missing bottom starts a fairly narrow band of design over twenty-eight coils from the center. Pattern included three sets of stacked solid triangles alternating with three sets of double zigzags, and with an extra solid triangle motif close to one of the latter. Needless to say, there is much openness and simplicity in this design.

An all-over effect is expressed in a majority of these baskets, whether pattern is close-set or spaced out. The one exception in this grouping is a tray with an outer band only. Too, it would seem that life forms are rare, and when they do appear they are quite different from those on later baskets. In the one example cited, and in a second one not mentioned, the human figure is a bit more realistic, with slightly more rounded form than later, when it is square-cut.

Feet are wider-spaced. In one of the two opposed figures, there are no hands or fingers on the upraised arms, while on the other are four fingers on each hand.

These points, then, would be some of the major features of older Western Apache tray baskets.

Lockett Collection of Trays, This is a small collection of old Apache basket trays purchased by Clairborne Lockett from Bill Lynch in Gallup, New Mexico. Originally Mr. Lynch obtained the baskets from the Kelsey Indian Trading Post, Zuñi, New Mexico.[7] Mr. Kelsey was a trader for many years at this Pueblo; he had purchased the baskets from these Indians who had used them in their ceremonies. Beyond this, no date has been available on the original source of this Collection (Fig. 4.18a–o).

The fact that Zuñis were using Apache baskets was not an unusual situation, for it is well known that certain Indian tribes in the Southwest have traded for the basketry products of other tribes for many years. Some groups ceased to weave baskets so long ago that it is still unknown whether they ever produced them in historic years, and if so, when they stopped production; quite naturally they were dependent on other tribes for any of their basketry needs. Old photographs show such baskets at Zuñi including Apache pieces; some of these go back before 1900.

There are sixteen baskets in this collection; one is more like a Navajo piece and will not be discussed herein;[8] the remaining pieces are Apache. The general state of their preservation is poor. It requires very careful scrutiny to determine design for they have been dimmed by time and use or even destroyed in part.[9] There is no question that the baskets were used, for bottoms were worn through in most of them, in some to be patched, worn through again, and patched a second time. Interesting indeed are the patches; some are of canvas or other cloth, some of buckskin or rawhide.

Of further interest in connection with the patches is the variety of materials used in sewing or attaching fragments to the baskets. These include plain buckskin thongs, two-ply, twisted buckskin, native cordage of two-ply yucca, commercial string, willow splints, and baling wire. The native cordage is of particular interest, for it, too, probably supports greater age than the other materials. On the other hand, the commercial string would deny any great antiquity for this collection of baskets, for it would date at about 1880 for its introduction into the Southwest.

The manner in which patches are attached to the baskets is varied and often ingenious. In one instance, Basket *a* in this Collection, a piece of canvas was apparently glued on without benefit of any further security. In Basket *e* a big canvas patch was sewed onto the inside of the tray and a second one on the outside. Mere scraps are left of the latter. Native fiber cordage and rawhide strips were used for stitching and/or mending. Mending or patching of the basket might be attempted without using cloth or skin; in such instances, wire, thongs, or string were used to catch a break in the basket wall or base. For example, all three were used in Basket *f* in an effort to save the piece for further use. The majority of patches were put on with long running stitches; however, one exception shows every stitch independent of the other, with knots at both ends holding each in position.

Rims as well as bottoms in the baskets of this Collection show ravages of time and use; in fact, no one is complete. In several of the baskets the rim is sufficiently preserved to allow for analysis of the relation of design to rim. In practically all Apache baskets rims are consistently finished in the same stitch as used in the rest of the basket; the six specimens in which this feature was preserved include Baskets *a, c, e, f, j, n*, all finished in regular sewing. In the remaining ten baskets there were no remnants of this last coil; therefore, little can be said regarding rim finish as a whole. It is likely that the plain rim predominated in these early pieces, with seemingly very little pattern showing in the rim coil, both typical early Western Apache traits.

In size, these baskets vary to a considerable degree. The range is from the smallest diameter of 11½" and depth of 2¾" to the largest, 21½" in diameter and 6½" deep. In general, as diameters decrease, so too do depths. Where base diameters are measurable, the same general trend is to be noted; in the largest basket the base measures 11"; in the smallest it is 7½". Measurements appear below for each specimen. It must be kept in mind that absent rims would indicate that most of these dimensions are relative, but probably close to being complete.

Technologically, all of the baskets of this Collection adhere to typical Arizona Apache standards of construction and materials. Seemingly willow is used for the main material, and its natural color, now a dull tan, serves as the background for the design which is created in black devil's-claw (*Martynia*). Both materials were slit into relatively narrow and even sewing splints. Foundations are consistently of three rods arranged in the usual Apache manner, two below and one above. The small, round, and even size of the rods, combined with even stitching, facilitates the production of small and regular coils throughout the majority of the baskets.

Coils count four to seven per inch, but most of the baskets have six or seven coils per inch. Stitches show greater variation; they count from eight to fifteen per inch, with a clustering around nine to ten to the inch in nine specimens. The following chart gives the detailed distribution of these traits in basket walls, with the number of baskets below.

Stitches Per Inch:	8	9	10	11	12	13	14	15
	1	4	5	1	0	1	2	1
Coils Per Inch:	4	5	6	7				
	1	3	5	6				

Form in each of the fifteen baskets in this Collection tends to vary but slightly. In the main, it is a relatively shallow tray with a flat bottom. These trays tend to start from the rim with a straight side and curve inward to a larger or smaller flat bottom. This open tray form should be kept in mind as one peruses the illustrations with the data presented below.

In this Collection design elements include primarily squares and rectangles, lines of stitch or coil width and bands of greater dimension, plus solid or outline circles. From a combination of one or several of these, simple or more complex units and motifs are created. These may include a variety of triangles, solid, or open ones

with stepped sides, built up of squares in attached rows, or as independent and usually larger motifs; simple or complex checkerboarding; various other geometrics, such as hourglass figures; a fat, upside-down T, or an H-like figure; wedge-shaped wide bands; a maltese cross; and open or solid stars. Combinations of elements or units and motifs resulted in the more complicated and complete designs on those baskets.

In later years, the Arizona Apaches seem to have expressed great variety in the number of divisions to the major part of the total pattern. This is true to a degree of the Collection of baskets under discussion here. There are five examples of three-divisional pattern, two with nine and three with ten divisions, one basket each of five and twelve divisions, and one with a combination of a five-part central motif and a seven-part star or floral outline. The remaining two baskets have multiple units of design in bands. Certainly one could not pick a characteristic style of division of pattern from this hodgepodge!

Each basket now will be analyzed as to its total pattern as well as other pertinent features (Fig. 4.18a–o). The accompanying photographs will supplement these descriptions. Later an analysis of some of the above design traits will be given.

Fig. 4.18
a.

Basket a. Diameter 21½", depth ca. 6", base 11". Ten stitches and seven coils per inch. Rim incomplete with smaller design into parts of rim; center present; large canvas patch on outside bottom. Noteworthy in this basket is the very small black center and the animation in the bands of triangles emanating from the black circle. The design is basically simpler than most of the later Arizona Apache patterning, although this style was favored for many years.

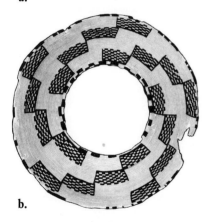

b.

Basket b. Diameter 18", depth 5", base 9½". Nine stitches and seven coils to the inch. Both rim and center missing. Mending done with buckskin thongs and a patch of the same on the base. The rather irregular rectangles of checkerboarding are made dynamic by their radiating in a curve from toward the center to the rim, each moving from the left tip of the previous one. Each of the five motifs is made up of four such rectangles of checkers, with the innermost one related to a ring of small blocks out from center.

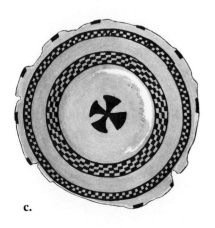

c.

Basket c. Diameter 17½", depth 5", base about 9". Ten stitches and seven coils to the inch. The rim is largely missing, center is complete. Some buckskin thong mending in long vertical stitches. This design anticipates some of the later and quite popular styles. The small central circle is extended to form a maltese cross, with a wide blank space separating this from a first band of checkerboarding; fairly large rectangles form the latter motif. A narrower space appears between this first and a second band which is made up of smaller black and white checkers. Although there is little of the rim preserved, there is enough outer design to suggest small black units alternating with wide white spaces close to or at the edge.

Basket d. Rim diameter 17½", depth 5½" (irregular), base not measurable. Ten stitches and seven coils per inch. A badly worn edge with no part of rim, but center complete. There is also a badly worn and heavily mended area beyond the center. In this tightly woven basket there is a simple and rather formal pattern. The black center "cog wheel" and two outlining line circles are unique in this Collection; so, too, are the black hourglass patterns repeated nine times. Like so much in Apache design, they are irregular in both spacing and form, but they are enclosed by banding lines which are very definite in this basket. Seemingly, there was no continuation of pattern close to the rim.

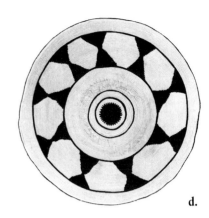

d.

Basket e. Rim diameter 17", depth 5", base diameter 8½", approximately. Fourteen stitches and five coils per inch. A small part of the rim remains, while the center is complete. A large canvas patch appears on the basket interior; there was also one on the outside but only scraps of it remain. Rawhide strips were used for mending, as were two-ply cords of native fiber.

Of particular interest in this tray is the fact that definitely there was no black center. This is very rare in later Apache baskets, but slightly more common in early years. Too, it is unusual to find such a light feeling in twentieth-century Apache baskets as in this piece, created by the outline patterns; this feature is not unusual in this small Collection. The design motif, which might be called a fat T, is also uncommon in Apache designing, but letters are encountered in this weaving. Placement of the triangle above this T near the rim is another odd detail.

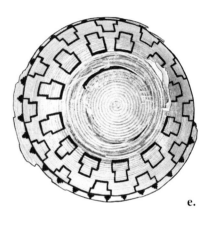

e.

Basket f. Rim diameter 16", depth 4¾", base diameter about 8" and very flat. Very little rim, and where present it is black. Center present, black circle 1½" diameter. Mending with heavy wire, rawhide, and what appears to be commercial string.

Although the design is in outline, the form of the pattern is more like some in later Apache baskets than is the pattern in Basket *e.* On the other hand, it is simpler than most later expressions. Because of the small center, the line connecting the major motifs, and the repeated, double-outlined, stepped diamonds, the layout in this case should be called organizational-banded, and it is continuous; small parts of the rim are preserved; they would seem to indicate that the design terminated in it. All horizontal parts of the design are two coils wide except the first extensions above the base, which are three coils wide, and the topmost and rim portions of each of the three units which are one coil wide. Each unit varies somewhat from the other two, with a discrepancy of more than 1¾" between the widths of the largest and smallest patterns. The design in this basket is well preserved.

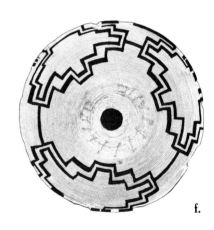

f.

Basket g. Rim diameter 15¼", depth 4½" (incomplete), and base about 6". Nine stitches and six coils to the inch. All of the rim is destroyed. It would appear that there might have been a fairly large black center but this is doubtful: the exterior is so badly burned and the interior so discolored that it is impossible to be sure in this matter (black center restored in reproduction). Interior red coloring could have been accidental as it appears rather irregular at its outer edge.

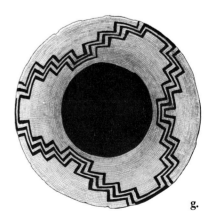

g.

The design in this basket has a feeling of lightness much as in Basket *f* except for the possible black center. Here, however, the simple stepped outline of three units is triple rather than double as in the previous specimen. Further lightness of pattern is stressed in the black single-coil horizontal lines. Because of this feature, the vertical lines seem heavier in spite of the fact that they are only two stitches wide in both baskets. The pattern in this basket is more even throughout than in *f*.

Basket h. Rim 16½" in diameter, height 4½" (incomplete rim). Base 7". Coils average a little over nine to the inch and stitches count six to the inch. On the interior of the basket a piece of flour sacking was pasted over the worn area. On the cloth is printed in yellow, blue, and red: "Hard Wheat, Patent Flour, Bayfield Milling & Power Co., Bayfield, Colorado. Blended 24 lbs. Bayfield. Hard Wheat Patent."

In the center of the basket is an unusual motif, a black circle about two and one-half inches in diameter with five radiating broad bands which terminate in still broader extensions on the top sides. Next is a seven-pointed, double-outline star or floral theme with very small triangles at the innermost points. The same star theme, in triple outline, extends beyond this and probably went almost to the rim. This design, as the last two, resembles only the simpler of the same in later Apache basketry patterning.

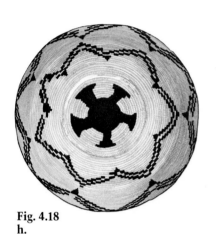

Fig. 4.18
h.

Basket i. Rim 14" in diameter, height 3½" (no part of original rim remains). Estimated base, about 7" (covered inside and out). The patching is most interesting. On the outside a large piece of canvas-like cloth is caught in position by long running stitches in wire which also hold a smaller piece of cloth on the basket interior. On top of the latter is a still smaller round cloth patch held in position by long running stitches in buckskin; these stitches also appear as a second and inner row on the outer patch. Edges of the two inner patches were turned under and kept in place by the sewing, while in the large outer round piece the edge was left raw.

Although the design in this basket consists of no more than the spotting of numerous H-figures over the surface, there is some slight attempt at arranging them in a repeated manner. Too, beyond the heavily covered base of the piece, there appear three of these figures in more or less moving units, with sets of two between. The H is always on its side, and it is heavy and irregular in form and size. The layout would be called all-over if there is no black center; otherwise it would be banded, or possibly organizational-banded.

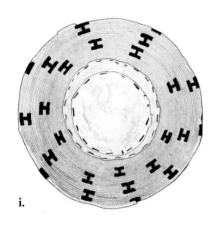

i.

Basket j. Rim 14½" diameter, height 4" to incomplete rim, approximate 9" base. Stitches 22 and coils 7 to the inch. Stitching close but irregular. Base completely missing and area covered with undetermined multiple layers of cloth, including one piece of canvas and several of lighter-weight materials. In addition to the base patching, there is rim mending including a 10" rawhide strip sewed on with wide running stitches of buckskin, and a second but narrow cloth piece sewed well down onto the basket wall. Too, there is mending of coils by sewing two or three of them together with buckskin or willow.

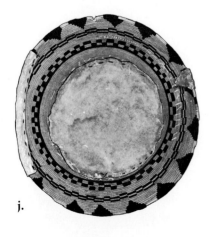

j.

The design in this basket is made up of one half-band and two (maybe) organizational bands, each encircling the piece, with blank spaces between them. Innermost is a checkerboarding of alternate black and natural rectangles each two coils high, and in two rows pendant from an inner solid line. Next is a bandlike arrangement of long and narrow rectangles of single coil width and in four rows of coils. Close to or pendant from the rim are solid stepped triangles, possibly seventeen in number; these are irregular in size and shape. Checkerboarding is found later on and tends to be heavier than it is in this basket.

Basket k. Diameter 14″, height 3¼″, base about 7″. No rim is left; the entire original base is missing and there are heavy canvas patches sewed on with short stitches made in small copper wire. Stitches are fine, averaging 15 to 16 to the inch; coils count 5 to the inch. One motif in the design is indicated in the tips of a possible three-pointed "star" in single outline. Outlining the points on two sides are two parallel lines; it could be that these paired lines did follow the full lower outline of the stars. Because of the worn condition, it is impossible to say what the original design layout was in this basket.

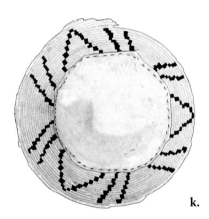

k.

Basket l. Diameter 13″, height 3″ (no rim coil), and approximately 8½″ at base. Thirteen stitches and just under seven coils per inch. Because neither base nor finishing coil is preserved, it cannot be said whether the design starts from a black center or ends within the rim. A large, quite evenly cut patch is sewed onto the basket interior; it has a second and tiny patch on it to one side. Both of these patches have neatly turned edges; the smaller is attached to the larger with overcast stitches. In turn, the larger patch is sewed onto the basket with fairly long simple running stitches in rawhide; these stitches also catch a comparable piece on the basket exterior.

Design is tripartite, with two themes, all in stepped outline style. In the center of each motif is a double-outlined diamond which is open toward the rim and covered toward the missing interior. This is outlined on each side by triple lines. This pattern is also simpler than in later Apache styles.

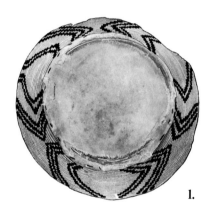

l.

Basket m. Diameter 13¼″ at rim, approximately 7″ at the base, and height about 4″. Most of the base was worn at the point of stress and was resewn to the wall with white and green cordage; although badly worn, coils were still present. All of the rim missing. Stitches nine to ten per inch, and coils five to six per inch. The very bottom of the basket, which had worn away and was then attached again, was mended with a raffia-like material for about two to ten coils. A light-weight piece of cotton cloth was used to mend the exterior of the base, sewed on with cotton string.

It would appear that the center of the design of the basket was a large solid black circle; from this issue ten black wedge-shaped bands, each gradually widening toward the rim. At each side of the wedges is a narrow line which goes about half-way up toward the rim. Illustrative of the irregularity of so much Apache designing are two features in the wedges: one, they vary greatly in width; and

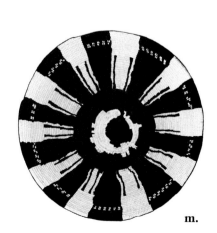

m.

two, close to the rim of each are two coils with three to six pairs of alternating black and white stitches. Even the narrow bordering lines vary as several are of single stitches all the way while most of them are single stitch part of the way and of two stitches closer to the top. Except for the base, this design is very clear and well-preserved, and not like most early patterning.

Basket n. The incomplete rim 11½″ diameter, base 6″, height 3″. Stitches 10 to 11 and coils 6½ per inch. The beginning of this basket is coiled, and the coils move in a counterclockwise fashion typical of all Apache basketry. Except for some wear on the base and rim coil, the basket is in good condition and has no patchwork on it.

Attached to and emanating directly from a central solid black circle are ten curving and swirling bands which become larger as they approach the edge of the basket. Too, these bands vary in width; this is most evident at the edge where they vary from 1 to 2⅝″. Wear and "filler" from use have partially obliterated the edge of the center circle, but it could be about 3 inches in diameter.

Fig. 4.18
n.

All of the band motifs are built up in the same manner, each has alternate black and white lines one coil in width except for one row of two-coil-width closer to the rim and another at the edge. Adjacent bands have alternating black and white horizontal lines or bands which do not match; thus more motion is suggested in the resultant horizontal step effect. Several baskets of apparent later date have been observed which have practically the identical pattern in them.

Basket o. Rim 11½″ in diameter, height is 2¾″, and base 7¼″. The first two measurements are probably inaccurate as the rim is missing, but the last is probably quite accurate in spite of the fact that the base is completely missing; however, the measured coil shows great wear, indicating that it was the base edge.

o.

Design is made up of three motifs spotted on the remaining side wall; to all appearances they started about the turn of the wall from the base. With the base missing, there is, obviously, no indication of a central circle. Each of the motifs is roughly H-shaped, with verticals of stacked elements and horizontal bars with three pendant units, all of these made up of rather large and fairly irregular triangles. Spacing between motifs is also irregular.

In summarizing the above data, a number of points can be made relative to the Lockett Collection. First, as to its age, the following incident can be noted.

Dr. Keith Basso, Department of Anthropology, University of Arizona, Tucson, kindly consented to submit the designs taken from this collection of baskets to an elderly Apache woman.[10] This woman, Gertrude Henry of the native village of Cibecue, White Mountain Reservation, Arizona, was perhaps 50 to 60 years of age, and a full-blooded Apache woman belonging to the Des ĉiden clan. Basso gave the following report of the woman's comments regarding the baskets.

Gertrude said she thought these baskets were old, yet she had seen
some of the designs in her Grandmother's wickiup. She said that it was
too bad that not more of these designs were made today. She labelled
all but one (the Navajo example) definitely Apache; she knew of no one
who made this particular design. The H-pattern (Basket i) she had seen
before. The spiral design in Basket n, she said, "would take a long time
to make." Interestingly, Gertrude prefaced each remark with "I may be
wrong, but..."

Again, these comments would seem to support a probable age of
the late nineteenth century for this Collection of baskets, with the
possible exception of *m* and *n*. All of the baskets in the home of
Gertrude's grandmother could not have been new, if known cus-
toms of the Apache weaver can be applied here.

As to the condition of these baskets, they obviously present a
much-used collection. Worn and patched, and even repatched, bot-
toms, rims, and walls testify to extensive use. Indeed they must
have been valuable to their owners, for these conditions reflect the
fact that a basket was a big investment on the part of a native and
that she had to get the most out of it. Only one example in this
Collection was minus any kind of patching; even that one was worn
on the bottom until the foundations showed through, and the rim
was completely gone. As previously noted, partial rims were present
in six baskets only, *a, c, e, f, j,* and *n,* and even in these there were
but small sections preserved.

In her book on the *Basketry of the San Carlos Apache Indians,*
Roberts notes that "Worn baskets are sometimes patched very clev-
erly, although by no means invisibly...." True. These San Carlos
baskets are all coiled pieces. Methods of patching described in this
Lockett Collection are also given by Roberts: bottoms "sewn to the
side walls by lashings of rawhide," or "new bottoms of canvas or
some similar material replace the coiled one," or there may be "a
rim patch." Further, she notes, "The patched specimens at the
American Museum are all of very old coiled baskets."[11]

In those baskets where bottoms were presented and not covered
or obliterated, the beginning was coiled and coiling was counter-
clockwise; in all baskets except Baskets *b, i, j, k, l,* and *o,* these
features could be observed; no revealing parts remained in these
listed pieces. Sizes of coils and stitches are quite even and regular
in each basket of the series, and many are very fine.

In shape, these baskets are largely wide-bottomed trays with slop-
ing sides. Only one has a small base, Basket *n*. Two baskets, *a* and *b,*
have more curving walls than the rest. Basket *k* appears more shal-
low and *m* deeper in relation to their respective rim diameters; this
observation is significant despite the fact that rims are missing in
both cases.

Designs in these baskets present some interesting features. In the
first place, all patterning is geometric, with no life forms, another
feature of early basketry. Second, layouts are slightly varied. Third,
all designs are in black. Fourth, with three exceptions, all patterns
are far lighter in feeling than is true of later Apache basketry. The
first and last comments, no life forms and light designs, would apply
to much basketry of this tribe which can be dated pre-1890.

Design layout is difficult to analyze in six of these baskets because of missing or patched bottoms, Figure 4.17b, i, j, k, l, and o. However, nine baskets are complete and can be analyzed as follows. One is organizational-banded, Basket *e,* with two rows of heavy outlined T-shaped figures dominating; *f* belongs here also because of the small center circle. Baskets *a, g, m,* and *n* are considered all-over patterning, for their designs cover all or most of the surface in each of these pieces; in all but *g* the main pattern takes off from the black center. Composite layout is represented in Baskets *c, d, f,* and *h,* for there is a black center motif in each plus one or two bands beyond it; *g* would also fit here if the center really belonged to this basket. Baskets *c* and *d* are center-banded while *f* and *h* are center-organizational-banded (or *f* is just organizational-banded).

Centers are missing from, or patches cover over the beginnings of the remaining baskets, *b, i, j, k, l,* and *o.* Guesses will be hazarded regarding possible layouts of these six pieces. All of them are probably composite, with the possibility of two, maybe three, all-over. If Baskets *b* and *j* had large black centers, they would be placed in the second category. The only other likely all-over example is Basket *i,* in the event that the H-figures continue to the probable black center. Otherwise this basket belongs in composite layouts, with its predictable black center and an organizational band of the H-figures.

Because of the nature of their designs and the general character of the rest of the baskets in this collection, *k, l* and *o* are possibly composite in layout. In Basket *k* the triangles, if that is what they are, with their bordering lines, would form an organizational band, which, with the presumed black center, would put the pattern in this category. On the other hand, if the triangles turned inward at their bottoms, to form a diamond, and so too with the paralleling lines, and if all touched or nearly touched a black center, the layout would be all-over. In Basket *l* the typical Apache outline diamond would terminate almost immediately beneath the patch, making this an organizational band and thus a composite layout with the normal black center. Basket *o* shows a terminating organizational band; with the black center, it too would present a composite layout. Because small black centers were dominant in early Apache baskets, and despite the two exceptions in this Collection, Baskets *g* and *m,* these are more than mere guesses favoring composite layouts.

The number of divisions or parts of design is interesting in relation to this Collection. Not a single basket has a four-part pattern. Three seems to have been the favorite number, for there are five baskets with three-part designs, *f, g, k, l,* and *o.* One basket each has a five *(b)* or seven *(h)* division scheme. Nine repeated major motifs appear in designs on Baskets *a* and *d* while ten is the number of times for design repetition in Basket *m* and *n,* and 12 for *e.* Baskets *c* and *j* have two bands of repeated small elements, and Basket *a* has repeated all-over units of pattern.

Design elements and units in these baskets are strictly geometric and include lines and bands, squares and rectangles, triangles, solid and outline circles, a maltese cross and a five-armed variant of the same, H-figures, and a T-shaped large element with a heavy upper part. These elements and units are combined into slightly more elaborate motifs or into the total pattern, such as curving lines or

bands of triangles, bands or steps of checkerboarding, meandering stepped lines, outline stars, or an hourglass figure of two large triangles.

No two patterns are exactly alike, although Baskets *c* and *j* are similar. In their arrangement and parts, designs tend to be irregular throughout the Collection. Elements and units, or even motifs for that matter, may be quite varied in shape; in a single basket, the repeated triangle, square, or other unit may vary considerably in size. Spacing between elements or motifs is often irregular.

As a whole, the designs tend to be lighter in this Collection, with the exception of Baskets *m* and *n*. Basket *d* design is a little heavier than in the remaining pieces. This general lightness is attained in several ways; by the use of line and outline rather than solid patterns; through wide spacing of motifs; in the use of small elements repeated at wide intervals; through the use of limited solids; and simply in the limited use of pattern.

One last feature might be mentioned in connection with these baskets, a detail revealed by the torn nature of the specimens. All of the baskets except e and *k* have certain features in common: they have a tight and short "teardrop"-type stitch; walls tend to be firm (or even stiff) and smooth to the touch; and all are of three-rod foundation. Baskets *e* and *k* differ in these respects: they have long and straight stitches, and a softer and much more corrugated wall.

In summary, it might be said that the baskets of the Lockett Collection seem to be simpler in details of overall designing. In the majority, there is more open space than in later styles; there is greater simplicity of design, a lightness of pattern in most pieces. There are fewer motifs in a single basket, and no life forms are depicted. There is irregularity of spacing and motif forms. These features, plus the remarks of Gertrude Henry given above, would seem to indicate that the Collection could well be pre-1890 in time.

Jars

There is some question as to whether the jar was a form developed by Apaches for Apaches—or for the white man. As noted, several researchers have not observed jars in use in the wickiups of these Indians. Great variety in forms has also been noted previously, with emphasis on limitless combinations of varied body and neck sizes and shapes (see Fig. 4.2), as well as extremes in stitch counts.

A sample of ninety representative jar baskets was analyzed from the standpoints of various dimensions and stitch-coil counts, with the following general results. Rim diameters ranged from 3½" to 22" with the largest number of them, 13 baskets, between 9" and 10" and with more on the smaller side as might be expected, between 7" and 9". Neck heights measured from 1" to 6", with the majority 3" to 4", and with heavier weighting between 1" and 3" than between 4" and 6". These dimensions reflect a very broad relationship between neck diameter and height; for example, vessels with rims measuring around 9" to 10" have necks from 3" to 4½" high.

Diameter of jar shoulders (the widest point in the jar body) ranges from 7" to as much as 29". Jar heights measured from a low of 6" to a high of 35½" and with a fairly even scattering between these measurements. Six jars were 12" to 13" high, seven were 17" to 18", and

eight were 24″ to 25″ tall. Base diameters ranged from 4″ to 11″ with most of them in the 7″ to 8″ grouping, and with more of the remaining pieces on the smaller side. This last point might also support the premise that baskets were made to sell rather than for native use, for despite the fact that they sit rather well, it is difficult to imagine the smaller-based ones having much use on a dirt floor and with much of anything inside them. It is interesting to note that some jar bases are smaller than rim diameters. One vessel which is 12¾″ high has a base diameter of 5¼″ and a rim of 7¾″. Of interest also is another jar which has a rim diameter equal to the height dimension, both 10½″; this piece is also the only one in this entire sample without a neck.

Sewing is not so good in jars as it is in other Western Apache basket forms, particularly in the tray. Stitch count to the inch runs from five to 20, but there are few above thirteen. The typical sewing counts eleven to thirteen stitches to the inch, with the largest number of jars averaging twelve to the inch. Coils run from two to six to the inch, with the large majority counting four. The jar is probably the most difficult piece to weave, for the worker moves from a flat bottom upward and outward to the greatest diameter, then back inwards to the neck, then in and/or out as the planned shape of the neck demands.

Design in Western Apache jars is quite another matter, for the majority of patterns tend toward the more complex. Practically every jar in this sample is of all-over decoration literally, for every piece had base, wall, and neck designs. Total pattern was related to this scheme in one of several ways. In some instances, the base motif was comparable to the solid black central circle of the tray, with perhaps the addition of an encircling line or two. Or this center bottom motif might be a star or other design, with its parts integrated into the wall theme, this starting on the base or on the wall.

General arrangements of the elaborate patterns would include vertical, diagonal, horizontal, or network effects or spotted motifs, or some which might be called a combination of several of these

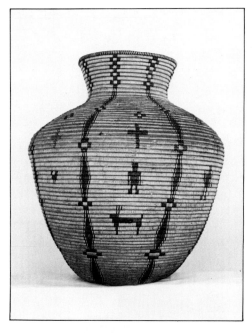 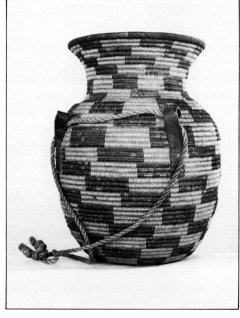

Fig. 4.19. Jar forms and layouts. (a) A high-shouldered jar with vertical arrangements of both joined and scattered elements *(AF 1188)*. (b) Heavy steps move diagonally around this simple shape, and onto its outflaring neck *(AF 1194)*.

styles (Fig. 4.19). In all of these arrangements it is rare to find a sole unit or motif. One theme may be dominant over another, or there may be a large and dominant single one, such as great zigzags, but at least small geometrics or life forms will be added at regular or irregular intervals, to break the monotony. Most common are two major motifs on a single basket: for instance, a wide vertical band of checkers and between them a vertical band of continuous solid and blended diamonds with a narrow outlining line on each side. Sometimes the pattern is all-over large diamonds, checkered in their lower halves and with large solid black figures of animals in their plain upper halves. Another device was to cluster a group of animals and/or humans to balance a large motif, for example, in the open areas created by the touching tips of great triple-outlined zigzags. Even in earlier pieces where design tends to be more sparse, it is still of the same general arrangement, with comparable motifs and with more open space between them.

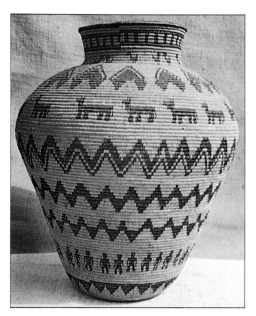
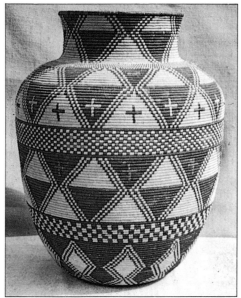

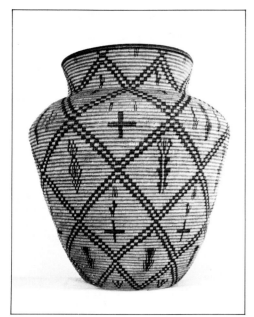
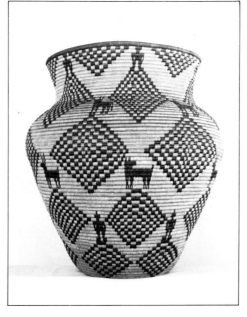

Fig. 4.19. (c) An open horizontal plan on a high-shouldered, shapely jar *(ASM GP52658)*. (d) A horizontal layout on a less shapely form *(ASM E2796)*. (e) An all-over network covers this high-shouldered jar from base to rim *(AF 1189)*. (f) Large checkered diamonds are spotted over this wide-mouthed jar *(AF 1190)*.

Several examples of horizontal arrangements will illustrate this style (Fig. 4.20). In one large jar a five-petaled flower moves out from the base onto the wall so that the tips barely show. From here onto the neck are successive horizontal bands of diamonds: in this form in one row are men, dogs, sahuaros, and swastikas, and in the diamonds of the second and third rows are varied arrangements of men and dogs. On the neck are diamonds and dogs. On another jar with a high broad shoulder are four successive rows from just above the base to just below a low neck: from bottom up are the following: a double-line meander, a triple-line zigzag, pendant triangles with triple outlines, a band of small animals and humans, a triple zigzag just below the neck, and more life figures on the neck. Enough space is left between bands to make for a pleasing pattern.

Zigzags made up of two or three plain and/or stepped lines were very popular for jar decoration. Sometimes they are so spaced out as to fit into the horizontal style, often with insignificant little animals here and there. Sometimes a dominantly horizontal feeling is created by stepped patterns with few and shallow risers and wide steps; one jar has these close together from base to rim, basically

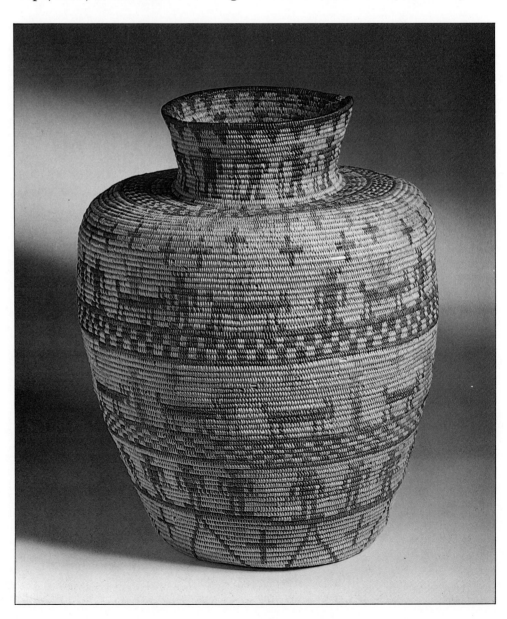

Fig. 4.20. Western Apache jar decoration
(a) Basic checkered horizontal bands support figures of men and horses, with an additional row of men at top and bottom of the jar
(photo by Ray Manley, private collection).

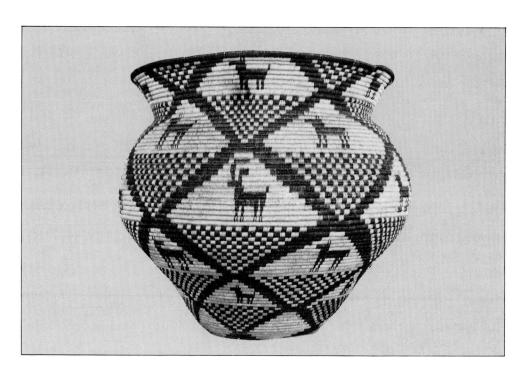

Fig. 4.20. (b) Although basically horizontal, this jar design has a feeling of both horizontal and network styles *(AF 1192)*.

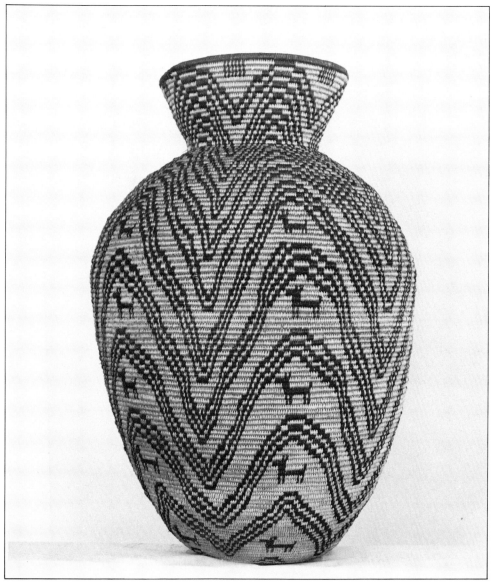

Fig. 4.20. (c) Any feeling of the horizontal is lost in the great depth of these parallel zigzags *(AF 1191)*.

plain. A horizontal organizational layout is represented by the following arrangement from the base up: a stepped zigzag, joined open diamonds, a row of men and animals, a double-line fret, a double band of small, alternating squares, and on the rim, pendant triangles. Sometimes red and black alternate in the figures of these horizontal bands. Too, life forms were favored in such arrangements, usually alternating with bands of geometrics.

Vertical plans of design were numerous (Fig. 4.21). Among the simplest would be the use of a single major motif, this running in parallel bands from base to rim. One such would be a solid black band with zigzag edges, narrow near the base and on the neck, wider toward the center, and with a narrow stepped line on each side. In one jar the design was very clean, for there were no animals, no small geometrics thrown in here and there. Next in simplicity would be stacked black diamonds with double and plain outlines alternating with other joined diamonds of alternate red and black. Pendant from the rim are alternate black and red triangles. Again, there were no additional life or small geometric forms to detract from the basic simplicity of pattern.

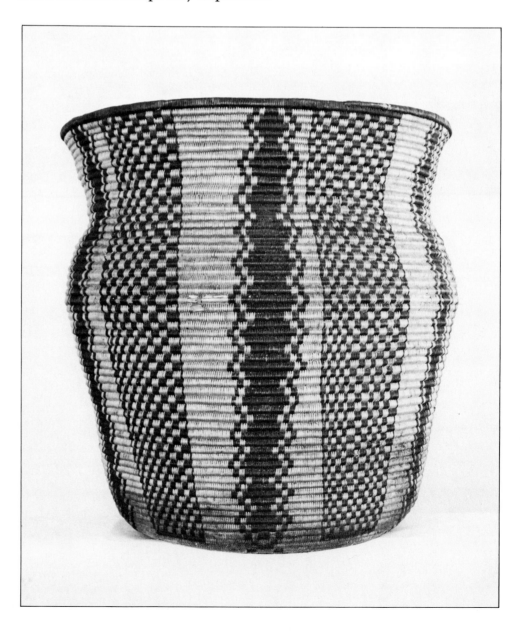

Fig. 4.21. Vertical arrangement on jars
(a) Alternating wide bands reach from base to rim on this jar
(AF 1193).

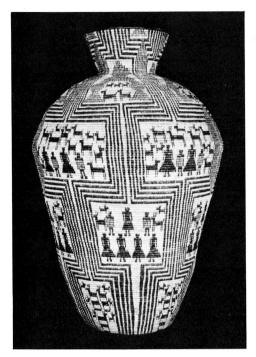
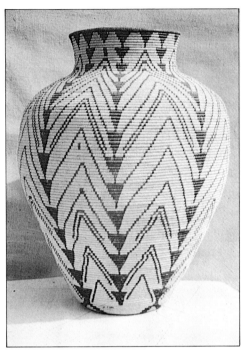

Fig. 4.21. (b) An elaborate vertical plan of five-outline frets which create open areas filled with figures of men, women, and animals *(ASM 3626)*. (c) The vertically stacked triangles are dominant as the zigzags are so very light on this delicately shaped jar *(ASM E2800)*.

Comparable in a way but more complex is one of these arrangements with four vertical rows of stacked, checked diamonds from base to rim. Alternating with them are vertical rows of large figures of the following, from the base up: a cross, a dog, a man, two men, man and dog, and dog and man. Common were other vertical alignments of varied diamonds plus equally varied arrangements of animals and men, all stacked one above the other. Stacked triangles were arranged in like manner.

Much lighter in treatment is the decoration of a more rounded jar with three alternating motifs, all vertical. One is a joined line of small black triangles and open diamonds; a second is a triple line of zigzags, and a third is made up of four crosses and four dogs. Quite a bit more elaborate is the vertical decoration on a 28" high jar with a very wide mouth, 22". Repeated five times are eleven vertical, stacked units, each unit made up of a lower and two upper black triangles, all joined, with a white one between them. Between the rows is a hodgepodge of animals, men, and geometrics, plus a wide-banded meander filled with repeated dots. There are many other arrangements of stacked vertical triangles in combination with a variety of like rows of geometrics and animals; often these are not particularly well organized.

Meanders were popular as vertical themes. Sometimes they are neatly arranged as doubles, or singles may appear with the doubles or with some other motifs. Rectangles created by double meanders may be left plain or they may accommodate life figures and/or geometrics, either within or on these forms. Sometimes these meanders are so arranged that they are joined all the way around a jar.

Diagonal patterning was less popular for basket jars than were some other styles (Fig. 4.22). In its purest expression, the surface was usually covered with successive rows of stepped lines or blocks from base onto the neck. These diagonal bands may be many-

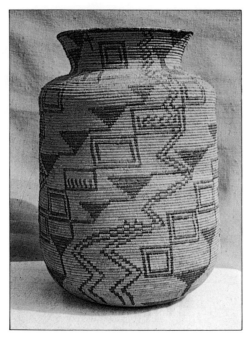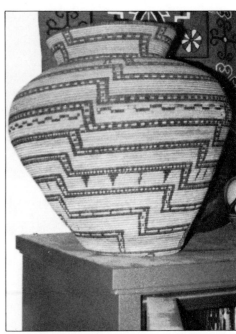

Fig. 4.22. Diagonal designs on jars. (a) An arrangement of elements moving up from left to right *(ASM E4125)*. (b) A relatively simple diagonally placed design showing the more common lower right to upper left movement *(Dewey-Kofron Gallery)*.

stepped or have but five steps; they may be double lined or triple; they are usually all black but sometimes may be made up of black-red-black lines. Some are plain, but others may have additional small geometrics added here and there. Sometimes a layout may appear at first glance to be vertical but upon closer investigation turns out to be slightly on the diagonal. One such jar has a series of stacked triangles leaning from near base up to the left. Along the straight side of the triangle is a plain light line, while along the opposite side is a heavier stepped line.

Giving a feeling of the diagonal is another design, namely, wide-spaced and deep zigzags. This might be labeled a double diagonal, for obvious reasons. Variety is expressed in number, width, and nature (plain or stepped) of the lines or bands making up the basic motif, and in whether they appear in single, double, or triple forms. Not uncommonly, additional small elements are thrown in here and there, such as men, horses, dogs, deer, arrowpoints, coyote tracks, crosses, or other geometrics. These may be few or many in number, they may be under or on top of peaks—or anywhere.

A network style is one in which there is a meeting or crossing of lines in such a manner as to create a netlike effect over the surface of the jar (Fig. 4.23). This may result from the meeting of the points of diamonds, zigzags, or other geometric lines; it may result from the use of a single row of great diamonds with the beginnings of another row above and one below, all contributing to the formation of the netlike effect. Or there may be multiple rows of diamonds, five or six of them, forming a more delicate effect. One basket in the first style has but a single row of diamonds of double outline steps in the center, a row of smaller ones below, and an incomplete row of the same above. Enclosed in the center of each of the great diamonds is a dancer wearing an elaborate headpiece, with a like but smaller figure below, an animal to the right, and a number of coyote tracks, or parts of them around the central figure. Fewer figures appear in the lower diamonds and in the partial upper ones.

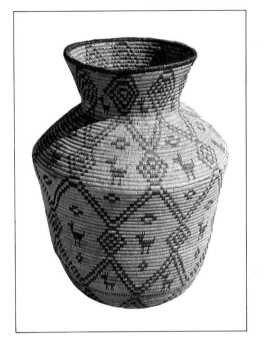 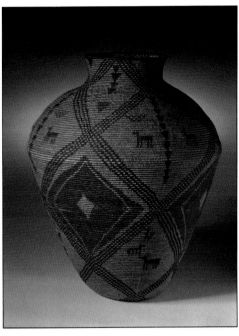

Fig. 4.23. Network arrangements on jars. (a) An interesting network joined by double outline diamonds *(private collection).* (b) An open network with an unusual heavy red design in the nets of the row below the jar shoulder *(photo by Ray Manley, D.H.C.).*

In another basket of this style the figures in the diamonds are more numerous and very crowded.

Another jar, and a beautifully shaped one with a high shoulder, has an all-over network of diamonds; some of these which are low on the piece are almost rectangles. Each form is double outlined. In the lower angle of each of the topmost diamonds is a solid triangle, the heaviest element in the entire pattern. Three figures, separate or joined, appear in each of the larger enclosures, two in the smaller ones. There is also a man in each of the open triangles below the neck, plus totally unrelated "squiggles" on the neck of the vessel. On other jars the figures enclosed in the diamonds may be much larger, in one instance taking up the major part of the space.

There are many "in between" styles in jar decoration, that is, not clearly belonging to one or the other of the above described styles. An example which illustrates this point is a jar with the following body pattern. There are three wide and two narrow bands which would suggest horizontal banding. In the first are spaced-out large checkered diamonds one above the other, these strong enough to suggest vertical banding. Thus this piece would seem to combine the two styles.

Not many spotted layouts were noted in Apache jars. One suggestive of this style, but again all-over, has four rows of checkered diamonds, smallest at the jar base, largest at the widest diameter. Each row overlaps with the one above and/or below. On the tops of diamonds is a man in the bottom and top rows and a horse (or dog) on the tops of the diamonds in the two central rows.

It can thus be seen that, even though basketry jar decoration is almost limited to all-over layouts, emphasis on several subtypes is apparent. Too, there was no dearth of design elements used in the decoration of this form; frequently there was a wide variety of smaller geometric and life forms on a single jar. Many examples of this form reflect a happy meeting of adaptation of design to form and high artistic skill.

Round Bowls

Round bowls were not woven in any abundance by Western Apache women, but obviously some few were produced as indicated in flat bases and exterior sewing (Fig. 4.24). More than 100 of these were studied; as with other forms, there was some variation in size and design and some fluctuation in form. More specifically, there was quite a range in diameters but more of a clustering in depths. Diameters ran from 5″ to 22½″, depths from 1½″ to 10″. Forty-two baskets out of a control group of 75 measured between 10″ and 16″ in diameter, and of this same group 62 were between 2″ and 5″ in depth.

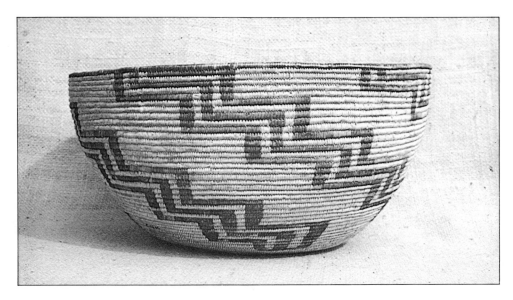

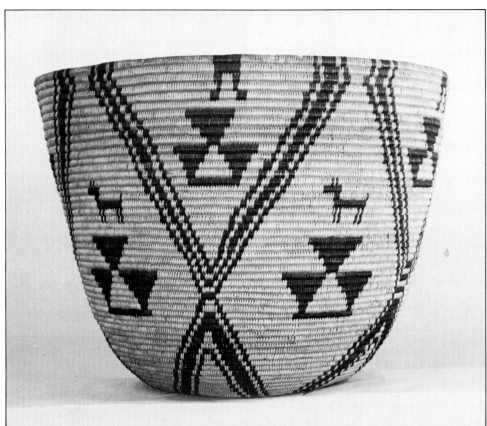

Fig. 4.24. Western Apache bowls. (a) A deep round bowl with a diagonal pattern *(ASM E2210).* (b) This bowl is straight-sided and deeper, with an almost-net effect enclosing small elements of design *(AF 1186).*

Of this same group of 75 basket bowls, the following would indi-
cate good craftsmanship in much of this work. Stitches ran from
seven to twenty-six and coils from two to nine per inch. Forty-three
bowls in this selection had from ten to fifteen stitches to the inch,
while 47 of them had from four to eight coils per inch. Of interest is
the fact that quite a few of the old baskets have very small coils,
many in one collection counting seven or eight to the inch. One
bowl basket which seems quite old is patched with a still older
piece: the basket counted nine stitches and six and one-half coils to
the inch while the comparable counts in the patch were sixteen
stitches and eight coils.

Form varies in bowls (see Fig. 4.1b), although the majority of these
pieces have flat bottoms, with gently sloping sides from this base to
the rim. This slope might be straight or gently curved, usually out-
ward and often with a very slight incurve into the rim. Otherwise
bowls might have a distinctly outflaring rim, sometimes taking off
more abruptly from a wide, flat base. Some deep bowls, and some
shallow ones, too, have very wide flat bottoms and turn abruptly
into straight-walled and rather severe sides. For instance, one bowl
which is 10½" in diameter, 4" deep, and with a base of 7", has sides
with a straight-up thrust. Another with a rim 13" across, a base
of 8", and a depth of 7", also has a straight and abrupt side wall. An

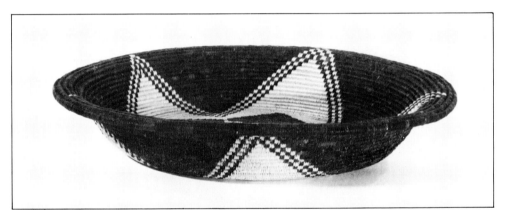

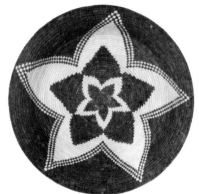

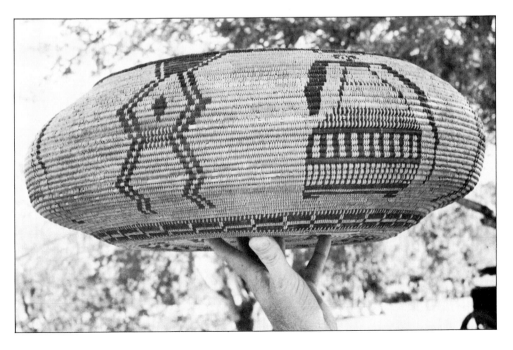

Fig. 4.24. (c) An unusual shape in
this flare-rimmed bowl. The pic-
ture on the right gives the full
design featuring star themes
(ASM E8064). (d) A very rare shape in
Western Apache basketry in this
shallow bowl with sharply incurv-
ing rim *(Rick Rosenthal, Tucson).*

old flat-bottomed piece has comparable dimensions of 14¾″, 8″, and 6″. One very large bowl basket has a diameter of 18½″ and a base almost the same, and, of necessity, a straight wall. This piece is 5″ in depth. Thus some bowls look like large cups, some are pan shaped, some flare out like a fancy soup dish. Diverse dimensions add variety to this circular bowl form.

As in other Western Apache baskets, decoration in the bowl is in black on natural or off-white. Red occurs occasionally, either substituting for or alternating with the black. Usually red appears in smaller quantity, and it was never observed as used alone in a bowl decoration.

Of the sample of 75 bowls, several are missing centers; thus, design layout could not be established in all. However, with some, coil count, fine stitching and the general appearance of the basket, plus the design that remains, all allow for an "educated guess" as to original layout. Several such have been included in the following analysis of 66 of the 75 pieces.

These Western Apache weavers were indeed clever and capable in adapting designs to form. The bowl with the gentle curve from center to rim allowed for any layout style—a pattern from center to rim, or one concentrated in the center plus a farther removed band, or a band near the rim—whatever the whim of the planning moment. With an out-turned rim, pattern might be adjusted to this area alone, or tied to a great black center. An abrupt turn from a wide flat base might invite the weaver to use a side design alone, or a pattern on the generous base, or to combine the two.

From the above remarks, it is obvious that several layouts were applied to the round bowl form. Following are specific schemes with numbers of baskets into which they were incorporated (Fig. 4.25). Banded designs are to be noted in two basket bowls, while organizational bands, which were very popular in early times, numbered 13. There was but one example of a half-band style, but there were six centered-banded layouts. The largest category is all-over, with 44 baskets covered quite completely with design. There is some variation in this last category, particularly with pattern touching the rim or but a short distance from it.

Half-band layouts were not favored in any Western Apache baskets, for in all forms the black center is rarely left out. One example to the contrary is to be noted in a round bowl. In one deep piece, with a rounded side, four sets of triple steps were planned to hang from the rim, leaving the base undecorated, for there was not even a small center circle. One of six examples of centered-banded has a fairly large, black center with a mass of slightly slanting lines emanating from it. Three coils away from their tips starts an organizational band made up of a series of nine vertical lines with squares or rectangles alternating along its two sides. This might be classed as an all-over design, but it has more undecorated space than is usual in this layout. A second example has a central black circle with two black encircling lines, each separated from the other by a white coil. About a dozen plain coils away is a double band of small alternating triangles, and again, about ten coils distant, a repeat of this decorative band. The latter touches the all-black rim.

The Western Apaches' preference for using a black center circle or a more important theme here, in any form, would explain the rarity

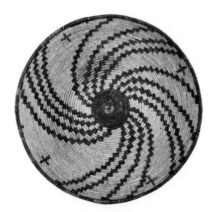

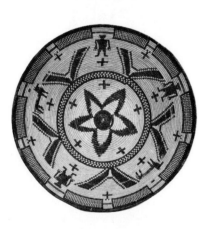

Fig. 4.25. Western Apache bowls with all-over designs. (a) A dynamic pattern on a flat-bottomed bowl *(ASM 1594)*. (b) This layout is also on a flat-bottomed bowl but a deep one with a slightly outflaring rim *(ASM E2818)*.

of true banded layouts. Two such pieces have all white bases, with design confined to the wall. One piece has a black line just above the turn onto the wall, above this a ten-point outline zigzag, and closer to the rim a single coil of alternate black-white stitching. All in all, this is a most delicate pattern. The second piece is also very simple: on the wall of a very small bowl, 6¼" in diameter and 2½" high, are five each alternating black-white coils.

The next grouping of thirteen bowl baskets labeled organizational-banded includes a number of what appear to be very old pieces from the Hubbell Trading Post, Ganado, Arizona. These bowls are flat-based and decorated on their side walls; one has an indistinct dark central area which could have been black but is no longer so. Least elaborate in this group is a design comprised of a band of four simple and short-stepped vertical zigzags. A thin and flexible bowl with a canvas patch on its base has a triple line meander encircling its wall. A very old-appearing basket has two simple motifs: a pair of solid bars opposite each other, two deer on one remaining side and one deer on the other, all of these arranged in an organizational band. Another bowl is decorated high on its wall with seven vertical stepped zigzags.

Most elaborately decorated of these thirteen bowls is one about 11" deep and 13" in diameter. It has almost a ridge at the base of a perfectly straight wall. The base is undecorated, but there are two organizational bands on the wall. In the lower band is a mixed arrangement of simple geometrics, men, and quadrupeds. Above is a more orderly sequence of three joined triangles alternating with figures of a man and a woman. All of the humans in these two bands have upraised hands.

The last category in bowl decoration is the all-over style. At best but a few of the 44 representative pieces can be described, but general arrangement schemes, elements, units, and motifs will tell something of this most varied style of bowl decoration.

By far the most common all-over theme is the star or flower. There may be the usual small or larger center circle with points taking off directly from this. In one case, a six-pointed star does just this, and from its points moves a second six-pointed star, and from tips of the latter the beginnings of still another, all in outline. In some examples of bowls the star is totally removed from the center circle, but follows the same scheme just described. In another basket there are three rows of checkers attached to the center circle, and several coils beyond them a seven-petaled flower. On petal tips and between them and the rim are individual design units including diamonds, coyote tracks, crosses, and men. Further variety is expressed in another bowl where there is a fret band, then a triple zigzag between the star and the black rim. Or, in another bowl, there is a checkered band beyond the black center, then a triple outline star which extends to within four coils of the rim. Quite lively is a five-pointed star repeated four times, with a swastika within each of the points of the third outline and with a man, a dog, and a vertical fret within each point of the fourth star. Additional variety is offered in solid central stars, in heavy outlines, in decorated points. Frequently life figures and small geometrics may be thrown in anywhere in the star or floral patterns in the usual Western Apache manner.

Another fairly popular all-over bowl decoration presents a black center circle alone or with one or several single black coils about it, plus a dynamic series of stepped squares or lines moving out from this central unit. In one instance seven triple wide-stepped lines so move to the rim. The number of spiraling units may vary, but generally they move from lower left to upper right. Spiraling lines do the same; one basket is decorated with four sets of four each of these. Rather unusual is a comparable style made up of five spirals, each starting out with two triangles then continuing to the rim with rectangles. Dynamism is equally great in all these styles.

Another favored Western Apache design used in all-over layouts is the checkered triangle with curvilinear outlining lines. In one bowl there is a black center, two white coils, then a row of four checkered triangles. Out of the center top of each of the latter starts a second row of the same, then a third row in like manner. Each successive row has larger triangles, and the last row touches the rim. Although more quiet than the spiral pattern, there is nonetheless suggested motion in the curving outlines of the triangles.

More static than the spirals are designs which take off in a straight line from the center circle or close thereto. Lines or bands so move from center to or close to the rim. Frets or opposed frets may do the same; so too with stacked triangles. Frequently there are small geometrics or life forms scattered in between these straight-out motifs.

Sometimes there is an all-over design made up of various geometrics arranged more or less in bands, and attached row to row, to cover most of the surface of a bowl. Somewhat in between this banded style and that in which the design takes off in a straight line from the center is a very unusual bowl. In this basket is a black center, two black circles, and then ten men standing in spoke-like arrangement on the outer edge of the black circle. These men hold hands; too, they have large white (negative) crosses on their chests. Beyond the men and touching the rim are five black rectangles with a man in negative in each. Between the rectangles are strangely shaped horses with a geometric above each animal.

These are the main layouts and designs for bowls. Certainly the weaver used as much ingenuity in decorating this piece as in other forms, with the exception of the tray.

Oval Bowls

Oval bowls were not commonly woven by Western Apache women but some were produced and were typical of this tribe in design. Some variations occurred on this form, but all within the traditions of the group. Most of these pieces were woven from the exterior, but one out of a group of 24 such baskets was woven from the interior. Although some of these bowls are shallow, the fact that they were woven from the exterior would indicate that they were not meant to be trays. Scarcity in numbers would seem to indicate that this form was not made for native use, nor did it become popular as a sales item.

In size, the range in oval bowls was from an almost-miniature, 5¼″ by 4¼″, to a large one 22¾″ in length by 13″ in width, with the majority 15″ in length. Depth is amazingly shallow in a number of

these oval baskets, with almost half of them 2" or less deep. Round bowls are rarely this shallow. One interesting feature in several of these bowls is that they are deeper at the ends, more shallow at the sides. For instance, the largest bowl in this group cited above measured 5" in depth at the ends, 4" at the sides. Were these odd dimensions, or even the oval bowl itself, the results of a whim of the moment? Do they support the thesis that the oval bowl was not made for native use? Perhaps so.

Quality in weaving is about average in these oval baskets; the majority of those observed counted fourteen to fifteen stitches and four to five coils per inch. Walls in some were quite heavy, particularly in the recognizable San Carlos pieces, yet several were remarkably thin. Although black rims were obvious in more than half of these baskets, black and white alternations, either in stitches or in wider areas, were a fairly close second. Only one white rim was noted. One of these oval pieces had a black-white-red-white color sequence; this was most unusual for a Western Apache coiled basket rim.

For the most part, design was adjusted to the oval shape of this piece, always beginning with a long wrapped coil and with sewing into this with the next coil. Eighteen of the twenty-four centers were black; two were of alternate black-white stitches, and only two were white alone for any distance. Two more had the single wrapped center coil in white and the next two of alternate black and white stitching. Of the above mentioned black-white rims, two were of alternate black and white stitching while four had design into the rim; in two of these, meanders terminated in the rim, in the third alternate black and white rectangles formed the rim, and in the fourth a terraced outline triangle ended in the basket edge.

Design on oval bowls seems to "go wild" even more frequently than on trays. Irregularities occur rather commonly, from an even number of motifs in one row to an uneven number in the next. In one large piece, there are dog, man, man, dog at one end, and in the same position at the opposite end are man, foot, man, man, dog. Spacing is quite irregular also; stepped and slightly curving diagonals in a small oval basket are nicely spaced out for the most part, but in some spots they are directly one on top of the other—spacing completely forgotten. Balance is sometimes askew. In a large oval piece there are three units at each end, a man, a massive geometric, and a man. These could have been balanced, but they are so spaced that the large geometric is not centered at either end, thus losing this quality altogether. Four of the same geometrics are fairly well balanced on opposed sides of this basket.

Design layouts on oval forms are limited to centered-banded, all-over, and banded (Fig. 4.26). In most of these pieces a heavy center tends to appear, whereas the rest of the patterning may be either heavy or light. Several pieces have no center decoration. Some weavers observed the turn from base to wall in design planning, but most ignored it completely, carrying design over the entire surface without adapting it to separate areas.

Regular and organizational bands are combined in the banded style. One piece has two organizational bands and a regular band between them, all sufficiently narrow and open so as to give a light feeling to total design. Another basket has an alternate black-white

stitch coil three coils from the center, and, touching this, a wide band made up largely of two stacked diamonds which are solid except for mere slits in the centers. Needless to say, this is a very heavy pattern.

Only one basket of the centered-banded style has a true band; the rest are all organizational. In the first piece there is a long black center, four natural coils, then a black coil from which the pattern emanates and then moves on to the rim. This design is made up of eight double steps, each with short risers and with dots in each of the three horizontals. Again, the feeling is one of lightness for the total design. Fairly light also is a pattern composed of a three-coil black center, a three-coil white band, a row of alternating black crosses and red dogs, more plain coils, and a row of small spaced-out rectangles which extend to within three coils of the black rim.

Much heavier in design appearance are three baskets with large black centers and dominantly black patterns arranged in organizational bands. One piece features alternating stacked solid and outline diamonds. The band in a second basket is made up of stacked coyote tracks which alternate with San Carlos arrowpoints, the latter joined by horizontal lines. This design is well spaced and attractive. Neither light nor heavy is the design in one other oval bowl in this centered-banded style. A black center is outlined with a band of three-coil alternate black-white stitching; four plain coils beyond is a checkered band on top of which stand twelve men. These fellows are solid black, rather bulky, and have massive hands. The total pattern is lightened a bit with small outline triangles pendant from the black rim.

Two general types of all-over patterning are to be noted in Western Apache oval bowls, one in which all or nearly all parts of design are joined, and one in which motifs are scattered all over the basket. One example of the latter involves double-outline diamonds over the space between a center dark line and a double meander which touches the rim. Comparable is a second piece in which a central long line and a black rim form space where solid and outline triangles are scattered, with several dogs and other units thrown in here and there.

More dramatic but no more esthetic are heavy black diagonals taking off the black center and moving to a rim design or to the rim itself. In one basket arrowpointlike themes move from one row to a second of the same, then to a narrow checkered row, and finally to a row of crosses—all preserving a static outward-moving line from near center to rim. Elongate triangles in rows accomplish the same feeling in a second such piece. Much more dynamic is a familiar tray design adapted to an oval bowl; a black center, a five-pointed outline star pulled out of shape to adapt to the oval lines of the piece, and then several rows of Apache diamonds in outline—all motifs touching or nearly touching adjoining ones. In another and quite elongate oval basket the same idea is expressed in more sharply angular outlines.

The oval bowl, though greatly limited in numbers, can be said to be fairly varied in design style. Whether quite elongate or closer to the round form, design was often pleasingly adapted to this piece. Irregularities in patterning may well have been due, at least in part, to the unfamiliar oval shape. Similarly, evidences of creativity may be cited in one basket design where the weaver developed

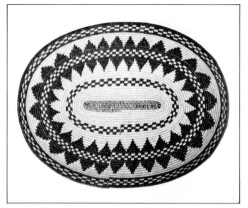
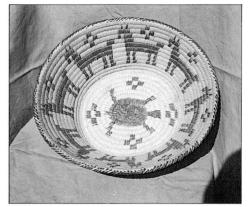
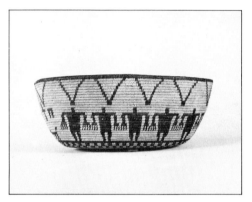
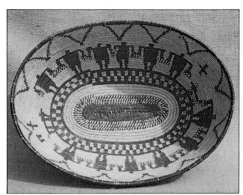
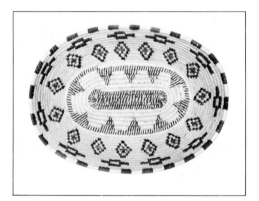
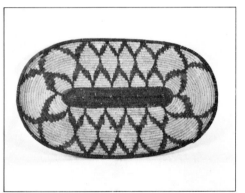
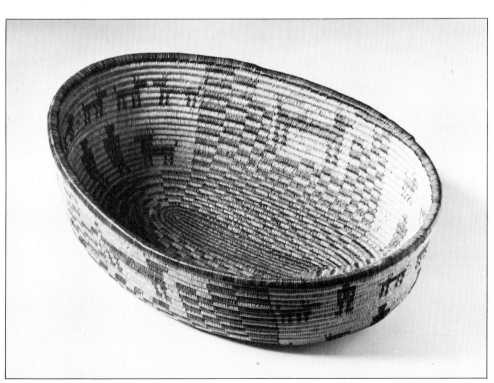

Fig. 4.26. Oval bowls and their decoration. (a) A simple sequence of organizational-organizational-regular bands in an oval bowl that has a light central element *(AF 1184)*. (b) A very slightly oval bowl with a turtle motif on the bottom and a row of horses on the wall *(private collection)*. (c) Side *(left)* and inner *(right)* views of this piece show a large geometric base theme and a row of men around the wall *(ASM 1574)*. (d) A center of black and white stitches and a half-band ornament the base, with spaced-out diamonds and coyote tracks on the wall *(ASM E2786)*. (e) A black center with zigzags attached to it on the base and continuing onto the wall of this shallow bowl, with more zigzags on the long side walls *(ASM 1573)*. (f) Large checkered areas take off a black center and create a small space on the side wall in which is a single animal and wide open ends in which are men and animals. Irregularities and poor spacing would label this Western Apache *(photo by Ray Manley, private collection)*.

on each long side a "frame" for a large animal by bringing up, in stepped fashion, an extensive checkered area. This same checkerboarding covers completely the flat base from a central black oval to the wall upturn. At the two ends of this piece the weaver clustered two rows of men and dogs.

Oval bowls are, comparatively speaking, few in number. Too, they present some interesting overall differences which might indicate that they were not produced for Apache use; irregularities in shape might support this contention. Design does not seem to be as artistically adapted to this form as it was to others, such as the tray.

Miniature Baskets

Through the years not a great many miniature baskets have been produced by the Western Apaches. In fact, more have been woven in the past ten years than ever before. On the other hand, many small pieces were made, even in early years when they served the purpose of training Apache children in the direction of their adult duties. Most of these small pieces were water bottles or burden baskets, and in no way could they be considered miniatures for they were seldom under 8" or more in height. Miniatures, on the other hand, are defined as 5" or less in height for the two forms just mentioned or in diameter for trays.

Miniature burden baskets present an interesting expression which was stressed in the mid and late 1970s, although a few appeared before this time (Fig. 4.27). A group of 15 such pieces, all from the San Carlos area, will indicate general trends in this basket style. First it may be said that these miniatures did not exceed 3¾" in rim diameter and the same in height. All but one were decorated in brown on natural, a common combination for the contemporary larger baskets of this area. Other details also reflect a favorable comparison with the larger piece; for example, interior bottoms of all these miniatures are raised, and all beginnings are as difficult to identify as they are in the larger basket.

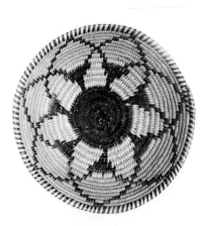

Fig. 4.27. Western Apache miniatures. (a) A miniature coiled tray, 2¼" in diameter *(ASM E2753)*. (b) Two very small (left, 2¼"; right, 3" high) burden baskets with a simple geometric on each *(O'Odham Tash, 1982)*.

Four vertical chamois bands ornament the sides of these minia-
ture burdens, each ½" more or less in width. The first real conces-
sion to smallness of size is in the appearance of two thongs, rather
than the usual four at the rim top of these bands, and none at mid-
point. Thong lengths are adjusted to basket size also, and range
from 2½" to 4", and all have the usual tin tinklers on their ends.
To complete the similarities between miniature and full-size bas-
ket, the former has a bottom patch on all examples, with thongs
attached all around the chamois piece.

Design is also a reflection of the same in the larger burden, natu-
rally with greater simplicity, with single rather than multiple bands
of pattern, but with no duplicates. Most popular in design elements
on the miniatures were diagonals, most of them of three or four
brown stitches running from lower left to upper right in the bands.
Also most of these basket patterns lacked banding lines, but several
did have such on both sides, and in one design there were two
banding lines on each side of the diagonals. In one piece, repeated
vertical stitches alone form the decoration; in a second miniature
there are three such on each side of a horizontal line; and in a third
example there are two bordering lines on each side of repeated ver-
tical stitches. Although fourteen of these miniatures were orna-
mented in brown on natural, two had a third color, green, and a
last example is ornamented with two parallel horizontal black lines,
these just two stitches apart.

Two White Mountain miniature burden baskets differ in their
designs from the above San Carlos pieces in the use of red alone
rather than brown or black. One piece has a red rim, three rows of
natural stitching, two rows of red, three of natural, and two of red
again. Both have rather simpler decoration than is true of most San
Carlos miniatures.

Two other Western Apache miniature burdens of unknown origin
show slight variation in design and color. One has alternate black-
white areas in a horizontal band of four lines, but there are three
stitches in each black and each white area rather than the single
stitch in each of the above examples. A second is 4⅝" at the mouth,
4½" high, and has the most complex design of all these miniatures.
In the first place, it has three decorative bands, each band consisting
of a bottom bordering red line, a center one of alternating red-black-
yellow, and a top bordering line of red. Five natural stitches sep-
arate the colored bands. Another elaboration on this tiny burden
basket is two groups of thongs on each vertical buckskin strap
rather than the single arrangement on the San Carlos pieces. This
use of buckskin, plus a darker natural color, would indicate that this
is the oldest example of miniatures herein discussed.

Thus it may be concluded that the modern Apache basket weaver
who produces miniature burden baskets is definitely influenced by
the larger utility piece. Form in all these small pieces is basically
the typical bucket shape, with a few deviations which are to be
expected in small reproductions. Certainly decoration, in both color
and design style, follows the typical Western Apache trends as does
the addition of chamois bands and straps.

Five miniature jars were observed. One of these is a plain twined
tus, the other four are coiled and decorated. The tus measures 2" at
the rim, 1¾" at the base, and is 3¼" high. It is woven in a diagonal
twine. The entire surface is covered with pitch; further the small

piece is like its large counterpart in the addition of two small loops to accommodate a carrying strap.

Coiled basketry miniatures present an equally "Apache" picture in form, technique, and decoration. Jars and trays are the two forms represented; in their proportions and details they resemble large pieces of comparable shapes. They have three-rod foundations and are woven in counterclockwise fashion. Decoration is in black and follows the styles of large pieces, either "almost copies" or simpler than their large counterparts.

Two of the four coiled jars are about the same size, the smaller one about 2½" in rim diameter and height, and with a base of 2⅜"; the second piece is but a fraction larger. The first jar is very well woven, with fourteen to fifteen stitches and a little over five coils to the inch; the second was slightly coarser. As to be expected, decoration is simple in both pieces. The better jar has three sets of double vertical black zigzags and between them one or two tiny dogs and a leg-like motif with out-turned feet. The second miniature jar has two vertical bands, each made up of a line with suspended dark brown, repeated rectangles.

The other two jars are larger than the above. One is 3" at rim diameter and 3½" in height, with the wide mouth tapering gently into a slightly rounded body. A more rounded body and more slanted neck characterize the second piece; it is also a little larger, 5¼" at the rim and 5½" high. Stitch count is eleven and coils five in the smaller of these two baskets while the larger is very finely woven, with twenty stitches and four coils to the inch. On the larger of these two pieces is this decoration: a star on the base, and a wall design of repeated vertical arrangements of two narrow lines enclosing tiny squares plus seven solid, stepped triangles along the outside of each line. There is no base design to the second of these two pieces; side wall decoration included two themes, alternating and vertically placed: four outline diamonds joined by lines and four sets of two elongate solid diamonds with outlines on each side.

As to be expected, the most elaborate of all miniatures are trays. To be sure, design in these pieces is also simplified, but compared with other diminutive pieces they are more ornate. Both colors and design elements are the same as found in larger trays. In weaving miniature trays, the Apache woman often executed some of her finest work, although some pieces were poorly done. For example, in four trays, sewing went from poor to very fine. The lowest stitch count was twelve and coils six to the inch, while the other three trays had stitch and coil counts of 15 and 6½, 20 and 8, and 22 and 6, respectively. Sizes of these four pieces were: rims 4¼" to 5" and depths 1" to 1½".

Designs tend to be all-over in tiny trays, and understandably so. Least all-over and more nearly composite yet filling most of the basket space is this pattern on one of the above trays: a large central black star plus a band of alternate black and white stitches, a row of repeated black rectangles, and the all-black rim. A second tray starts with a large five-pointed central star with a stepped black diamond —or arrowpoints—between points and the same theme but checkered at the star tips. Between the latter are coyote tracks pendant from squares. The last motif terminates in the otherwise white rim, thus making for a rim coil of alternate black and white

blocks. An attached note suggests that this piece may be Yavapai; however, the arrowpointlike motif would suggest San Carlos Apache.

Each of the other two trays of this group of four has a black center, one with continuing pattern and the other with a white coil between it and the banded design. In the first piece seven stepped solid black triangles rest their pointed tips on the center circle. From the two outer corners of each and extending to the alternate black-white stitch rim is an outline Apache diamond. This design is pleasingly balanced, dynamic, and typically Apache. Equally attractive is the pattern in the second miniature tray; between the black center circle and the all-black rim is a graceful pattern made up of nine outline, stepped triangles, then two rows of nine each outline Apache diamonds, also stepped, and all joined.

Although a 5″ limit for height and diameter has been set arbitrarily for miniature baskets, one tray which is over this dimension is going to be described here because it is such a fine piece of craftsmanship. Too, it is here reiterated that baskets of this size were not woven by Apaches for their own use.

This piece is a flat-bottomed tray with a gently curving side. Its diameter is 7″, its height 1⅛″. Stitch count is twenty-two to twenty-three, and coil count is eight or more per inch, with very close and very even sewing, all contributing to a fine, thin-walled piece. Designing is lovely and as appealing as is the weaving. Pattern begins with a fairly small black center circle with an attached heavily outlined five-pointed star. Beyond this is another star of lighter outline. In each depression between star points is an outline, stepped diamond with a small black element in the center of each. Between the tips of each diamond and the black rim is a heavy line with four attached stepped triangles (five in one spot). Between every two of these units and also close to the rim is a dog. Withal, it is a pleasing, balanced, and symmetrical creation.

From the above, plus a few other observed Western Apache miniature baskets, it would seem that geometric patterning prevailed in these pieces. The life form on a jar plus the one on the 7″ tray were the only two noted in miniatures; more have been seen on small baskets, of course. Feeling for design, whether in a coiled tray or a burden basket, is definitely Apache in all of this miniature basket weaving.

Odds and Ends in Shapes

Perhaps a word should be said about "odds and ends" in the way of Western Apache basketry forms. Fortunately, not too many of these were woven, for in general they do not reflect the artistry and beauty of so much of the basketry of this tribe, to be noted in their jars, trays, and bowls.

Of five pieces observed, one is deep and straight-sided, a second is a cup and saucer, and three others are flat plaques. Seemingly, they are all three-rod foundation, sewing is counterclockwise, and designs are within Apache range. Color is black on natural on two of the plaques but the third one has the addition of red and yellow, a combination not often found on Western Apache baskets. Three points would make the cup and saucer suspect: one is the use of

yellow in the design (Havasupai?)[12], another is cross-stitching on the rim, and the third is the very shape itself—it is the only cup and saucer observed among many hundreds of baskets labeled Apache. It would be a pleasure to rule this out.

However, a little more about the cup and saucer. The outside of the cup is counterclockwise in weave and better woven than the interior. Measurements indicate about 4¼" and 5⅞" for cup and saucer diameters, respectively, and 2⅜" and 1" for their heights. The rim coil for each is white; both are decorated with black outline crosses with yellow centers.

The straight-sided, flat-bottomed piece has several Apache features. Its rim is 11" in diameter, its total height 7½". Natural and black are used for design production on the base, a simple, basic pattern of a central circle, five white coils, and one black coil. Wall design features seven rows of vertical stacked black diamonds, all joined and with varied negative elements in each, such as squares, two joined coyote tracks, a cross, and a meander. Between the diamonds are small units including double stepped chevrons with points up or down and solid rectangles each with a short upward projecting line. The total pattern is typical of much Apache designing.

One flat plaque, 12½" in diameter, is not Apache in several features, particularly in its color treatment. It has a thirteen to fourteen stitch count and a coil count of just under five to the inch. Non-Apache is its rim, which is white with red-black-red alternations in areas where pattern ended. Design could be Apache but un-Apache are design colors, with an eight-pointed star outlined in red and with each point in yellow; one area with alternate black, white and red; and another area of red stepped chevrons with a yellow substitution in several of these. It is possible that this plaque could be Jicarilla in origin, although no other plaques have been observed for this tribe.

The other two plaques could be Western Apache. One is from Whiteriver; it is 7⅝" in diameter and has twelve stitches and five and one-half coils to the inch. Pattern compares favorably with some in Apache trays: a medium-sized black center circle out of which twelve straight-sided elongate triangles move directly to the white rim. There is pleasing balance between black and white. Irregular sizes of triangles and of spaces between them would be rather typical Apache features. Larger is the second flat plaque with its 14½" diameter. It is almost as good technically as the first one, with eleven stitches and five coils to the inch. Typically Apache is the decoration, with its black center circle, a white coil, then four vertical pairs of joined black diamonds with two stepped outlines on each side, all moving to a black rim. Between every two of these vertical units is a man, each with five to seven stitches straight out from the top of his head, and three like stitches out of his hands. One man is different—he has only two stitches out of his hands and beside each of his arms an arrowpoint. This slight variation in one figure is typical of much Western Apache designing.

Whether any or all of the above basketry pieces are Western Apache, with the likely exception of the last, might well be questioned. Certainly, if they are, their very small numbers would indicate that Apache women wasted precious little time in making oddities.

In foregoing pages, attention is given for the most part to Western Apache baskets in general, with no particular emphasis on origins, for in a majority of cases the sources of the baskets are unknown. This, of course, is especially true of many old collections. Undoubtedly there are examples of White Mountain Apache pieces mixed in with the baskets previously described. Because of these facts there follows a brief summary of basket styles of known White Mountain origin, the Guenther Collection. This should point up specific traits of the baskets of these more northerly peoples. Reverend Guenther arrived in this area about 1911, with part of his family remaining there continuously to the present moment. Here were acquired through the years the White Mountain baskets of this Collection. Conferences with Mrs. Guenther substantiated these statements and added many details relative to these baskets.[13]

GUENTHER COLLECTION

White Mountain Apache Indians have continued to make coiled and wicker baskets into recent years, although in greatly diminished quantities as with other Western Apache tribes. Many of the individual pieces in the Guenther Collection are of considerable age, dating back to around 1900.

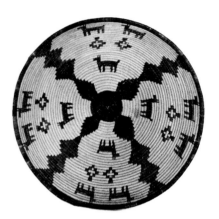

One of the most common Western Apache decorative styles found on trays of both the White Mountain and San Carlos Reservations is all-over with emphasis on a star or flowerlike motif (Fig. 4.28). This style runs the gamut from very simple to quite complex; no White Mountain example has been noted to equal in elaboration this style as expressed by the San Carlos Apaches. Several distinct features are involved, particularly White Mountain delicacy of line and a lack of general heaviness, the latter often due to the use of large quantities of black by the San Carlos weavers.

In its simplest manifestations by the White Mountain weavers there will be a larger or smaller black circle in the center with two single or double outline stars or flowers beyond this, the outer one often touching the rim. One example has a tiny black center and two single, seven-pointed outline stars. A second has a medium black center, a four-unit double line and inner soft-curved, flowerlike theme, and an outer motif like this except that it has five petals. A third example with black center, five single then five double petals seems more complex as the latter ends with a not-too-large black triangle at each tip, then there are several white coils and a second black triangle into the rim. The rest of the rim is white which adds to the general lightness of feel of this all-over design.

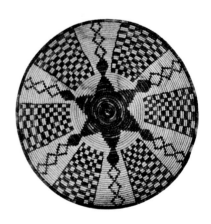

Still heavier in feeling but lighter than many San Carlos pieces is another all-over style which has a black double star. Star tips terminate some coils below the black rim but are connected to it by a slightly bending cluster of three stepped lines. Further embellishment occurs in other pieces in the addition of a plain, narrow circle between stars, or the same about the black center plus multiple short pendant lines at the rim.

The most elaborate of this White Mountain all-over style involves the addition of geometric and/or life elements between rows of star outlines or flower petals. Again, the tendency is toward smaller and lighter added elements. Such may be confined to designs at the inner and outer tips of the main motifs, or they may

Fig. 4.28. White Mountain (Fort Apache) trays with all-over layouts. (a) Stacked, irregular diamonds to the rim, with life and geometric elements between them *(ASM 56965)*. (b) Alternating themes, again with diamonds, from a central star to the rim and a checkerboard between them *(ASM 56964)*. *(All baskets in Figs. 4.28–4.32 are from the E. E. Guenther Collection, Arizona State Museum, Helga Teiwes, photographer.)*

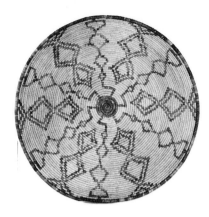

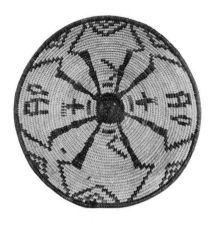

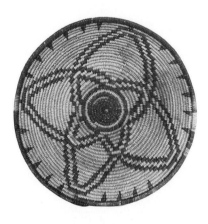

Fig. 4.28. White Mountain trays. (c) Outline, stacked diamonds, single and double, give a lighter feeling to this total pattern *(ASM 56967).* (d) Opposed single but double-topped open designs with additional elements within and between them *(ASM 56955).* (e) A four-petaled flower in outline *(ASM 56956). (Guenther Collection)*

appear within the leaves of the outer flower and again between tips toward the rim. In an even more ornate piece are small elements within and between all open spaces of two outer five-pointed stars; the small innermost third star has no additional decoration. Variety is introduced in one piece as the weaver produced negative triangles between a centered black flower and the lower edge of a black star. Beyond are two outline stars, one at the very edge of the basket, and between them a multitude of small creatures, several geometrics, a $ sign, and "January 7, 1922." This Guenther collection piece was so marked as a result of the family giving a calendar to the Indian weaver.

Certainly this all-over star style typifies the White Mountain basket, whether with no additions or many, and the latter are almost always quite light in feeling. Occasional solid black elements do occur, such as lizards in one basket, triangles in another. Thus it may be said that there are probably some White Mountain baskets of this type in the general Western section, but also these examples support the thesis that the heavier styles are products of the San Carlos Apaches.

Occasional examples of tray designs cannot be placed absolutely in one layout style or another, a situation previously noted as one to be expected of hand crafts. One such White Mountain piece appears at first glance to be composite, of the centered and organizational-banded style, but really is all-over. Centered is an outline star with negative patterning, and just slightly overlapping with this are six double-line , stepped motifs which reach to a black-white rim of alternate stitching. For good measure a few small life figures and crosses are thrown in between the steps. Use of lines and the negative star add to the lightness of the design.

Another all-over style popular with White Mountain Apaches involves the movement of elements from center or near-center to the edge or close thereto. Two distinct trends in this style involve static or dynamic motion, with some examples really just in between. One, for instance, has a black center off which spin three alternating pairs each of broad and narrow elements; in turn, each line continues into two stacked diamonds, then a half-diamond, and on to the black rim. Motion is slightly from center to edge, left to right. The solid diamonds and half-diamonds are made lighter by outlining on both sides.

More typical, and found in both White Mountain and San Carlos areas, is a highly dynamic motif which moves right to left from center nearly or completely to the edge. Wide-stepped double or triple lines touch a small black center or start several coils from the same, and move about a quarter of the way around the basket. Typical greater simplicity prevails in these pieces in that no further elements occur in these designs in the White Mountain examples.

Even more abundant in the White Mountain area than in the San Carlos are baskets decorated with static designs from center to edge. One severe example has a dozen elongate triangles which move from a medium black circle to touch a white rim. Rare as it is, it would almost seem that the Whiteriver Apache weaver added the latter feature, the white rim, to lighten this total design as it was heavier than usual for this area. A second unusually substantial pattern for the White Mountain Apache basket weaver has three heavy black triangles extending from a black center, with a black

touch added to them at their broad outer extremities in the form of a negative cross in each. In each light area between the black motifs is a cross with a U-shaped element beneath it. Short diagonals connect the tops of the triangles to a black rim.

Between the above more heavily designed baskets and the typical light styles of the White Mountain area are several pieces with narrower dark elements extending from small dark circles in a static line to or toward the rim. One example has four rows of stacked diamonds with life forms and coyote tracks between. A second piece has eight narrow and irregular lines extending rimward from a small central black circle. Before they reach the rim, they become narrower lines which zigzag their way to the rim and which also manage to join every two of the static themes. Odd elements are thrown in here and there including an A on two opposed sides.

A typical White Mountain style involves single or double outline diamonds which progress from center to edge in four to six straight lines, often with two to a dozen of these elements in a group. Often outline life forms or geometrics are thrown in between rows, or, perhaps, there are just the vertical rows of alternating single and double outline diamonds.

Quite unusual is one other all-over decoration in a White Mountain basket. A rather large six-pointed black star terminates in small diamonds, one solid, the rest outline, which extend to the rim. Between them are rectangular clusters of small-square checkerboarding. The latter adds lightness to what might otherwise have been a heavy design.

Not as popular with these weavers as some other tray decoration is the banded style (Fig. 4.29). Two examples will illustrate this, both showing an almost severe quality which appears now and then in basket designs of this area. One piece has a centered medium-sized, pleasingly outlined five-petaled flower motif. Two bands of small, outlined, and joined triangles carry design to a black rim. The second tray has a medium-sized black center circle with four lines extending to a joined row of eight double-outlined petals. In turn, these touch a narrow band of light checkering. There is then a plain band, and last a row of very small outline triangles pendant from the rim.

The composite of centered-organizational-banded style tends to be fairly favored among White Mountain Apache weavers (Fig. 4.30). Again there is quite a range in this style, from simple to complex. At the first extreme might be a black centered motif, such as a star or simple projections on a circle; then a distant circle of double zigzags,

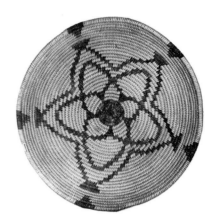

Fig. 4.28. (f) A five-petaled flower in outline *(ASM 56959, Guenther Collection).*

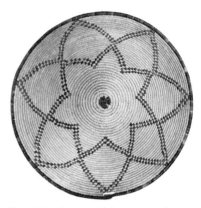

Fig. 4.29. A tray with an organizational band (favored over the regular band) in a simple, duplicated, outlined, seven-pointed star or floral theme *(ASM 56963, Guenther Collection).*

Fig. 4.30. Trays with centered-organizational layouts. (a) Beyond a centered star are the rather typical White Mountain outline major motifs with lesser motifs between them *(ASM 56966).* (b) A more elaborate star, and double outline steps in the band *(ASM 56957).* (c) An all-black floral motif forms the centered theme, and solid diamonds with outlines plus heavy swastikas make up the band *(ASM 56958). (All from the Guenther Collection.)*

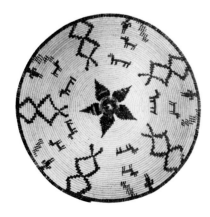
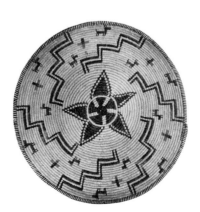
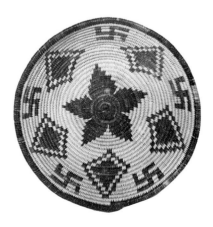

and dots pendant from the rim. Complexity can be noted in more elaborate center themes such as a large or more intricate star or other motif, and a wide band of alternating elements such as outline diamonds and small life figures or more powerful solid and outlined diamonds interchanging with large swastikas. In the simpler style there is more blank space; in the complex are rows or a row of motifs which tend to fill most of the tray space, plus a more commanding central theme.

As elsewhere, not many oval bowls were produced in the White Mountain area, and perhaps these also were made for the white man (Fig. 4.31). Most of the layouts here were all-over, for the black oval center, which was dominant, was combined with a banded pattern. Design might be either separated from or attached to the center motif. Occasionally a black oval line in place of the solid gave more of a feeling of banding to the layout. One such example has two stacked and heavily outlined crude diamonds on the side wall and one such at each end flanked by smaller figures of men. Bands in other baskets have patterns taking off close to the black center oval and often practically filling this space. In one piece eight elongate checkered areas alternate with a simpler geometric closer to the rim. In another are spotted crosses and dogs, while in a third are outlined solid triangles and dogs to the rim.

Fig. 4.31. Oval bowls in the Guenther Collection. (a) Side view of an oval bowl showing a tendency to weave higher ends; diagonal patterns move from the base onto the walls *(ASM 56970).* (b) A centered black oval, and an organizational band with stacked coyote tracks alternating with a smaller motif of a cross plus stepped triangles *(ASM 56969).* (c) A simple black oval center, a line of poorly spaced crosses alternating with animals, and a line of simple rectangles *(ASM 56968).*

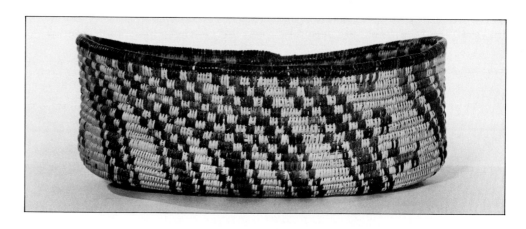

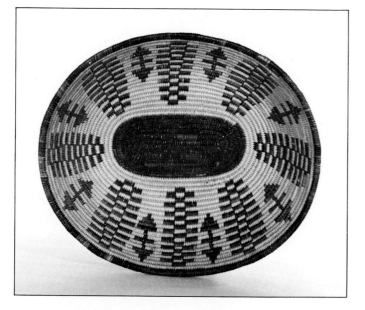

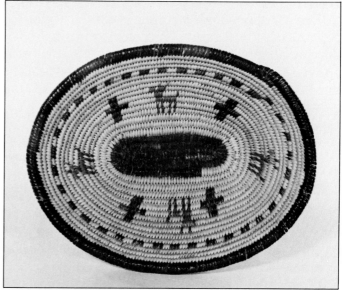

In two other oval bowls design touches the central black area to continue to the rim in one example and to a band below the rim in another. In the first piece, parallel lines become diagonals on the wall and, in part, checkered near the rim. A few dogs are thrown in at several spots. Stepped diagonals take off from the center of the second and smaller piece, to end in a wide checkered band.

White Mountain jars tend to be less varied and simpler in form and design than those of the San Carlos area, although occasional pieces are elaborate (Fig. 4.32). Seemingly they were not as commonly made as they were to the south. One piece of a simple rounded form has vertically arranged, large outline diamonds, each with a slender center pattern, with arrowpoints or coyote tracks, alternating with attached long vertical lines.[14] The wall of a second jar is covered with six wide, double-line steps which encircle the piece. A third jar is decorated with five vertical rows of large solid black and outlined diamonds reaching from the base onto the neck. Between these is a short vertical row composed of a cross, an outline diamond, and a coyote track, these adding a light touch to the finished piece. A last jar has its walls covered by a network which creates open diamonds; within all are varied arrangements of one or more crosses, coyote tracks, dogs, and/or double crosses. Each of the last three jars has a shoulder. Other life forms are represented

Fig. 4.32. Jars from the Guenther Collection
(a) A deep but wide-necked style with rounded shoulder lines; double zigzags are arranged in a horizontal manner *(ASM 56973)*. (b) An outsloping neck with this line repeated to the shoulder and with a fairly wide body to the base; life forms and geometrics fill the network spaces *(ASM 56971)*.

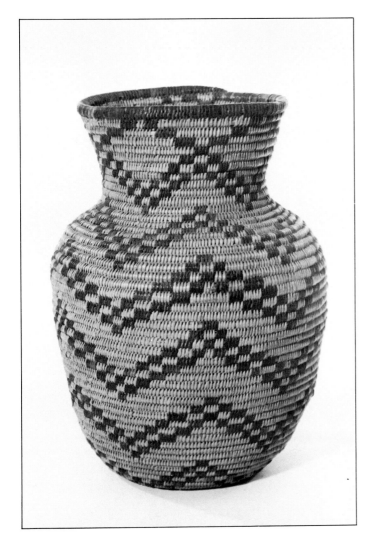
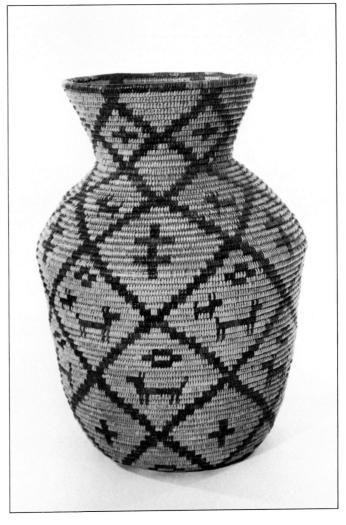

on a Whiteriver piece, including a man, dog, horse, deer, and a Gila Monster.

All in all White Mountain Apache baskets would seem to express a feeling for lighter patterning, although occasionally there are definitely darker designs. Forms present the same array as to be noted in San Carlos baskets, namely, trays, oval bowls, and jars, with far less variety in each individual form. Further detail expressing differences, traits which might well be cited as diagnostic of White Mountain styles, would include the following. There are more outline forms in design, fewer solids; small elements were favored over large ones; sometimes pattern was definitely on the severe side; and there was more empty space between motifs. Design was sometimes almost stark with black standing out against a larger white background; more frequently it was static in contrast to the common dynamism of San Carlos basket pattern. Evenness of design can be stressed; there is great regularity in repetition, and there are fewer odd bits thrown in here and there, all again in contrast to many San Carlos styles. Center circles tend to be smaller. There is more emphasis on geometrics, less on life forms; there is a tendency to use fewer and smaller elements and units on a single basket. Withal, there is, seemingly, a greater adherence to original plan in total design, with less deviation on the part of this White Mountain Indian woman as she progresses in the weaving of her basket.

All in all, Western Apache basketry is by far the most vital, the most varied, the most abundant of any weaving by all of these tribes. Part of this can be attributed to contact and the possibilities of selling these products, but more is due to the creativity of the Indian woman herself. These women adhered to the basic forms which they used in daily tasks but these and their own design elements and units they developed into ever more interesting creations.

Fig. 4.32. From the Guenther Collection
(c) A wide-mouthed, fairly sharp-shouldered piece, with vertical alignments of both the major stacked diamonds and lesser geometrics between them *(ASM 56972)*.
(d) A jar with rounded body; open, stacked diamonds create a vertical scheme *(ASM 56974)*.

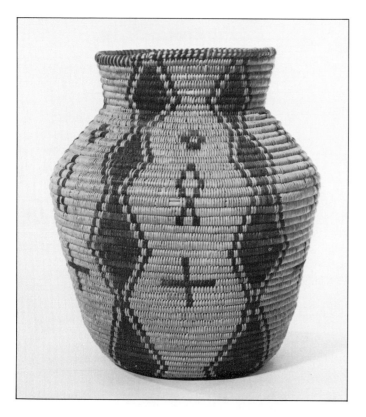
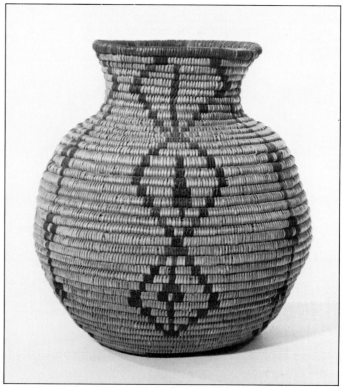

There is much asymmetry in large or small details, but there is also pleasing symmetry in Western Apache basketry. There is great creativity in shapes, with much variety in San Carlos pieces in particular. Balanced repetition is typical, but this is frequently broken by the addition or shift in position of some small figure. Frequently, too, the latter would seem to be more intentional whimsy than poor weaving, and more characteristic of San Carlos than of White Mountain weavers.

Jicarilla Apache Basketry

JICARILLA BASKETRY covers a long span of time, although little is known about this craft until about the 1880s. Like the Mescaleros, their wandering habits took them over a wide territory, with practically no evidence of their weaving left along the way until their settlement on their present Reservation in 1887.

Several aspects of this basketry give cause for questioning: What is the origin of the braided rim, the five-rod foundation? Did they acquire these traits from the Rio Grande puebloans during their wandering years or later? Or did they get them from other Indians? Certainly these are not Apache traits in terms of Western and Mescalero Apache basketry.

Ellis and Walpole in their important article, "Possible Pueblo, Navajo, and Jicarilla Relationships"[1] conclude that the pueblo coiled basket is probably the real ancestor of Jicarilla basketry. In their survey they found evidence of the long life among these puebloans of certain traits later found among the Jicarillas. These traits include the braided rim, five-element foundation, the use of sumac, and even the use of similar designs.

Later the puebloans cut down on their basketry production and, seemingly, then traded with the Jicarillas for this craft product. Evidences of continued contact, as cited by Ellis and Walpole, include trade, which goes far back into their history. Too, they noted that Jicarillas visited in the homes of the more northerly puebloans during dances and left gifts "in the form of beadwork and baskets."[2] Thus Jicarilla basketry continued to be popular among puebloans until the craft dwindled, then almost disappeared into the 1950s. It was in the late 1950s that the Jicarillas started a revival of their basket craft.

TECHNIQUES AND MATERIALS

All Jicarilla baskets are of coiled weave; the technique was well developed by this tribe, with some accomplishments unique to them such as the elaborated five-rod foundation. Like other tribes they used materials available in immediate or close-by areas.

For coiling, sumac was the chief material,[3] although some willow was used. Foundations were of three or five rods of sumac or willow, and usually the same material was split into even sewing elements for the wefts. Aniline dyes as well as natural colors were employed both in early years and after the revival of basketry in the late 1950s. However, some native colors were used, for example yellow (root of barberry) and a brown or a red-brown (root bark of Mountain Mahogany), preceding the acquisition of the earliest anilines. All materials for the coiled technique were prepared by gathering the long withes, removing leaves and bark, then storing them against future use. As with other tribes the withes were dampened to make them pliable for weaving.

Coiled baskets were started in a manner that made them look like the Navajo beginnings: a small section of foundation was wrapped and curled on itself to form a circle; then the first coil foundation comes out of this and is wound about and sewed into this circle. The start looks splayed out. Often the first coil or two or three may be small, but the regular coil size of the total basket is quickly established and carried to the rim. The end of the last coil is gently tapered. Typically, sewing is quite good, fairly tight, close, fairly even. All of the rim is covered with braiding, a trait distinctive of Jicarillas among all the Apaches.

Although sewing in much of this Jicarilla basketry is even and fine, occasionally it is spaced to the extent that the foundation can be determined. Stitches are generally straight up and down, but sometimes they are more pinched at the top. Stitch and coil counts are well represented by 105 baskets from several collections including that of the Western Archeological Center, Tucson; Laboratory of Anthropology, Wheelwright Museum, and Indian Arts Fund at the School of American Research, all in Santa Fe; plus a few pieces

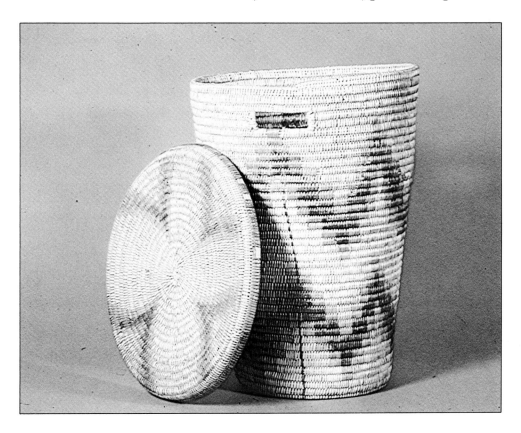

Fig. 5.1. Handles on Jicarilla baskets.(a) A "woven in" handle. The weaver turns back for two coils on each side of what is to be the opening, then goes over the top the next time around, wrapping the coil and sewing into this; then she repeats into the remaining coils *(SAR 341)*.

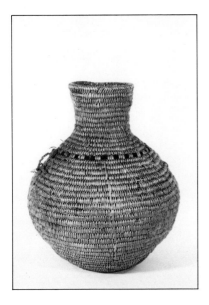

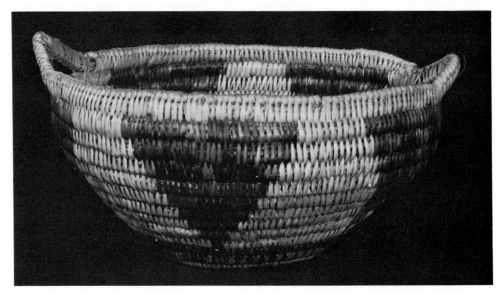

Fig. 5.1. More handles
(b) Handles on jars vary in materials. Here they are of twisted hair, one showing on left side. (Dark cloth was inserted over two or three stitches and under three to create this rare decoration.) *(ASM GP52685)* (c) Another method of handle creation is to bend the top coil up and out, wrap it, and continue with normal rim sewing *(ASM E7781)*. This can also be done at the side of the basket, usually for two coils.

from miscellaneous private collections. For stitches, the range was five (1 example) to ten (1), with other counts as follows: six (38), seven (47), eight (16), and nine (3) per inch. Coils were two to the inch (33), two and one-half (35), three (32), three and one-half (4), and four (1). The five-rod coil foundation is unique; whether of three or five rods, walls are very firm and have a massive feeling.

Generous-sized Jicarilla trays could have been put to many uses, for a large number of these pieces ranged from 17″ to 25″ in diameters. Too, the hamper was definitely made for utility purposes, again as size would indicate, for many were 20″ to 28″ in height. Of course, there were some smaller trays, hampers, and jars; these may or may not have had native use.

Several small features which appear now and then on Jicarilla coiled baskets should be explained. Handles on trays and hampers are often made by simply wrapping and extending outward a section of a coil, continuing with regular sewing into the basket wall, then sewing the next coil into this extended one and repeating into the regular coils to the rim—thus forming a secure opening or a handle (Fig. 5.1). A few coiled jars had free handles over the neck—these were simple independent braided pieces secured to the basket shoulder at two points, each opposite the other.

FORMS

Jicarilla forms include trays predominantly, jars, bowls, hampers, the creel (Fig. 5.2), and occasional other odd pieces such as a footed jar. In earlier years when basketry was made by these Indians for their own use, trays, bowls, and the water jar tended to be larger in size. When their native craft center was set up and baskets were made for sale, these people tended to turn to smaller sizes.

As a whole, the Jicarilla tray was of deeper form than that of either the Mescalero or Western Apache. Too, its sloping sides terminated more abruptly in a flat bottom. This tended to encourage an emphasis on separate bottom and side patterns, the former as a single or complex circle, the latter a wider or narrower band. Occasionally trays had two handles, one at each side. Bowls were often oval in form, straight-sided, and sometimes had lids. The circular bowl definitely had a flat bottom, and the sides, although sloping, were straighter than in the tray. All measured examples of this bowl type indicate proportionately greater depth than in trays. A third

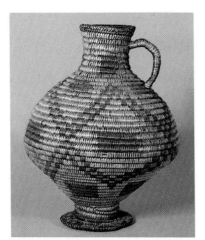

Fig. 5.2. (a) Jicarilla "pitcher." An unusual footed jar with a single handle *(SAR B366)*.

bowl style is smaller in size. From its widest diameter there is inward sloping to a smaller mouth, resulting in a rounded piece. These are often decorated.

Jars are basically of a coiled, round-bodied style; this form has a medium or small neck, usually straight, though sometimes it was outflaring. Sometimes there is a handle from the shoulder top over the opening. Also the slightly outflaring neck is often wide; one such piece, with a five-rod foundation, had a slightly squashed body. Seemingly this piece served as a water jar; it varied little in shape from the usual rounded body, except for rare double-lobed bodies, and all had a tendency toward a flat bottom. This coiled jar is sometimes decorated.

Hampers were surely a concession to the white man. These were tall cylindrical pieces, usually with lids, and they were attractively decorated. Apparently this form has been continued into recent years. There are other deep forms, some resembling buckets and not quite so deep as the hamper. Like the hamper, the creel also was made for the white man; it was oval in form, slightly pinched toward the center, with a lid which was secured to the basket on one side. Also there was a small square hole in the lid. Creels were apparently not made in abundance, but they are certainly associated with the Jicarillas, even though they were made for whites.

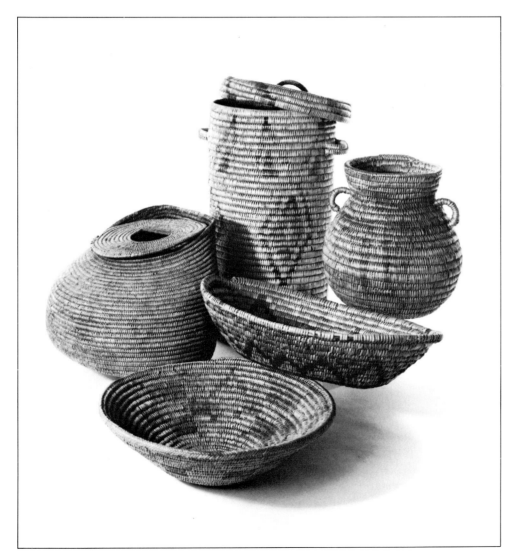

Fig. 5.2. (b) Jicarilla basketry forms: Front: a fairly deep tray form *(ASM E2)*; leaning against the tray is a bowl *(ASM E5187)*. Back row from left: a creel, oval-shaped, and with a hole in the lid into which to drop the fish *(ASM E7387)*; a tall hamper with a lid and projecting handles *(ASM 8096)*; a jar with two handles *(ASM 8074)*.

Odd forms in Jicarilla basketry appear now and then. Like the creel, some were obviously the result of the Indian woman seeing an object used by a white man, then experimenting a bit. Foremost in this category are footed pieces, usually a jar, or a tray, the former with or without a handle. One jar has a foot, a handle, and a spout. Another piece is like a large cup with a handle.

DECORATION

Like the Mescalero basketry design element and unit list, that of the Jicarilla is fairly extensive, later even more so; also like the other New Mexican Apaches, they tended to use them more simply in individual baskets in earlier years than did the Western tribes. However, sometimes there are examples of the use of more units of pattern in a single Jicarilla basket than was true of the Mescaleros, the difference based primarily on time, for the older Jicarilla baskets more closely resemble those of the Mescaleros in simplicity, the later ones presenting elaboration in design as a whole. In fact, before the revival of this craft, Jicarilla design can be characterized by the term massive simplicity, and it can be added that there are few elements on each basket. Among elements which are used are large stars, crosses, terraced diamonds, and zigzags, a list also quite typical of Mescalero basket decoration. In general, life forms are found more frequently on Jicarilla baskets than on the Mescalero; here too there is more conventionalization in the earlier Jicarilla style, a little less later on.

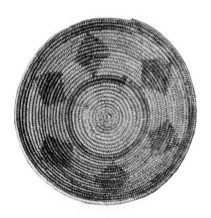

Lines and bands were commonly used by the Jicarillas; sets of parallel vertical bands were sometimes decorated with short horizontal bands taking off from them, or bands may take off from geometric shapes. Both lines and bands may encircle a tray, singly or in multiple units, the band often one coil wide, the line a single stitch. One, two, or more coils forming encircling bands often terminate with a short opening (Fig. 5.3), the latter commonly called a "spirit path."[4] Sometimes these bands enclosed other design elements, or they might appear alone.

Chevrons were narrow or broad. In one instance a vertical series of them was enclosed by lines at either side, with short lines taking off from their uprights. Single, wide chevrons appear as spotted units along with other designs, or as arranged near the rim of the basket. Crosses are generally heavy armed, often with a small square on each outer corner which is mindful of a Navajo style. Very small, simple crosses are also used, generally in conjunction with and secondary to other motifs; or this unit may appear alone, or not infrequently, it is placed inside another geometric form. For example, a brown cross appeared in the center of a red stepped diamond.

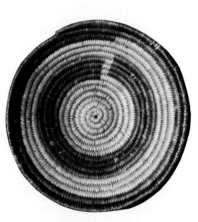

Fig. 5.3. Bands on Jicarilla trays. (a) Brown interior and edge lines create a regular band in which appear six diamonds *(ASM E5)*. (b) A regular band with an opening called "the weaver's pathway" *(LA 23458/12)*.

Coyote tracks seem to have been and still are popular with the Jicarillas. For the most part they are positive, but occasionally a negative style was used. Like the cross, this unit may appear inside another geometric form or it may be used alone between other designs. This theme may have tiny squares at the corners, quite like crosses. Too, there is often play of color in coyote tracks: the four squares or rectangles forming the unit may be one color, for example brown, and the center a different color, such as yellow. There are also double coyote tracks, one above the other, with a central square or rectangle serving as part of both units.

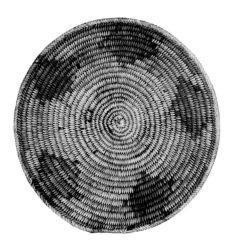

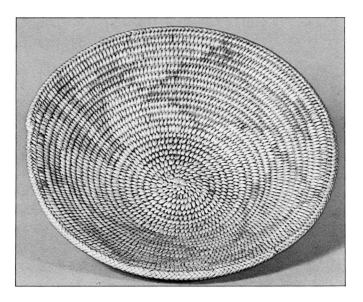
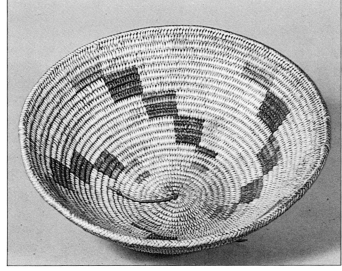

A center circle is used by the Jicarillas more than by the Mescaleros, with considerable variety in this feature. Variations run from a single encircling band of color to a full circle of one or several colors. Plain centers predominate, of course, particularly in older pieces, but many recent baskets have featured more decorative centers. One of the latter starts out with two coils of yellow, four coils of alternate black-white stitches, then three more yellow coils, all touching. Rather large solid dark centers of green or brown are not uncommon, and alternating dark and light brown-tan coils are also favored. Design may be integrated at the edge of the colored center, or start a coil or two away, or several coils beyond the center theme.

Diamonds were popular Jicarilla motifs for their basket ornamentation (Fig. 5.4). They may be stepped or almost straight-sided, a single color or outlined in a second color, or outlined and with an added unit either within the main form or attached to it. One example is yellow with a red outline and a green central cross. This diamond unit may appear by itself, perhaps between the points of a zigzag, it may constitute the main motif, or it may be integrated into the total pattern. In shape, the diamond may be equal-sided, more elongate, or of the "Apache style" described above, that is, more outcurved and large in its upper portions and smaller, with more incurved sides below. Withal, diamonds can be quite simple or very elaborate.

Fig. 5.4. Use of diamonds in Jicarilla baskets. (a) Five red and blue, irregular diamonds which touch the rim *(WAC 997)*. (b) Four large diamonds with a design in the center of each and a line extension toward the basket center *(WAC 4633)*. (c) A more complicated Jicarilla diamond *(LA 23466/12)*. (d) Three Apache-style diamonds with a spirit opening in place of the fourth one *(SAR B165)*. (e) Dynamic lines of joined diamonds (some squares?), red and blue, which move from center to rim *(SAR B362)*.

Triangles are also varied as used by the Jicarilla Apaches (Fig. 5.5). In form they may be equilateral, right angle, isosceles, or very flattened. Like the diamond they may be stepped; in older baskets particularly, they may be smooth sided. Points are usually toward the basket interior, although an occasional reversal is to be noted; sometimes tips touch and form an hourglass shape. Triangles may be stacked one above the other with points touching the center of the one below, or they may be arranged along a vertical line. Like some other units, a large triangle may have a smaller one at each of its upper corners. Triangles are of solid color, or frequently they are solid and outlined—for example, of tan with a red outline. Outlines are sometimes on two sides only. Color is also handled in an unusual manner in some Jicarilla triangles, namely, in an alternation of horizontal one-coil bands. For example, there may be a succession of red-green-red-green from tip to wide top. Once in a while a triangle appears inside another geometric, such as a diamond.

As in all basketry, squares and rectangles are prominent in Jicarilla designs. Both are used for outlining, and, perhaps more frequently than in baskets of other tribes, they may be used as separate units. Squares or rectangles may serve as motifs alone or with another one. Often these two forms have a center of one color and are outlined in another, for instance red and green, respectively. Often too, they may be added to another theme, such as small squares at the corners of coyote tracks or tips of triangles as mentioned above. There may be squares (or rectangles) within squares (or rectangles). And, needless to say, they are basic to the formation of many another unit of design, perhaps more obviously in Jicarilla baskets because of their use of many colors. For example, a diamond may be made up of successive colored outlines of red, green, and yellow about a red square center—here it is obvious how rectangles and squares constitute each part of the diamond.

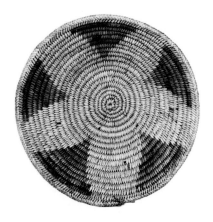

Fig. 5.5. Triangles used to decorate Jicarilla baskets. (a) Five quite smooth-sided red triangles close to the rim. These create a floral pattern *(WAC 4631)*. (b) Example of a larger triangle with smaller ones at the upper corners *(LA 23478/12)*. (c) A row of yellow diamonds toward the center and blue-outlined red triangles at the rim *(SAR B78)*.

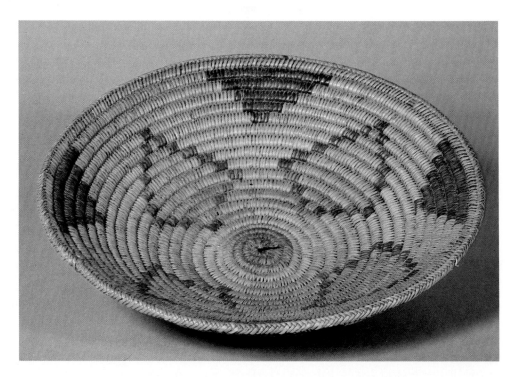

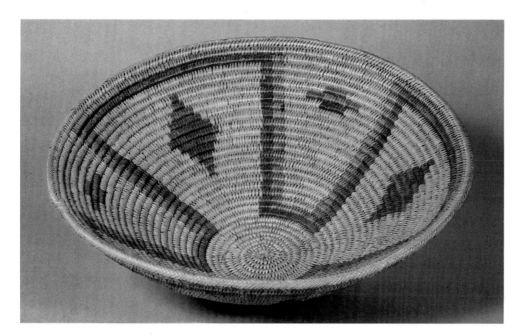

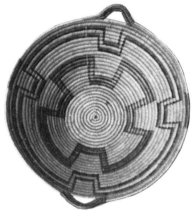

Fig. 5.6. Frets or meanders in Jicarilla baskets. (a) Deep meanders were popular on these trays, here woven in a four-part, red and green combination, and with a diamond within and a coyote track between fret lines *(SAR B288)*. (b) Two frets on this basket are quite different, the inner red-green-red and more closed, and the outer quite open and largely purple but with one line with blue added *(LA 23457/12)*.

Meanders are characterized by great depth on some Jicarilla baskets. They may be of a single color, but often they are double outlined in two colors, such as red and green (Fig. 5.6). Except for their great depth they are relatively plain. There is some variation on this theme, for example, as a side-to-side balanced motif which is really made up of meandering steps. Zigzags are more commonly used than meanders; they occur alone and with other units of design. Extremely deep zigzags are common on the tall slender hamper, while on trays they are more shallow. They may be of a single color, or often of two colors with one each of two outlines of the zigzag or one in the center and another on each side. Zigzags are made up of steps of squares or rectangles.

The star was not favored in Jicarilla basketry as much as it was in that of the Mescaleros and Western Apaches, but it was represented (Fig. 5.7). Early turn-of-the-century pieces are more apt to feature this theme than later ones. Like other units or motifs the star was also apt to be of several colors, in one instance of a deep blue-green and tan, in another red, yellow, and brown. Both of these were in stepped outlines, one four- and one five-pointed. Outlines were sometimes quite heavy in the Jicarilla star which appears on their trays. There are occasional examples of negative stars.

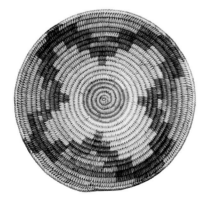

Fig. 5.7. Jicarilla floral or star themes on trays. (a) A soft brown center, then white to form a negative floral pattern which is outlined in varicolored steps, with an uneven distribution of red, gray, green, brown, and almost-turquoise *(WAC 4635)*. (b) A five-pointed star made up of squares of red, yellow, and a faded purple *(LA 23466/12)*.

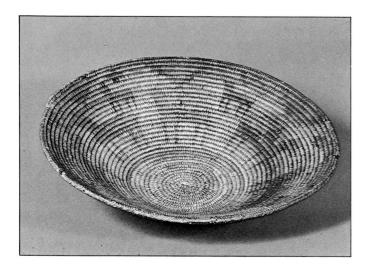
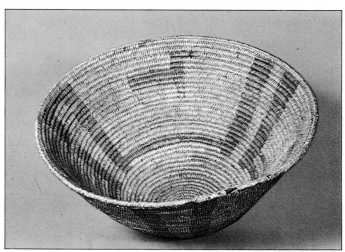

Fig. 5.8. Life themes in Jicarilla baskets are not common. (a) Here are horselike creatures, large and small, on an old basket. All are crudely presented *(SAR B166)*. (b), A deep meander with a horse (?) in each of the wider areas *(SAR B169)*.

Life themes are found occasionally in older Jicarilla baskets, more often in later pieces (Fig. 5.8). On an earlier tray are larger and smaller creatures which are probably horses; they are stiff-bodied, straight- and narrow-legged, and have a large neck and head which are also on the geometric side. A later example of the same animal has a better general outline and a suggestion of shape in legs, head, and ears. Generally, definite flowerlike themes occur later in time. In one example there is a suggestion of a flower on the ends of each of three graceful stems; in another there are leaves on each side and a bloom on the top of a central stalk. Occasional other life forms appear.

All in all, this demonstrates that design elements and units in Jicarilla basketry are essentially comparable to those in Mescalero pieces. However, the results differ considerably in their use of much more color and in the ways in which the units are put together for the final design. There is greater variety in number and kinds of motifs; frequently there are more elements or units in a single basket; life forms are more common; and, particularly in more recent years, there is more vitality and life to the total basket design.

Decoration of individual baskets woven by Jicarillas responded to forms as well as to current style in designs and colors. As among all other Apache tribes, the tray was most popular and received the greatest attention in its decoration. The form of the hamper, tall and narrow, seems to have limited design both as to number of elements and the method of application of them. Jars and bowls were limited in numbers; therefore design seems to have been neither abundant nor varied.

Earliest known pieces, from about 1880 and continuing to about 1930, were limited as to color combinations on a single basket, for example, a pale natural brown on a light ground. Other colors, such as black, red, yellow, and purple, seemingly were also obtained from natural sources, such as clays and plants. Purple may well have been some other color in its original state, later turning into this faded shade. One or several of these colors might be used on a single tray on the natural light ground of the willow or sumac, and in a simplified pattern. As among so many other Southwestern Indian tribes, both red and green aniline dyes appeared among the Jicarillas before the turn of the century and remained popular for a while. Color changes in the late 1950s will be discussed later.

In early pieces of about the turn of the century and for several decades following, tray designs exemplify typical Jicarilla patterning and colors. One tray 12¼″ in diameter and 3″ high has four stepped triangles of alternate red and green coils pendant from an encircling band of three tan coils with touches of red here and there; these triangles are interrupted by smaller green ones pendant from the rim. Another tray which is 15½″ by 5¼″ has a five-rod foundation which makes for large coils. It is decorated with five rather large red diamonds. Overlapping this dominant motif is a sizeable yellow circle coming out from the center. The diamonds are quite smooth-sided.

In a tray which is 16″ across and 5″ deep there are four diamond-like units, each with a pendant line extending toward the plain basket center. Each motif is a bluish in color with heavy tan borders. Beyond the diamonds are a pink coil, a natural one, another pink, and a natural rim with irregular pink areas, all of this a not uncommon Jicarilla treatment. A flower theme ornaments another large tray; it is in a double-stepped outline style which moves to the rim from beyond a small tan center. The inner step is red, the outer green; this color combination and the general appearance of the basket might well date it to about the turn of the century. Possibly of about the same age is a large tray which has five shallow-stepped triangles with a flowerlike pattern taking off from their tips and moving into the rim. Again, red and green are featured colors.

Other designs which are featured on trays would include the following. One has a combination of red-outlined green diamonds in two overlapping rows and red triangles to the rim coil. On another basket, two rows of brown triangles join at their tips to form a wide band of hourglass designs, the band made complete by horizontal line extensions from the upper and lower tips of the triangles. Four large coyote tracks with tiny squares at all outer corners create an organizational band on another Jicarilla tray. Four massive red-green-red outline Apache diamonds, joined except at one point, present the sole decoration on a different and very large tray. On a 23″ tray are two meanders, an inner one of red-green-red outline and an outer one of double outline in brown. Quite different is the decoration on another tray, an organizational band of alternate motifs: two facing, vertical stacks of brown triangles and a vertical stack of

Fig. 5.9. Variations in designs on Jicarilla trays
(a) Large coyote tracks with tiny squares on outer corners *(SAR B168).*
(b) Triangles which meet at their tips, thus forming an hourglass motif *(SAR B70)*

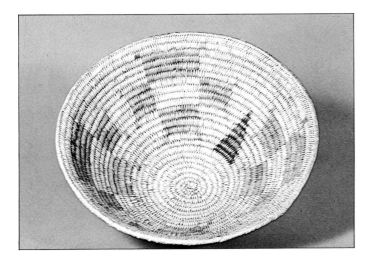

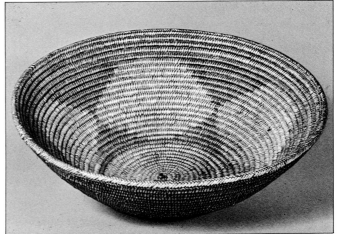

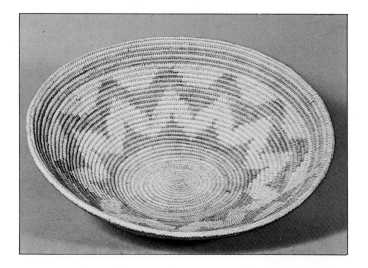
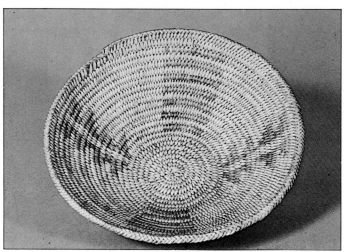
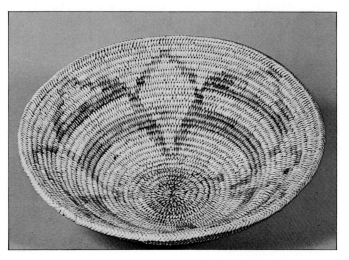
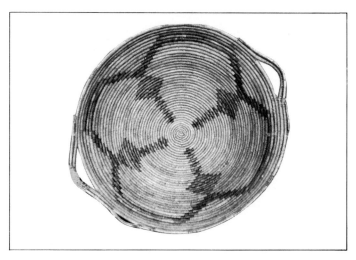

Fig. 5.9. More variations (c) Three different motifs on a tray, an inner row of joined triangles, a heavy zigzag, and close to the rim a double line *(SAR B69).* (d) Two motifs alternating, short parallel lines in vertical arrangement and double vertical rows of triangles, each row along a line *(SAR B164).* (e) An elaborate arrangement of joined alternating motifs, largely short bands and archlike themes *(SAR B280).* (f) An outline floral theme with diamonds touching their inner tips and with six stacked, small coyote tracks pendant from each diamond *(LA 23546/12).*

alternating brown and natural lines. There is an unusual tray with two encircling rows of alternating elongate bands of tan and brown, each with an opening at the same point. One of the most dynamic of earlier pieces has four rows of design curving out from left near-center to the right and to the rim. The pattern is also dynamic on a deep tray which features two wide zigzags spaced between an inner and an outer plain band, all in red and green (Fig. 5.9).

Animals are to be noted on rare examples of early Jicarilla trays. Three sets of bands, two vertical and a horizontal one, combine to create a space on one tray in which there is a horse. The animal is a long rectangle with a smaller rectangle for a head and mere lines for legs, all in brown. A second animal-decorated tray is more ambitious, both in its brown and faded purple colors and in the number of animals, ten. Six horselike creatures parade to both right and left, while four smaller ones appear above these, all very angular.

The hamper seems to have been a popular Jicarilla form, for quite a few appear in various collections (Fig. 5.10). Layouts on this form are varied, with vertical and horizontal organizational-banded styles two of the favored. Either of these can be true bands, or the bands can be so close together, or even overlapping, that they create an all-over style. Other all-over arrangements also occur.

Zigzags were popular for hamper decoration. These vary; on one piece a simple large seven-pointed, red-blue-red form just below center is combined with dim but similar red ones at the top and

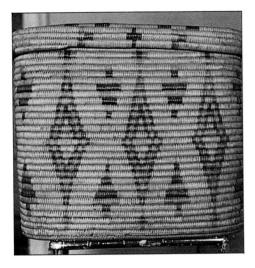 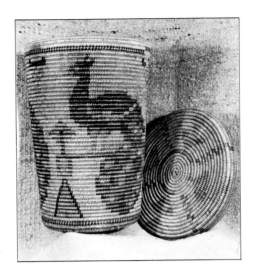

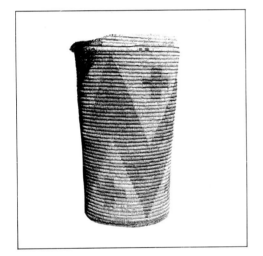 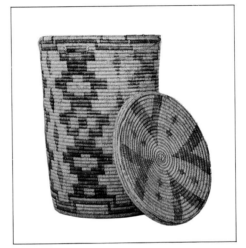 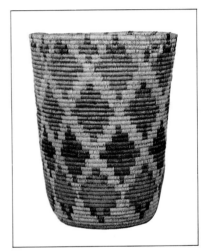

bottom. This hamper was 16″ high, with handles at the very top of the basket. Two parallel zigzags ornament another of these pieces, with their tips starting a few coils above base and reaching to the handle openings a few coils from the rim. The two handle openings are well made, each two coils high and evenly rectangular. The lid design repeats the body pattern colors—red on each side of a green-brown line, these lines forming four chevronlike units.

On another hamper five parallel zigzags cover practically all its surface; because of the number, the motifs are much smaller than in the previous examples of the same theme; red-brown is the color of the design. A two-coil handle on each side of this piece is located four coils below the rim.

In all of the above hampers the zigzag is the sole or the dominating pattern. In another piece it is one of the dominant themes, for heavy crosses appear both above and below and between points. The zigzag here is the heaviest noted: it is 6″ in width. Too, its four upper points touch the top of the hamper, and below they touch a red coil at the base. This zigzag is made up of two outer red bands and an inner purplish-brown one. The lid to this piece is decorated with a four-pointed, green-red-green outline star, and with double purplish-brown chevrons at its very edge and between star points.

In another Jicarilla basket hamper, a four-pointed zigzag appears on the upper half of the wall but shares the lower half with four massive crosses. Colors touch in the zigzags and include red, green,

Fig. 5.10. Hamper decoration by the Jicarilla basket weaver. (a) A wide hamper with vertically elongated diamonds in red, purplish, and yellow as the chief motifs and with arrowpoints in red and purplish between them *(Wyoming State Archives, Museum and Historical Department 5433.2ab).* (b) Hamper with an elaborate peacock decoration *(The Heard Museum Collection, Phoenix, Arizona).* (c) A slender hamper decorated with a deep zigzag in red and faded purple, and with crosses between tips of the zigzags *(Wheelwright Museum).* (d) An elaborate arrangement of heavily stepped diamonds in vertical rows *(SAR 78-1-29).* (e) All-over diamonds in orange, red, and blue-green *(SAR 78-1-128).*

orange, and blue. Two of the crosses are, from inside out, orange, blue, red, blue, while the two others are the same plus an extra red on the outside—this little extra touch of a color is frequently added by the Jicarilla basket decorator. All colors are in lines. On the inward sloping (to the rim) short neck of one hamper are two rows of small triangles, while on the wall proper are three very large "Navajo style crosses," that is, with tiny designs at the corners; in this case, they are coyote tracks. In the center of each cross is a purple square; from the corners of this start a green outline cross, then there is a red outline which forms the outer and dominant element in the cross. This basket is 19½" high.

Illustrative of the vertical organizational-banded style of layout is the design on a 26" tall hamper. Four large elongate diamonds stretch from near base to rim, these done in successive outlines of brown, green, and red. Geometric and life forms are vertically stacked between the great diamonds, these repeating the above mentioned colors plus orange. An oval hamper features similar elongate diamonds, three on each side and one at each end. Fair-sized arrowpoints between the larger motifs make the diamonds seem smaller than they are. One beautiful hamper design involved peacocks with tails in full glory of green and purple!

An additional vertically aligned pattern presents another stacked arrangement, this time a half-diamond, three full diamonds, and an ornate, almost-coyote track, all heavily stepped, and featuring red with blue-green and/or orange and yellow. Small, elongate diamonds vertically arranged and spaced out appear between the colorful major motif. The lid is ornamented with four large chevrons in brown, red, and blue with tiny coyote tracks between them. The bottom of this hamper is plain.

A last hamper in this series is in the all-over style of decoration. It has four overlapping horizontal rows of stepped diamonds, eight each, in a variety of colors. From the bottom, the first row has solid orange diamonds outlined in brownish-purple, the second row is solid red, the third is blue or gray, the fourth this same last tone but with other colors added at the tops of the diamonds. Varicolored coyote tracks appear at the very top of this series, between the main motifs. This hamper is 22" high, 16¼" at the rim, and has two handle holes each 1" by 1¾". A careless design of colored or partially colored coils decorated the base.

Two pitchers or jars with a single handle each, and footed, reflect several typical Jicarilla details; they are woven of the same materials used by this tribe and are decorated in typical designs and colors. Pedestal or footed bases are in red and natural in one jar and there is a purplish line on the other. On the lower part of the rounded body of one pitcher there are six repeated stepped diamonds in a purplish color plus other faded tones, above them a two-coil line. Large stepped diamonds appear on the wall proper; they are in solid orange with a faded purple, then a red outline. A single coil line with the double coil below form the enclosure band for this main theme. On the neck are six small, elongate, purplish diamonds.

The second pitcher repeats the arrangement on the lower body of the first, but design is in the form of rectangles; then there are two zigzags on the body which touch points, thus making diamonds, in each of which appears a green, outlined red rectangle. This last element is repeated outside the top zigzag and again on the neck.

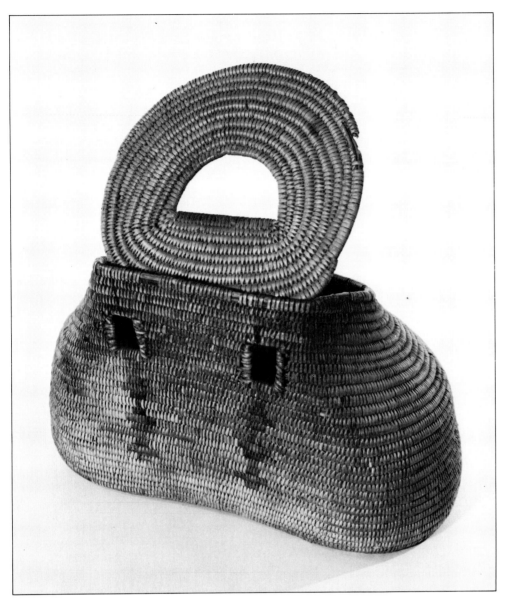

Fig. 5.11. Jicarilla creel decoration: on the bottom is a red circle; on the rounded face are three double diamonds with red interiors and green edges (these show on interior only); on each end is a dim, wide diagonal red band. The only design that really shows is on the flat back side: three coyote tracks in green with red interiors *(ASM E7387).*

Creels reflect general decoration traits of Jicarilla basketry (Fig. 5.11). For example, one had a 3″ red band of design. On the rounded front originally there were three double diamonds, each with a green interior outlined in red. A wide and diagonal red band ornaments the ends, while on the back side are two stacked coyote tracks, again with green interior squares and red outer squares.

A water jar reflects typical Jicarilla interior pitching and decoration showing on the exterior; however, the latter is very dim. What little remains would indicate zigzags of red and green.

In summary of these earlier styles of Jicarilla basket decoration, the following generalizations can be made. Trays have sloping sides, flat bottoms, and are relatively deep. Coil beginnings are splayed out in the manner of the start of the Navajo basket. Coil endings on the braided rim are predominantly gentle; stitches are generally close. For the most part it would seem that willow rods were used for foundations while sumac was favored for sewing, but all-willow or all-sumac combinations were noted. Outlines of designs in brown or red-brown may range from one to six stitches or occasionally more. Designs may be solid, or made up of rows of two alternate colors, or in a solid color outlined with one or more other colors.

Simplicity characterizes much of the patterning in early Jicarilla basketry, a simplicity which often verged on the sophisticated. Yet there was variety in design, in elements, units, and motifs, and in their arrangements.

With the revival of basket making among the Jicarillas in 1958 or 1959, these tribeswomen continued with some of their old traditions but also as a group stressed some new directions. They continued to use willow and sumac, they perpetuated the three- and five-rod foundations, and some women in particular continued the fine sewing of their traditional background. Some of the old colors continued to be used, but the wide range of commercial dyes appealed to many weavers.

To be sure, there were a few Jicarilla women who continued to weave through the decades and up to this revival time. Some designing was strictly conventional and traditional, while an unusual individual now and then ventured into some experimentation with new colors and designs, some were more creative. The story of Tanzanita Pesata, as told by Joyce Herold,[5] presents just such a picture of a Jicarilla woman who continued the traditional but also whose creativity brought into focus new ideas. Perhaps the fine pieces woven by this capable woman might be labeled "transitional," for they combined the best out of the past and foreshadowed much that was to be evolved after 1958. Undoubtedly Tanzanita influenced many of the women who became involved in the "revival," for some of her baskets were on display in the early 1960s at the first Jicarilla Tribal Fair. Too, the white man who had taken over the Dulce Trading Post entered a group of baskets made by the women of this tribe in the Gallup Ceremonials and the entry took a first place, which offered great encouragement to the Apache women to continue weaving.

Specifically, Tanzanita's work reflected the traditional in the following traits: Some of her trays were deep and flat-bottomed; she produced the old-style hamper with a lid, the creel, and the round-bodied, coiled water jar. The past and present met in her colors, for even though she favored "a more traditional palette of the primary directional-symbolic colors of black, yellow, and blue or green on the white of the background,"[6] she also used much red and brown in her basketry. Apparently she also favored "commercial fabric dyes" for some of her work, apparently using the "Navajo Rug Dyes" introduced by the trader at Dulce, this last used extensively by the revival weavers.

Tanzanita used a variety of designs as indicated in the following. On a coiled water jar are slightly curved oblongs in yellow outlined in a darker color. Geometrics are applied to a hamper in the form of repeated, vertical, and elongate triangles with a lesser theme in between them. An example of one of her creels features stacked pairs of joined triangles alternating with a vertical series of small squares. One deep tray is ornamented with four treelike devices with branches of alternate red and green. Between the trees are two double and stacked triangles, each half black, half yellow, and with the colors alternating from lower to upper triangle. Animals appear in several of Tanzanita's baskets on display in a 1963 exhibit at Dulce. Animals in the two baskets, a horse in one, a deer in the other, are more realistic than the much earlier examples of the same

cited above. One tray is decorated in the center with a wide and solid yellow circle which is outlined with two black circles. On the wall are two opposed deer (a), each with great horns; four symmetrical plants with two branches of balanced leaves on each side and a flower on the top (b), all in red, green, and yellow; and two pairs of stacked yellow-red and red-yellow triangles (c). The rhythm of repetition of these three major motifs is abcb, then this is repeated again. Two or three motifs occur commonly in Tanzanita's basket decoration.

The description of Tanzanita's basketry decoration would apply to much of the revival style. These described pieces plus others at the 1963 exhibit, both by this outstanding weaver and other Jicarilla women, plus additional baskets observed at the Gallup Ceremonials in the 1960s, will serve as a basis for further comments on revival-style Jicarilla weaving (Fig. 5.12).

Forms featured in the later baskets are the tray first, a few bowls both circular and oval, and even fewer additional forms, such as jars.[7] Trays are characteristically deep, as they were in earlier years. A few more shallow trays have handles which are produced by extending outward the last coil or two. In general, a light background prevailed, with various colors applied to this. However, a few of the pieces noted would have a wide band in a darker color and then have designs in negative against this dark ground. Colors in the "Navajo Rug Dyes" ran the gamut from light to dark and with a wide range in primary and secondary colors. In individual baskets there was everything from brown designs on an aqua background to a combination of black, red, yellow, two shades of green, and natural on a single tray. Favored were red, black, and yellow on a natural ground, this noted on a number of trays. Other colors observed were blue, orange, and turquoise.

Design elements and units included the old and familiar lines, tiny squares and rectangles, large and small triangles, squares, chevrons, diamonds (including the previously described "Apache" style), crosses, and coyote tracks. The star or floral theme was not common. A highly stylized bird was noted on several baskets, as were unusual floral or plant themes. Although many of the elements and units were the same as used in earlier years, they are combined in quite different ways in these later baskets, almost always with a larger number of elements on a single basket.

Fig. 5.12 Revival style baskets of the Jicarilla (post-1960) (a) A 1975 example which shows characteristic designs and colors: diamonds in red, green, yellow, and black, alternating with two stacked triangles in red, green, and purple *(Gallup Ceremonials)*. (b) Six sets of joined, stepped pairs of right-angle triangles in black and orange *(ASM E5673)*. (c) A 1963 basket, aniline dyed, with a long favored floral pattern in red, purple, orange, and black *(ASM 5674)*.

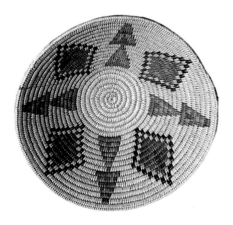
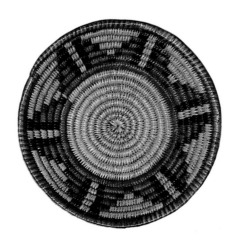
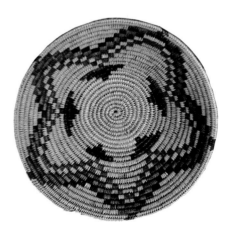

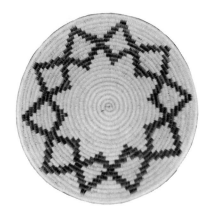

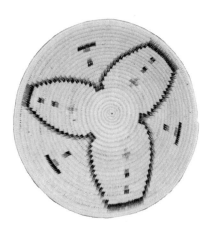

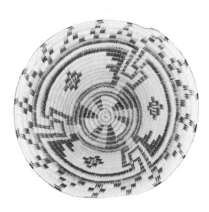

Fig. 5.12. These photographs, as well as those on the facing page, illustrate designs which deviate from the old styles. A great variety of colors is used. All above are from Dulce, New Mexico, 1963. (d,e) Two simple patterns, with joined outlined diamonds on the top, a three-petaled flower on the bottom. (f) A very complicated pattern with a rayed center, then three swastikas moving into a double-lined band, next alternating coyote tracks and almost-triangles in a band at the rim.

Design arrangements in these pieces were of two basic types, an organizational band (less often a true band) featured on the walls, and a composite centered-banded style which often covered most of the basket. This second layout may sometimes appear more like an all-over arrangement, but on closer examination it is almost always organizational- or true-banded. Centers might be solid yellow or brown, with or without a darker enclosing circle line or lines of black or other color, and often of large size. In the banded style centers are often in the natural light color of the weft. Alternate black-white or dark-light stitching is also involved with center themes of the composite style. A dark solid center circle or encircling line might also have attached elements such as bent lines, which in one basket formed a swastika-like motif, in other pieces heavy V-shaped figures or coyote tracks. In one basket there was a central dark circle which formed the body of a great-winged bird.

The organizational style band ran the gamut from simple to complex. One basket had joined outline diamonds, another a simple outline three-petal flower with a few tiny geometrics thrown in here and there. A little more complex was a four-unit outline cogwheel of two colors, with stepped diamonds in between. An oval tray has hourglass motifs, two of lighter centers and dark outlines and more curvilinear, and between them Apache diamonds in heavy outline steps. Beneath each hourglass figure is a fair-sized coyote track.

Both floral and animal life themes, such as plants and horses and deer, occur rather more commonly than they did in early years, and generally in the composite layout style. The animals tend to be more naturalistic, as mentioned in relation to Tanzanita's basket decorations. Too, proportions are better, legs are more shapely, the deer more realistic with its great antlers. Floral motifs may be merely suggestive or slightly realistic, the latter sometimes topped with a flower. These elaborations are often combined with very simple centers.

The centered organizational-banded layout is also well represented in the basket with the bird motif mentioned above. This centered creature is very large and highly conventionalized, while the band is less impressive and less dynamic for it is a broad meander outlined in a darker shade; a cross is enclosed in each open area which tends to slow down what little motion the meander may have. The bird is quite dynamic because of its curved and triple-coil line wings. A second example of this composite style is represented in a Tanzanita basket. The center is made up of several yellow coils, four coils of alternate black-white stitches, then three more yellow coils. Six natural coils away is another band of alternate black-white stitching, then the wide decorative band. In this are arrowpoint-like motifs alternating with a figure designated as a "butterfly," both woven in black, red, and yellow. The outer edge of this decorative band is a repeat of the several coils of alternate black-white stitches.

Most of the baskets observed in this composite style involve geometrics. The center may be plain, or it may be complex. In one basket is a large black center with two bands of geometrics between this and the rim. Or there may be successive rows of spaced out geometrics, all arranged in organizational bands.

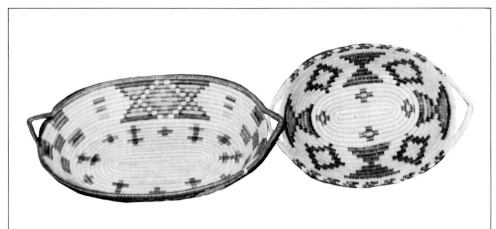

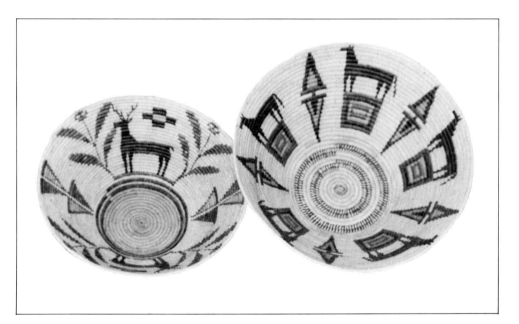

Fig. 5.12. (g) On the left an oval tray with hourglass-diamond-hourglass patterns on the sides, large coyote tracks at the ends, and small elements below and in between. Right is a solid hourglass on each long side, with an outline diamond bordering each, three vertically arranged and varied triangles at each end, and small elements bordering all both inside and at the rim. (h) A spread-wing bird within an elaborate geometric border. (i) Life forms are a little more popular in this revival style basketry. On the left is a deer bordered on each side by a plant, and these alternating with opposed stacked triangles which are one color in one half, a different color in the other. There is a dark center bordered by a double-line circle with the weaver's pathway opening at one point. On the right are varied geometrics with a horse standing on each of four rectangles which alternate with vertically joined triangles. *(5.12d through h, courtesy of Dorothy Cumming.)*

In summary of the revival style of Jicarilla basketry, the following may be noted. In materials and in technique, the weavers followed established tradition. They added a wide variety of aniline dye colors; frequently they used more colors in a single basket, and more design elements in a single piece, more elaborate designs. Withal there is more control in the handling of color, less in the way of haphazard insertion of a touch of a different color here and there. Patterns tend to be better spaced, better balanced. Traditional outlining of one color by another persists. Despite these comments, it cannot be said that Jicarilla revival basketry is better than many of the fine old pieces of turn-of-the-century times.

Mescalero Apache Basketry

A T A YOUNG GIRL'S puberty ceremony "The girl crosses the blanket, stepping on the painted footprints, and then runs four times around a basket, in which eagle feathers have been placed. A number of children run about with her and pass her the feathers. She is then bidden to run to an indicated tree or bush. When she reaches this, she is expected to go to her home....Later the girl brings a basket of fruit to the priest, who places some of it, together with pollen, in her mouth. Until this is done, she is not allowed to eat."[1]

Thus it was written in 1909 of the use of the native-made coiled basket of the Mescalero Apache for the Coming Out or Puberty Ceremony, called "Gotal" by this tribe. This custom, with some variations in construction and design of the basket, and with differences in the ceremony itself, was common among the three Apache groups of the Southwest.

In their earliest years in the Southwest and Plains areas, certain aspects of the social order may well indicate the use of baskets by the Mescaleros. "Mothers and daughters were inseparable,"[2] whether pursuing agriculture or gathering wild foodstuffs. Presumably, when in the Plains area in the fifteenth century, these Indians not only hunted big game but also gathered and, in some parts of the area, did a bit of farming. All of these activities would have encouraged the use of baskets. As some of these Indians in the Plains traded with the Puebloans, it is possible that they were influenced by the basketry of these New Mexico village people.

It is also thought that some of the Apaches, probably including the Mescaleros, began raiding into New Mexico for horses around 1620. This animal gave them more freedom. However, as other Indians acquired the same advantages, some set upon the Mescaleros, driving them into the mountains of New Mexico in the early 1700s. Now as a separated tribal entity, it is likely that they developed their own basketry styles. Their increased gathering of piñon nuts, pear cactus fruit, and mesquite beans made more baskets advantageous.

Trouble ensued during the eighteenth century, with further wandering occurring at this time. Toward the end of the century, in part

about 1881, it seems that the Mescaleros "also traded beautiful willow baskets women made to Mexican orchardists for peaches, grapes, etc."[3] In 1895, when some Navajos were imported into Mescalero country to teach them weaving, it is thought that "basket making declined."[4] Poverty increased, and from the 1880s to the early twentieth century some crafts were produced for sale in order to bring in a little cash to the Mescaleros, including basketry which was reputedly well made.[5]

In a report of 1931 it is evident that the earlier willow basket of the 1880s was now made of another material and undoubtedly by a different technique. These Indian women used "two rods placed one above the other in each coil of the foundation.... Above the rods are placed two or more strips of leaves to serve as a welt. The material used for sewing is chiefly obtained by splitting the leaves of the narrow-leaved yucca. These are used green, partly bleached to a yellow, or entirely bleached to white. A red material is obtained from the root of the yucca. These decorated baskets are made principally for sale, although they are used to some extent for storage."[6] Writing in 1939, Douglas adds two variations to this foundation: "three rods and a bundle; and a quite wide thin wood slat and a bundle."[7] Thus the Mescalero style of coiled weaving and color were well established by this date (1939), forms were hinted at (jar for storage and the tray probably for sale), and design was present as mentioned, the star pattern in particular as illustrated in the report in a tray decorated with this motif.

Goddard, the author quoted above, goes on to say that "The water jars are similar in shape to those made by the Jicarilla, but they are frequently pitched on the outside as well as inside. Burden or carrying baskets are still in common use. They are made by varied processes of twining which produce decorative effects. The material most desired is mulberry, the twigs of which are exceedingly durable. In most cases the women do not assign such names to the designs as would lead one to think the patterns are intended to be symbolic. One old woman, however, pointed out on a very crude basket the milky way, morningstar, and a rainbow. These particular things are considered very sacred, and in spite of the denials of many of the women it is probable that Mescalero baskets do often have symbols on them which are expected to benefit the users of the baskets."[8]

This last quote indicates additional Mescalero basketry features by the 1930s and, very likely, for some years prior to this time. Most of the Mescalero water jars have straight or almost straight and tall necks and round bodies. They were coiled and usually undecorated as were those made by the Jicarillas. The burden basket description sounds more like a Western Apache style. As to design symbolism, one never knows to what extent the Indian is attempting to please the white questioner. Certainly as these baskets were commercialized they lost any symbolic meaning—that is, if they ever had any.

Little is recorded about Mescalero basketry before 1900, and the tribe's wandering habits would have destroyed evidences of basketry. However, there are some relatively brief comments by ethnologists and others for the first three decades of the nineteenth century. These are supported by actual pieces in museum or private collections. The following discussions are based largely on research of the latter.

TECHNIQUES AND MATERIALS

To summarize and elaborate upon the above statements, it can be said that two techniques were commonly used by the Mescalero Apaches, wicker and coiled. The first was productive of their burden baskets while the second technique was used in the weaving of water bottles and all other forms. Douglas says that all Mescalero water bottles were coiled.[9] Wicker involved two styles, plain and twined, the second indicating double and triple strand, the latter usually involved with decoration.

As noted previously Mescalero coiling, except in water bottles, is quite different from that of the other Apaches. In the first place, the foundation was of two or more rods, one above the other, and often with another and different element on top. It is the style of two rods, one above the other plus two or more strips of leaves which serve as a welt, that was more often observed than any other. It is into or under this welt that the sewing is done in each succeeding coil. Walls of these Mescalero baskets are characteristically thin and flexible. Different colored threads are inserted or carried under the coiling on the wrong side (inside of jars, outside of trays) until needed. Sometimes these are obvious. Frequently a thin strand is placed between rods.

The basket is started with a wrapped circle, sometimes quite rough, and the first coil usually takes off directly out of this center and is sewed into it. Coiling stitches are long and slender, and coils move outward in a counterclockwise fashion. Stitches are vertical throughout and into the rim; they are either even and well done or, not infrequently, rather coarse, uneven, and split. Basket edges are finished in the same stitch as the rest of the piece, with design often terminating in the rim, regardless of form. For example, this has been observed in jars, trays, and deep, straight-sided forms.

Adding to the above comments regarding materials, Bell and Castetter report that *Yucca baccata* and *Y. torreyi* "were employed by the Mescalero Apache for the main portions of their baskets and their roots were used to produce a red pattern."[10] White came from interior leaves and the green of designs came from the "outer greenish-yellow coarse part." Opler presents an interesting explanation for yellow as produced by the Chiricahuas, one tribe within the Mescalero group: "To turn the yucca yellow, put dry leaves among the leaves in the yucca plant while it is standing in the ground; then set fire to the grass. The fire and smoke turn the leaves yellow."[11]

Opler further notes that the basket tray used in the Chiricahua girls' puberty rite must be decorated in black, this color derived from the unicorn plant (devil's-claw). Both willow and cottonwood were rarely used in these baskets; like the typical Mescalero, these Chiricahua tribeswomen used yucca for sewing and sumac stems for the foundation. Their burden baskets were woven of sumac or mulberry, their water bottle of sumac "or less frequently, of mulberry." On the latter, Opler says, hide or wood was used for handles; for the former, buckskin or rawhide was employed for the bottom patch.[12] Burden baskets are also decorated in the weave with elements which have been colored with native dyes; too, they may be further ornamented with tin tinklers and buckskin thongs.

Like other Apache tribes, the Chiricahuas cover the water jar with piñon pitch to make it waterproof. Opler says that they pour soft pitch into the bottle with hot rocks, turning the basket until the interior is coated. The outside is sometimes pitched. First the weaver may cover the surface with red ocher. A stick with buckskin on its tip is dipped into hot pitch, the worker then rubbing the water-proofing material over the jar. While "still a little warm, she dips her hand into water and smooths the jar to make it prettier."[13]

FORMS

Mescalero basketry forms are rather limited in number. They include the tray, bowls, burden baskets, water bottles, straight-sided and deep forms (Fig. 6.1), and a few odd shapes. There is some slight variation within each basic shape but not the variety to be found in Western Apache baskets.

Most important is the tray; this seems to have been an all-purpose piece in this tribe and the form was pleasingly adaptable to commercial purposes. The basic tray is shallow and with a continuous line from rim to base, with almost no variation in these two features.

Bowls were fairly common, but not as abundant as the tray; perhaps they were more common when used by the natives. Both round and oval forms were woven by the Mescaleros, and both had flat bottoms. The majority of these pieces did not have lids but some few did. Lids tended to be simple, with a lower extension fitting into the basket proper and usually without any kind of handle.

Burden baskets were of two basic shapes, a simple cone and a bucket style like the Western Apache (Fig. 6.2). It is likely that the

Fig. 6.1. Forms of Mescalero baskets. From the top: a very flat tray form is typical. A few bowls were woven. Straight-sided forms, from shallow to deep were not uncommon. This is characteristic of the form of the coiled jar (wicker ones were also woven). A more bucket-like shape was typical of the burden basket, some of them more shallow than in this sketch.

Fig. 6.2. Mescalero burden basket. This piece is like the type described by early writers: straight-sided and with tin tinklers tied close to the basket wall, originally with short buckskin thongs *(private collection)*.

cone-shaped style served the Mescaleros in their seed gathering days but may well have gone out of style as these Apaches became more agricultural. Too, this form has never been particularly popular as a commercial item. Bucket-shaped burdens were probably never too abundant among the Mescaleros; perhaps the idea of this form came to them by way of Western Apache contact, perhaps even by way of the Chiricahuas. Few of this form of burden have survived.

Undoubtedly water bottles were very important during the wandering days of the Mescaleros even after they retreated to the mountains of New Mexico where they had more abundant water resources. The fact that they show little variety in shape would support the contention that they never became commercialized, for these Indians were prone not to vary basket shapes to any degree for their own uses. In general the body is round, sometimes more elongate. An occasional bottle is shouldered. Fairly straight and long necks predominate, although occasionally there is slight deviation from this standard, for example, an outflaring of the upper part of the neck.

Another jar was produced in the flat, wide-coil technique; yet its shape was very much like that of the above water jar, round bodied and straight necked. It is quite likely that this piece was the commercial answer to a jar style. To further support its probable commercialization is the fact that sometimes this jar has a large woven handle which reaches from the neck rim to the fullness of the rounded body, thus making it more of a pitcher. This jar was decorated, whereas the water bottle seldom was.

A last general form is straight-sided and deep, sometimes like a wastebasket, sometimes like the Jicarilla hamper. Wastebaskets were often slightly smaller in the base diameter than at the rim, whereas the hamper is much more nearly the same in rim and base measurements. Seemingly the Mescaleros did not produce the very deep hampers such as made by the Jicarillas.

Mescalero Apache baskets varied some as to size. When using these pieces themselves, they tended to make larger sizes; a few fairly large ones survived into the days when baskets were made by these Indians to sell, but the general trend was in the direction of smaller pieces, particularly trays. Water bottles and forms other than trays were rarely made in these later days. In 1975 a few water jars were observed at the Mescalero Arts and Crafts Center. Trays are from 12″ to 24″ in diameter, from 3″ to 8″ in depth. Oval bowls seem to have been almost exclusively for native use; an average size would be 16¼″ by 10″ in diameters and 8″ in depth. Some were smaller, some larger. Oval bowls were limited in production and all observed seemed to be old; this is reflected particularly in more simple decoration. On the other hand, round bowls were more abundant, especially in later years. One of these is 15¾″ in diameter, 5¼″ in height.

As noted, deep forms vary; some are more like wastebaskets, others are like hampers with lids. One of the former measures 9¾″ at the rim and is 11⅞″ high, another is 9″ in diameter and 7″ high. Usually this form had a slightly smaller base while the hamper tended to be more cylindrical. Dimensions of one of the latter are 11″ in the rim and about the same in base diameter and 11″ in height.

Coiled jars were on the small side, one measuring 10¼ + " high, 4" at the rim, and 10⅛ " at the widest part of its bulbous body. Water jars are often about the same size, larger for certain native uses and generally smaller when made for sale, as in some late pieces. One measured 9" in height, 9¼ " in rim diameter, and was a little larger in greatest body width. Too, it has been said that larger jars were used for tizwin (a native drink), smaller ones for water.[14] Burden baskets are not numerous; one which was observed measured 8¾" at the rim and was 11¾ " in height.

DECORATION

Decoration on Mescalero baskets is simpler by far than that on either Jicarilla or Western pieces. Subdued color is the dominant decorative approach. A fair variety of elements and units in color is used but, characteristically, a limited number appear on a single basket. Most common in this decoration are yellow and a soft reddish brown with occasional use of other colors. Green was undoubtedly used, and, more rarely, both blue and black. As a matter of fact, it is likely that more green was originally used, but the green yucca had a tendency to yellow with age.

Another decorative technique involves the addition of other materials, particularly buckskin and tin tinklers. These are neither as abundantly nor as flamboyantly used as they are on Western Apache baskets. Apparently the more common use was to place a ring of tin tinklers at the rim on the outside of the burden basket on short pieces of buckskin (see Fig. 6.2). In examples of burden baskets studied, more commonly there was no use of either buckskin or the metal tinklers. It is possible that they have disappeared but more likely that they were never employed for decoration. Occasionally bottom patches are to be noted.

It should be noted that form rested on its own laurels as decoration in some baskets. This is particularly true in the coiled water bottle, but even here, there was, seemingly, little variation from a basic rounded form (see Fig. 6.1). As mentioned in this general discussion of form, there was slight experimentation with the neck, with an outflaring rim perhaps the most common result. Body forms were serviceable first, decorative as a second thought. As observed, little more than the elongation of the rounded style was in evidence in the Mescalero bottle body-form variation.

As in the burden basket elsewhere, encircling bands of design were typical of this piece (Fig. 6.3). As elsewhere, too, these varied in width and in numbers. There were fewer elements of design comprising these bands in Mescalero pieces than in Western Apache baskets. Squares, solid narrow horizontal bands, wide and short and vertical bands, diagonal lines and bands were dominant in the Mescalero burden basket designs. Brown and white comprised the usual color combination, although blue was noted in one piece.

Even though the twined water bottle was undecorated usually, Mescaleros ornamented their coiled jars in color (Fig. 6.4), and sometimes added a handle. In one example, on the base were a plain yellow center and a yellow encircling line. Yellow and red-brown diamonds and a composite element plus yellow coyote tracks ornamented the walls and neck of this piece. Another jar pictured in

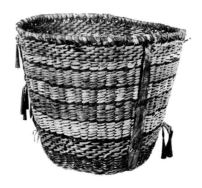

Fig. 6.3. Mescalero wicker burden basket of bucket shape, woven of yucca, with bands of yellow plus outlines of red-brown *(ASM E6799).*

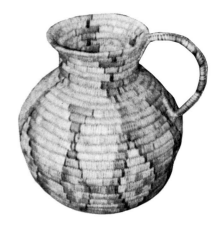

Fig. 6.4. This coiled Mescalero jar, obviously unpitched, reflects the predominantly round-bodied wicker style, but this one has a more graceful outcurving neck and the addition of a handle and color decoration *(LA 14405/12).*

Lamb [15] apparently with a low neck (but it is broken) has zigzags in yellow and red-brown; lower on the slightly sloping-sided jar, and from the bottom, there are in succession two red-brown, one yellow, one red-brown, and one yellow unit. Higher, and almost to the widest diameter at the shoulder are two other zigzags, one red-brown and one yellow. Seemingly there is design on the shoulder, but it is not clear. Another, and more squat form has decoration all in yellow; again, zigzags prevail. From the flat bottom are the following: a very wide zigzag and a narrower one, a blank space, then two more of the latter narrow zigzags onto the flat shoulder. Around the base of the neck are two plain yellow coils.[16]

Both waste baskets and more cylindrical forms were often decorated in much this same style, with slight differences here and there (Fig. 6.5). Bottom designs were often lacking, but they do appear in some of these baskets and are unclear because of wear. Simple patterns often are featured on the side walls. In one instance, large negative and joined diamonds reached from near base to near rim, and inside each was a smaller yellow-centered, red-outlined diamond, all on a yellow background, a simple but effective decoration on this piece. On another deep form a pattern came up from the base and a seven-division design was pendant from the rim, both featuring stepped triangles.

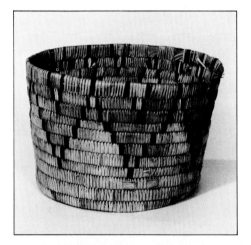
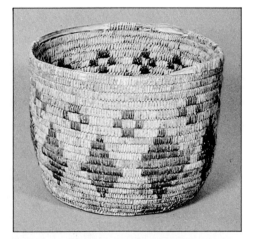
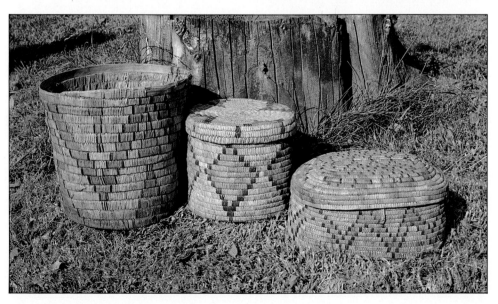

Fig. 6.5. Mescalero straight-sided vessels. (a) A shallow piece with wide bands of yellow outlined in red pendant from the rim, dated 1926 *(ASM GP4282)*. (b) A slightly deeper straight-sided basket decorated with red-brown diamonds and coyote tracks *(SAR B158)*. (c) Three straight-sided baskets, two decorated in zigzags, right and left, and one in diamonds, center *(private collection)*.

Not only were trays the most abundantly made piece, but they also incorporated the greatest variety of elements, units, and motifs in Mescalero designs. The simplest elements used included lines, squares, rectangles, triangles, diamonds, chevrons, and the cross. Any of these might be used in the simple or more complex form. And one or more of them might be combined into bands, zigzags, steps, meanders, coyote tracks, arrowpoints, stars and flowers, plus other more complicated themes.

Mescalero Apache trays are perhaps the most important of all forms, for they present numerous pieces produced through the years both before and after native use dwindled or disappeared. The tray is also a form in which the total design can be seen at one time; hence they have tended to be popular as a sales item. It may be that, because the basket always tended to be large, designs followed the same trend; too, greater size may have inspired simplicity of pattern which dominates in most of this work. Tray patterns present what might be called typical Mescalero design.

All designs used by the Mescaleros are to be found in their trays. Foremost among the units is the star. Then follow triangles, squares, diamonds, rectangles, lines, circles, chevrons, and some combinations of several of these used as single units, such as the cross.

There is considerable variety in the use of each element and unit, and in the combinations of several of them to form a theme which is often used in the manner of an element or unit. Each of the elements or units may be used in simpler or more complex form. Specific examples will illustrate each of these matters.

In one large tray (14½″ diameter) there is a star (or flower) which fills the piece, touching the last plain rim coil (Fig. 6.6). This five-pointed motif is outlined in two stitches of red-brown. All of the interior of the star is plain, natural material except for the last five internal coils which are yellow or light brown. Although the star points are not regular in size, the design is appealing, for no other elements appear to detract from it. The plain rim coil serves to frame the simple large star. Quite like this star is a second one

Fig. 6.6. Mescalero trays with their most popular design, a star or flower. (a) An excellent star motif formed of a broad yellow band with narrow red outlines on both sides *(SAR B162)*. (b) An early example of a four-petaled flower with outline triangles at the rim between the petals, all poorly executed *(ASM 13957)*. (Also see Figs. 6.7b; 6.8a, b; 6.10b; and 6.12.)

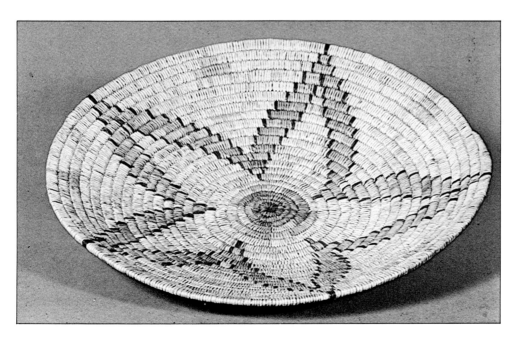

which ends in the rim coil of a 16½"-diameter piece. Added to duplicated color features of the first star is yellow between the lower parts of the points reaching to the yellow on the inside of points. This treatment has a tendency to make the design seem heavy. There is also comparable irregularity in sizes of points (or petals). Another star alone is eight-pointed; four points go into the rim, four end two coils from the edge. The full points are yellow, each outlined with one or two brown stitches.

Elaboration of this motif is to be noted in several additional Mescalero baskets. In one, there is a large central circle made up of a complex of plain white and tan coils plus some coils of alternate brown and white stitches. Taking off the edge of this is a six-pointed white star (or flower) which has, successively, a narrow brown outline, then another narrow brown outline. As the total pattern flows to the last natural rim coil, it leaves six light triangles edged by the last brown outline stitches. Again, except for the slightly heavier central circle, this pattern as a whole is quite subtle.

In a fifth large tray, this one 20" in diameter, is a still more complex floral or star theme which extends to within two coils of the edge. Here is a massive four-pointed design, each yellow petal with a diamond within it. Diamonds are very slightly darker than the leaf; the former is outlined in two red-brown stitches, the latter in three of the same. Each of these details of color and outline is repeated in four very large, curving-edge triangles which seem to hang from the rim, each with centered diamonds. Between the outer edge of petals and triangles is created a broad outline of a four-petaled flower.

Simpler is a finely woven piece with a ten-pointed star outlined in broad yellow and this, in turn, in red. Compensation for the large diameter, 23", of another tray is a heavy (three to six stitches) outline of a simple, four-pointed yellow star. The red outline goes into the rim. More complex is still another flower, a four-petaled one, with two pyramids of four steps each projecting out of their tips. The steps are yellow with red-brown narrow outlines. One simply outlined five-pointed star in another basket is white, while beyond the red outline the background is a mottled yellow. Because dating of these baskets is so difficult, it is of interest to note a basket collected by Hough, and pictured in Mason's 1904 work.[17]

Here the large star, emanating from a yellow center, is in negative, with the background in yellow. As the star goes to the second coil from the edge, the yellow background becomes triangles. At the tips and between the six points of the star are two-coil, T-shaped units in the same red-brown of the star outline.

The majority of flower or star outlines are stepped, some simply, some with definite squares for each step. Some steps are regular and even, some are irregular. Dark tips of each point or petal are not uncommon. Natural colored (white) centers are the usual style, but quite a few are yellow. The star or flower as the sole design motif in individual baskets is found frequently, but some additional unit or other motif is more often a part of the total design, with fair variety in the second theme.

Diamonds are quite popular motifs in these baskets (Fig. 6.7). In one, six stepped, outlined diamonds encircle the basket; yellow interiors fade into lighter centers. In another basket, six white diamonds outlined in red stand out against a yellow background.

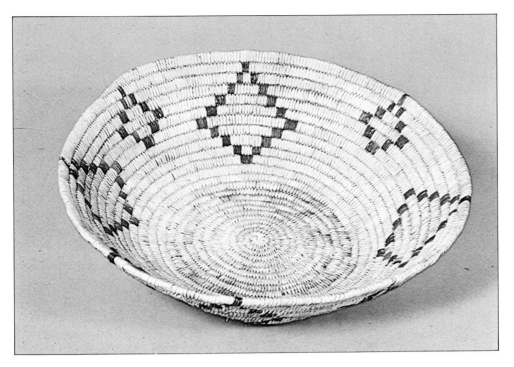

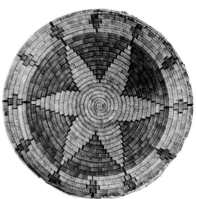

Fig. 6.7. Use of the diamond by the Mescalero Apaches. (a) A deep tray with four large and four smaller diamonds, all in yellow outlined in the usual red-brown *(SAR-B159)*. (b) Although the floral or star motif is dominant, the border consists of spaced-out small, stepped diamonds of yellow with a narrow red-brown outline *(ASM E6800)*.

In a 14″ tray five large double-outlined, touching diamonds dominate the decorative area; on the inner area five lines extend from a three-coil white center into the open area between the lower halves of the diamonds. A more elaborate arrangement occurs on a smaller basket of 12½″ diameter, with three overlapping rows of seven diamonds each. The rim is in alternate yellow and white stitching. In a 16″ tray, there are four large diamonds with outlines in red-brown squares, all stepped and moving into the otherwise plain rim. Between the larger themes are smaller diamonds of the same style.

There are other variations on the diamond motif, but this theme is not as common as the star or flower. However, like the latter, there are not only other variations in this motif but also additional themes combined with it. Colors are much the same, with the main theme plain or yellow, outlines red-brown. Further, the diamond often appears in combination with the star. For example, a six-pointed, double-outline star with a coyote track at each tip shares attention with six heavily outlined stepped diamonds.

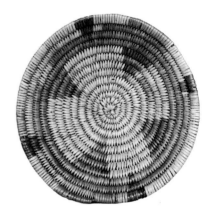

A variety of other motifs occurs in these Mescalero trays, none as popular and often not as dominant as the above two. A few examples will include chevrons, the meander, arrowpoints, triangles, steps, lines and bands, rare life forms, and combinations of varied geometrics.

Triangles are not commonly presented alone; more frequently they are part of or even created by another motif, particularly by the star (Fig. 6.8). Triangles may well be the result of the use of chevrons, especially at the rim of the basket. Here the V-shaped element may be outlined in darker color on two sides, letting the rim serve as the third side of a yellow triangle.

On the other hand, in a basket illustrated by Miles and Bovis [18] are independent triangles, eight fairly small, solid dark ones scattered over the surface and, closer to the rim, four more or less outlined ones. The dark triangles are almost right angle and are stepped on one side only; the light ones are equilateral and stepped on both sides.

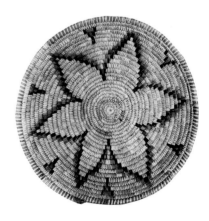

Fig. 6.8. Mescalero use of the triangle as tray decoration. (a) This negative cross (or flower with squared-off petals) is formed by triangles pendant from a band near the rim *(ASM 57063)*. (b) Very small, stepped triangles between the petals of the more dominant flower *(ASM 13517)*.

Another Mescalero tray has five simple curving lines near the center and five stepped triangles just beyond, all in white outlined in irregular red-brown stitching. One interesting basket has sets of three paired and stepped triangles, broad side up, alternating with the same but with broad edges down. All triangles in the pairs are connected by a narrow line. In some trays, stepped triangles which have a line extending downward look like highly conventionalized trees. More complicated in color are the triangles in another tray,[19] here combined with a floral theme which creates four large, curved-edged triangles which are mottled and move into the rim coil. On the yellow ground of these are smaller triangles, each made up (from outer edge to center) of a narrow red-brown line, a broader one of white and yellow, and a white center, obviously each outline and center repeating the triangular form.

Meanders are quite uncommon in Mescalero basketry (Fig. 6.9). One instance shows a stepped meander with a yellow center and brown outline on both sides. This motif is narrow in its verticals, and one-coil broad in its horizontal parts. This is a characteristic treatment. Some meanders are smooth, some are stepped. Chevrons are presented with points down, usually, but one example shows these V-shapes with points up, a row of them between the petals of a double floral theme. Some chevrons are single; some are stacked one inside another. Also, some are straight-sided; some are made up of squares. Zigzags, which are not common, are vertically arranged and may be single or double.

Stepped themes may be independent or they may form specific geometrics. Stepped edges are common to diamonds, triangles, and other forms, even to the edges of the star or flower. Steps may be only two or three stitches wide or they may be substantial squares or rectangles.

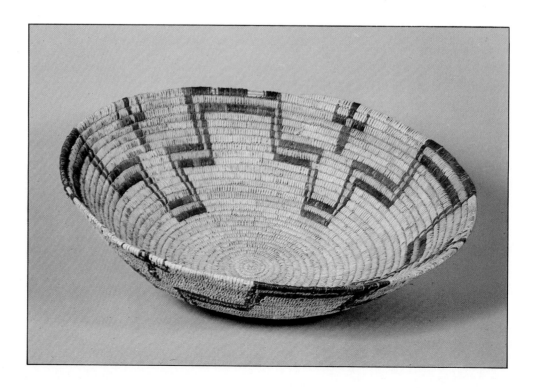

Fig. 6.9. Mescalero meander pattern. This example shows the usual yellow design here outlined on both sides with red-brown. Odd crosses appear near the rim *(SAR B291).*

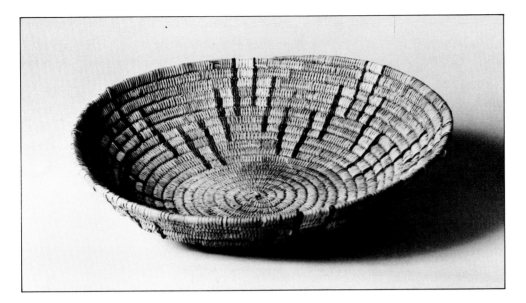

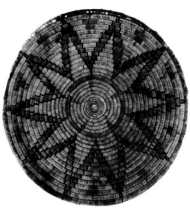

Lines and bands are quite common but are so often secondary to another design unit that they go unnoticed. Both are used extensively in Mescalero Apache tray decoration as outlining devices. Both may also appear independent of other geometrics. For instance, single, double, or multiple colored encircling coils form narrower and wider bands. Some bands are short, in vertical (Fig. 6.10) or diagonal arrangements on these baskets and usually in association with other units or motifs of design. One interesting example shows a vertical series of ten bands of varying short lengths stacked one above the other and between and beyond four diamonds. Outlining lines may be of single stitches; most commonly, they are of two, sometimes three stitches. They may be in positive (red usually, some yellow) or negative (white). Lines may be encircling, diagonal, vertical, and single, multiple, parallel. They are also used as fillers of geometrics. Although lines predominantly outline geometrics, occasionally they are used to create a new and different form. One of the most common of these is a vertical double line or band base supporting a short horizontal line out of which spring three equally spaced short vertical lines. The result is mindful of the Apache gans dancer headpieces of carved and painted wood.

Fairly common in Mescalero coiled basketry decoration is the coyote track, as usual, four squares or rectangles about an open central square or rectangle (Fig. 6.11). Various color combinations appear, as four yellow squares about a white center, or four white squares about a yellow center, or several others. This form may appear singly, or one on top of or beside another, and either style may appear independent of other decorative features. Or the coyote track may be in negative inside a yellow diamond or in positive at the tips of star points.

In like manner, the plain cross may appear in the center of a diamond. One example of a maltese cross shows it as a dominant centered theme, in dark yellow (probably from age). A possible arrowpoint (a large triangle with a smaller one cut out of its center top) projects from the top center of each of a group of triangles, and between these are coyote tracks. All in all, these units and motifs are combined into a rather unusual design for this Mescalero tribal basket. Other "arrows" of this type appear at the tips of star points.

Fig. 6.10. Bands and lines used in Mescalero basket designing. (a) This large tray, 16″ in diameter, is unusual in its line decoration in red-brown against a yellowed ground *(photo by Ray Manley, private collection)*. (b) Mescalero flowers or stars were commonly outlined in bands, this one of yellow with the usual red on both sides *(ASM GP52650)*.

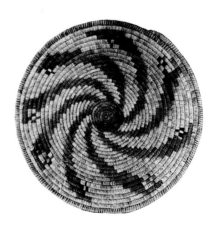

Fig. 6.11. An example of a small coyote track near the end of spirals built up of rectangles. In all but one instance, the track is attached to the spiral *(ASM GP53195)*.

Little more need be said of squares and rectangles, for they have commonly appeared in this discussion as forming other themes (coyote tracks, plain cross, chevrons, etc.), or as outlining the same or other geometrics (triangles, diamonds, etc.). Uncommonly they may appear as independent units of design, generally along with more important motifs. In one instance, four dark stitches, alternating with yellow in a band, suggest repetitive squares. In another tray brown-outlined squares are secondary to four large yellow diamonds. An interesting treatment of the rectangle is one with a yellow center with narrow red-brown sides, but with the red-brown missing on top and bottom.

Composite geometrics are unusual but do occur now and then in Mescalero basketry. For example, one combines the following elements built up from the inside out toward the tray rim: a diamond supports a long vertical line which has a horizontal rectangular crossbar a little above center and also supports a square at the top. All is in yellow outlined in red-brown. A second form involves a succession of the following, one on top of the other: a bottom square, a rectangle with a line out of the center top, a square, a rectangle, and a top square. One other interesting but odd geometric is made up of two vertical red lines with white between them and with two rectangles sticking out horizontally to right and left, alternating in placement on either side. The rectangles are yellow with red end stitches. There are five of these units encircling the tray.

Life forms were rarely used by the Mescaleros for basketry decoration. One tray presents two men and two women, all in yellow outlined in red-brown except the arms, which are slender and in the darker color alone. Very simple geometric horses are rarely woven into these trays (Fig. 6.12).

In summary of Mescalero tray design, it may be said that it is basically simple, often confined to a single motif. Seldom are more than three units combined to create a full design. Geometrics prevail, with life forms very rare. Yellow is the dominant color, with some of this unquestionably green in the original weaving. Red or red-brown is used primarily to outline, to emphasize form, and rarely to create separate parts of pattern. Stars, triangles, and diamonds are the dominant motifs. Withal, a simple sophistication prevails in Mescalero design.

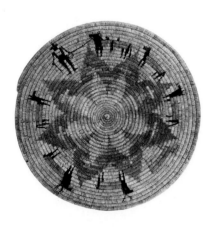

Fig. 6.12. A rare example of a life form in Mescalero basketry. Here a cowboy, complete with big hat and quirt in hand, has a horse by a rope, a saddle on this first animal. Then come three more horses, two deer, and another horse. One animal is all yellow; bodies of the rest are the same but the head and forelegs and the tail and hind legs are red-brown. Figures are between the points of a yellow outline star *(WAC 477).*

Problems and Perspectives

M ANY PROBLEMS HAVE ARISEN as a result of this study; some of them will be approached in terms of attempting to solve them, and, although some of them will be answered, some will go unanswered. Perhaps the latter may serve as projects for the student of tomorrow, for many of them need to be approached with additional knowledge regarding all of the following matters.

DATING APACHE BASKETS

One of the major problems is that of dating, and this is one which can be only partially answered. Unfortunately, there are too many collections which are not dated at all or they are misdated. It is amazing how many times this writer has been told of grandfather's collection which was made around 1870, giving the present owner a far greater age than he (or she) would confess to be; on second thought, the date of the collection was quickly changed. Occasional collections are accompanied by some information which will aid in establishing certain factors which are helpful in dating. An approximate or rough date and place of collecting the baskets is often of help in this matter. Thus, the dating of Apache baskets is a hazardous pastime, despite the fact that there are individuals who feel that they have all the answers.

Photographs are important in relation to problems of dating; at best, most of them are usually for a general time period and not of a specific date. Here too there may be pitfalls. However, if one has a reputable photographer's work in hand, with dates known when he was with a tribe, this can serve as a general control. But if a photograph is labeled "1860" without reason, or if it is indicated that the photo is "thought to be 1860," one must be wary. One other caution: photographers sometimes have their own props and take them from one Indian group to another for the purpose of enhancing a picture that is to be taken. One such photograph titled "Mescalero Indian" showed an Indian lady of this tribe with a Western Apache basket. Unfortunately, volunteer and other workers in museums or

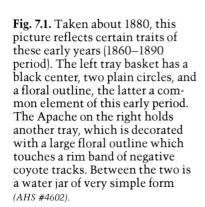

Fig. 7.1. Taken about 1880, this picture reflects certain traits of these early years (1860–1890 period). The left tray basket has a black center, two plain circles, and a floral outline, the latter a common element of this early period. The Apache on the right holds another tray, which is decorated with a large floral outline which touches a rim band of negative coyote tracks. Between the two is a water jar of very simple form *(AHS #4602)*.

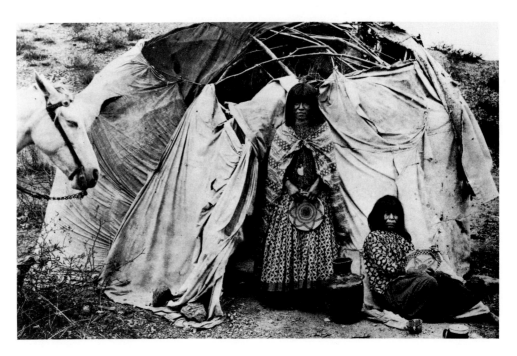

with other collections sometimes take it upon themselves to date specimens, often with questionable results, this perhaps more in the past than today.

If approached with caution baskets can often be dated, at least within a certain time span, on a basis of total characteristics of design, weave, and form. Some of these identifying features are bound to linger for a longer or shorter period, but the complex of all the traits is more apt to be limited in time. On the basis of total assessment of details of design and form, plus the use of photographs and a few more reliable dates of collections, the following broad periods have been set up for Western Apaches[1]: 1860(?)–1890, 1890–1910, 1910–1940, and post-1940. Even these dates are not absolute; rather are they relative.

For the 1860–1890 period (Fig. 7.1), the majority of the baskets observed had the following traits. In form they tend to have more gentle and simpler lines; trays, for example, are shallow and have sloping side walls from rim to a rounded or flat base, the latter, of course, often the result of use. Simple, too, is the water bottle outline, with a fairly long neck and a rounded body. Wittick photographs support these comments which are based on actual pieces.

For this earliest period, design analysis would fit into the category of the same basic simplicity. Much less design is encountered at this time on all forms. The burden basket may have two or three bands, in one instance each a little different in width but with the same designs within each. Another had one band with simple but dark-brown diagonal lines and a second band with a hardly discernible light diagonal line. The tray is most abundant in this earliest time; it too is characterized by the least amount of patterning, the fewest elements, and the largest undecorated areas between motifs. Although pattern was sometimes scattered over the entire tray basket, there was still a feeling of lightness to the complete design; more frequently it was restricted to a limited area. There are some solid and fairly heavy diamonds which reach from center or almost center to edge, but even here there is not the heaviness of the same theme

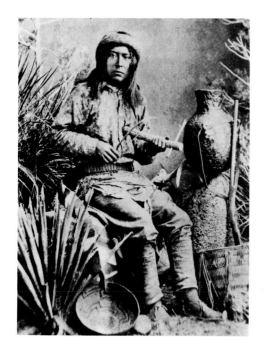
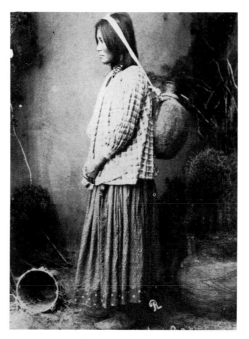

Fig. 7.2. Baskets of the 1860–1890 period. (a) This photo is dated at about 1886. The tray basket is decorated with a simple stepped pattern which reaches from near center to the rim; irregularities are noticeable in spacing and different widths of the steps. Banded patterns are to be noted on the burden basket to the right, the dominant feature of this decoration early and late *(AHS #30397)*. (b) This Apache woman shows the way the water bottle was carried *(AHS #51450)*.

as used in later years. Adding to all of this lightness is a typical small center circle, or, in some instances, no center motif at all.

Irregularities are to be noted in these earliest baskets in everything from organization of design to execution of pattern (Fig. 7.2). In layout, two styles dominate: one, organizational-banded, with the encircling pattern narrow and of small elements, and with some radiate, both static and slightly dynamic; two, all-over. In the all-over style, triangles along a line may take off a central black circle and move to the rim. Pattern may appear in one to five, or occasionally more divisions. Irregularities occur here also, for instance, in an a-b-a-b alternation of repeated single and double motifs, one is triple; or, in another basket, there are six paired motifs and a single one. Irregularity also extended to additional arrangements of motifs, with several pieces having different patterns on each opposed basket half.

Further details of design analysis can be applied to dating Western Apache baskets, as well as for characterizing decoration of this early period. For example, single elements predominate in each piece, although occasionally there may be two units, rarely more. These are the fewest elements in a single basket of any time.[2] Frequently there may be but a single line forming a meander, or rectangles, triangles, or squares, these forming radiate dynamic lines or narrow encircling bands, or stacked triangles, or zigzags. Other elements or units are rare. Some few of these arrangements are regular, but the vast majority are irregular.

Irregularities, then, characterize much of this earliest work except for quality of weave; however, there is an occasional basket which is well executed in design. It is not a careless irregularity, so often found in later work; rather, it has the feeling of a beginner's work. Perhaps these first known pieces have moved little beyond the first efforts of basket decoration on the part of these Western Apaches. Although the earliest observed Jicarilla baskets were a little more sophisticated, it is quite likely that they were influenced at an early time and in their beginning efforts by the puebloans.

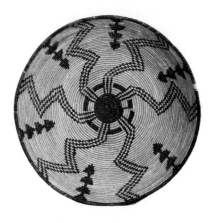

Fig. 7.3. A typical turn-of-the-century Western Apache tray basket (1890–1910 period). This example shows the use of two motifs: triple parallel zigzags and stacked triangles, the former showing action and many irregularities *(ASM 1593)*.

Despite all these less developed qualities in the earliest Apache baskets, there is one feature not again equaled to any degree, namely, wall thickness. Walls on Western Apache baskets are quite consistently thin in a majority of cases on pieces thought to be the oldest of all observed. Despite their age, some still have a flexibility not characteristic of later Apache basketry. Apparently, the oldest Jicarilla pieces do not share this quality with Western Apache baskets. Stitching may account for much of this in the latter's basket for it is short, often fine, and the coils are very small.

In the transition to the 1890–1910 period, it would seem that the Western Apache basket weaver stressed two traits, the addition of one or more elements and motifs to each basket design and a greater variety of layouts (Fig. 7.3). Irregularities remain, both in individual parts of design and particularly in spacing. Added, too, was a verve, a spirit of joy in creation, and a happy carelessness in much of this work.

Caution was sometimes exerted in the addition of elements, with lines and triangles, or tiny combined squares making up several motifs in a single basket. Or caution was thrown to the winds and a number of elements were used in a single piece such as the "1902" basket, described above, with squares, the date twice, men, quadrupeds, and line patterns, plus the larger motif, the flower with solid and outlined diamonds at each petal tip, plus additional small individual figures and crosses.

Layouts in this second period continued the encircling, organizational band; more often now there were two or three of them, with each band made up of different but repeated units of design. Rectilinear patterning was the rule in baskets of the previous period, but both rectilinear and curvilinear styles are to be noted in the 1890–1910 years, particularly as the floral type became so popular; the latter also contributed to more all-over layouts. There is more apt to be a circle in the center of these later baskets, also, and often it is larger; however, it is occasionally small or, rarely, absent. Centers may become large motifs, thus sometimes creating composite layouts.

All-over layouts became popular along with the growth of more elements and more elaborate motifs. In one example is the usual black center circle, a line several coils removed, then vertical zigzags almost to the rim; pendant from the rim is a composite motif made up of six sets of paired slanting lines, each line with three attached black triangles. Needless to say, the space on this basket was quite well filled up. Very popular are flowers with multiple rows of petals and usually with one or several small elements scattered throughout the arrangement.

Regular band layouts were not common during the 1890–1910 period. Often there was a more elaborate center motif with a circle enclosing it, then beyond it one or several bands between this and the rim; thus was created the centered-banded layout. Plain banded layouts are also uncommon. There are additional examples of layouts which can be identified as composite because of spacing; centered organizational-banded is the most common. This means a larger and more outstanding central motif with some variety to the organizational band. When all motifs become more closely arranged, they are, of course, all-over layouts, and these were the most popular of all.

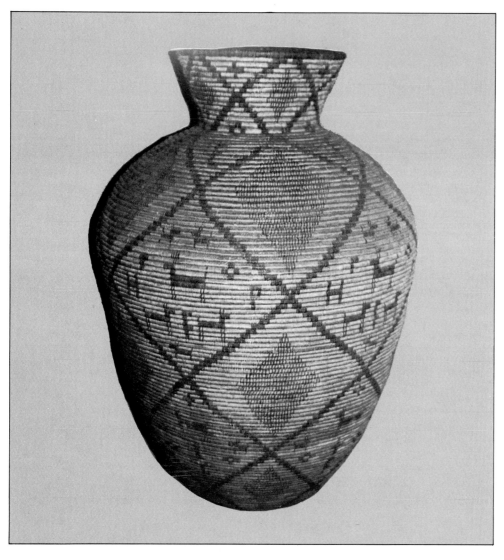

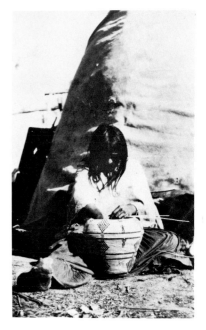

Fig. 7.4. Two baskets from the 1910–1940 period. (a) A fine example of Western Apache weaving, this jar basket is 34″ tall, 24½″ at its greatest diameter, and was woven by Hattie Randall in 1927–1928; reputedly it took her 14 months to weave the piece. Openings in the well-planned network are filled with life forms, coyote tracks, and letters or with diamonds *(private collection)*. (b) An Apache woman working on a coiled jar *(AHS #4575)*, dated 1928. Excellent form and even patterning characterize this piece.

In summary, it may be stressed that the most popular style for this period was the all-over—and there were many, many of them. There was also an exuberance that came with a feeling of freedom after the first faltering steps of the previous period.

From 1910 to 1940 there was further elaboration of the styles of layout discussed for the last period. Even more important, there were well-organized individual pieces, with better executed elements and motifs (Fig. 7.4), but there were also a great many other baskets which would be hard to distinguish from those of the earlier period. Also these same trends continued on into the post-1940 years (Fig. 7.5), with a growing simplicity in some of the coiled baskets, and a definite decline in production. In the early 1980s there was little coiled work done by the Western Apaches, and that in the traditional manner but not of the most ornate styles.

Several additional problems will be dealt with before turning to a summary of tribal styles and then, last, a brief statement relative to artistry as a whole in Apache Indian basketry. Among others, one problem pertains to the lack of reference to names of basket makers. Another is involved with the relationship of Apache-Yavapai basketry, a still unsolved question. Some obvious differences are apparent, but then again there are many which are not so readily recognized. Then there is the problem of symbolism. Differences in techniques and rims are of interest also.

Fig. 7.5. A 1975 Western Apache tray basket which shows traits which characterized this piece for many years: good weaving, a pleasing pattern, and some irregularities in the design, for example, in varying sizes of petals. This pattern is not as complicated as many from the 1900–1940 period *(private collection)*.

PROBLEMS OF NAMES OF BASKET WEAVERS

Before passing on to these other topics, a word might be said relative to names in Apache basketry. A woman provided her family with the necessities produced in this craft. Never did she "sign" her name, and it was not until recent years that some interest was generated in "who made what." A few names were known along the way but not many. For obvious reasons, basket makers' names have been omitted in this survey. Certainly most were unknown, and no one woman became famous for basket making among the Apaches, although several fine weavers have been recognized along the way.

SAN CARLOS VERSUS YAVAPAI BASKETRY

Similarities and differences between Western Apache and Yavapai basketry have been mentioned several times: these pose a problem which should be discussed.[3] Some points relative to the baskets of these two tribes may also be added to further indicate why such a problem exists. Pertinent to all of this is, of course, the fact that these two tribes lived together on the San Carlos Reservation, as well as wandering together about the state before this period, as mentioned above. Too, Yavapai baskets are often labeled "Yavapai Apache," or, for that matter, an Apache piece is not infrequently termed Apache-Yavapai.

In form there are both similarities and differences between Yavapai and Apache baskets.[4] Both produced similar tray forms with a greater variation in Apache styles. The same can be said in general for jar forms with the notation that Yavapais emphasize a more squat style which is deep, with lower and protruding shoulders, and with a very wide often neck-less mouth. Some bowls in both tribes may be alike but occasional Yavapai pieces can be heavier; oval forms of bowls are comparable. All in all, Apache forms exceeded Yavapai in far greater variety in the two major styles, trays and jars.

In many other gross characteristics in addition to shapes there are similarities as well as differences between Western Apache and Yavapai baskets. Sizes are comparable, with a decrease in this feature in both tribal products into the twentieth century. Stitch and coil counts are about equal, because materials, foundations, methods of preparation (thus sewing elements), and techniques were the same. Thus the outward appearance of baskets from the two tribes would be practically identical.

It is, then, in general appearance of design that problems arise, for here are combined traits not particularly distinctive of either tribe or, even, some traits peculiar to one, some to the other in a single basket. On the other hand, there are some baskets with designs which are distinctively Apache or Yavapai. To be sure, each tribe claims certain designs as its own, but this would seem incredible and impossible. Yavapais say that the diamond is *theirs,* that they invented or developed it—yet it is to be noted on some of the earliest known Western Apache baskets.

In general appearance of pattern Yavapai baskets as a whole have a more clean-cut, more organized, more evenly spaced and better arranged design (Fig. 7.6), yet there are individual Apache pieces which would fit this description also. Yavapai patterning is more

Fig. 7.6. Differences in organization of design in Yavapai and Western Apache baskets. (a) A Western Apache tray which reflects typical helter-skelter arrangement of elements and motifs *(photo by Ray Manley, private collection).* (b) A basket of unknown origin which illustrates the Yavapai qualities of clean and clear-cut organization of design in relation to its background *(private collection).*

symmetrical; there is less cluttering for the Apache so often is apt to throw in extra geometrics or life forms at any point, which the Yavapai does not do. In fact, these additions which are common and which seem unplanned in the Apache piece seldom appear on a Yavapai basket—what is there has been planned from the start to be there; there are fewer of them. There are independent small elements along with larger motifs, but they belong to the total pattern. The better spacing of all motifs adds to this feeling of orderliness.

The same design elements and motifs are frequently found in baskets of both of these tribes (Fig. 7.7). One difference is that there are usually, but not always, fewer of them in a single Yavapai basket design. There are the same Apache diamonds (as well as plain ones) and curvilinear triangles, the same floral or star motifs, the same squares and rectangles, stacked triangles and diamonds, the same men, dogs, and deer. Further, there is variety in Yavapai elements and motifs, but it is more controlled in a single basket than in Apache pieces. For example, there may be a solid central star and a double-outlined one beyond it, or a central black circle with solid curvilinear triangles attached to it and pendant straight-sided triangles with tiny negative patterning within them at the rim. There are, then, fewer different elements or motifs and fewer variations of any one of them in a single Yavapai basket.

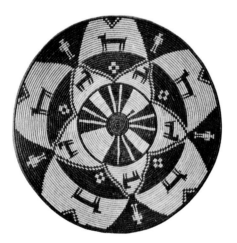 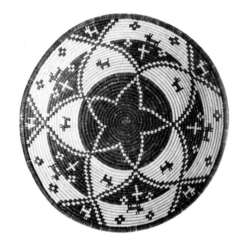

Perhaps the diamond was the most varied element or motif used in Yavapai baskets. It might be solid black and stepped, plain or with a stepped outline; it may have a coyote track, square, dot, or cross in the center, it may be positive or negative. Diamonds were often heavily outlined and plain; they were stepped with corners top and bottom filled in; they were concentric; they were commonly of the curvilinear Apache style. Frequently diamonds were stacked. Triangles also had some of these same variations; solid black ones might be put together in such ways as to create squares, or negative floral patterns, or even negative diamonds.

There is more joining of elements or motifs in Apache baskets, more spacing of them in Yavapai pieces. Also, many more of these elements and motifs are larger and black in Yavapai baskets. Even the positioning of elements or motifs is more regular in Yavapai work, more scattered in that of the Apache. For example, if a man appears, the figure will be repeated in a row in the same position around the wall of a Yavapai basket, but he may well step out of line in an Apache piece.

Fig. 7.7. Two examples of trays which show elements and motifs as used by Yavapais and Western Apaches. (a) This piece reflects Yavapai traits in a single negative coyote track in each Apache triangle of the inner circle and a single man in each of the same in the outer circle. Too, there is an individual animal in each of the areas between triangles *(AF 1113)*. (b) Contrarily, this design is typically Western Apache, with a cross and two coyote tracks in the second circle of triangles, a dog and two tracks in each of the outer light areas, a dog in each of the outer triangles, and all triangles bordered on two sides with white and black stepped squares *(AF 1123)*. Yavapai design is more discrete, Apache more flamboyant.

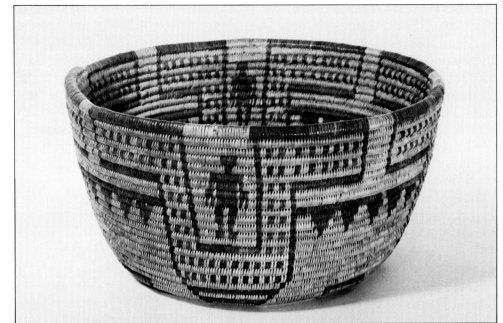

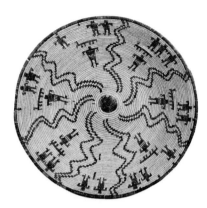

Fig. 7.8. Two baskets which reflect Western Apache "throwing in" of numerous figures and the Yavapai tendency to "frame" a single figure. (a) In the areas between zigzags which move from near-center to the rim are two to four scattered figures of men and a very strange, long-bodied animal—a typical Western Apache scheme *(ASM 26497-X13)*. (b) A bowl basket of the early nineteenth century from Yavapai County, where the tribe of this name has lived since the turn of the century. The U-shaped motif frames a large, single figure of a man, a typical Yavapai trait *(ASM E7364)*.

Layouts in baskets of the two tribes differ little, for both stressed banded and all-over design arrangements. Here again what appears to be Apache at first glance can be properly identified as Yavapai by better spacing, more exact repetition of elements and units, and more blank space.

Although the Yavapai favored concentric bands and floral or star themes, they used an additional variety of other motifs. Many of these overlap with the Apache, thus the basket in question must be distinguished as one or the other on the basis of additional features.

Life forms were frequently used by the Yavapai, but more often they were "framed" in the basket designs of this tribe whereas they might be thrown in at any point in an Apache piece (Fig. 7.8). In one Yavapai tray men appeared in negative within large curvilinear triangles; a row of these triangles created another row of the same shapes to the rim, and in these light areas appeared comparable men in black. The usual Yavapai order prevailed in the total design.

It may be said, then, that Yavapais used more black both in solids and in heavy, wide outlines (Fig. 7.9). Rims were predominantly black with few of all-white or black-white. Stars were more common in Yavapai baskets and more frequently all-black or mostly so, and, of course, they were consistently more symmetrical. They

Fig. 7.9. Line and mass as treated differently in Yavapai and Western Apache baskets. (a) Labeled Yavapai, this tray typically features darker masses and heavier lines. Too, there is more undecorated space *(ASM E2772)*. (b) In spite of the all-over plan of this Western Apache design, it has a light feeling. Outlines of the circle and star are small squares and relatively small rectangles. Scattered beyond the circle are numerous but small crosses *(photo by Ray Manley, private collection)*.

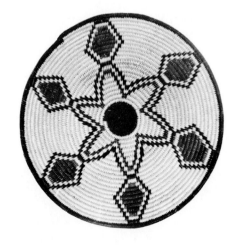

were varied: of triple heavy outlines, plain or with a black center; often with one other design on their tips; and in various combinations of positive and negative and with other designs within them. Arrowpoints, typical of San Carlos according to Roberts, appear on the tips of some of these stars.

Certainly, as a whole, there is greater simplicity in Yavapai basket designs, and there is also less variety and less action. Their patterns have a feeling of being placed in position to stay while the Apache design suggests that it could move away at any moment. The latter is particularly suggested in life forms with one man out of eight with an arm upraised, or several animals actively looking backwards while the rest march forward.

There are many overlappings in all of the above traits. As examples, some baskets in various collections used for these analyses could be Yavapai, yet some with solid black or heavily outlined designs are frequently so irregular as to suggest the greater likelihood that they are Western Apache. Also there are examples of excellent, regular, and even execution of baskets known to have been made by Western Apaches. Certainly in between the typical well ordered and darker Yavapai and the typical carelessly executed Western Apache baskets are many which could well be either. Unless provenience is definitely known, classification of such pieces remains a well-educated guess.

SYMBOLISM

One problem in relation to Indian art in general and to baskets in particular is that of symbolism.[5] Seemingly Sigmund Freud and the American Indian were "discovered" simultaneously, and ever since everything Indian, *everything* is symbolic in the minds of some people. All too serious studies have been made relative to this situation but not on firm foundations. To be sure, almost everything religious or ceremonial is apt to be full of meaning but as a whole there is little or no carry-over into the non-religious except in the minds of the over-zealous.

Frequently the Indian will obligingly give a symbolic interpretation to a design, but in such instances three Indians would most likely give three different interpretations for the same pattern. This is not symbolism. A symbol is a design taken by a *group,* and this group gives a specific meaning to that pattern. The group may be the entire tribe or some segment of it bound by common beliefs or responsibilities or background. A clan symbol belongs to a related group of people and specific meaning has been attributed to that symbol. A religious priesthood often has many such symbols.

In the typical Indian situation there is no carry-over from the religious design into the non-religious in meaning, and least of all into the objects made for sale to the white man. "Names" for designs may be offered but there is a wide gap between this and a symbolic design. Further, a survey of the growth of Apache design as given herein would tell that design came from many sources other than the religion of the Apache tribes. Sources include traditional patterns and those related to technology, themes borrowed from other tribes such as the Yavapai–San Carlos exchange, and contact-situation-inspired designs such as the Christian cross, and cowboy hats and boots.

Thus all the stories told about symbolism of individual designs should be questioned. Legends "woven into" a basket are a figment of the imagination. And "spirit line" explanations, in the main, should be forgotten. The only known exception to this statement would be the open "line" in the Navajo wedding basket which is a truly symbolic detail which apparently evolved over a long period of time. Even here this art expression is meaningful only in a specific ceremonial situation. It is possible that a "line" in some Jicarilla baskets may have had symbolic meaning, but that was long ago and such details have not survived in recent or modern Jicarilla patterns. It is also possible that this feature in old Jicarilla baskets may have had something to do with the development of the comparable feature in Navajo baskets which became so highly symbolic.

Another feature which has frequently been credited with meaning is some small irregularity in the weaving of a basket design. Such irregularities were noted in above chapters time and again, particularly in Western Apache baskets. Nothing but the whims or even carelessness of the basket weaver can explain these for they are too abundant, too varied, and too unpredictable to have meaning. When symbolism is attached to such a feature usually there is some predictable part or whole relative to the total design which can be established.

A BACKWARD LOOK AT MATERIALS, TECHNIQUES, AND FORMS

In the foregoing chapters it has been demonstrated that Apache Indians have been prolific in basketry production and have reached high levels of artistic attainment along the way. It is quite likely that these Indians learned this craft after they arrived in the Southwest, probably from other Indians here or in Mexico, and that the craft was largely utilitarian until late in the nineteenth century when production began for commercial purposes. Trade with other Indian groups certainly preceded this last incident, particularly by the earlier wandering Western Apaches. This is indicated in the provenience of some Apache baskets from "Zuni," "Hopi," and other Indian groups[6] and in random sources for various collections both private and institutional. Of course, some of this basketry came directly from the Apache reservations. Unfortunately, not enough is known pertaining to this matter to give as clear a picture as desired in relation to such problems as San Carlos versus White Mountain styles or Apache versus Yavapai design.

One point relative to Apache baskets in general should be made: there are literally hundreds of well preserved Western Apache pieces in perfect condition dating from the 1880s on to the present. Neither Mescalero nor Jicarilla early basketry is available for study in any comparable quantities, although there is a good later representation of both also in well preserved condition. Much of this testifies to basketry production for sale.

It would be well to briefly summarize the materials and technologies used by the three Apache groups plus the forms they developed. This will bring into focus the basis for the following discussions on the design characteristics of the basketry of each group.

Differing environments are reflected in the woody materials such as willow and sumac, used by Western Apaches and Jicarillas, as opposed to yucca, basically employed by the Mescalero weaver. Martynia, used by Western Apaches, is also significant in relation to design. Preparation of these materials is of further import, for sturdiness of the end product, quality of design, and other factors are related to this feature. In the overall picture Western Apaches were outstanding in the production of fine sewing withes, even though teeth and fingernails and bone awls were the sole involved "tools" in earlier years, these replaced later by metal knives and awls.

That the Western Apache basket weavers frequently did a fine job of material preparation is reflected in both shorter, more blunt but regular stitches, and longer, more slender and often fine ones, both over three small-rod foundations. Jicarillas also produced excellent sewing materials in the same manner but often their stitches were a little heavier and longer, particularly about the five-rod coils. Mescaleros frequently produced irregular sewing elements, for the "grassy" yucca which they used was more difficult to control without some aids other than fingernails and teeth. Too, their vertically stacked foundations were wide, and relatively thin, giving a flat and cruder appearance to the basket wall.

Although occasional other materials were sometimes employed in the making of burdens by Western Apaches, nonetheless the woody type was used predominantly in this basket. Contrary to their usual practices in coiled baskets, the few Mescalero twined burdens observed were also woven of more durable woody substances, with rare exceptions.

Technology in basketry involves the development of three basic methods of producing receptacles, coiled, wicker, and plaited. It may be that at some point Apaches used the plaited method, but surely there is no evidence for this in their older preserved pieces nor is there any suggestion of such in recent years today. As this is a basic technique and perhaps the oldest of the three, its absence may support the thesis that Apaches learned basketry after they arrived in the Southwest, and perhaps relatively late at that.

Twined weave was used by Western Apaches and Mescaleros for the making of the burden basket, and by Western Apaches, in addition, for the tus or water bottle. As described, the burden basket was frequently well woven, often in a diagonal or twill twine or in a plain twine. More careless was the twining of the tus among Western Apaches; here again was a practical approach, for the piece was to be covered with ground leaves and ocher, then all was pitched with piñon gum; thus the nature of the weave seldom showed.

Coiling was productive of all Jicarilla baskets, of all but the burden for the Mescaleros, and for all but burdens and the tus for Western Apaches. The list for the three groups would include trays, bowls, jars, and a few odd forms which each produced.

Shapes of Apache baskets catered to their own needs, basically; even after commercialization these old forms continued to dominate the items made for sale. There are a few exceptions, of course, as illustrated in such whimsies of the moment as pitchers, a cup, a flat plaque, all made in very limited numbers. Reflective of catering to the white man's wishes also were the hamper and the creel which were produced by the Jicarillas for a relatively short time, and the coiled jar, woven over many years by the Western Apache.

Otherwise a brief summary statement will cover the native forms. Both Mescaleros and Jicarillas produced simple forms with less variation in each, while the Western Apache had a fair variety of basic forms and diversity in each. Traditional forms were produced by all of these groups as long as they used them. Most useful and therefore most numerous were trays made by all three; the white man favored this piece for he could hang it on the wall. Mescalero styles were shallow and large; Jicarilla were quite wide, often straight walled, deep, and frequently with two handles; the Western Apache trays were in between these two—they show more variety in general forms, neither excessively shallow nor exaggerated in depth, with numerous combinations of straighter or more curving walls, and flat or rounded bottoms.

Both burden baskets and water jars were next in native-use importance. The pail or bucket shape prevailed for both Western and Mescalero Apache burdens, while the coiled water jar of the Mescaleros and Jicarillas was very simple, with straight neck and rounded body. Coiled Western Apache jars were woven for white men apparently, and accordingly enjoyed great diversity of form. Water jars made by this same group reflect some variety also, perhaps because the imaginative Western groups let fancy play as long as it did not interfere with use value.

Sizes of almost all Apache baskets were larger when they were made for their own use. There are a few exceptions to this general statement—for instance, when the Western Apache made a smaller burden to train little girls to carry them. Or they preferred a smaller water jar to carry to the creek or even smaller ones when the piece was to be thrown over the back of the hunter or raider. Rare larger pieces were produced through the years for sale, some sheer novelties in great sizes.

RIMS

One small detail which is probably reflective of historic contact is the manner of finishing a coiled basket at the rim (Fig. 7.10). Several different styles are found in pieces dating from the earliest examples to about 1910. In 26 baskets of a group of 60 Western Apache pieces, rims were either entirely gone or there was not enough left to allow for identification. Of the remaining 34 baskets one had a braided rim (rarely others have been reported), 13 were overcast, and 20 were in regular coil stitching.

Designs on the baskets with these rim finishes correspond to early Western Apache styles. The one basket with a braided rim is typically Western Apache in pattern with two each alternating static rows of stacked triangles and diamonds, all solid. How typically Apache are some of the latter which are so carelessly woven as to look more like triangles!

In the group of baskets with overcast rims there are again, early Western Apache features; they include organizational-banded and all-over, with both radiate and encircling styles dominant. It is possible that several of the bands are regular and not organizational; however, the requisite enclosing line is too indistinct to determine this except in one piece. The same is true of elements and motifs for they are like early Western Apache types: triangles, often stacked

Fig. 7.10. Rims. (a) Western Apache rim in regular sewing, all black in this example.

and radiate static and dynamic; squares or rectangles forming zig-zags; outline flowers in organizational bands; and lines, usually in meanders.

Needless to say, a description of the remaining 20 baskets with regular coil stitching in this group of 35 would reiterate what has just been said: they would have typical Western Apache designs. There would be, of course, the addition of life forms.

So what do these three types of rim finish indicate as to origins of these baskets? Perhaps they mean that as a result of contacts with other groups the Western Apaches met with new ideas. For example, Pima Indians used both close overcasting and braiding on their basket rims. Certainly these two groups of people met, possibly in Mexico and certainly in southern Arizona. Another question may be asked here also: did the Western Apaches, on their migration into Arizona, have the same contacts with puebloans as did the Jicarillas? Certainly there is evidence favoring this possibility, particularly with the more northerly pueblos. They may well have picked up braiding from such contacts.

But the Apache is a practical fellow: overcasting added strength and longer life to the basket. Perhaps after white contact and particularly with the making of baskets for sale, the weaver settled down to the simpler regular coil stitch for the basket rim. Most of the earlier overcasting material is in black on a black rim, which adds little to decoration. It saved time and effort to leave off this additional sewing.

Jicarilla rims are predominantly braided. Occasional bowls are finished in the regular sewing stitch and often these have handles, this possibly a concession to selling the piece. Hampers, also thought to be a commercial item, frequently have rims finished in regular stitching. When Jicarilla basketry was revived over 20 years ago, the braid was the proper rim finish. Even though baskets were produced for sale, there was a look backward at tradition on the part of these weavers.

In a group of 49 Mescalero baskets, rims were all finished in the regular sewing stitch. There were some variations relative to color into the rim, although 32 were in the white or natural yucca. Eleven patterns went into the rim, terminating in yellow or brown along with natural, while 6 rims were of alternate yellow-white stitching, all of the latter regular except one which had two small plain areas between the alternate color stitching.

Thus each tribe developed its own style in rims and adhered thereto quite consistently. The only significant exceptions to this general statement are to be noted in connection with the Western Apache braiding and overcasting which probably reflect pre-commercial styles, and the regular-coil sewing of the Jicarilla which is found largely on non-traditional forms.

MESCALERO DESIGN

The oldest baskets of Western Apaches and Jicarillas made equal visual impressions, both profuse with simplicity. The Jicarillas developed beyond this point but were somewhat controlled by stressing the geometric alone, seldom attempting life forms until recent years, and then always in a restrained manner. On the other hand,

Fig. 7.10. Rims. (b) Jicarilla Apache braided rim, the usual manner of finishing baskets by this tribe. (c) Mescalero rim, with regular sewing, the usual manner of finishing a basket by this tribe.

Western Apaches quickly left simplicity to the past, and ventured into dramatic presentations of a wide variety of geometrics or combinations of geometrics and life forms. Because of placid natural colors of materials used and wide coils, plus massive and usually single motifs, the Mescaleros seldom moved beyond a basic total simplicity of design. There is an almost mottled effect to some backgrounds.

Little is known of Mescalero basketry patterning in pre-1900 years. Limited references to or pieces from this date into the 1930s would indicate that patterning started and continued most simple, with this same trend for the remaining years of production. There is little or no deviation from the use of yellow, green, and white yucca with narrow red or brown outlines for designs.

Star or floral themes dominate all others in Mescalero basketry. These are usually single-petaled with a rare split-petal type (Fig. 7.11). This motif covers the greater part of the tray, thus creating an all-over style. Colors are very light yellow or green for the flower with a thin red-brown edging. Heavy floral outlines with the same edging are common, as occasionally the solid flower has a wide white band around it created by large curved triangles pendant from the rim. Often the flower is outlined and inner petal tips and/or inner space between petals will be filled in.

Other themes are treated in like manner, including triangles, diamonds, squares, lines, and rectangles. Distinctive of the Mescalero in the use of all these themes is the very narrow dark outline—it may be on two sides of a triangle or rectangle or completely around the same or other large or small motifs. Much patterning is massive but, as it is in light color and usually with no more than very narrow dark outlining lines, it seems less so than in much Western Apache decoration. Simplicity characterizes most of this work; rarely does a weaver create a more involved all-over pattern.

Thus, the outstanding traits of Mescalero basketry include the wide, flat coils, relatively poor and irregular stitches, an almost mottled background which frequently does not show because of pale colors, and massive, simple, light patterning.

JICARILLA DESIGN

Jicarilla designing, as intimated, ran the gamut from very simple to quite elaborate, the latter particularly in revival styles (Fig. 7.12). By no means can the basket designs of this tribe be summarized in so simple a manner as those of the Mescaleros.

Organizational bands dominate layout styles with some all-over arrangements which combine a darker center and often an outline flowerlike arrangement beyond it. Even in late years these two styles were still popular, but all-over layouts dominated over the organizational-banded. Seemingly in the earliest work a tan or brownish tone sufficed for design; quite early there were some other native colors used plus aniline dyes, red and green, and a few other colors which came into focus. With the revival of Jicarilla basketry in the late 1950s–early 1960s, a multitude of bright colors became the rule.

Earliest designing featured triangles, Apache diamonds, and some line work, these in solid or in heavy outline. Quite early the Jicarillas established a use of red and green together, either in alternate rows

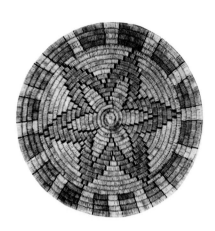

Fig. 7.11. Most typical Mescalero theme, a flower *(ASM 56928).*

to create such combinations as solid, elongate triangles, or in red diamonds outlined in green. Sometimes these geometrics were delineated in broad outlines alone, sometimes they had squares within them or projections from tips or corners. Usually there was a single geometric on a basket in earlier years; it was smaller and spaced or quite large and often joined, or less often, pendant from a band. Four repeats were most common, five quite usual, and more than five quite unusual. Most of this Jicarilla patterning was static, but occasionally a series of stepped bands moved dynamically in an organizational arrangement toward the rim.

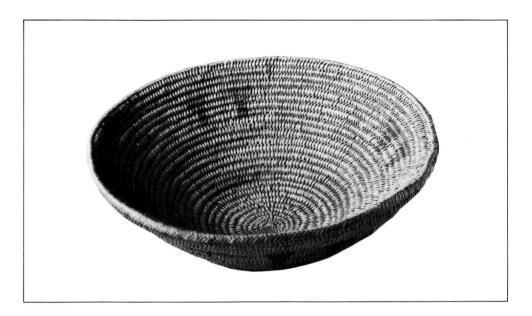

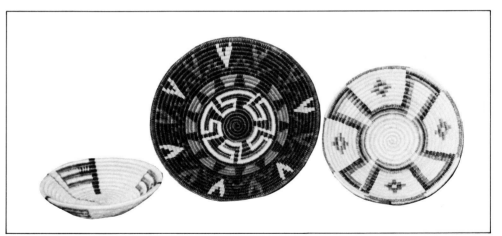

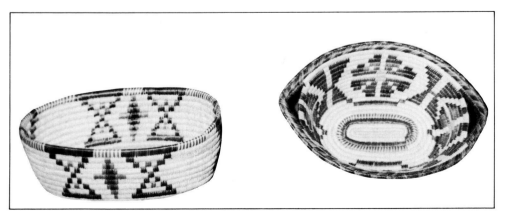

Fig. 7.12. Old and revival style Jicarilla baskets, from very simple to quite elaborate. (a) An old Jicarilla tray basket with the simplest decoration, a pair of small triangles repeated four times *(photo by Ray Manley, private collection).* (b) Revival style baskets showing emphasis on all-over designs, a number of different elements in a single basket, and a variety of geometric and some life motifs *(from Dulce trading post collection, courtesy of Dorothy Cumming).*

Plain bands, meanders, and floral themes occurred both early and late. Again color plays a part here, these designs running from a plain red, to red-green, to red-yellow-red bands, plus others. The bands of these colors might be plain or stepped, narrower or broader. A few bands are combined with a geometric, such as a diamond. One interesting feature quite frequently found with bands is the above mentioned opening which often lines up with the end of the basket rim; this could be the source of the same detail in the Navajo wedding basket band of decoration.

Then came the revival of the late 1950s and early 1960s, with traditional styles surviving in limited ways, as in an organizational band of joined large diamonds or a floral theme. Basket sizes were reduced, a great variety of aniline colors was added, and designs changed greatly. All-over layouts were more common, more design elements and units appeared on a single basket, such as a meander, crosses, and a great bird; or, on another basket, meanders, swastikas, outline and solid triangles, coyote tracks, and diamonds. Motifs comprised of several geometrics were common, such as a stepped diamond closely bound by two triangles touching at their tips, and all units stepped and of several colors. Animals are more common and plants appear.

Withal there was a pleasing balance of pattern, usually good spacing, and imaginative combinations of elements. Add to this capable weaving, more patterning, and the new Jicarilla basket carries on in a different but desirable manner. Distinctive are the shiny quality when sumac is employed, the large coils especially when five foundation rods are used, handles on some trays, variety and brightness of color in recent years and even a few in old styles, and large designs earlier and more complex ones in revival baskets.

WESTERN APACHE DESIGN

It seems almost impossible to think of summarizing the design characteristics of Western Apache basketry, for this subject presents such a complex story it will of necessity leave more out than it can include (Fig. 7.13). Nonetheless, the high points will be touched upon in an effort to present a logical summary and a basis for the following artistic analysis.

Color was emphasized as significant in design for both the Jicarilla and Mescalero baskets. All that need be said for the Western Apaches is that black on natural offered a basic and almost sole contrast whether in positive or negative, whether in small or larger quantity. Variety of pattern offsets any boredom which might have resulted from this simple black-white combination.

Very early Western Apache basketry can be briefly presented yet it promises a certain variety in years to come (Fig. 7.13a). Limited design, small units, poor spacing, single or very few elements in a given basket, often irregular design, radiate static (rarely dynamic) arrangements, flower designs, and very small organizational-band and scattered all-over layouts—these traits would characterize this earliest work.

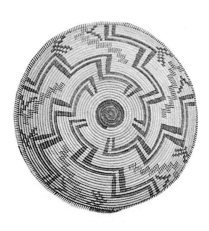

Fig. 7.13. A variety of Western Apache baskets. (a) Early basket decoration stressed a single and usually small element, which was often irregular. Early steps were often uneven *(private collection)*.

Then came a burst of vigor and enthusiasm along with commercialization of the basket of these Western Apache groups (Fig. 7.13b). Layouts became really all-over in many more instances as a part of this new vigor; design became dynamic for the same reason. Floral or star themes started near center and multiplied to the rim; as though this were not enough, many small elements, both geometric and life forms, livened up pattern as they were thrown in here and there. Single bands became multiple, with each one often featuring different motifs or elements. Four straight lines of stacked triangles of earlier times frequently became six or more of curving triangles or squares. Poor spacing, careless figures, irregularities all continued into this period and some of these traits persisted into much later baskets.

In like manner, new and different qualities began to be expressed, even in the 1890–1910 years. Some of the floral or star themes became more evenly spaced, more regular in form, whether with or without additional small elements. More alternate motifs were used, and some were regular and not confused as in so many earlier baskets. Dynamic curving motifs became more popular than they had been before. Small and large animals appear in the same basket, and men are represented in a variety of forms.

All of these trends extend into the 1930s and 1940s, with even greater variety (Fig. 7.13c). The same elements and motifs continue in popularity but appear in new creativity, for example a nine-petaled flower is made into quite a new and different design by checkered diamonds extending from their inner tips toward the center. Men and/or quadrupeds stand on as well as between the steps of dynamic motifs moving from center to rim. In some better baskets there may be greater regularity and evenness in points; the same is true in the common placement of men and animals in relation to this motif.

In Western Apache coiled baskets, from about 1900 into the 1940s most patterns are in positive, but there are some in negative and still others in equally balanced positive-negative. One negative piece, for instance, has a single outline flower, a double outline star, then a band to the rim of alternating elaborate geometrics plus vertical zigzags, all composed of white squares on a black background. One example of a balanced positive-negative design has swirls of step-sided black bands well balanced in size and shape by like white ones. A popular and often repeated style is made up of successive rows of black curvacious Apache triangles so arranged as to leave the same shapes in white between them; there may or may not be white figures in the black motifs and black ones in the white triangles.

The central circle in earliest pieces was absent or very small; in later years it became larger or changed into a simple or complex design element or motif, usually related effectively to the total pattern. Sometimes the basic motif will directly join the center circle or other form; for example the center may be a flower and other petals may take off this to the rim. As noted, this was a favored motif.

Among other popular treatments in this longer period of time were larger motifs with more smaller elements between them.

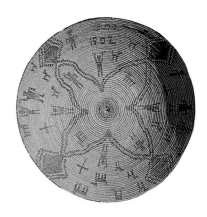

Fig. 7.13. (b) Floral themes with life figures added were also quite early *(private collection).*

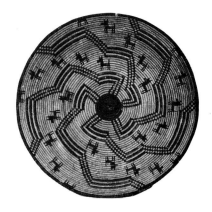

Fig. 7.13. (c) Steps were also ornamented with life figures between them *(ASM GP4323).*

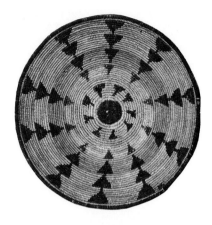

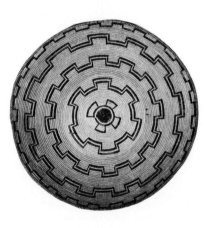

Swirls, usually of stepped squares or rectangles, became more numerous as well as more dynamic. Most popular were the Apache triangle and diamond, both in many and varied combinations, solid black or heavy or light outline, with figures within them or not, plain or with outlines. Regular diamonds were rarely presented in the old style, in a joined row around the tray. Meanders not only remained popular but also were developed to a high point. They were used alone or two were opposed, they were in single, double, or triple outline and were arranged horizontally or vertically. Steps became even more prevalent through the years, either alone or to create other forms.

Then there were bands, bands large and small, many horizontal, some vertical bands containing triangles, diamonds, coyote tracks, checkers, zigzags, and other geometrics. In addition, many of the same geometrics formed organizational bands.

Last were small elements. These may appear in organized relation to various geometrics, such as positive or negative life forms or geometrics in triangles or diamonds. There were the numerous small elements, again geometrics or life forms, which were thrown in between main motifs, either in a planned or haphazard manner. These may complete a design or may crowd a pattern.

The above comments obviously apply primarily to tray baskets, and essentially the same would apply to bowls. A summary word or two might also be said regarding the coiled jar. Western Apache jars feature all-over patterns, with a definite design on the base often connected to the body pattern. Although horizontal plans were executed, far more were vertically or diagonally arranged on the jar. Essentially the same elements, units, and motifs were used in decoration of this form as in trays; the main difference was in adaptation of total pattern to details of form in individual baskets.

Certainly one would recognize a jar as Western Apache by its feeling of all-over decoration; by the common placement of miscellaneous small life forms or geometrics here and there among great meanders; or within and/or about joined or independent diamonds and triangles in outline or in checkers. Side walls may feature vertical rows of stacked triangles or diamonds, or horizontal arrangements of zigzags of three or four parallel lines of stepped squares, or zigzags. Many of the large geometrics served as frames for the smaller life forms and geometrics, as these appeared both inside and outside such forms. Massive crisscrossing of the wall by double,

Fig. 7.13. Western Apache baskets. (d) Both early and late, stacked triangles were popular *(ASM 13514).* (e) Many patterns were better executed in later years, as were these frets *(ASM 8010).* (f) Steps became more numerous and more complicated as the years went by *(ASM E2813).* (g) Later, too, encircling bands were better done *(ASM E2769).* (h) Floral themes, too, were better executed *(ASM 2777).*

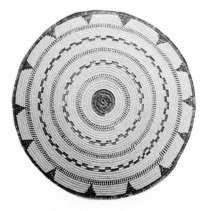

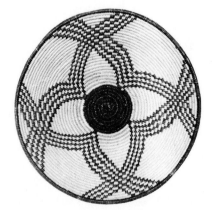

triple, or even quadruple lines of squares or rectangles created large areas for crosses, coyote tracks, diamonds, plus other geometrics, and individuals or rows of men, women, horses, dogs, or deer.

Once in a while a jar pattern may be more spaced out but the majority are quite well covered with patterning. This, as noted, would surely be a later form with the likelihood that it was made solely for commercial reasons. This sales aspect, of course, is commendable, for without that commercial urge, Western Apache basketry, like so many other tribal crafts, would have disappeared.

The post-1940s trends in which Apache coiled basketry declined in both quality and quantity as a whole, with some individual pieces still at a high level, were due to many factors. The war effort, wage-earning jobs, and other economic changes, plus a lack of the commercial urge, were responsible for much of this. The burden basket, however, continued to be used by Western Apache women for some years, but gradually this too ceased to be made in some areas and dwindled in others. There was, nonetheless, a brisk production of this form even into the 1980s for commercial purposes.

This burden basket found favor with the white man and was woven in the San Carlos area in particular. Significant changes included a more conical or smaller based form, emphasis on design in deep brown or black, or both colors, and more elaborate patterning. One of the most significant changes occurred in design in 1980, namely, the introduction of life forms with more of them into 1982. Four deer were woven into a fairly large burden in the first observed piece, along with additional geometrics plus the inevitable bands above and below. Otherwise geometric designs prevailed as always with greater elaboration in the usual bands. For example, in one piece there are three plain brown bands and in the wider ones between them are black, joined coyote tracks which also look like simple checkers. Another of these late design trends is the large geometric in bands. Otherwise, it should be reiterated that there was great variety of design early and late in the wicker burden basket because of alternation of colors and of geometric forms both vertically and horizontally arranged in the encircling bands.

ARTISTRY OF APACHE BASKETS

It is of interest to note that craft arts are today accepted in the realm of fine arts, and well they should be! Many individual pieces of Apache basketry would fit into such a classification for they possess qualifications for such recognition. The greatest artistry of the Apache basket is in its synthesis of all characteristics, form, creativity in design, and in execution of all its parts. Craft arts are produced basically for utility purposes and may be decorative; fine arts more often are independent expressions with no use value beyond the esthetic. With commercialization, the latter is more often expressed by the Indian woman.

All aspects of basketry will be included in this artistic or esthetic analysis. First, of course, would be materials. Here the Indians refined through preparation and added color to enhance inadequacies in raw materials. Perhaps the use of yucca by the Mescalero Indians

would disqualify their basketry for a place in the fine arts, for its softer nature does not allow for some of the better qualities possible in the use of woody substances. Sumac and willow allow for the preparation of more regular and even elements, and they are more readily manipulated and controlled by the weaver. Further, with age both of these materials assume a soft, golden tan color; sumac has an additional soft sheen which is a pleasing foil for the many colors used through the years.

Handling of color presents interesting tribal differences in artistic approach. Many attractive soft tones as well as unattractive and harsh ones were used by Jicarillas through the years. Here again, as with great paintings, time has changed basic colors, often softening or changing those used by Jicarillas in particular. Mescalero Apaches started out with and never deviated from soft greens, yellows, and a dark but equally pleasing brown or red-brown.

Western Apaches, on the other hand, were influenced by readily available materials and were far more limited in color; they used stark black on stark white, the white softening with age. These Apaches then sought more artistic expression with their limited colors through balanced positive against negative, through concentration on more complex and interesting patterning. Perhaps even the whimsy of an irregular bit of designing was not alone to satisfy the weaver but also to appeal to the buyer.

Technology can impose limitations on design. In this area, Apaches expressed artistry in the preparation of thin and even elements, and in the fine sewing process to produce slender or short pointed stitches. Certainly one or the other was maintained throughout the basket. Mescaleros featured long narrow but irregular stitching, while Jicarilla weavers were adept in producing shorter but more regular sewing. Western Apaches maintained the smallest coil and best sewing, therein having the best basis for finer technology. Fine stitching of this group allowed for equally fine and even small designs.

Great esthetic value can be related to basket forms. Some, to be sure, are pedestrian, some become so by constant repetition. However, as among primitive folk, once the use-value has been supplied in a given shape, variation takes place to the creator's desire, and does so among the Western Apaches in particular. Interestingly, even with commercialization, little deviation from the use-value forms is to be noted.

Flowing lines are typical of the tray forms, often most graceful. Bowls are more stiff and show little variation. Apparently they were not used to any degree by the Apaches, for a deep tray would serve the same purpose, nor, seemingly, was the bowl acceptable to the commercial world. Greatly preferred was the tray, for its entire design could be seen at one glance; thus, the white man could display it advantageously. Many form variations were expressed in the jar also, almost none in the hamper. Then, to add to the artistic, there was a development of style of decoration well adapted to differing forms. In fact, in many instances decoration was so cleverly adapted that it emphasized shape.

A sense of design was apparent in Apache basketry from the beginning. Simple though the arrangement of pattern was in earliest baskets, nonetheless there was, many times, a pleasing adaptation

of the limited design to the shallow trays. Then, rather abruptly as noted, there was a great splurge, a tremendous increase in quantity and quality of pattern. Often it was pleasing even though it showed the exuberance of sudden expansion, and often displayed the errors of lack of control of figure placement.

A few qualities typical of the craft arts but ones usually dropped with the development of easel painting, except in the general sense, are symmetry, balance, and repetition. Symmetry is expressed time and again in basketry design, in total pattern, and in major motifs and minor elements. The same is true of balance, for a triangle or other geometrics reflect left-right balance; so too does a man unless one arm is raised. Balance is to be noted as left-right, up-down in regular diamonds but there is left-right balance only in the curving Apache diamond.

Repetition is basic to basketry patterning for repetitive stitches invite it. Creativity expresses itself here in the transition from repetition of one motif to several alternations. The simplest is exemplified in a triangle pendant from a line in a very early Western Apache basket; Mescalero designing is dominated by this simplest type of repetition throughout its basketry development. The same is almost true of Jicarilla baskets but the situation is relieved by the use of alternating colors, such as successive rows of red and green in each repeated design motif such as a triangle. Later there is some variation from this basic style. The earliest repetition lingers through the entire development of Western Apache basketry design; it is obvious today in the repetition of the same rounded petals in three identical rows of flowers. But these same Western Apaches broke from the simpler style of alternating motifs, for example a man-dog-man-dog, or sometimes more complicated alternations such as man–dog–coyote track–dog–man. Then there were those breaks in alternations which may have been planned or may have involved spur-of-the-moment changes; not uncommonly there might be two men for five repetitions, then one man. Most of the breaks in this type of repetition occur in small elements and not in major motifs.

Western Apache basket makers certainly had a sense of light versus dark and intentionally played it up many times with most artistic results. Perhaps the classical examples of this are the above mentioned black triangles or diamonds so woven as to create white ones between them. Also intentional smaller positive and negative figures within larger ones of opposite nature reflect this same awareness of the play of light and dark.

Although static designing predominated in early Western Apache work, it was not long before these Indian women discovered dynamism, and apparently it pleased them. Some of their patterns in this style surpass the work of any other Southwestern basket makers. They expressed every degree possible of movement in basket patterning from the barest tilt to an outward moving meander to one starting near center and ending halfway around the basket. Multiply the number of moving units by 21 and the end result is dizzying!

Variety was expressed in a number of other ways by these basket weavers. Light to heavy treatment is not uncommon in Western Apache pieces. Some floral patterns are so delicate as to be veritable

tracery. Progression from this goes from multiple lines, usually no more than four to a unit such as a meander, to checkerboarding as in bands, to complete solids, for example in large black diamonds.

Despite their shortcomings in much poor spacing, in irregular figures now and then, in lack of exact repetition, and a few other unexpected details, this Western Apache basketry is often beautifully executed. Even some of the irregularities may have a charm all their own, and, like some devices in modern art which are no better conceived, they are "attention getting."

All in all, there is artistry in the basketry of the three groups, Jicarilla, Mescalero, and Western Apaches. There is great beauty in individual pieces, in color, in design, in the overall execution. And there are many Western Apache baskets which, in their total qualities, reveal a high level of the esthetic. Esthetic perception of many individual Apache basket weavers transcended the controls of materials and techniques and allowed the expression of works of art in fine pieces of basketry.

It may be said that Apache basketry can be identified by the manner in which elements, units, and motifs are coordinated into a design, a design that says "this is Apache." It is history, culture, environment, and the individual combined which produce a San Carlos or a Jicarilla piece; inasmuch as these are not the same in each Apache group, neither is their basketry. Thus San Carlos, White Mountain, Jicarilla, and Mescalero baskets can be identified as products peculiar to each of these groups. Like forms have been discussed, but they are not the same. Identical design units and elements are used by Western and Eastern Apaches alike, but their respective backgrounds and feeling of creativity come into focus and identify each for its tribal affinities. Thus do the basketry products of each Apache group reflect the background and individuality of the weaver; in so doing, they are works of art.

Chapter 1

1. Aikens 1970:133–53.
2. Jennings 1957.
3. Loud and Harrington 1929.
4. Rouse in Kidder 1962:1–49.
5. Haury 1976.
6. Cosgrove 1932 and 1947.
7. Morris and Burgh 1941:Figs. 24, 27, 30, 31.
8. Cosgrove 1947:99–113.
9. Roberts 1929:129–30.
10. Basso 1971:12.
11. Getty 1963.
12. Arizona Commission of Indian Affairs 1980.
13. Dobyns 1973:1.
14. Ibid:1–17.
15. Ibid:16.
16. Ibid: 33–34.
17. Ibid:34–39.
18. Ibid:39–53.
19. Ibid:53–62.
20. Ibid:68.
21. Ibid:61–84.
22. Opler 1946:3.
23. Smith 1966:62.
24. Ibid:67–69.

Chapter 2

1. Gifford 1931:3.
2. Goodwin 1969:463.
3. James 1903.
4. Field 1964:14 and Plate No. 6C.
5. Mason 1904:510.
6. Butler 1976 (unpublished ms.).
7. Roberts 1929:139–46.
8. Ibid:139–40.
9. Ibid:137.
10. Ibid:135.
11. Cumming conferences: 5-15-63, 2-19-81 (plus others).
12. Douglas 1940:195.
13. Roberts 1929:156–57. Also see Morris and Burgh 1941:24.
14. Ibid:158.
15. Ibid:146.
16. Ibid:147.
17. Holmes 1888.
18. Basso conferences: 12-13-78, 6-5-81.
19. Mason 1904:510.
20. Ibid:511.

Chapter 4

1. Roberts 1929:Fig. 18, far right in third row from top.
2. The large jars are also used for tiswin. "'One drink of tis-win,' remarked a soldier who tried some of it, 'would make a jack-rabbit slap a wildcat in the face.'" (Barnes 1941: 51)
3. Hrdlicka 1905:85.
4. "A privilege enjoyed only by clan 1 was the right to paint a decoration about the shoulder of their basketry water bottles. If individuals of another clan dared to decorate their water bottles likewise, people of clan 1 might destroy the vessels." This observation by Goodwin (1969:117) is interesting as it applies to no other Apache basketry decoration.
5. Roberts 1929:151.
6. For further examples of Western Apache coiled baskets, see Roberts 1929; Robinson 1954; *Arizona Highways*, Vol. L1 7, July 1975, ibid. Vol. 53, No. 7, July 1977, and advertisements in *American Indian Art Magazine* 1976–1982.
7. It is a well-known fact that Apache baskets were used at Zuñi for some years in the late nineteenth century. See Stevenson 1883.
8. Jeancon and Douglas 1931 (n.p.) reported that Apaches, among others, made "marriage baskets" for the Navajos.
9. The designs on these baskets were produced by photo drawing.
10. Basso conference: 8-1-67.
11. Roberts 1929:164.
12. See McKee *et al.* 1975.
13. Guenther conference: 8–15-16–75, 11–7–75.
14. As Roberts designates the arrowpoint as distinctive of San Carlos basketry decoration, this is an interesting occurrence. It could mean a spread of this motif, or perhaps a case of intermarriage.

Chapter 5

1. Ellis and Walpole 1959.
2. Ibid:182.
3. Douglas 1939:151 (cites sumac only).
4. Bennett 1974. In her book Bennett discusses the "spirit trail" and "weaver's pathway" concepts in Navajo rugs. Navajo baskets also have this opening as herein described for the Jicarilla.
5. Herold 1978.
6. Ibid:31.
7. Additional information on revival baskets was provided by Dorothy Cumming in letters, photographs, and conferences.

Chapter 6

1. Goddard 1909:393.
2. Dobyns 1973:4.
3. Ibid:63.
4. Ibid:72.
5. Ibid:74–75.
6. Goddard 1931:160–61.
7. Douglas, December 1939:151.
8. Goddard 1931:161–62.
9. Douglas, February 1940:195. Wicker styles were also noted by this writer.
10. Bell and Castetter 1941:35.
11. Opler 1941:380.
12. Ibid:381.
13. Ibid.
14. Ibid.
15. Lamb 1972:111.
16. Mason 1904: Plate 227, upper.
17. Ibid: Plate 227, lower.
18. Miles and Bovis 1969:95, Plate 65.
19. Evans and Campbell 1952:Fig. 16.

Chapter 7

1. Inasmuch as a great deal more is known for this Western Apache group, it was thought wise to use these approximate dates and to summarize developments within them.
2. Occasional later baskets may also have a limited number of design elements.
3. Conference, Gerald Collings: 12-2-79 (plus others). Many of these points were discussed and agreed upon.
4. Barnett 1968:16, 34–38.
5. Saw 1971.
6. Stevenson 1883:369, several Apache baskets mentioned under "Collections of 1879—Zuni." Figs. 541, 542, labeled under "Collections of 1879—Wolpi." Both appear to be Apache, and 542 would seem to be unquestionably Apache. Certainly they are not Hopi as "Wolpi" would imply.

Bibliography

Aikens, C. Melvin

 1970 Hogup Cave. *Anthropological Papers,* No. 93. Salt Lake City: University of Utah.

Arizona Commission of Indian Affairs

 1980 *Tribal Directory.* Phoenix, Arizona.

Arizona Highways

 1975 Vol. L1, No. 7, July 1975. Phoenix, Arizona.

 1975 Vol. 53, No. 7, July 1977. Phoenix, Arizona.

Barnes, W. C.

 1941 *Apaches and Longhorns.* Los Angeles: Ward Ritchie Press. (Reissued 1982, Tucson: University of Arizona Press.)

Barnett, Franklin

 1968 *Viola Jimulla: The Indian Chieftess.* Prescott Yavapai Indians, Yuma, Arizona.

Basso, Keith H., editor

 1971 *Western Apache Raiding and Warfare.* Tucson: University of Arizona Press.

Bell, Willis Harvey and Edward Franklin Castetter

 1941 The Utilization of Yucca, Sotol, and Beargrass by the Aborigines in the American Southwest. *Ethnological Studies in the American Southwest* VII, Biol. Series, Vol. 5, No. 5. Albuquerque: University of New Mexico.

Bennett, Noel

 1974 *The Weaver's Pathway.* Flagstaff, Arizona: Northland Press.

Butler, Denwood

 1976 The Plant Materials Used in the Basketry of the Southwestern American Indians. Unpublished paper.

Cosgrove, C. B.

 1947 Caves of the Upper Gila and Hueco Areas in New Mexico and Texas. *Papers of the Peabody Museum of American Archaeology and Ethnology,* Vol. XXIV, No. 2. Cambridge, Mass.: Harvard University.

Cosgrove, H. S. and C. B.

 1932 The Swarts Ruin: A Typical Mimbres Site in Southwestern New Mexico. *Papers of the Peabody Museum of American Archaeology and Ethnology,* Vol. 15, No. 1. Cambridge, Mass.: Harvard University.

Dobyns, Henry F.

 1973 *The Mescalero Apache People.* Indian Tribal Series, Phoenix, Arizona.

Douglas, F. H.

 1939 Types of Southwestern Coiled Basketry. *Department of Indian Art Leaflet* 88. Denver Art Museum, Denver, Colorado. (December)

 1940 Southwestern Twined, Wicker and Plaited Basketry. *Department of Indian Art Leaflets* 99–100. Denver Art Museum, Denver, Colorado. (February)

Ellis, Florence H. and Mary Walpole

 1959 Possible Pueblo, Navajo, and Jicarilla Basketry Relationships. *El Palacio,* Vol. 66, No. 6. The Museum of New Mexico, Santa Fe, New Mexico.

Evans, Glen L. and T. N. Campbell

 1952 *Indian Baskets.* Texas Memorial Museum, Austin, Texas.

Field, Clark

 1964 *The Art and the Romance of Indian Basketry.* Philbrook Art Center, Tulsa, Oklahoma.

Getty, Harry T.

 1963 The San Carlos Indian Cattle Industry. *Anthropological Papers of the University of Arizona,* No. 7. Tucson: University of Arizona Press.

Gifford, E. W.

 1931 Indian Basketry. In *Introduction to American Indian Art, Part II.* The Exposition of Indian Tribal Arts, Inc., New York, New York.

Gifford, James C.

 1980 Archaeological Explorations in Caves of the Point of Pines Region, Arizona. *Anthropological Papers of the University of Arizona,* No. 36. Tucson: University of Arizona Press.

Goddard, Pliny Earle

 1909 *Gotal: A Mescalero Apache Ceremony.* Putnam Anniversary Volume. Cedar Rapids, Iowa: The Torch Press.

 1931 *Indians of the Southwest.* American Museum of Natural History Handbook, Series No. 2. New York.

Goodwin, Grenville

 1969 *The Social Organization of the Western Apache.* Tucson: University of Arizona Press.

Haury, Emil W.

 1976 *The Hohokam, Desert Farmers and Craftsmen.* Tucson: University of Arizona Press.

Herold, Joyce

 1978 The Basketry of Tanzanita Pesota. *American Indian Art.* Vol. 3, No. 2, Scottsdale, Arizona.

Holmes, William H.

 1888 A Study of the Textile Art in its Relation to the Development of Form and Ornament. *Bureau of American Ethnology Sixth Annual Report,* Washington, D.C.

Hrdlicka, Alex

 1905 Notes on the San Carlos Apache. *American Anthropologist,* n.s. 7.

James, George Wharton

 1903 *Indian Basketry.* Pasadena, California.

Jeancon, Jean and Frederic H. Douglas

 1931 The Navajo Indians. *Department of Indian Art Leaflet* 21. Denver Art Museum, Denver, Colorado. (April)

Jennings, Jesse D.

 1957 Danger Cave. *Anthropological Papers,* No. 27, Department of Anthropology, University of Utah, Salt Lake City.

Lamb, Frank W.

 1972 *Indian Baskets of North America.* Riverside, California: Riverside Museum Press.

Loud, Llewellyn L. and M. R. Harrington

 1929 Lovelock Cave. *University of California Publications in American Archaeology and Ethnology,* Vol. 25, No. 1, Berkeley.

Mason, Otis Tufton

 1904 Aboriginal American Basketry. *Annual Report, Smithsonian Institution* 1902. Report of the U.S. National Museum, Washington, D.C.

McKee, Barbara and Edwin, and Joyce Herold

 1975 *Havasupai Baskets and Their Makers: 1930–1940.* Flagstaff, Arizona: Northland Press.

Miles, Charles and Pierre Bovis

 1969 *American Indian and Eskimo Basketry.* Bonanza Books, New York.

Morris, Earl H. and Robert F. Burgh

 1941 Anasazi Basketry: Basket Maker II through Pueblo III, A Study Based on Specimens from the San Juan River Country. *Carnegie Institution of Washington Publication* 533, Washington, D.C.

Opler, Morris Edward

 1941 *An Apache Life-Way.* Chicago, Illinois: University of Chicago Press.

 1946 Childhood and Youth in Jicarilla Apache Society. *Publications of the Frederick Webb Hodge Anniversary Publication Fund,* Volume 5, Southwest Museum, Los Angeles.

Reagan, Albert B.

 1931 Notes on the Indians of the Fort Apache Region. *Anthropological Papers of the American Museum of Natural History,* Vol. 31, New York.

Roberts, Helen H.

 1929 The Basketry of the San Carlos Apache Indians. *American Museum of Natural History Anthropological Papers,* Vol. XXXI, Part II, New York.

Robinson, Bert

 1954 *The Basket Weavers of Arizona.* Albuquerque: University of New Mexico Press.

Rouse, Irving

 1962 In Kidder, Alfred Vincent, *An Introduction to the Study of Southwestern Archaeology.* New Haven, Conn.: Yale University Press.

Saw, Ruth L.

 1971 *Aesthetics: An Introduction.* Garden City, New York: Doubleday & Company, Inc.

Smith, Anne M.

 1966 New Mexico Indians: Economic, Educational and Social Problems. Museum of New Mexico Research Records, No. 1, Santa Fe, New Mexico.

Stevenson, James

 1883 Illustrated Catalog of the Collections Obtained from the Indians of New Mexico in 1880. In *Bureau of American Ethnology Second Annual Report,* Washington, D.C.

CONFERENCES

Basso, Keith H. 12–13–78, 6–5–81
Collings, Gerald 12–2–79 (plus others)
Cumming, Dorothy 5–15–63, 2–19–81 (plus others)
Guenther, Mrs. Edgar 8–15-16–75, 11–7–75